STANLEY SPENCER

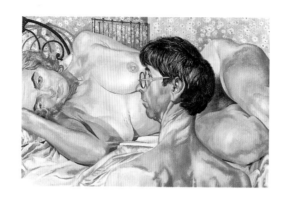

STANLEY SPENCER

Keith Bell

Frontispiece:
Cat 223
Self-Portrait with Patricia Preece
1936

Phaidon Press Limited
Regent's Wharf
All Saints Street
London N1 9PA

First published 1992
Abridged paperback edition 1999
© 1992 by Phaidon Press Limited
Text © 1992 by Keith Bell

A CIP catalogue record for this book is
available from the British Library

ISBN 0 7148 3890 X
Original edition 0 7148 2735 5

Printed in Hong Kong

Contents

The idea for a complete catalogue of the paintings of Stanley Spencer was first suggested to me by Norman Rosenthal while I was working on the 1980 Royal Academy *Stanley Spencer RA* exhibition, for which I chose the paintings and wrote the section introductions and entries for the catalogue. Even then it was clear that it was becoming increasingly difficult to trace many of Spencer's paintings as the original owners died and the works passed into other hands. In addition, a certain group of works, those in public and a few in private collections, tended to circulate continuously in exhibitions and publications. The outcome was a certain view of the artist's work which did not permit a complete idea of his artistic production, notably in the area of landscape and portrait work and the later figure paintings. It was clear to me, despite Spencer's sometimes disparaging remarks about his practice as a landscape and portrait painter, that his works in these areas was both important to him and a substantial contribution to British art. Furthermore, critical opinion had tended to favour Spencer's early work over the later series of 'imaginative' paintings. One of the purposes of my work on Spencer was to provide a broader view of his contribution to British art which would avoid the earlier selective approach of some critics.

The 1980 Royal Academy exhibition and catalogue were extensive enough to help provide a broader survey of Spencer's production, but until the publication of my *Stanley Spencer: A Complete Catalogue of the Paintings* in 1992 there was no comprehensive reference work for scholars, collectors and dealers to refer to. In addition, the Academy catalogue has long been out of print. Since the publication of the 1992 *Catalogue*, interest in Spencer's work has if anything become more intense, culminating in the recent exhibition *Stanley Spencer: An English Vision* (1997), organized by the Hirshhorn Museum and Sculpture Garden, Washington, DC, in conjunction with the British Council, which brought the artist's work to a broader audience in North America. It is therefore both useful and appropriate that this new edition of my 1992 book, containing the full narrative text and an abridged catalogue section, should be published now with the intention of providing the growing audience for Spencer's art with a comprehensive study of his work.

During the research for this book many people have been unfailingly generous with their time and knowledge. First among these must be Shirin and Unity Spencer whom I first met when I began work on the Stanley Spencer exhibition for the Royal Academy in 1978. Their help and support have made my work not only challenging but a real pleasure. Among those who knew the artist well I would particularly like to acknowledge the help of Nancy Carline, the late Richard Carline and the late Gilbert Spencer, who spent many hours patiently answering my questions and discussing ideas, particularly about Stanley Spencer's early career. Similarly, the late Nicholas and Andrew Tooth generously gave

me access to their archives and photographic records, as well as helping me to trace numerous paintings. Without their help, and subsequently that of Simon Matthews, this book would have been impossible to produce. In addition I would like to thank Duncan Robinson, himself a Spencer scholar, who first suggested Stanley Spencer to me as a subject for study, and who subsequently provided continuous support both for my work on the Royal Academy exhibition and for this book.

I have been assisted at every step by the staff of numerous institutions and private galleries. Of these, the Tate Gallery Archives, which contain the Spencer papers, has been one of the most important. The staff of the Archives always went out of their way to facilitate my research. Curators and archivists at other institutions not only in Britain but also in Australia, Canada, New Zealand and the United States have all been equally generous with their time and information. Among the private galleries I would particularly like to acknowledge the interest and help provided by Tooth Paintings, the Bernard Jacobson Gallery, the Anthony d'Offay Gallery and the Piccadilly Gallery. Many others have gone to great lengths to answer my requests for information and have helped trace the owners of innumerable paintings.

From the earliest stages of my research on Spencer I have relied heavily on the records and the expertise of the staff at the major sale rooms. Graham Southern of the Department of Modern British Paintings at Christie's and Janet Green of Sotheby's, together with their colleagues, were unfailingly helpful in assisting my search for elusive paintings and in helping me to contact the owners.

Any book about the artist and his paintings is also a record of the owners of those works. Stanley Spencer always attracted committed collectors, like the late Wilfrid Evill, who not only bought his paintings but got to know the artist as well. During my research I have been helped by many collectors who have supplied me with information and invited me into their houses to view the pictures at first hand. I would like to thank them both for their time and for the enthusiasm which they communicated about their Spencer paintings and their friendship with the artist.

Among those collectors and enthusiasts are the past and present Trustees of the Stanley Spencer Gallery, Cookham, in particular Marjorie Metz, Alec Gardner-Medwyn and Carolyn Leder. I would like to express my particular appreciation for their support and assistance, as well as the very helpful information contained in Ms Leder's book, *The Astor Collection* (Thomas Gibson Publishing, 1976, limited edition).

I would like to thank the following: Mary Bone, Ivor Braka, Daphne Charlton, Andrew Causey, Keith Clements, Clare Colvin, Joseph Darracott, Sarah Fox Pitt, Honor Frost, Sophie Gurney, Bernard Jacobson, James Kirkman, Lady Pansy Lamb, Isabel Powys Marks, Catherine Martineau, the late Jack Martineau, the late Philip Metz, Lord Moyne, Graham Murray, Anthony d'Offay, Geoffrey Robinson, Helen Robinson, the late Sir John Rothenstein, Norman Rosenthal, Dr A.D. Taliano, Pauline Tooth-Matthews, the late Lord Walston, the Rev. Canon R.M.L. Westropp and Elizabeth Wood.

I would like to acknowledge the assistance of the University of Saskatchewan in providing time release from teaching and a publication grant while this book was in the process of preparation.

In addition, there are many other people who have helped me in various ways during the production of this book. They include my Phaidon editor, Bernard Dod, and the picture researcher, Philippa Thomson, whose care and patience have been exemplary. Mary Frances Schmidt did a superb word-processing job in the production of the complicated manuscript. Others, including D. Douglas, L. Biggs and a number of my colleagues have also helped me in a number of ways. In particular, I would like to thank Dr Lynne Bell for her intellectual rigour and unfailing support during all the time it took to produce this book.

Last but not least I would like to acknowledge the unfailing support of my family: my sister Sheena Rolph, and my parents Edith Muriel Bell and Thomas Forest Bell, to whom this book is dedicated.

1891 Born 30 June at Cookham on Thames, Berkshire, the eighth surviving child of William Spencer, organist and piano teacher. Educated at a morning school run by his sisters. First painting lessons from artist and designer Dorothy Bailey.

1907 Entered Maidenhead Technical Institute.

1908-12 Studied at the Slade School under Tonks, where his contemporaries included Christopher Nevinson, William Roberts, Mark Gertler, David Bomberg, Paul Nash and Edward Wadsworth. During this period he lived and painted at home. Awarded a scholarship, 1910; the Melville Nettleship Prize and the Composition Prize, 1912.

1912 Exhibited *John Donne Arriving in Heaven* and drawings in Roger Fry's *Second Post-Impressionist Exhibition* at the Grafton Galleries.

1915-18 Enlisted in the Royal Army Medical Corps and was stationed at Beaufort War Hospital, Bristol, July 1915. Posted to Macedonia in August 1916 and served with the 68th, 66th and 143rd Field Ambulances until August 1917, when he volunteered and joined the 7th Battalion, the Royal Berkshires. Commissioned to paint an official war picture on his return to England in December 1918.

1919 Lived and worked in Cookham. Member of the New English Art Club until 1927.

1920-1 Went to live with Sir Henry and Lady Slesser at Bourne End, near Cookham. Stayed at Durweston, Dorset, with Henry Lamb during the summer of 1920.

1920-2 Lived with Muirhead Bone at Steep, near Petersfield, Hampshire, and then at lodgings in Petersfield.

1922 Visited Yugoslavia with the Carlines during the summer. Moved to Hampstead in December.

1923-4 Enrolled at the Slade School for the spring term, 1923, then joined Henry Lamb at Poole, Dorset. Worked on a series of designs for the mural decoration of a chapel based on his experiences during the war. They were seen by Mr and Mrs J.L. Behrend, who decided to build a chapel at Burghclere, Berkshire. Returned to Hampstead, October 1923, where he used Henry Lamb's studio on the top floor of the Vale Hotel in the Vale of Health.

1925 Married Anne Hilda Carline at Wangford, near Southwold. A daughter, Shirin, born.

1926-7 Completed *The Resurrection, Cookham* in 1926 and exhibited it in his first one-man show at Goupil Gallery, February-March 1927. It was purchased by the Duveen Paintings Fund for presentation to the Tate Gallery. Moved to Burghclere to decorate the Sandham Memorial Chapel.

1930 A second daughter, Unity, born.

1932 Completed the Memorial Chapel and moved from Burghclere to Lindworth, Cookham. Elected ARA and exhibited five paintings and five drawings at the Venice *Biennale*. In October Dudley Tooth became his sole agent.

1933 Invited to Saas Fee, Switzerland, by Edward Beddington-Behrens to paint landscapes. *Sarah Tubb* exhibited at the Carnegie Institute, Pittsburgh (honourable mention).

1935 Resigned from the Royal Academy after the rejection of *Saint Francis and the Birds* and *The Dustman or The Lovers* by the hanging committee. Visited Zermatt, Switzerland, for a second time with Beddington-Behrens.

1936 One-man show, Arthur Tooth and Sons Ltd.

1937 Divorced by Hilda. Married Patricia Preece, 29 May. Spent a month in St Ives and also visited, and painted at, Southwold.

1938 Exhibited at the Venice *Biennale*. Stayed with the Rothensteins and Malcolm MacDonald until December, when he moved to a room at 188 Adelaide Road, London. Began the *Christ in the Wilderness* series.

1939 Exhibited at J. Leger and Son in March-April, moved to the White Hart Inn, Leonard Stanley, Gloucestershire, with George and Daphne Charlton, 30 July.

1940 Commissioned to paint pictures of shipyards by the War Artists' Advisory Committee. Made the first of a series of visits to Lithgow's yard, Port Glasgow.

1941 Stayed with Mrs Harter, Sydney Carline's mother-in-law, at Epsom.

1942-4 Returned to Cookham, 7 January, as the tenant of his cousin, Bernard Smithers, with whom he stayed until May 1944. Continued to visit Port Glasgow where he stayed at the Glencairn boarding-house. Continued to work on *Shipbuilding on the Clyde*. Began *The Resurrection, Port Glasgow* series on which he worked until 1950.

1945 September, returned to Cookham to Cliveden View.

1947 Retrospective exhibition, Temple Newsam, Leeds. The Chapel at Burghclere was presented to the National Trust by Mr and Mrs J.L. Behrend.

1950 Created CBE. Rejoined the Royal Academy and elected RA. Hilda Spencer died in November.

1954 Visited China as a member of a cultural delegation.

1955 November-December, retrospective exhibition at the Tate Gallery.

1958 Knighted, Hon. D. Litt, Southampton and Associate of the Royal College of Art.

1959 14 December, died at the Canadian War Memorial Hospital, Cliveden.

Stanley Spencer

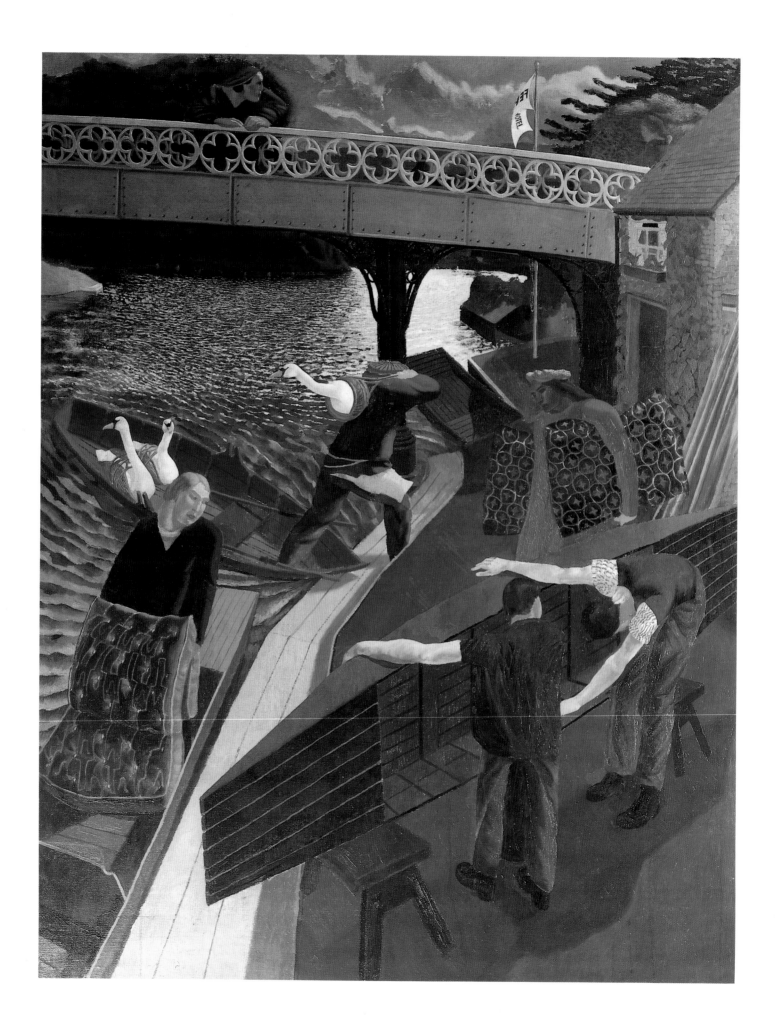

Figure Paintings 1906-15

Stanley Spencer was born at Cookham on Thames, Berkshire, on 30 June 1891, the eighth surviving child of William and Anna Spencer. Spencer's father had been a master builder by trade, but taught the piano and played the organ at nearby Hedsor church for a living. He was a powerful patriarchal figure as well as being one of the last of the talented village amateurs who had abounded earlier in the Victorian age. The Spencer household was a musical one and Mr Spencer taught his two elder sons, William and Harold, to play Bach and Schumann.[1] The Spencer children received little formal education, as their father objected to the new ideal of universal education then beginning to be put into practice throughout England; they were taught by the elder daughter, Annie, in the shed at the bottom of the next-door garden. Spencer was not a good pupil, and Annie let him draw instead; his first work of art was a thrush copied from an engraving in *Great Thoughts*.[2] Most of his book learning was probably gleaned from his brother Sydney (killed in action, 1918), who was interested in art and literature. Spencer's early imagination was also stimulated by passages from the large illustrated family Bible, and by regular visits to the chapel or parish church.

Painting was not a subject of much importance in the Spencer family before Stanley Spencer's birth, but Fernlea, the Spencers' home, did contain a few paintings and prints of the type usually found in the more modest late Victorian households. These included reproductions of Pre-Raphaelite works such as Rossetti's *Annunciation*, Millais's *Ophelia*, and *Cherry Ripe* from the *Pears Annual Supplement*, engravings of Turner's *Approach to Venice*, and Rubens's *Descent from the Cross*; together with a number of other reproductions including the *Bengal Lancer*, *A Sailor and his Lass*, *Blind Man's Buff*, two Dove scenes, *Una and the Lion* and *Christ among the Disciples at Gethsemane*.[3] Familiarity with these few images was supplemented by the annual expeditions to view the Royal Academy summer exhibitions, to which Mr Spencer took Stanley and his brother Gilbert when they were old enough.[4] These early contacts, with the Pre-Raphaelites, imaginative subjects and the Royal Academy, were essential elements of Spencer's art for the rest of his life.

To begin with Spencer drew because it meant avoiding Annie's lessons, but gradually his drawings began to take on new meaning for him. Free to amble around Cookham he became absorbed in the spirit of the place, which felt to him like the centre of a Garden of Eden. Later, in the 1930s, he was to transform Cookham in his imagination into a village in Heaven. Soon, however, he began to feel that his existence needed some further affirmation: 'I could not stand with any assurance on Widbrook Common,' he wrote, 'only with a vague expectancy.'[5] Somehow he needed to join his feelings for a place with the place itself; as he wrote in 1935: 'My life is a continual uniting and marrying a finding [of] my eternal state of union with everything I can

feel this state with.'[6] This union, Spencer discovered, could best take place through his art: 'I am aware that all sorts of parts of me are lying about waiting to join me. It is the way I complete and fulfill myself,' he wrote.[7]

At first Spencer was uncertain how to proceed, drawing inspiration from illustrations found in books belonging to the family library.[8] These included the family Bible,[9] *Pilgrim's Progress*, cartoons by Heath Robinson and Dicky Doyle, a volume or two of the *Royal Academy Illustrated*, Ruskin's *Seven Lamps of Architecture* and a variety of children's stories, including Hans Andersen,[10] Heinrich Hoffman's *Struwelpeter*[11] and Ruskin's *King of the Golden River*. Some studies, for example *The Pilgrim*, copied from a plate in Bunyan's book, were unsatisfactory,[12] but others, in particular E.H. New's illustrations to Gilbert White's *Natural History of Selborne*, encouraged Spencer to draw the village with a sharpened eye for interesting and unusual details.[13] One of these studies was a view of Sarah Sandall's cottage, inspired by 'sitting among the hollyhocks and runner beans'; this was, 'the moment when I realized there might be a next step . . . I felt there was something there that was very much my business.'[14] These drawings were supplemented by mythical and biblical subjects: 'Hercules pushing a great boulder of

rock' (1906-7), 'Sinbad' (1906), 'Christ in the Corn', and 'Illustrations to Pa's poems' (1906-7), perhaps inspired by plates in *Pilgrim's Progress*.[15] Spencer also copied a Brer Rabbit illustration from Stead's *Books for Bairns*,[16] which he liked for its 'homely' quality.[17]

When Spencer was sixteen he announced his intention of becoming an artist. William Spencer had expected all his family to become musicians, but he arranged for Spencer to take lessons in watercolour painting from Miss Dorothy Bailey, who lived across the road.[18] Shortly afterwards it was decided that a more formal education was needed, and he was sent to the nearby Maidenhead Technical School, to attend classes given by a Mr Cole.[19] There Spencer was taught to make 'stipple' drawings from casts of antique sculpture, there being no live model to draw from.[20] For a young artist already committed to drawing the Cookham landscape, or imaginative studies from poetry and novels, and with only the vaguest concept of Classical art, this type of work must have appeared confusing or even irrelevant. Later, Spencer was able to talk of the school with affection, and Mr Cole treated him kindly: 'but he seemed to look very askance when at a late stage of my stay there, I began to wish to do compositions and illustrations to stories.'[21] Indeed Spencer's list of paintings from this period records virtually nothing from his work at school, the majority of the drawings being landscapes or more copies of book illustrations, *The Flying Dutchman*, *Pied Piper*, *King Midas*, *Una and the Lion*,[22] and others.

Through these various influences, Spencer struggled to bring some form of clarity to his work. To begin with he was hampered by sheer inexperience; for instance, in his drawing of *King Midas* – unfamiliar with examples of suitable historical interiors in which to set his subject – he was 'obliged to get my ideas of affluence from the range of antique casts on the shelves of the antique room at the [Maidenhead] Tech.'[23] When the idea was based on his own environment, however, Spencer felt more comfortable. At the turn of the century Cookham had yet to be discovered by commuters and retired stockbrokers, and the villagers formed a closely knit community.[24] As Gilbert Spencer recalled, both he and Spencer were filled with a strong 'place feeling' for Cookham, with their home

King Midas and the Girl, c.1906.
Pencil, 9¾ x 13½ in/
24.8 x 34.3 cm.
Private collection

The Fairy on the Waterlily Leaf,
1910. Pen and ink,
16½ x 12 in/41.9 x 30.5 cm.
Cookham, Stanley Spencer
Gallery

The Last Day, c.1909.
Pen and wash, 16 x 23 in/
40.6 x 58.4 cm.
Private collection

('we all loved home') as the focal point of their existence.[25] This is apparent in his study of the *Stables at Ovey's Farm*,[26] where he drew a group of village children. 'I need people in my pictures, as I need them in my life,' he wrote. Later he added: 'a person is a place's fulfillment, as a place is a person's.'[27]

Spencer's feelings for people and places were intensely poetic, influenced no doubt by his early reading, and it is possible that had he received more formal training, he might have become a poet rather than a painter. This is reflected in his self-consciously elegant letters to Desmond Chute[28] and in the carefully crafted *Letter from Stanley Spencer*, published in *The Game* (vol.1) in 1919. In the thirties, Spencer wrote as much as he painted, but this later work lacks the literary polish of the early pieces. Like Rossetti (an important early favourite with him) Spencer did not begin by copying from nature, but instead 'began with a vision or a dream, which he sought to render as concretely as possible.'[29] This explains the strength of his early figure paintings, which were not illustrations to a story but the visual representation of a poetic mood, usually inspired by the 'marrying' of a place with a 'feeling,' often biblically based. As Spencer discovered in his early work, pure landscapes copied, as Hunt and Millais copied them, directly from nature could not evoke the same powerful set of emotions and therefore remained poetically inert.

In 1908, following the advice of William Spencer's patroness Lady Boston, Spencer went up to the Slade School of Fine Art to be interviewed by Professor Brown and Henry Tonks. His portfolio was impressive and the usual entrance examination was waived, and he was accepted, supported by Lady Boston who paid his fees until he won a scholarship in 1910.

Writing in 1949 Spencer was to dismiss the Slade experience as mere 'barnacles on this me that makes this journey [through life]';[30] but in fact the experience firmly established his reliance on drawing in the Slade style, and brought him into a circle of artists with whom he was to associate for the next twenty years. Hilda Carline, whom Spencer married in 1925, was of the opinion that Spencer's Slade years were a 'formative time' for him, and 'a large amount of his technique or means of expression is derived from that. It has even a

bit moulded his art character and outlook, so that one might say he was set into that form.'[31]

When Spencer arrived at the Slade his practical experience was limited to 'stipple' drawings and his own self-taught illustrative pen technique. This he now expanded, working at first in the Antique Room with Walter Russell, and later in the Life Room under the supervision of Henry Tonks. During this time Spencer deliberately confined himself to drawing, later claiming: 'In the four years I was at the Slade, I did about three days painting from one model – three days out of four years.'[32] Spencer's choice undoubtedly arose from the illustrative, literature-based subjects of his pre-Slade days; but this approach was to some extent encouraged by the Slade as well. As a member of the Slade Sketch Club Spencer was able to continue his interest, producing a total of thirteen drawings, all prompted by biblical or literary themes, such as *Moses and the Brazen Calf*, *Jacob and Esau*, and *Scene in Paradise*.[33]

These studies show Spencer moving away from his early pen and ink technique towards the subtler outline and shading methods of the Slade style, combined with a growing interest in the Pre-Raphaelite tradition, which at this time remained popular with some Slade students. As Causey observed (p. 20), Pre-Raphaelitism was still seen as a continuing tradition in English painting; and indeed a large number of the late followers of the movement, notably E.R. Frampton (1872-1923), Thomas Cooper Gotch (1854-1931) and John Liston Byam Shaw (1872-1919), lived well into the new century. With artists like F.C. Cowper (who was painting in the style even in the late twenties), it was possible to regard Pre-Raphaelitism still as a real choice. This was reinforced by exhibitions at the Tate Gallery in 1911-12 and 1913, and by books like Percy Bates's *The English Pre-Raphaelite Painters*, published in 1910.[34]

In Spencer's work this influence formed a natural continuation from his interest in illustrations and the English landscape. This is apparent in the *Fairy on the Waterlily Leaf* (1910; RA, no. 1) which combined the careful outlines of Pre-Raphaelitism, his interest in Arthur Rackham,[35] and the Slade drawing model (in the awkward hands and legs). Elsewhere and in *Scene in Paradise*[36] this new crisper drawing style was combined with a

fresh compositional format, with the figures placed near the front of the picture and strung out across it, as in Millais's drawing *Claudio and Isabella* of 1848.[37] Sometimes Spencer would also adopt other details; for example, the long distorted faces used by Millais in drawings like *The Disentombment of Queen Matilda* (1849) are closely paralleled by those in *Scene in Paradise*.[38]

Spencer confined his work at the Slade to drawings made from the model, reserving his creative drawing and painting for Cookham, to which comforting ambience he returned religiously each day on the 5.08 train from Paddington. Here he taught himself to paint, displaying the same stubborn amateurism with which his father had approached music. According to Carline (p. 29), Spencer would first square up his canvas (or paper), and then transfer his drawing study, outlining the detail of the subject on the canvas in pencil. The spaces were then filled in with paint, beginning at the top left and working downwards, a method not unlike that of fresco painting.[39] In the pre-war years he usually made small oil studies, like *Study for Zacharias and Elizabeth* (c.1913; 15) and *Study for Mending Cowls* (c.1915; 24), to establish the shapes and tones of the painting, as well as numerous drawing studies including a definitive working drawing, such as that used (with minor alterations) in *Zacharias and Elizabeth* (see RA, no. 19). At this period the studies were normally firmly drawn in pen or pencil, often with a heavy sepia wash to give volume and establish the play of light and shade. Later, around 1920, Spencer moved to a softer pencil outline accompanied by delicate sepia shading; the studies also became larger.[40]

Spencer's first recorded painting, the *Loaf of Bread* (1909-10; 1), previously unremarked in the literature and now missing, was probably an experiment, inspired perhaps by a still life he had seen on a visit to the National Gallery. His fourth, *Two Girls and a Beehive* (1910; 4), represented his first serious attempt at oil painting, marking as he recalled: '. . . my becoming conscious of the rich religious significance of the place I lived in. My feelings for things being holy was very strong at this time.'[41] Later, in 1940, Spencer again emphasized the importance of the relationship between people and their settings: 'They seemed to me like all those places in Cookham coming to life . . . I thought about and had

visions about these girls and I was on the lookout for them every day. In several drawings Dot (one of the two) was planted in places in and around Cookham.'[42]

Spencer clearly felt that a familiar human presence was essential in order to express the spiritual atmosphere of the place. This had been lacking in the pure landscape paintings which were therefore devoid of emotional conviction. *Two Girls and a Beehive* combined Spencer's feeling for Mill Lane, Cookham, with his friendship towards the two girls, Dorothy and Emily Wooster. The shadowy figure of Christ behind the fence sanctifies the scene, and adds to the mysterious presence of the beehive in the foreground.[43] The painting is Pre-Raphaelite in the presentation of two figures against a landscape background which sets the mood of the scene (like Millais's *Autumn Leaves*) but the handling of the paint is still comparatively crude, with the three figures flattened and indefinitely drawn, when compared to the startlingly real beehive in front of them.

Spencer's next important painting, *John Donne Arriving in Heaven* (1911; 10), was inspired by a reading of John Donne's *Sermons*, from which he imagined Donne walking 'alongside of heaven,' while the four people 'pray in all directions because everywhere is heaven so to speak.'[44] In 1940 he commented that he was: '. . . struck by the fact that this desire . . . to have everything prayed to has been the main theme of *Adoration of Girls* [226] and *Adoration of Old Men* [227] and the couple pictures [274a-j].'[45] Spencer later felt 'more sure of the praying figures that I am of Donne,'[46] and this small painting certainly had an experimental feel about it. The artist's awkward reading of Donne demonstrates his often imperfect understanding of his literary sources at this time, which sometimes led to unusual interpretations in his paintings, notably *The Betrayal* (second version, 91).[47]

Later Spencer learned more about literature through discussions with Edward Marsh, Rupert Brooke and Desmond Chute,[48] but in part this was probably an attempt to keep up with his better-educated friends. He confirmed this in a note made in the thirties, recalling the 'hunt for praise'[49] in his early life, which he called 'pseudo-intellectual pratting, e.g., reading Carlyle's *French Revolution* and not understanding it.'[50] In *John Donne*, Spencer

Cat. 4
Two Girls and a Beehive
c.1910

was attracted less by the sentiments expressed in Donne's sermon, than by the feeling or emotion aroused by it.

Most critics have remarked on the new influence – that of French painting – in *John Donne*, in the flattened simplified forms, and the limited colour range; this observation was reflected at the time in Tonks's accusation that Spencer had fallen under the influence of the Post-Impressionists, recently on show in Fry's exhibition at the Grafton Gallery.[51] Spencer's angry reaction to this (he called Tonks a 'damned liar')[52] should not be taken at its face value, as he took any suggestion of influences in his work as a direct threat to the purity of his creative vision. In 1911 *John Donne* must have appeared peculiarly 'modern' to most viewers, and the picture could easily be compared with Vanessa Bell's very radical *Studland Beach* (private collection) painted that same year. Consequently Clive Bell was impressed enough to include the painting in the *Second Post-Impressionist Exhibition* at the Grafton Gallery in 1912, where the critic of the

Connoisseur advised him to 'cast off the artificial conventions of Post-Impressionism'.[53] Andrew Causey has suggested the influence of Symbolist art on the painting's meaning and subject; and the isolated figures, winding paths, and broad empty spaces are certainly reminiscent of some Symbolist artists, notably Puvis de Chavannes, who was very popular in England at this time.[54] However, Spencer's own taste in art also points to early Italian painting, particularly his favourite Giotto, whose large bulky figures and simplified landscapes are not dissimilar to those of *John Donne*.

Spencer was assisted in his understanding of Giotto by reading Ruskin's *Giotto and his Works at Padua*, a gift from Gwen Raverat, his Slade friend, in 1911.[55] The importance of the book to Spencer has been discussed at length by Robinson and Leder;[56] but the point should also be made that Ruskin's discussion emphasized Giotto's roots in contemporary Paduan life, roots that Spencer could identify with in his own existence in Cookham. Spencer's connections with Ruskin's work went back to his childhood, and the family edition of *The Seven Lamps of Architecture* and the *King of the Golden River*. These were his father's books, and, as William Spencer had apparently once visited Holman Hunt in his studio,[57] it would seem that the Spencer home was pervaded with Ruskinian and Pre-Raphaelite ideas. Certainly Spencer's own approach to art seems to follow the Ruskinian idea of the 'Education of the Senses' in *Modern Painters* ('To see clearly is poetry, prophesy and religion');[58] and Ruskin's concept of *Theoria* or contemplation – 'the exalting, reverent and grateful perception of it'[59] – comes close to Spencer's own ecstatic experience of painting. This Ruskin took further, in his teaching that 'a right response to visible beauty should lead to a religious apprehension of the world and its creator,'[60] exactly the approach taken by Spencer in his search for the precise place in Cookham in which to set his paintings.[61]

Spencer looked at French art again when he came to paint *The Nativity* for the Slade Summer Composition Prize, of 1912, which he won.[62] This extraordinary painting, Spencer's first large oil, represented in a microcosm the peculiar mix of Renaissance, Pre-Raphaelite, and French influences which affected the last generation of Slade students before the war.

Here Spencer drew on a variety of

Cat. 10
John Donne Arriving in Heaven
1911

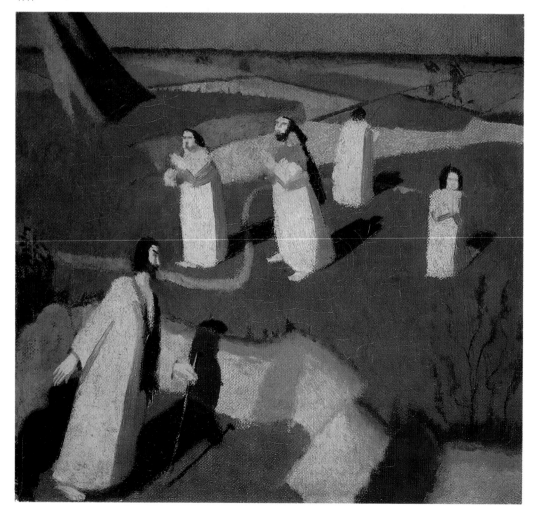

Renaissance sources, notably Piero della Francesca's National Gallery *Nativity* for the rather isolated Christ Child set in the open before a background of rustic architecture; and Botticelli, whose Mercury in the *Primavera*[63] may have been the origin, in reverse, of the figure of Joseph. Concurrently Spencer also turned to Gauguin, as Robinson noted (1979, p. 18), for the sharply receding fence on the left and the horizontal division of the composition, which is reminiscent of *Bonjour Monsieur Gauguin* and *Little Girl Keeping Pigs*, of Gauguin's Breton period.

Spencer's adoption of a long rectangular canvas, with the figures extended along its length, had its origins in early pen drawings like *The Last Day* (RA, no. 2; see p.15), and ultimately in Pre-Raphaelite paintings such as Millais's *Christ in the House of His Parents*; (1849-50; Tate Gallery) and Holman Hunt's *The Hireling Shepherd* (1851; Manchester City Art Gallery), where the eye is drawn sharply back to the distant field by a row of trees, which perform a similar role to Spencer's iron fence. Pre-Raphaelite, too, is the warm sunbathed landscape with a carpet of wild flowers, and a symbolic row of horse-chestnut candles appearing to float over the manger; all painted with a care and attention to detail worthy of Inchbold or Arthur Hughes.[64] After the spartan, barely recognizable landscape in *John Donne*, Spencer returned to a more precise setting, a view looking towards Sir George Young's estate, which in 1933 he described as his inspiration: 'The marsh meadows . . . leave me with an aching longing, and in my art that longing was among the first I sought to satisfy. . . . It is one way, not of joining creation, but in a way showing the creation';[65] a passage not dissimilar in its approach to nature to Wordsworth or Ruskin.

Spencer redoubled his interest in French art when he came to paint *Apple Gatherers* (1912-13; 12), which he later called 'my most ambitious work.'[66] The painting again expressed Spencer's mystical identification with nature, which has parallels with Samuel Palmer's love for Shoreham. In 1938 he recalled the magical way the painting and the landscape seemed to merge in a perfect, unbroken harmony of life and art: 'When at the end of each day it had begun to get too dark to paint in the kitchen of "Wisteria" where . . . I was painting *Apple Gatherers*, I used, sometimes, to stand . . . and look from the cottage window to the still bare branches of some spindle-like trees which were hidden in a confusion of overgrown yew hedge and other shrub-stuff. . . .'[67] In the painting Spencer represented this experience in the formally balanced apple gatherers and lush plant-life around them. As he explained: 'The apples and the laurel and the grass can all fulfill themselves through the presence in their midst. . . . The central figures are still related in the universal sense, not this time so much through any specified religion but through a consciousness of all religions. . . .'[68] In about 1948, Spencer described the ecstatic feeling which came over him when he painted the picture:

> In the Apple Gatherers I felt moved to some utterance, a sense of almost miraculous power, and arising from the joy of my own circumstances and surroundings. Nothing particularized but all held and living in glory. The sons of God shouted for joy, the din of happiness all around me everywhere. . . . That is what the Apple Gatherers is, it is an ernest [sic] request from whence what is marvellous in themselves (God given) can be revealed and expressed. . . .[69]

The sources for *Apple Gatherers* were again varied, for example, Spencer exhibited the same kind of eclectic choice that can also be found in Henri Rousseau's contemporary work.[70] The major influence, however, was the painting of Gauguin, and possibly Maurice Denis, whose works, exhibiting a similar non-perspectival space combined with distortions of scale, Spencer must have seen at Roger Fry's *Monet and the Post-Impressionists* exhibitions at the Grafton Gallery in 1910.[71] There more than forty Gauguins were exhibited, including several religious subjects, notably *Adam and Eve*, *Joseph and Potiphar's Wife* and *Christ in the Garden of Olives*. The last of these, as Leder suggested, probably provided an important source for the painting. Gauguin's dream of an undisturbed Eden, reflected in his Breton and Tahiti paintings, had parallels with Spencer's own religiously inspired image of Cookham, and was an ideal to which he would have been receptive through the Pre-Raphaelites' own setting of biblical themes in the English landscape.

Apple Gatherers also had close connections

Cat 11
The Nativity
1912

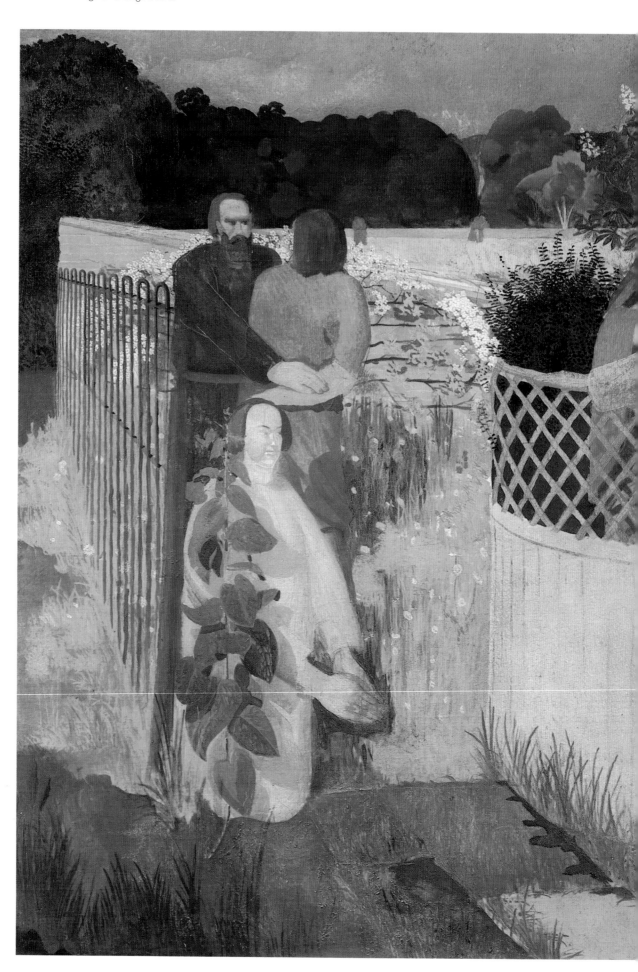

with the solemn monumental figure style of Spencer's Slade friend, Mark Gertler. In 1954 Spencer told Christopher Hassall that he had 'always been a tremendous admirer of Gertler's work.'[72] Gertler's painting had become more radical under the influence of Post-Impressionism and the early Italians, and in a series of paintings beginning in 1913, including *Family Group* (1913), *Rabbi and His Grandchild* (1913), and *Family Group* and *Rabbi and Rabbitzin* (a drawing, 1914), he painted a number of Jewish subjects which have the same Byzantine solemnity, and the exaggerated arms and hands also found in *Apple Gatherers*.[73]

Although Spencer later called *Apple Gatherers* 'my first ambitious work,' the painting reflected the influence of other artists too closely for the style to retain its influence long. Writing in 1937, Spencer recalled that at the time he was 'quite oblivious . . . of the fact that the subject of the picture not being specifically religious, was not concerning me,' and he went on to call it a 'conception,' implying that the painting was not as deeply rooted in his own world as *The Nativity*, or his next major work, *Zacharias and Elizabeth* (16).[74]

Spencer's activities at the Slade School were somewhat curtailed by his departure each day for Cookham and it was really only later, through his friendship with Edward Marsh, that he finally became properly acquainted with the London art world. The Slade itself was not altogether attractive, and Paul Nash later called it 'the typical English Public School as seen in a nightmare,'[75] a conclusion backed by Spencer's own claim that he was 'badly treated' there.[76] However, as all Spencer scholars have pointed out, the Slade was going through a renaissance unseen since Augustus John's generation and Spencer was only one of a talented group of students which soon included the Nash brothers, Mark Gertler, C.R.W. Nevinson, Ben Nicholson and others. Among these Spencer made particular friends with R. Ihlee, M.G. Lightfoot, Adrian Allinson, Gertler, Nevinson, Wadsworth and Roberts. Most of these students, like Spencer, had been affected to some extent in their early work by the Pre-Raphaelites; Paul Nash's early drawings had been influenced by Rossetti,[77] and even Nevinson, who had a wider experience of French art through his visits to Paris, had grown up in a house full of reproductions of Pre-Raphaelite paintings.[78]

By 1911 a number of these students, led by the popular Gertler, and including Nevinson, Wadsworth, Allinson, Claus, Ihlee, Lightfoot, Currie and Spencer, had formed a loosely associated group known as the 'Neo-Primitives.'[79] This often remarked party were enthusiastic about the early Italian painters such as Giotto, Masaccio, Fra Angelico and Botticelli – whose work particularly influenced Gertler, and through him Nevinson. Inspired by Pre-Raphaelite ideals, they appeared to be moving towards a revival of the movement through a return to its sources in Italy. Their interest was part of a general resurgence of concern with Italian art among younger painters which was encouraged by a series of important Italian exhibitions held in London before the war.[80] These included important showings of Botticelli, Mantegna and Giorgione at the Royal Academy in the winters of 1908, 1910, and 1912; the Umbrian School (Gozzoli, Piero della Francesca, and Signorelli) at the Burlington Fine Arts Club, 1910; and the Grafton Gallery's *Exhibition of Old Masters* in aid of the NACF, containing works by Giotto, Duccio, Masolino, Gozzoli, Signorelli and Giorgione, during October to December 1911. Other examples of Italian painting could be seen at the National Gallery, where Spencer was a habitual visitor, and informed commentaries on the paintings could be found in articles like Roger Fry's 1901 piece on Giotto in the *Monthly Review*, later reprinted in *Vision and Design*.

The Neo-Primitives were also interested to varying degrees in the avant-garde art exhibited at Fry's two Post-Impressionist exhibitions. There they observed a similar primitive expression in the art of some modern painters, notably Gauguin and the Pont Aven school. In the years immediately preceding the war, English art in some respects echoed French and German interest in so-called 'primitive' art – notably in Fry's circle, where connections with Parisian painting were strongest. However, even in Bloomsbury there was a powerful interest in the early (or primitive) Italian painters who, in their respectable connections with the Pre-Raphaelites, were probably more acceptable to the rather conservative English artists than the predominantly non-European artefacts that influenced their continental counterparts. Despite their apparently opposite positions, most factions of the English avant-garde were surprisingly similar in their appreciation of the

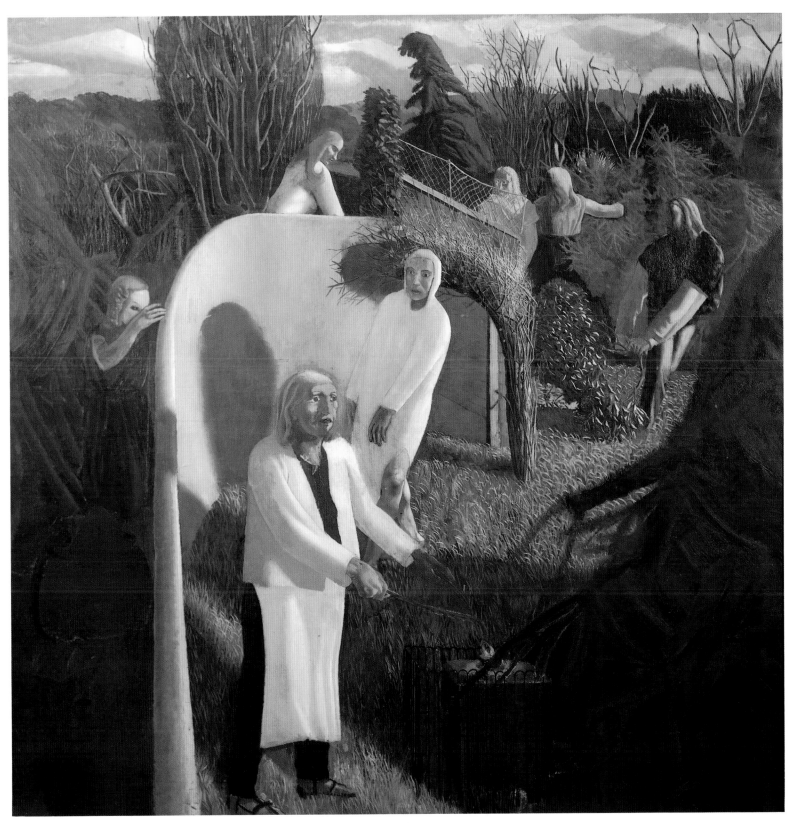

Cat. 16
Zacharias and Elizabeth
1913-14

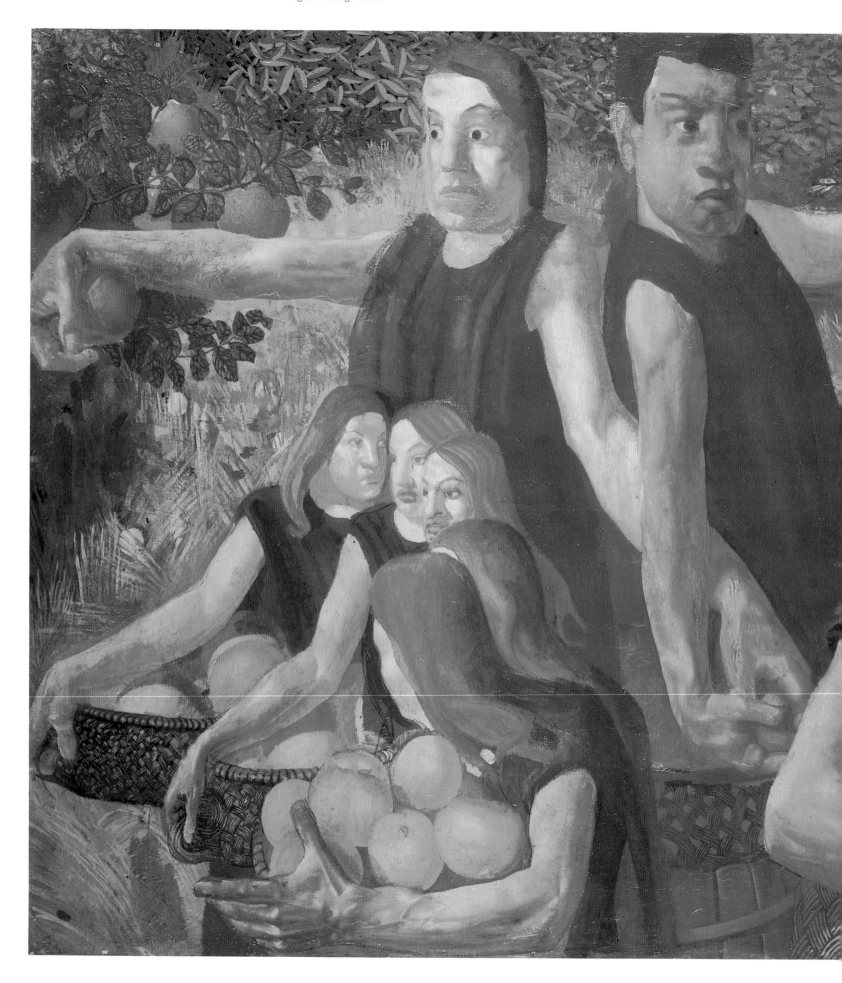

Cat. 12
Apple Gatherers
1912-13

importance of primitive art and its place in the modern movement.

This was evident as early as 1913, when Clive Bell wrote an article entitled 'Post-Impressionism and Aesthetics' for the January *Burlington Magazine*:[81] 'Post-Impressionism has a great future,' he wrote, 'but when that future is present Cézanne and Matisse will no longer be called Post-Impressionists. They will be the primitive masters of a movement destined to be as vast perhaps, as that which lies between Cézanne and the masters of San Vitale.' Bell went on to declare that of the art that 'moved' people the most, 'the greater part is what is called "primitive" . . . In primitive art you will find no accurate representation, you will find only significant form. Yet no other art moves us so profoundly.' From this comment it is clear that there was considerable common ground between Bell and an artist like Spencer, and it is easy to see that Spencer, through his interest in Giotto, was striving in *John Donne* and other works for a kind of 'significant form' (he would have called it 'spiritual atmosphere') which went beyond the repetition of everyday natural appearances.

Bell's 'neo-primitive' term was taken up by critics the following year, when as Causey remarked (p. 22), the *Observer* review of the NEAC used the term to describe a diverse group of artists including John, Lamb, Spencer, Currie and Lightfoot.[82] Indeed one suspects that Nevinson's own use of the expression may have been borrowed from the critics in retrospect, rather than being the original name of his group of fellow artists. In any case, 'neo-primitivism' was not often used again after the war except by inference in *The Times* critic's commentary on the 1926 *Resurrection, Cookham*, which he called the work of a Pre-Raphaelite who 'had shaken hands with a Cubist,' a comment which by this date revealed the outmoded nature of Spencer's style.[83]

Spencer's later denial that he had been influenced by any form of contemporary art – an opinion repeated to me by Richard Carline in 1979 – seems in retrospect to be based on the artist's intrinsic belief in the uniqueness of his own vision, rather than any real hostility to Post-Impressionism. In later years Spencer took a distinctly 'modern' view in choosing Grant and Epstein as the 'finest' painter and sculptor in England.[84] Where he eventually parted

company with Fry, Bell and other modernist theoreticians was over the role of subject-matter in his paintings, which he felt was essential to the expressive nature of the work. By contrast, Spencer felt that 'abstract art looks like the product of exams. Very contrived and within the rules.'[85]

Spencer's experience of developments in contemporary art in London was probably considerable, and Tonks's comments on *John Donne* were perceptively accurate, forming as they did part of the latter's attempts to shore up the Slade against the infiltration of Post-Impressionism.[86] As Paul Nash later recalled, 'the Slade was then seething under the influence of Post-Impressionism,'[87] an observation which was supported by Roberts's comment that 'at the Slade we were all familiar with the work of the French Cubists.'[88] While these statements were clear enough in retrospect, the actual situation at the Slade was much more confused, and the production of the majority of the students was highly tentative in its approach to the new influences. In the ideological battle between Tonks and Post-Impressionism most of the students took some time to make up their minds. Nevinson, for example, as Richard Cork has pointed out, while fully engaged by the teachings of Marinetti in 1911, could still turn out a thoroughly realistic *Self-Portrait*, 'under the influence of Gertler . . . doing highly finished heads in the Botticelli manner.'[89] Roberts, too, displayed a strange combination of styles in *The Resurrection* (1912) and *David Choosing the Three Days' Pestilence* (1912), although the influence of Futurism was more clearly marked in the latter.[90] Given the uncertain reaction of some of the more sophisticated Slade students, the wide variations in style between *John Donne*, *Apple Gatherers* and *The Nativity* were not exceptional. Moreover, faced with the powerful personality of Henry Tonks it was not surprising that a number of Slade students, including Wadsworth and Nevinson, did not become seriously involved in Vorticism and Post-Impressionism until after they left the school; while only Roberts and in particular Bomberg, were able to make the break while they were still students.

Spencer, on the other hand, remained close to the position taken by the Slade and the NEAC, and only borrowed from Post-Impressionism and Futurism (or Vorticism)

However, Spencer's insistence on the individuality of his work did not prevent the critics from drawing their own conclusions about its connections. In his review of the 61st Exhibition of the NEAC in *c.*1920, P.G. Konody grouped Spencer with the Neo-Primitives, whom he proceeded to attack: 'True to its early tradition,' he wrote, 'the NEAC still waves the banner of rebellion, although the fight is now for an altogether different ideal. A whole group of artists, whose pictures occupy the most prominent positions on the wall, make a laborious effort to return to the archaic simplicity of the Primitives. . . . If we are touched by the naivete and sincerity of the Primitives, we are more likely to be repelled by the archaistic affectation of our own neo-primitives.'[92] Konody went on to criticize Spencer's *Zacharias and Elizabeth* for its affinities with neo-primitivism, although he had fewer objections to *Swan Upping*, which he felt was a more independent work.

After Spencer left the Slade in 1912 he was able to maintain contact with his friends through a new acquaintance, Edward Marsh, to whom he had been introduced by Mark Gertler in November 1913.[93] Marsh was engaged in collecting the work of a few young English artists, assisted by John Currie, and by Gertler with whom he had become acquainted in June 1913. According to Marsh, Gertler and Currie both admired 'Cookham more than anyone else,'[94] and, with £400 inherited from a 'mad aunt,' Marsh planned to 'go a bust in Gertler, Currie and Cookham,'[95] a circle which he soon expanded to include William Roberts, Isaac Rosenberg and Duncan Grant. This was followed shortly by Marsh's purchase, for fifty guineas, of *Apple Gatherers*,[96] which he had seen at the Contemporary Art Society in October, and in 1914 he returned from a visit to Cookham with Spencer's large *Self-Portrait* (17), a bargain at £18, and his first serious landscape, *Cookham* (1914; 19).[97] Earlier, in February, he had proposed a volume of reproductions of *Georgian Drawing* to go with his anthology of *Georgian Poetry*, containing work by Stanley and Gilbert Spencer, Gaudier-Brzeska, Gertler, Currie, Ihlee, Nevinson, Roberts, Rosenberg, Seabrook, Tryon and Paul Nash;[98] almost a roll-call of the old Slade 'gang.'

Marsh had originally been a collector of eighteenth-century art, and his taste was not particularly radical: he thought *Apple Gatherers* a

when it helped him develop his personal image of Cookham and its inhabitants. Later he even tried to play down the influence of the Slade, declaring that: 'The thing which originally turned me in the direction of wanting to draw and paint was my local surroundings.'[91] The primary position of the village in his life and art meant that Spencer remained unconcerned with ideological matters, and his personal dislike of organizations of any sort meant that he was temperamentally unsuited to any but the loosest of artistic groupings.

'great picture,'[99] but told Rupert Brooke, 'I can't bring myself to acquiesce in the false proportions.'[100] However, his interests under the tutelage of Currie and Gertler perfectly suited Spencer's own ideas, as Marsh told Michael Sadleir: 'Blake and Giotto are the only people he [Gertler] will let me admire, so I am naturally rather narrow about the new International show – of course I am allowed Gauguin, Cézanne etc.'[101] Marsh's group also provided an alternative to Bloomsbury and the growing Vorticist movement, although some fringe members, Gaudier-Brzeska, Nevinson and Roberts, were also involved with the other parties. Marsh himself remained unmoved by the more radical aspects of the art world, and, after attending a Marinetti tirade at the *Bookshop* in November 1913, told Brooke that it was 'on the level of a good farmyard imitation.'[102] He was also hostile to Fry, remarking of another artist: 'I'm afraid he has come under the noxious influence of dear Roger Fry whom I love as a man but detest as a movement. . . . It seems too wretched that he should spend all his time painting square people because someone tells him to.'[103] Marsh was also suspicious of Wyndham Lewis, whom he

suspected of being a 'pose.'[104]

Spencer's friendship with Marsh benefited him in other ways, particularly by giving him an entrée into London intellectual life denied him by Fry and Bloomsbury.[105] Through Marsh he met Geoffrey Keynes, Rupert Brooke, Gaudier-Brzeska and others,[106] and the assurance which he gained from these meetings undoubtedly transformed him from an untutored and socially inept country boy, into an altogether more sophisticated and better-read personality, capable of holding his own in any discussion.[107] This is apparent in his letter-writing style, which improved from the semi-literate notes to Lamb in 1912-13 to the fine descriptive letters to Desmond Chute during the war years.[108]

Spencer's other important connection at this time was with the artist Henry Lamb, to whom he was introduced by his Slade friend Darsie Japp in June 1913.[109] Lamb was a friend of Augustus John and had lived for a time in Paris in 1907-8 and in Brittany during the summers of 1910 and 1911. Leder suggested that Lamb's enthusiasm for Gauguin influenced Spencer, presumably in *Apple Gatherers*;[110] however, the painting was almost certainly complete by the time they met, and

Cat. 18
The Betrayal (first version)
1914

Lamb's role was confined to that of a broker in the sale of the painting to Marsh.[111] Lamb was also instrumental in introducing Spencer to new friends and supporters; these included Mr and Mrs J.L. Behrend, the future patrons of Burghclere, and Augustus John, Boris Anrep and George Kennedy, with whom he spent some time in the early twenties.[112]

The first two pictures painted by Spencer after leaving the Slade, *Joachim Among the Shepherds* (1913; 14) and *Zacharias and Elizabeth* (1913-14; 16), show how tenuous his connections with avant-garde art in London could sometimes be. During this period, which ended with his enlistment in July 1915, Spencer's interest turned back with renewed intensity to the work of the Italian Primitive and Quattrocento artists and the Flemish painters. These he was able to study through reproductions lent to him by Lamb[113] and the Raverats,[114] a book on Donatello, and the series of sixpenny Gowans and Grey artbooks, which contained numerous monochrome illustrations.[115] In 1913 Spencer told Lamb that he wished 'the National Gallery was in Cookham,' and went on to explain how his collection of reproductions stimulated and 'quickened' his imagination.[116] Spencer used these sources as a compendium of images and techniques which he could draw on for a particular idea. For example, when making a portrait drawing of his brother Sydney in January 1913, he adopted 'Michelangelo's pen and ink work' in preference to his usual Slade drawing style;[117] and in *The Visitation* (1912-13; 13) he adapted the figures of Mary and Elizabeth from the right-hand section of Masaccio's *Tribute Money* in the Brancacci Chapel, which appeared as a separate plate in the Gowans and Grey *Masaccio*.[118]

These interests are clearly apparent in *Joachim Among the Shepherds*, a little-discussed painting[119] which, Spencer later recalled, was influenced by Ruskin's descriptions in *Giotto and his Works in Padua*. *Joachim* shows little or no evidence of the contemporary influences found in *Apple Gatherers*, and the figure style owes more to the stiff poses, simple gestures and broadly outlined forms of Giotto, whose own Arena Chapel Joachim was reproduced in Spencer's Gowans and Grey *Giotto*, and as the Dalziel woodcut in Ruskin (Cook and Wedderburn, *Works*, XXIV, p. 50).[120] The rich deep colours and glossy paint surface, which are naturally quite different from those of Giotto's frescoes, were probably derived from Spencer's study of Renaissance and Flemish oil paintings in the National Gallery, which was his main source for technical information on painting at this time.

After completing *Joachim*, Spencer moved on to a more ambitious scale in the beautiful *Zacharias and Elizabeth*, which he imagined was set in their own garden, in this case Saint George's Lodge, Cookham. In this painting Spencer achieved the perfect balance he sought between place and his deep sense of religious mystery. 'I like to take my thoughts for a walk and marry them to some place in Cookham,'[121] he wrote in 1937. For *Joachim*, this had been the 'bread and cheese hedge up the Strand ash path,' where 'Joachim and the shepherds gave their blessing.'[122] In *Zacharias*, a peculiar blend of the Bible and his own experience provided the inspiration: 'I wanted to absorb and finally express the atmosphere and meaning the place had for me.'[123]

For this feeling to manifest itself, Spencer needed to contemplate and absorb the sensations evoked by his surroundings. Wandering around Cookham his experience had the hallucinatory sharpness of a waking dream; a visit to Mrs Shergold's kitchen made him feel that he 'could paint a picture,'[124] and sent him hurrying home, happy 'because it induced me to produce something which would make me walk with God.'[125] And the next day after bathing at Odney Weir, he could imagine: 'How at this time everything seems more definite and to put on a new meaning and freshness you never noticed before.'[126] In this mood, spiritually uplifted, he would set up his work and begin a picture, only 'leaving off at dusk feeling delighted with the spiritual labour I have done.'[127] In this trance-like state Spencer found it difficult to leave home, telling Lamb in 1913 that 'this place Cookham has a lot to do with this new picture [probably *Zacharias*] I am going to do, it has everything to do with it . . . If I go away, when I come back I feel strange and it takes some time to recover . . .'[128] After the war, particularly during the thirties, Spencer had less time to absorb his ideas, and his paintings suffered accordingly.[129]

Spencer later discussed the painting in a short essay, which is worth quoting at length because it gives an unusually clear idea of how his paintings were conceived in the pre-war period. 'This picture is based on the words of

the first Chapter of St. Luke,' he wrote:

> 'And then they walked in all the ordinances of the Lord blameless.' These words were expressions to me of a level of human and spiritual consciousness bringing about a state of being the influence of which would be so strong as to show itself in their ordinary daily life and appearance.
> It struck me that it only wanted a very little changing in one's ordinary surroundings to at once reveal the more magnificent and beautiful way of life as is suggested in [Saint Luke]. So near was what I . . . read that I felt that I was really reading about something that I saw out of doors, that it was described to me not [as] a past lost and forgotten life, but life itself. It expressed a true state of being which nothing could alter and nothing could shatter.

From his vantage point in 1940, Spencer was also able to make some modest criticisms of the painting: 'It was an early work of mine and the strain on my capacity was great and shows in several parts of the picture where I have lost sight and included irrelevant matter, for instance I am quite sure about the . . . figure of a supposedly wingless angel who attends the priest in the foreground but I am not so sure of the feet of Zacharias in the foreground which seem to obtrude and not to be part of the vision.'[130]

In *Zacharias*, Spencer achieved a sense of wonder and mystery by transporting Zacharias and Elizabeth into the hidden garden, which was both familiar, through his visit, and yet strange, in the sense that a child might associate a fairy-tale with his secret playground. This effect is enhanced by the odd, distracted appearance of Zacharias and Elizabeth (who appear twice, as in an Italian narrative painting), and the high enclosing wall with its peeping figure (perhaps a proxy for the artist). By now Spencer had thoroughly absorbed his Italian influences; these are no longer reflected in borrowings from individual works but appear in the general Giottesque figure style and facial types and, perhaps, in the spatial disjunction of the curved wall.[131]

If Spencer remained deeply absorbed in his painting in Cookham, he did have some opportunity to witness the interesting events taking place in English art through his London

connections. These consisted mainly of Marsh's 'Georgian' circle and Henry Lamb. When he was unable to stay in London with Marsh, Lamb or the Morrells, they and others would journey down to see him in Cookham.[132] Despite his deceptively unkempt appearance, Spencer was an ambitious artist (in 1914 he admitted to Lamb that he 'was in danger of becoming "smug" on success'),[133] and it is unlikely that he remained totally untouched by the new stylistic developments in Bloomsbury and Vorticist circles.[134] Spencer probably obtained much of his information on modern art from his old Slade friend William Roberts, who had once visited Cookham for the weekend. Roberts was also interested in religious subjects, and his two studies of 1912, *The Resurrection* and *David Choosing the Three Days' Pestilence*,[135] contained the same blend of old and new influences which appeared in some of Spencer's work.[136]

Spencer's next two major paintings, *Mending Cowls, Cookham* (1915; 26) and *The Centurion's Servant* (1914; 21), departed substantially from his early post-Slade style in their geometrical forms, and broad flattish areas of grey and brown colour. In *The Centurion's Servant*, Spencer adopted a domestic setting, in this case the servant's attic at Fernlea, part of the house which was out of bounds to the children and therefore doubly steeped in mystery. Here the miracle (Luke 7:1-10), precipitated far away by the Centurion's plea to Jesus, is enacted with the Spencer children participating as models. As in *Zacharias and Elizabeth*, Spencer fused the drama of the biblical event with a familiar Cookham setting. The curiously animated figure on the bed, interpreted by Causey (p. 33) as a frightened child, and by Frank Rutter as a child terrified by an air-raid,[138] was adapted from a second unpainted panel originally intended as a pendant to the present work. Spencer later explained the development of the picture as follows: 'I was wanting to do a painting of the meeting between Christ and the Centurion to begin with. This seemed beyond me, but I began to find my mind in very out of door places in trying to imagine what this scene would be like [then] I wondered what the scene would be actually at the house where the servant was, seven miles away. Here I seemed to find a better foot hold.'[139] In its original form, Spencer planned the scenes of Christ and the Centurion and the Centurion's

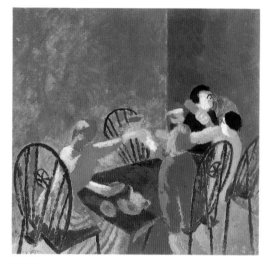

Cat. 23A
Untitled
c.1914-22

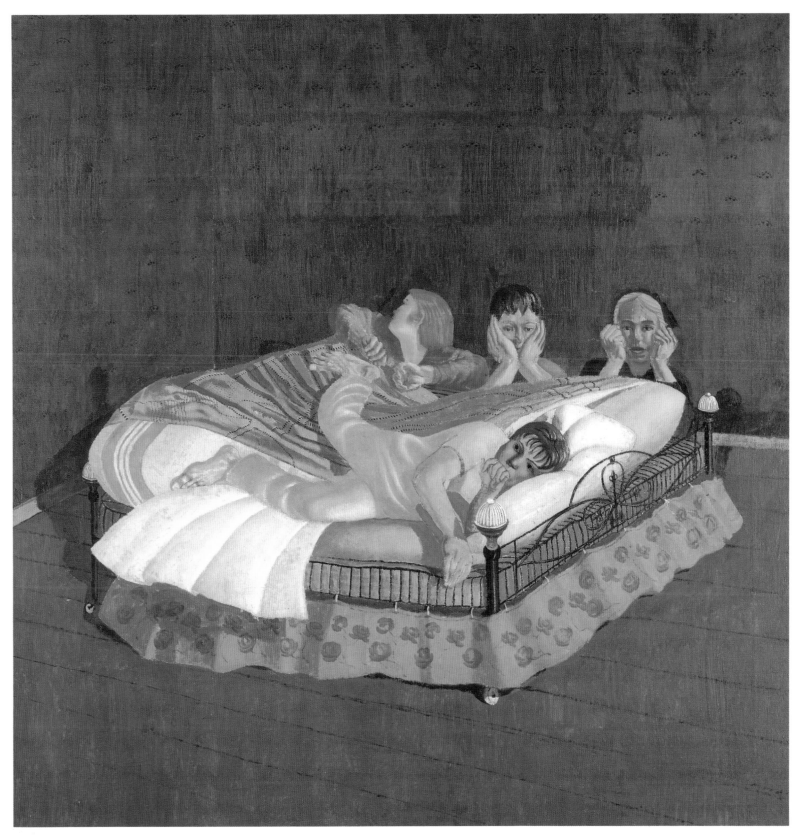

Cat. 26
Mending Cowls, Cookham
1915

servant to be arranged as 'two pictures in one frame.' When the former proved too complicated, he used a running figure from the composition for the Centurion's servant. Spencer also used 'my own praying positions in the people praying round the bed.' The painting represented another strand of Spencer's imaginative life, taken from the times when he lay in bed listening to the servant above talking through the wall to her opposite-number in Belmont, the house next door. To him it sounded as if she were talking 'to some angel.'[140] In this sense, *The Centurion's Servant* was the forerunner of the numerous paintings of domestic subjects with religious connections, such as *Going to Bed* (198) and *The Nursery* (197) which Spencer began in the early 1930s.

Mending Cowls was also associated with Fernlea as the veined tops could be seen swivelling in the wind from the nursery window. Spencer felt that the cowls had a life of their own, and the mystery of the strange hooded presence was enhanced by their inaccessibility, for he had never visited them. In 1944, Spencer recalled that 'their white wooden heads . . . served as reminders of a religious presence,'[141] which made the work 'one of my most religious paintings.'[142] This tendency to give a mysterious inner life to inanimate objects recurred frequently in Spencer's painting.[143]

Before Spencer enlisted for war service he had time to begin on one more painting, *Swan Upping at Cookham* (27), which remained only half finished when he left for the Royal Army Medical Corps (RAMC) in Bristol in July 1915. *Swan Upping* confirmed Spencer's ability to produce a string of fine paintings, each independent of the other, and often showing marked variations in style and influences. Spencer later commented that between 1910 and 1923 each of his paintings was a small 'self-contained' entity, whereas after Burghclere he 'began to feel the need for large schemes,' thereby creating 'incoherent pictures which were fragments of ideas.'[144]

Unlike *Apple Gatherers* which, though 'inspired by Cookham was not specially placed there,'[145] *Swan Upping* was deliberately set in the centre of the village by Cookham Bridge. Spencer saw this development as a growing site-specific identification of the sources of his spiritual pleasure, which gave the paintings a deeper meaning for him: '. . . as I progressed on this joy search I thought that it would help if I could show the very door steps on which it could be found.'[146] In this case the 'door steps' were small events witnessed in the village: swans bound in carpenters' bags being taken up the High Street in wheelbarrows on the annual wing-clipping day; one of the Bailey girls, mysteriously carrying a chair-cushion down the street;[147] and hearing punts being launched from Turk's boatyard during the Sunday service in Cookham church. This last gave the painting a religious dimension: 'The village seemed as much a part of the atmosphere prevalent in the church as the most holy part of the church such as the altar. . . . And so when I thought of people going on the river at the moment my mind's imagination of it seemed . . . to be an extension of the church atmosphere.'[148] Spencer then drew the picture from memory, before visiting the boatyard. Thus confirmed in his original feeling, he began the painting in the attic of the Ship Cottage, working from his imagination as he had in *Zacharias and Elizabeth* and *Joachim Among the Shepherds*, unconstrained by the need to observe directly from nature that he felt in his landscapes.

The painting that emerged was a curious combination of influences: Causey detected an Italian influence in the woman on the left, and the man carrying the swan;[149] while the right-hand boatman has the same outstretched arms as a Magdalen figure at the foot of the cross in Italian Trecento crucifixions. Behind him a dark-skinned Gauguinesque Polynesian woman, wearing what appears to be a wreath of flowers, replaced the Bailey girl carrying the cushions. There are other influences in the corbel-like figure leaning over the Victorian quatrefoil railing of the bridge, and the Rousseauesque landscape background and atmosphere.[150]

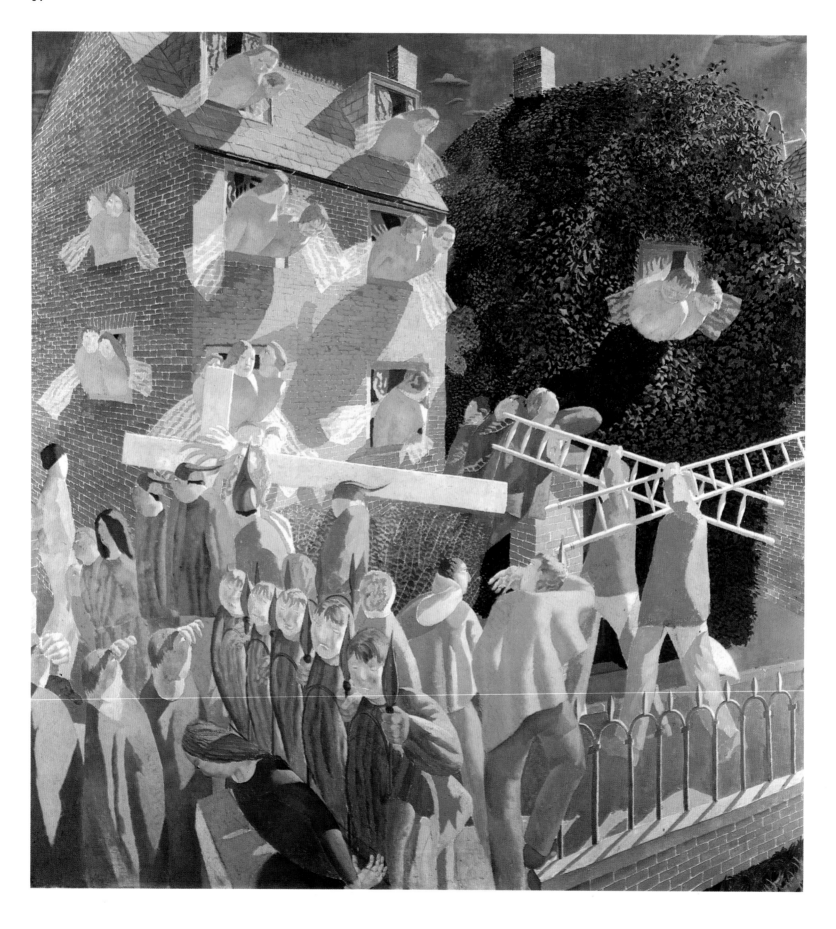

Figure Paintings 1918-32

Cat. 38
Christ Carrying the Cross
1920

W hen the war came in 1914 Spencer had several fine paintings to his credit, as well as a growing number of admirers who were willing to buy his work. He stayed out of the army long enough to paint *The Centurion's Servant* (21) and half of *Swan Upping* (27) before joining the RAMC at Beaufort War Hospital, Bristol, in July 1915, subsequently being posted to Macedonia, and finally returning to Cookham after the armistice in 1918.[1]

Spencer was later to complain that the war had somehow spoilt his vision, but the immediate effect of his service in Bristol and Macedonia was to broaden his hitherto narrow vision of life, and to present new possibilities in his art.[2] Writing to Desmond Chute from Tweseldown Camp in 1916, Spencer commented: 'I am looking back on "Beaufort" days and now that I am away from the worry of it I must do some pictures of it – frescoes.'[3] This feeling was enhanced by similar experiences in Macedonia which acquired added significance through parts of the countryside which had 'a very great spiritual significance to me . . . these mountains fill me with an eternal joy, which creates the desire to give perfect praise.'[4] At Beaufort and in Macedonia, Spencer was able to subdue his traumatic experiences at the hands of authority through immersion in menial work, which he was able to sanctify with the aid of Saint

Augustine's comment on 'fetching and carrying,' quoted him by a solicitous Desmond Chute.[5] Increasingly in the twenties, this prompted in Spencer's work a view of the universe which deemed all activities to be of equal importance in the eyes of God.[6]

Spencer's first completely new painting after the war was *Travoys with Wounded Soldiers Arriving at a Dressing Station at Smol, Macedonia* (1919; 30) commissioned, on the advice of Muirhead Bone, by the Ministry of Information. Bone had originally suggested 'a religious service at the front' in deference to Spencer's preference for religious subjects, but it was finally agreed that he should paint 'a Balkan subject,' chosen from among a number of drawings made after his return from the war.[7]

Spencer chose for this the arrival of wounded at a dressing station after a night of heavy fighting in the Dorian-Vardar sector of the front in September 1916. In the painting, Spencer used the same raised viewpoint as that of *Zacharias and Elizabeth* (16) and *Swan Upping*, with the Travoys spread out fanwise in front of the brightly lit church, now converted into an operating theatre.[8] As in those pre-war paintings, Spencer found deep religious significance in the scene, which was to convey peace in the middle of confusion, with 'the figures on the stretchers treated with the same veneration and awe as so many crucified Jesus Christs, and not as conveying suffering, but as conveying a happy atmosphere of peace.'[9] As Causey has perceptively observed, the resulting painting is similar to a traditional

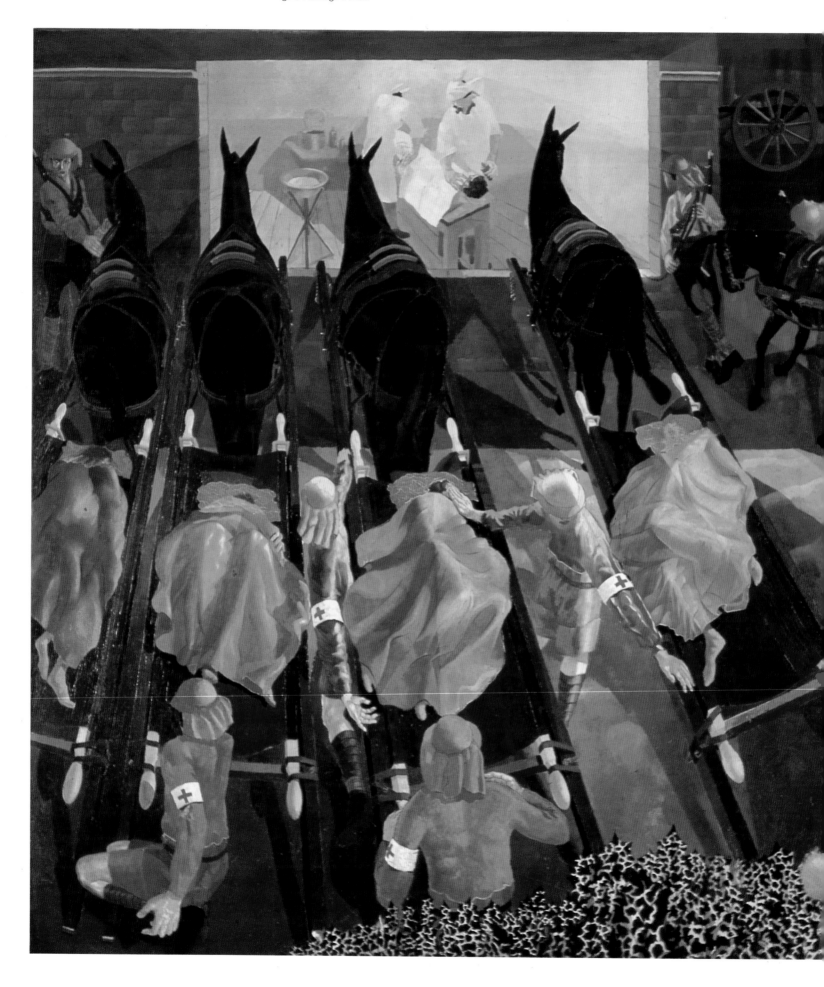

Cat. 30
**Travoys with Wounded
Soldiers Arriving at a
Dressing Station at
Smol, Macedonia**
1919

Cat. 31
Scrubbing Clothes
1919

Adoration, with the wounded replacing the kings and shepherds and facing a ruined church instead of stables, a scene which could also be read as a church service, with the operating table doubling as an altar.[10]

Spencer's emphasis on peace, a continuing theme in his work, gives the painting a deeper sense of purpose, which was only equalled by the war paintings of Paul Nash and Nevinson; and it contrasts sharply with the clumsy allegories attempted by artists like George Clausen RA and Frank Brangwyn ARA[11] or the jingoism of James Beadle and W.B. Wollen, whose paintings were updated versions of nineteenth-century battle pieces of the type popularized by Lady Butler.[12] When the painting was exhibited at the War Artists' exhibition at the Royal Academy in 1919 it received considerable critical attention. The *Times* critic called it 'the particular revelation of the show' which had 'the qualities of decoration, essential beauty, tenderness, simplicity and delightful, fanciful invention of a primitive Italian masterpiece.'[13] The exhibition, with nearly all the major British artists represented, was also a convenient time for stocktaking; the *Times* critic discerned a sharp change in the relative positions of the art community; declaring Sargent, Steer, Clausen, Cameron, Sims and Lavery to be the 'old men,'

and identifying Spencer, Lamb, Lewis, John and Paul Nash, and Roberts as the 'New.'[14] Spencer was therefore able to begin his post-war career comfortable in the knowledge that he had achieved an exhibition success, and that in some quarters at least he was considered one of the promising lights of the new generation.

After completing *Travoys* in June 1919, Spencer felt drained: 'I seemed to have lost my Balkanish feelings,' he told Yockney in July, when he refused a commission for two further paintings.[15] Instead, Spencer was eager to get on with new work. When he had returned to Cookham in December 1918, everything had seemed unchanged, and he had ascended into a state of 'bliss' as he ambled about the village.[16] This was only a temporary feeling, however. Spencer was now twenty-seven and the war had matured him; moreover, Fernlea was overcrowded and there was no peace to think or work.[17] Looking back on this period in 1944 Spencer recalled: 'I was longing to step on a stage before a highly appreciative audience. That audience I deserved. . . .'[18]

As Causey has observed, Spencer's feeling of disruption was not dissimilar to that of other young artists, such as Lewis, Nevinson and Paul Nash, who had just begun to establish themselves in 1914.[19] But, unlike Lewis,

Cat. 32
Making a Red Cross
1919

Spencer had never been seriously committed to the avant-garde, and he was now able to re-establish himself without the added problem of trying to revive a by now largely moribund art movement. Spencer made his compara-tively conservative position very clear to Richard Carline in a letter of November 1919: 'I am', he wrote, 'often accused of not taking any interest in or showing any curiosity towards modern work. This is the modern one's fault not mine,' but he went on, 'I am not incapable of feeling curious or interested to see a modern work.'[20] This guarded curiosity was to characterize Spencer's approach to his contemporaries throughout the early twenties.[21]

Spencer was too independent an artist, in both vision and character, to identify too closely with any individual group of painters after the war. He avoided Lady Ottoline Morrell's patronage, which she had extended to his brother Gilbert and Mark Gertler, and he was never accepted by Lewis or the Bloomsbury artists.[22] This did not, however, prevent Spencer from admiring the work of the Bloomsburyites as well as others. In a letter written to Gwen Raverat in 1934, he was to suggest an exhibition of 'British art' at the Royal Academy, to be chosen by Roger Fry and consisting of work by Walter Sickert and Duncan Grant ('in the main space'), and a

secondary area devoted to Vanessa Bell and Matthew Smith.[23] In the meantime Spencer took up his old friendship with Henry Lamb, and joined the unpretentious circle of artists who met in the informal atmosphere of the Carline family home at 47 Downshire Hill, Hampstead.

Spencer had probably known Sydney Carline as early as 1909 when the two had shared a drawing prize at the Slade School. It is not so clear exactly when he first met Richard Carline, but they were corresponding by May 1915, and shortly afterwards Richard went down to Cookham to view Spencer's paintings.[24] In a subsequent letter, the latter made it very clear why he came to look on Richard Carline as an important friend and supporter. 'It was very nice to have you to see my pictures,' Spencer wrote on 2 May: 'you allowed the pictures to look at you which is one thing that hardly anybody ever does.'[25]

The Carline circle in Hampstead was probably attractive to Spencer on a number of other counts as well. Firstly, the family had long been connected with the arts, reaching back to the eighteenth century when they had been stonemasons. More recently, George Carline (1855-1920), father of Sydney, Richard and Hilda, had become a professional painter of landscapes and portraits after studying at Heatherley's Art School and the Académie Julian in Paris.[26] This gave them the kind of roots in the English tradition of painting which critics often claimed to detect in Spencer's own work.[27] Secondly, the current generation of Carlines came from a similar professional background to Spencer's. Sydney, Richard and Hilda had all trained at the Slade School, and exhibited much the same emphasis on naturalism and drawing, combined with a cautious interest in Post-Impressionism, the Vorticist or Cubistic use of simplified planar forms and shading, as well as certain aspects of Camden Town or London Group impressionism.[28]

These concerns can be seen in the influence of Gauguin or Maurice Denis on Hilda Carline's *The Return to the Farm, Wangford, Suffolk* (1918), and of Sickert (or Whistler) on Richard Carline's *The Fish Shop* (1924).[29] Their ecleticism is also reflected in the places where they exhibited: the NEAC, the Goupil Gallery and the Royal Academy. Sydney and Richard also became members of the London Group in

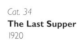

Cat. 34
The Last Supper
1920

1920, following the example of Henry Lamb who joined just before the war in 1913. Spencer (whose membership has not previously been remarked upon), had also been elected to the Group by March 1914, but never exhibited with them and his membership seems to have lapsed.[30] With the exception, perhaps, of two years (1920-2) after the war, he was not prepared to make the kind of commitment to a more painterly approach in his art, which was evident in that of Sydney and Richard Carline.

All three Carlines were also devotees of the colouristic principles of Percyval Tudor-Hart (1874-1954), a Canadian artist from Montreal, who, after training at the Académie Julian and the École des Beaux Arts in Paris, had established an atelier there for students in the Rue d'Assas in 1903. Later, in 1913, he moved the school to London where it became established in Hampstead as the Tudor-Hart School of Art.[31] Sydney Carline studied with Tudor-Hart in Paris during 1912, and his enthusiastic reports brought Richard Carline over to join him at the atelier in 1913. Richard then rejoined the school in Hampstead the same year, accompanied by his sister Hilda who stayed on until 1916, when she left to serve in the Women's Land Army.

Tudor-Hart had become preoccupied with problems of colour, such as the opposition of warm and cold tones, as well as with the analogy between musical and 'colour notes,' which he arranged in a series of complicated colour and tonal charts.[32] While these theories never fully found their way into print, Richard Bassett, a former pupil, explained that the use of scales and keys gave the artist the means to produce a painting like a 'tuned instrument . . . Like a musical composer, you paint a picture in a certain key and change keys if you feel so inclined.'[34] Spencer's writings never mention Tudor-Hart, but there is a heightened subtlety in the colour harmonies of his work of c.1920, notably in *Christ Carrying the Cross* (38) and *Bond's Steam Launch* (40), which may reflect a common topic of painting and conversation in the Hampstead circle after the war. Tudor-Hart's colour experiments were probably part of a wider interest on Spencer's part, which also took in the influence of the London Group artists such as Ginner (whom he met at the Carlines, in the early twenties), and the late Spencer Gore,

which is particularly apparent in his landscapes (see Ch. 5).[35]

Another aspect of Tudor-Hart's teachings may also have influenced Spencer through his contact with the Carlines. Tudor-Hart strongly recommended the avoidance of pretty and picturesque scenes which should, whenever possible, be replaced by their antithesis. Later, Richard Carline recalled, 'we were violently opposed to any element of flattery in art, even seeming to reject charm. If Hilda's nose appeared red, I would frankly make it so, and I think that the "kitchen sink" idea began then, with Stanley's use of dust-bins and litter as material for a picture.'[36] As Elizabeth Cowling has pointed out, Richard's work in particular is full of 'dourly matter of fact compositions,' both in still life and portrait paintings.[37] Thus in *Gathering on the Terrace* (1925, private collection), Carline chose the plain basement kitchen entrance of the Carline home at 47 Downshire Hill as the setting for his oddly gloomy group, rather than the fine drawing-room or splendid garden. A similarly direct unidealized approach can be found in other paintings such as *Portrait of the Artist's Mother* (1923) and *Interior of Studio* (1926), the latter being a reworking of Sickert's brownish Camden Town interiors.[38]

Spencer's own matter-of-fact approach to painting may have been further encouraged by his discussions with the Carlines on Tudor-Hart's theories;[39] notably in the severe composition and sombre tones of the apples and paper-bags in *Still Life* (1923; 97), which is very close to Carline's interiors of the same date, and decidedly unpicturesque landscape subjects like *Turkeys* (1925; 106), and *The Cultivator* (1927; 119). These influences may also be reflected in Spencer's figure paintings, such as those at Burghclere – particularly the hospital interiors – and more especially the Empire Marketing Board series (1929; 128a-e), where special emphasis is laid on the drab utilitarian spaces. By 1929, Spencer was probably also aware of the Mexican realists, either from Richard Carline, who made an extensive lecture tour through the United States and Canada in 1928, or through articles in *Studio* such as Eileen Dwyer's 'The Mexican Modern Movement' of October 1927.[40]

Spencer had first re-established his contacts with the Carline family after Richard and Sydney were demobilized in 1919. Hilda

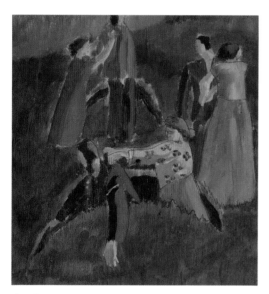

Cat. 42
Study for a Resurrection
c.1914-20

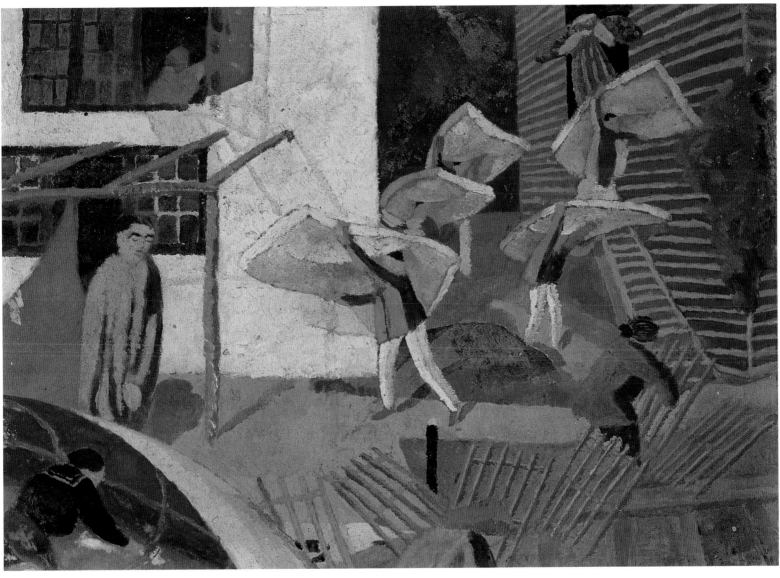

Cat. 43
Carrying Mattresses
c.1920-1

Carline, until recently a landgirl at Wangford, became a student at the Slade where Gilbert Spencer had returned to continue his studies – their meeting brought the two families together again.[41] Communication between Richard Carline and Spencer began with a letter from the latter in November 1919 mentioning Henry Lamb who was living nearby in the Vale Hotel Studio. The letter concluded: 'Would you mind if I suggested that he should pay you a visit?'[42] Subsequently, the Spencers and Lamb came to Downshire Hill for dinner, and reviewed the respective Carlines' paintings.

Later, in December 1919, both Spencers, Richard and Sydney Carline, and Henry Lamb were all represented in the exhibition of *The Nation's War Paintings and Other Records* at the Royal Academy, London.[43] This event prompted a letter from Spencer to Sydney Carline praising one of his paintings: 'Gil [Gilbert Spencer]

and Gilbert Solomon (you remember him at the Slade) admired tremendously your painting of the troops moving up along the road. We were all three of us liking it before we knew who it was by.'[44] Another letter, also referring to the Academy exhibition, made it abundantly clear that, at least in 1919, Spencer was very much aware of events taking place in contemporary English art, as well as having a useful forum for discussing them in the Carline circle: 'Since your feelings about my picture [*Travoys?*] were so extraordinarily good . . . I should like to know what you thought of Gil's, Robert's, Wyndham Lewis's, the Nash's and Meninsky's works. Oh and Colin Gill and Darsie Japp's . . . They seem to be rather fine. Perhaps they (the Meninsky's) are influenced by Peter van Brughel [sic] or whatever is his name, but I think not.'[45]

Seen together for the first time the group's

Cat. 37
The Paralytic being let into the Top of the House on his Bed
c. 1920

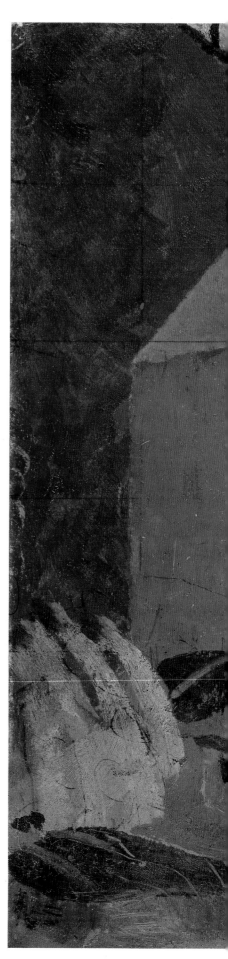

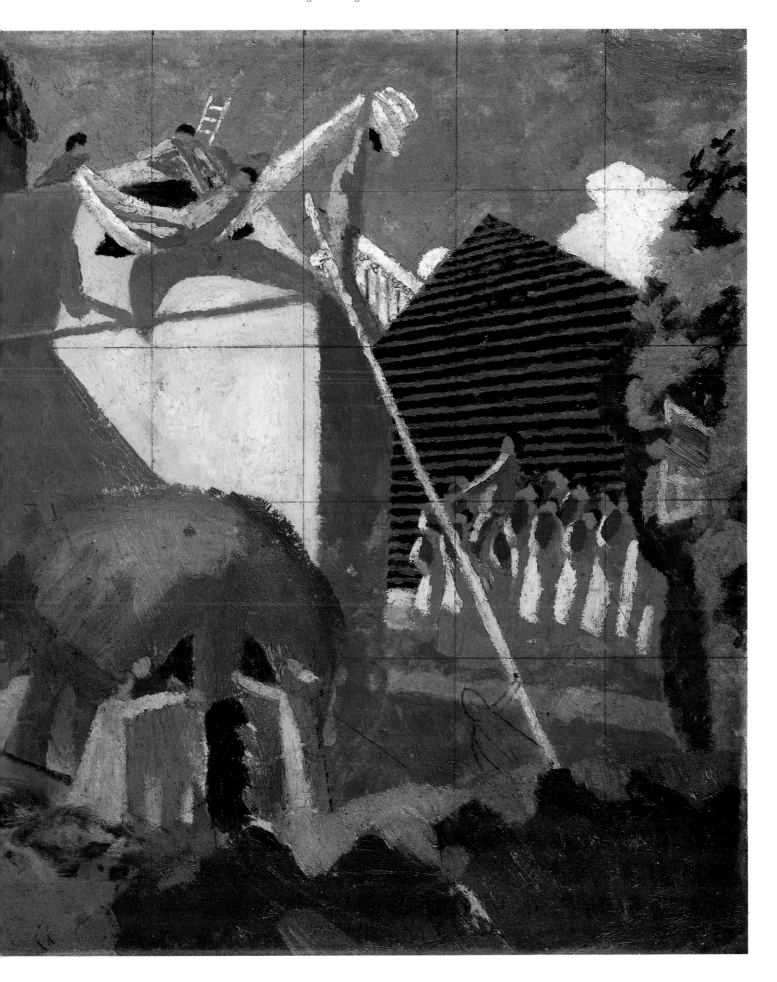

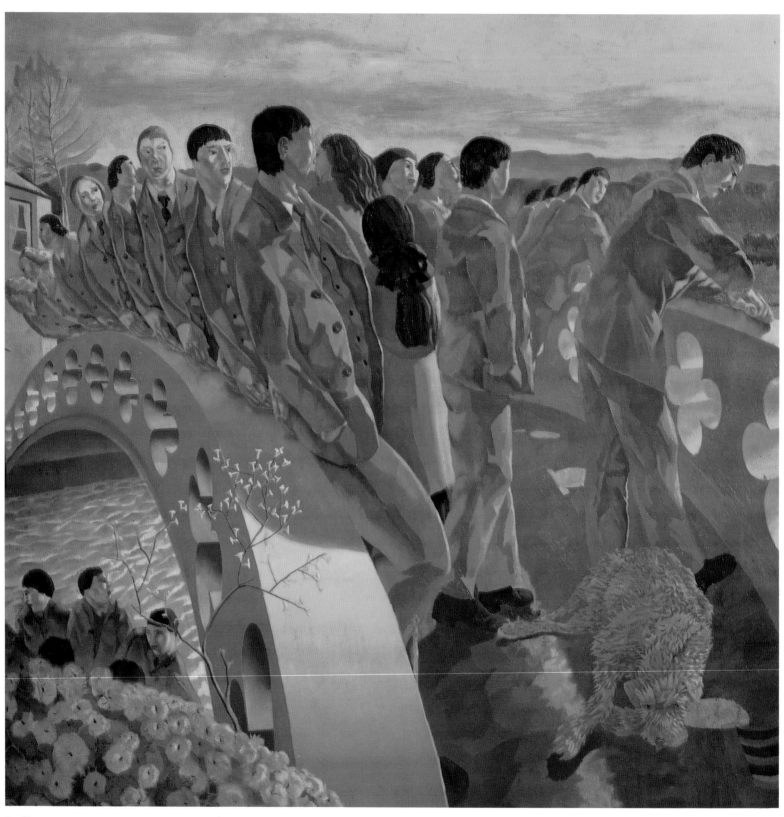

Cat. 39
The Bridge
1920

paintings also attracted the attention of the critics (see also above), and Frank Rutter, writing in the *Arts Gazette*, identified the Spencer and Carline brothers and Darsie Japp (an old Slade School friend of Spencer's) as a distinct group,[46] probably on the basis of their shared naturalism and passing references to Post-Impressionism. Japp was almost certainly included because of his painting *Royal Field Artillery in Macedonia, Spring* (1918; IWM), which shares the same jerky puppet-like figures also found in Lamb's *Irish Troops in the Judean Hills Surprised by a Turkish Bombardment* (1919; IWM) and Spencer's *Travoys*.[47]

After the war paintings exhibition, Spencer maintained his connections with the Carlines, frequently travelling up to London from Cookham and staying overnight either at 47 Downshire Hill, or with Lamb at the Vale Studio. Later, in 1922, he moved to Hampstead where he stayed for long periods at 47 Downshire Hill and in Lamb's studio, which he finally took over in 1924 after Lamb moved to Poole in Dorset.[48] He also took part in a previously unremarked exhibition of works by John, Matisse, Picasso, Gaudier-Brzeska, Nina Hamnett, Gertler, Modigliani, Allinson, Richard and Sydney Carline, Grant, Paul Nash, Gilbert Spencer, Meninsky and Sickert, held on the premises of the *Cambridge Magazine*, at 6 King's Parade, Cambridge, in November 1919.[49]

According to Richard Carline, the most frequent participants in the 'constant discussions about art' which took place in the Carlines' two studios at 14a Downshire Hill, were the Spencer brothers, Lamb, Jas Wood and Richard Hartley.[50] Others, such as Mark Gertler, the brothers Nash, Boris von Anrep, Charles Ginner, Nevinson and Roberts, were common if more occasional visitors. Gertler, for example, lived nearby in Rudall Grove, Hampstead, and had 'become a close friend'[51] of Richard Carline during the war, once complaining in 1917: 'I was surprised that you [Richard] had not called here [Penn Studio] these last two Sundays.'[52] A number of the so-called 'Downshires'[53] were also in contact with Fry and other exponents of 'advanced' art like Ben Nicholson (including Richard Carline himself),[54] but as he later recalled: 'While we did not always agree, there was much we felt in common.'[55] According to Carline, the skilful and diplomatic organizer of events at 14a and

47 Downshire Hill, discussions about art were usually long, stimulating and occasionally acrimonious, with Stanley Spencer often taking the lead part.[56] Some of the flavour of these events can be gleaned from Lamb's painting, *The Tea Party* (1926) which was set in his studio at 10 Hill Street, Poole. Spencer is shown gesticulating extravagantly to the assembled company of Lamb, Leverton Harris, the critic and collector, and two other unidentified guests.

There was probably plenty to argue about: Mark Gertler found himself unable to forgive Spencer 'for failing to admire Cézanne sufficiently,' while Jas Wood was greatly impressed by the theories of Kandinsky, an enthusiasm which was to lead him towards abstract painting. Richard Carline, too, was interested to some extent in European developments, as he stated in 1973: '. . . Sydney, Hilda and I thought of ourselves as adherents of the "modern movement," meaning the "post-impressionism" and "expressionism" which emanated from the continent.'[57] This was evident in an early painting, *The Jetty, Seaford* (1920), where the constructive forms of the ocean and jetty are set off in opposition to each other.[58] Later, after he left the Slade in 1924, Carline went further by renewing his interests in France: 'In Paris and the South of France in 1925,' he later recalled, 'I hoped to retrieve the freedom of expression, especially in colour, of which I felt a loss at the Slade.'

The enormous number of differing viewpoints which clearly made Downshire Hill a very stimulating environment also provoked some oddly flavoured discussions. One, reported by Henry Lamb to Richard Carline in 1920, goes some way to explaining Spencer's own peculiar stylistic position astride the Old Masters and contemporary painting. According to Lamb: 'The Stanley boys were up here [at 3 Vale Studios] in great form two nights ago. I musicated [on the piano] and we chewed oranges and argued – subject Raphael versus Cézanne.'[59] There were also disagreements, and there is evidence of divisions between, for example, the increasingly conservative Lamb, and artists like Gertler and Wood, who were moving slowly towards a closer identification with recent aspects of avant-garde painting in Paris and Munich.[60]

Despite the disagreements, however, the

Cat. 40
Bond's Steam Launch
1920

Cat. 44
**The Resurrection,
Cookham**
c. 1920-1

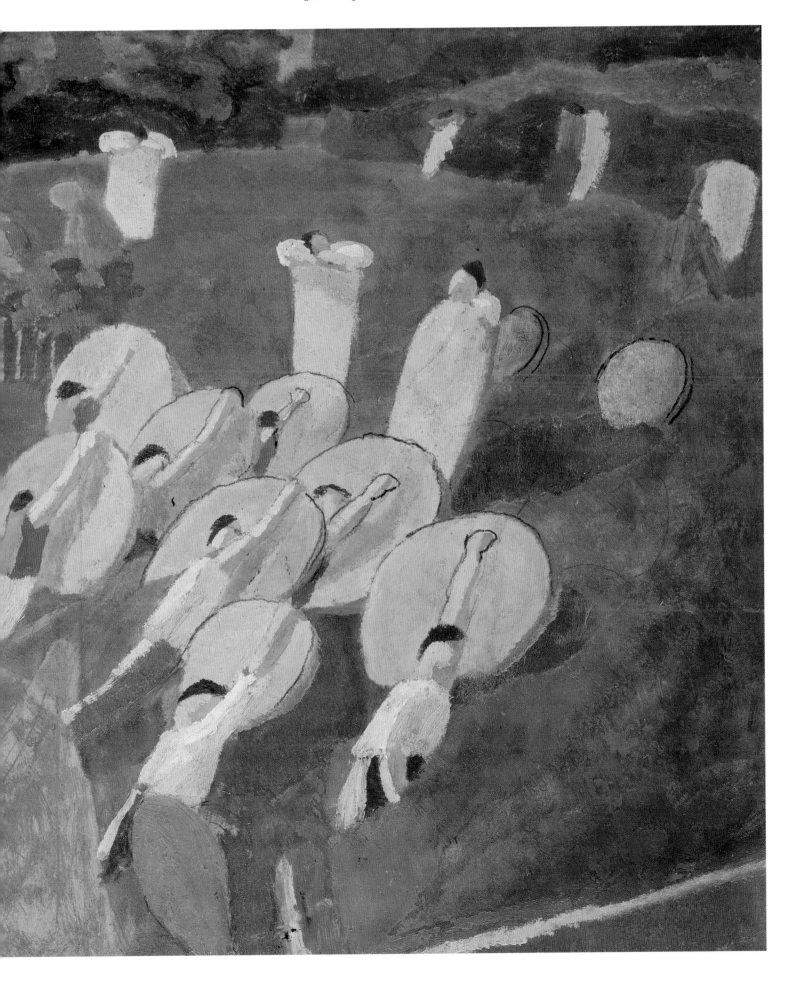

core of the group, including the Spencers, Carlines, Henry Lamb, John Nash and Wood, remained tightly knit at least during the early post-war years, when they formed a distinct clique or party on the English art scene. As such, the Downshire Hill grouping provided a forum for producing and discussing art which was essential for those artists, like Spencer, who found the Bloomsbury painters too radical, or too organized for their taste. Evidence that they felt some form of group identity can be gleaned from a series of letters and postcards written by Lamb to Richard Carline in the early 1920s. In two, Lamb concluded by giving his 'love to all the *cercle*,'[61] and in another wrote: 'to ask if Edwin John may be allowed to call on you to be admitted to the Cercle Pan-artistique of Downshire Hill. He is working at the R.A. schools and seems in need of the corrective stimulus he is likely to get in the above mentioned society. He is [already] acquainted with Cookham [Spencer].'[62] Despite his bantering tone, Lamb clearly had a more serious intention in referring Edwin John to the 'corrective stimulus' of the 'Downshires.'

Cat. 41
Fernlea, Cookham
1920-2

Association with the Downshire Hill circle also had practical advantages for Spencer. Richard and Sydney Carline both had studios at 14a Downshire Hill, where they and their friends would draw and paint from models like Betty McCann (see RA, no. 79). This activity also attracted other artists like Gertler, who commented to Richard Carline: 'Dorothy Brett tells me that you had drawing evenings and that there was a certain model female *fat* and rather "Renoiresque" . . .'[63] According to Richard Carline, Spencer was a frequent participant in these sessions, which were supplemented in the spring of 1923, when the latter enrolled for a term at the Slade.[64]

In 1922, the Carline circle gained a modest public forum for their ideas when Sydney Carline was made Ruskin Drawing Master at the Ruskin School in Oxford, on the recommendation of Muirhead Bone.[65] In May, the *Oxford Chronicle*, in an interview headed 'A New Era in the Ruskin School,' reported that Sydney considered his method of teaching to be similar to that of the Slade School, 'fostering a combination of direct observation with imagination.'[66] During Sydney's tenure, Gilbert Spencer, John Nash and Richard Carline all participated in the teaching programme,

and Stanley Spencer was invited to lecture.[67] Spencer talked on a number of matters, including 'Religion and Art,' 'Idea of Progress,' 'One's Own Way,' and on the *Resurrection, Cookham*, in which he informed his audience that he had been influenced by John Donne's idea of the 'Particular and General Resurrection,' and had chosen the 'General' for the theme of the painting.[68]

Elsewhere, in a remark which could well be taken as an early statement of his artistic philosophy, Spencer declared: '. . . I think an artist's life is very much a continual celebration of marriage between himself and what he wants to paint.'[69] In another lecture, Spencer gave an important description of the way in which he wished his pictures to be viewed:

> Just as a book will absorb you into a world so I hope my paintings do so. They are parts of this idea I have . . . of life and what is to me significant in it . . . When I read a book I want . . . to be held in the atmosphere of it because then you . . . live in it and there is no jump between you and the affairs of the book. This same absorption is possible in pictures and is a legitimate and proper thing for a painter to aim at . . . and expect the spectator to enter into . . . I wish people would 'read' my pictures.[70]

Spencer's frustration with the inability of some viewers to 'read' his paintings was later to reach greater heights in the 1930s, when his iconography became particularly obscure. In the meantime, his statement can also be read as a response to the kind of criticism levelled at his work by the Post-Impressionists.

Sydney Carline's appointment to the Ruskin School also resulted in what was effectively a Carline circle group show, held during April 1925 at the Oxford Art Club, and consisting of works by Sydney and Richard Carline, John and Paul Nash, and Gilbert and Stanley Spencer. Spencer exhibited the impressive *Unveiling Cookham War Memorial* (81), and *The Resurrection of the Good and the Bad* (23), while the others showed mostly drawings or water-colours.[71]

Unfortunately, Sydney Carline died suddenly shortly after the opening of his one-man exhibition at the Goupil Gallery in 1929, and the vacant position of Ruskin Drawing Master

Cat. 45
People by the River
c. 1920-2

was filled by Albert Rutherston. Sydney's death particularly affected Richard Carline, with whom he had been very close, and the Downshire Hill gatherings ceased.[72] By this time in any case the circle had begun to lose its coherence: Spencer had fallen out with Henry Lamb in 1927, and was by now absorbed in the Burghclere paintings;[73] Lamb had moved to Coombe Bissett near Salisbury; and Gilbert was a less frequent visitor to 17 Pond Street (the Carlines' new address), after the loss of Sydney who had been his closest friend.[74]

Spencer's period of association with the Carline circle was closest in the immediate post-war years, but even at this time there were differences. His art was still deeply rooted in Cookham and the Bible, and his mystical approach to painting was not shared by the others, who tended to look towards the more formal concerns of French art.[75] The influence of the Pre-Raphaelites and his early enthusiasm for the Italian Renaissance painters, too, still survived. As Spencer told Sturge Moore rather flippantly in 1924: 'The much wanted or unwanted exhibition of my pictures will be found in the book of words [Wilenski's 1924 Benn monograph on Spencer], so there will be no more trouble now, all is clear at last. Quite simple; just Gothic, Renaissance, Baroque: doesn't take long for these young

bloods to trot through these styles you know.'[76] Nevertheless, for a brief period in the early twenties, Spencer combined these ideas with an awareness of Post-Impressionism and Cubism, which undoubtedly derived from his association with his London friends.

This interest is clearly expressed in *Bond's Steam Launch* (1920; 40) in which Spencer, like Roberts, Lewis and Nevinson, adopted a contemporary subject, in this case Bond's pleasure boat on the Thames, with the figures painted in flattened bands of light and dark, and drawn in the same jerky, repetitive rhythms which were also characteristic of Vorticist art. Spencer had renewed his friendship with Roberts after the war, and must have seen his work at the *Nation's War Paintings and Other Records* exhibition at the Royal Academy in 1919, or at the Group X exhibition at the Mansard Gallery, Heal's, London in 1920. There, Spencer could have seen works like Roberts's *Brigade Headquarters Signallers and Linesmen* (1918),[77] which had figures divided into bands of light and shade which are very similar to those of *Bond's Steam Launch*. Significantly, one of the few reproductions of modern art which Spencer kept was a press cutting showing Roberts's *Judgement of Paris*.[78]

Traces of Vorticist or Post-Impressionist influence can also be found in a number of small religious paintings of 1920-2, including

Cat. 70
Christ's Entry into Jerusalem
1921

Cat. 75
**The Sword of the Lord
and of Gideon**
1921

Saint Veronica Unmasking Christ (74), *Christ Overturning the Money Changers' Tables* (72), *Christ Overturning the Money Changers' Table* (73), and *Rending the Veil of the Temple in Twain* (78). In each case the painting is constructed of broad areas of flattish colour, greys, mulberry, browns and whites, with the figures set off by plain backgrounds. But even here, Spencer's other interests, notably early Italian art, are also apparent in the distinctly Giottesque (if rather flat) look to the bulky figures, and the broad areas of their smoothly folded drapery. These paintings resume Spencer's pre-war use of compositions based on simple, related geometric shapes and large areas of gently graded colour tones, which can be found in *The Centurion's Servant* (21), and most notably in *Mending Cowls, Cookham* (26). The 1921 paintings, however, are more radical in their simplification and very shallow space; in *Christ Overturning the Money Changers' Tables*, the upturned red and white tables float against the greenish-grey background, with the figure of Christ acting as a kind of fulcrum in between. On the right, the shapes of the two money changers create a flat interlocking rhythm against the white rectangle of the table.

The dual influence of the Old Masters and contemporary art can also be observed when Spencer returned to a specific setting in Cookham for *Christ Carrying the Cross* (1920; 38) and *Christ's Entry into Jerusalem* (1921; 70). Here the flattened figures and distorted space, combined with the small regular constructive brushstrokes and chalky paint surface, have parallels with the Post-Impressionist artists whose work he could have seen on his numerous visits to London. As in fifteenth-century Italian painting, both works are full of incidental details, such as the elaborate draymen's hats, the workmen from the builder's yard, and the watchers from the windows of Fernlea and The Nest.[79] As Causey has observed, Spencer's setting is not unlike that which a Florentine painter would have created from his own surroundings. Spencer's purpose, however, tended to be more specific in his desire to draw the biblical event into the ambience of his own personal imaginative world, in which the presence of Christ provided confirmation of his joy in the intimate world of the village. As he recalled in 1937: 'I liked being able to combine the two atmospheres of Jerusalem and "Belmont" [the adjoining house to Fernlea].'[80] When the subject was set outside his home, Spencer frequently tried to re-create the 'heavenly' atmosphere of pleasure and security which he found in Cookham. In *Travoys* (30), painted the previous year, he had 'tried to introduce [a] homely atmosphere,'[81] with which to counteract the potentially unpleasant nature of the event. For Spencer, the painting: 'seemed a kind of lesser crucifixion; I mean not a scene of horror but a scene of redemption . . . from it and I was right in making it a happy picture.'[82] Quite clearly the 'redemption' involved here was personal as well as universal, and by painting the scene in a homely manner, Spencer was able to transform the traumatic and unfamiliar into terms he could cope with.

Spencer's Italianate interests were also reflected in *The Last Supper* (1920; 34) set in the austere red-brick surroundings of Cookham malthouse. Causey (p. 25) has convincingly suggested Donatello's *Feast of Herod* on the font in Siena Cathedral as the source for the over-all composition and the carefully painted brick walls. Spencer would also have been equally aware of Giotto's *Marriage Feast at Cana*, illustrated in his Gowans and Grey picture book on the artist, and in *Giotto and His Works at Padua* by Ruskin given to him by the Raverats in 1911 or 1912. Giotto's pervasive influence is evident in the austerity of the painting and the bulky but simply drawn figures, which have parallels in the *Money Changers* triptych (72, 73, 74) of 1921.

Spencer's revived interest in Italian painting probably resulted from his stay with Sir Henry and Lady Slesser at Cornerways, Bourne End, some three kilometres up-river from Cookham, in 1920-1.[83] Spencer's return to religious painting after the war had been influenced by his close friendship with the devout Catholic Desmond Chute, who was later ordained a priest. Spencer had met Chute while he was an orderly at Beaufort War Hospital, Bristol, in 1916, and the latter had almost persuaded him to convert to Catholicism.[84] It was Chute who had arranged for Spencer to stay with Eric Gill at Hawkesyard in January 1919.[85] This episode apparently put Spencer off the idea of established religion (even Gill's unusual version), but he must have been tempted by the possibility of becoming – like Gill – an artist for the Catholic Church. Spencer's

meeting with Sir Henry (later Lord Justice) Slesser the following year gave him an opportunity to fulfil this ambition on a private level as Henry Slesser was an important Anglo-Catholic. Slesser's house contained a private oratory for which Spencer painted *The Last Supper* (34) and the *Money Changers* triptych.[86] Later, in 1922, Spencer painted another altarpiece: *The Betrayal* (second version), with *The Robing* and *The Disrobing of Christ*, *Washing Peter's Feet*, and *The Last Supper* (91-5), as a predella. Spencer always felt the need to have a 'home' for his paintings, and in these works he was consciously measuring himself against the art of his favourite religious painters, notably Giotto, Masaccio and Fra Angelico.

In 1922, Spencer also became involved in an abortive project, conceived by Muirhead Bone, to paint a series of panels for Steep Village Hall as a war memorial.[87] Bone had accumulated £250 and invited Spencer to do the work, holding out as an added bonus the possibility of decorating the end wall in the refectory of nearby Bedales School (see 80). Bone apparently had in mind Spencer's unrealized drawings of his war experiences, which he had seen while working at the Ministry of Information in 1919.[88] Spencer's relationship with Bone proved unsatisfactory and the scheme fell through; however, the artist did produce at least one drawing study for the project – *Scrubbing the Floor and Soldiers Washing, Beaufort Hospital, Bristol* (RA, no. 64) –

which was later incorporated into three paintings at Burghclere: *Scrubbing the Floor*, *Ablutions* and *Scrubbing Lockers*.[89]

While living with Bone, Spencer also painted a small *Crucifixion* (77) based on his wartime recollection of a mountainside in Macedonia. This composition was to form part of a larger scheme in which the three ravines in the hill were to run up to the city of Jerusalem, with the Temple placed just behind the arms of the cross. Spencer experienced a number of problems with this design, but concluded in 1937 that he was: '. . . sure if I was commissioned I could carry out a great altar of the Crucifixion.'[90] In 1980 I suggested (see RA, no. 65) that the *Crucifixion* was intended as an 'altarpiece' for the Steep memorial, a possibility reinforced by Spencer's 1937 reference to the painting's proposed function. The Macedonian setting was certainly appropriate for the idea of a war memorial, and the theme of the painting would have symbolized peace and redemption in a once war-torn landscape.

Although the Steep commission proved unfruitful, it did start Spencer thinking again about his wartime activities. In 1919, when he rejected any further commissions from the Ministry of Information, Spencer had informed Yockney that any further war pictures would take '2 or 3 years to think about [but that] I still have hope in the next few years to do something good out of my Balkan experiences.'[91] The Steep experience clearly

Cat. 71
Expulsion of the Money Changers
1921

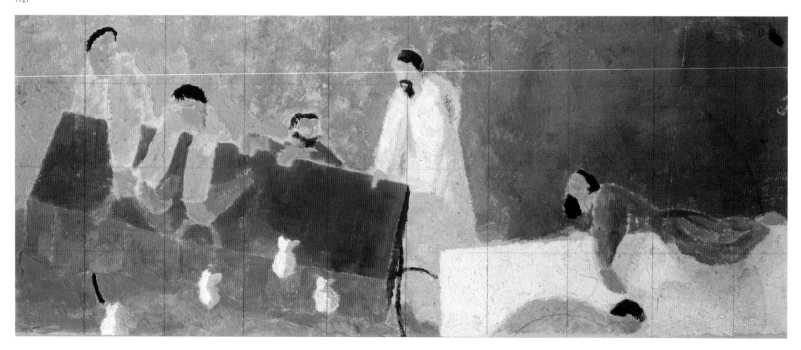

The artist standing in front of the half-finished canvas of *The Resurrection, Cookham* (116), c.1925

gave Spencer a better idea of the kind of setting the pictures commemorating these experiences should have; as well as showing him the need to have both suitable financial support (Bone's £250 would not have gone far), and artistic control over the whole process. When he began to compose the studies for what became the Burghclere project in June 1924, Spencer had a very accurate concept of his requirements to present to the Behrends.

In the meantime, Spencer began work on what was to be his most ambitious work to date, *The Resurrection, Cookham* (116), painted between 1924 and 1926 in the Vale Hotel Studios. The Resurrection theme had appeared several times before in Spencer's painting, and he clearly viewed it as the culmination of his labours as a painter of religious subjects.

From the beginning, Spencer chose the setting of Cookham churchyard, and in his earliest attempt (later covered by *Apple Gatherers*), he showed a number of figures rising diagonally through the air by the path leading up to the church porch.[92] Spencer tried again in 1915 with *The Resurrection of the Good and the Bad* (23); here he eschewed the punishments usually associated with a Last Judgement, and concentrated on the joy and wonderment of the Resurrection. In 1937 he commented: 'I love the Revelation and all it says but when I did the first biggish paintings of the Resurrection of the good and the bad . . . the punishment was to be no more than their coming out of the graves which was to be not so easy as in the case of the good.'[93] Leder has suggested that the trumpeting angels are derived from Fra Angelico's *Christ Glorified in the Court of Heaven*,[94] and Spencer certainly planned to place the pictures in one of the traditional sites for Last Judgements, over the chancel arch in Cookham Church.

Spencer painted a third *Resurrection* (44) in 1920 or 1921; this shows the porch of Cookham Church at the upper left, while all over the graveyard the resurrected clamber out of the ground using their tombstones as supports. The viewpoint used in this painting is probably not dissimilar from the first (overpainted) *Resurrection*, and Spencer was evidently trying to resolve the problems which had caused him to reject that design, keeping the figures on the ground, and raising the viewpoint to concentrate on the graves

themselves.[95] This 1920-1 oil study was the first post-war evidence of Spencer's interest in the Resurrection theme and, encouraged by Gordon Bottomley and Henry Lamb, he went ahead with a much more ambitious scheme which was clarified by November 1923.[96]

From the beginning Spencer was confident that the new *Resurrection* would be a success: 'I was on bedrock with this picture, I knew it was impossible for me to go wrong,' he wrote in 1937.[97] In the new composition Spencer rejected the high viewpoint of the 1920-1 study, employing instead (as Causey has observed) a fan-shaped pattern of gravestones and figures leading back (as in *Travoys*) to the figures of Christ and God the Father in the porch. The fan-shaped composition was a favourite of Spencer's, and reappears frequently, for example in an early study for *Christ Preaching at Cookham Regatta* (RA, no. 213). To the left the picture plunges back sharply into the distance, rather like a Mannerist painting. Spencer had employed this device before, in *The Nativity* (11) and *Zacharias and Elizabeth* (16), and it was also used on occasion by his contemporaries, notably Gore, in *The Cinder Path* (1912; Tate Gallery, probably exhibited at the *Second Post-Impressionist Exhibition* in 1912-13), and Duncan Grant in *The Hammock* (1921; Laing Art Gallery, Newcastle-upon-Tyne). In *The Resurrection* Spencer used a long rectangular format instead of the nearly square canvases of the early twenties.[98] In this he was probably influenced by the practical requirements of space, but he must have also been aware of Pre-Raphaelite compositions, for example, Rossetti's *Dantis Amor* (1859) and John Liston Byam Shaw's *The Blessed Damozel* (1895), both of which have, in addition, either a row of angels or choristers in the foreground, roughly corresponding to Spencer's prophets ranged in front of the church.[99] Spencer might also have found inspiration from Italian Renaissance paintings, but the Pre-Raphaelite flavour of *The Resurrection* points to a source nearer home. The dense mat of flowers in the foreground of Byam Shaw's painting is also close to Spencer's own work.

Spencer's other sources for *The Resurrection* were, as usual, varied and difficult to pin down. Causey (p. 26) has identified the influence of Bronzino's National Gallery *Allegory* on the nude figure of Richard Carline, and he suggested parallels with Michelangelo's

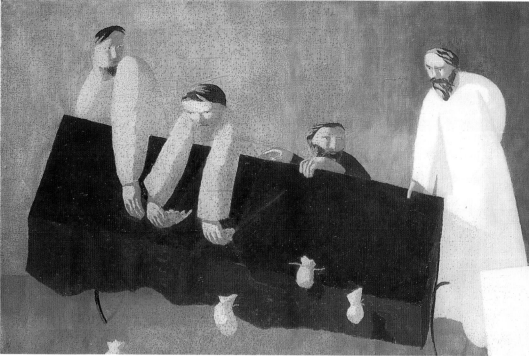

Cat. 74
Saint Veronica Unmasking Christ
1921

Cat. 72
Christ Overturning the Money Changers' Tables
1921

Cat. 73
Christ Overturning the Money Changers' Table
1921

Sistine Chapel prophets and sibyls, in the prophets and saints that line the church wall. Spencer may also have had in mind Michelangelo's Florentine *David* when he added his own self-portrait beside that of Carline. Elsewhere, Botticelli's *Primavera* may have been used as a model for the girl, centre right, who emerges from a grave covered in daisies, wearing a flowered dress. Spencer could have seen works by Botticelli at the Italian exhibitions at the Royal Academy during the winters of 1908, 1910 and 1912. The party of black people – who are assigned their own comfortably familiar patch of sun-baked soil – were adapted from illustrations found in Richard Carline's collection of *National Geographic* magazines. The 1920s was a period of rapid expansion in Britain's African colonies, and the topic was frequently discussed in the press. Richard Carline's own interest in African art was extensive, and he published on the subject as well as collecting Negro works of art in the 1930s.[100] By including the black people in *The Resurrection*, Spencer was almost certainly in part providing a modest reference to the more general Resurrection in the world beyond Cookham. Later, in 1935, he expanded this idea to cover all peoples in *Love Among the Nations* (172), where the races of the world were to be united at the Last Judgement in a collective orgy of love-making.

Apart from Spencer's references to Renaissance and Pre-Raphaelite art in *The Resurrection*, many contemporary critics also identified a number of modern influences, notably that of Cubism. *The Times of India*, for example, under the headline 'A Strange Picture,' commented: 'Technically it has been described as Pre-Raphaelitism out of Cubism: there is all the minutely faithful detail of flowers and so on of a Holman-Hunt; but the drawing and design are Cubist enough to make Holman-Hunt faint' (29 March 1927). The reviewer was probably referring to Spencer's distorted spatial arrangement of the tombs, the odd intrusion of the Negroes on their upward tilted path of earth, and the skewed perspective on the left (which Spencer later felt he had 'overdone,' 733.3.1), all of which were carefully arranged to draw the viewer's eye gradually through a series of verticals and horizontals to the figure of Christ, which was framed by the church entrance. There are also Cubist – or what Fry might have called 'constructive' – elements in the carefully faceted and very solid-looking church wall, and in the bulky figures of the row of saints, although the latter also have the appearance of medieval sculpture, in both their form and stony colouring. Finally, the naked figure of Richard Carline in the centre of the painting has the stiff, flattened, relief-like appearance of a sculpture by Epstein,

Gaudier-Brzeska or Eric Gill, all of whose work Spencer was familiar with.

In many ways, *The Resurrection* was, as Spencer recognized, the culmination of all his painting to date, with the numerous strands of his religious and secular life drawn together in Cookham churchyard: 'It was one of the things I felt in that Resurrection picture,' he wrote about 1941, 'the fact that I could put my varied likes together.'[102] There, in the lazy bliss of the Last Day, Spencer, his family and friends could absorb the warmth and pleasure of a May afternoon. In this, he was influenced by John Donne's reference to the idea of a 'particular' and a 'general' Resurrection. He interpreted Donne's words to mean that the particular dealt with the immortality of the soul, and the general with an overall state of being that the faithful could achieve on earth, an idea which corresponded roughly to the eastern concept of nirvana. In *The Resurrection*, Spencer chose to represent a combination of both, as he explained to W.G. Hall in the *New Leader* of 25 March 1927: 'He [Spencer] does not believe necessarily that the resurrection of the dead is a physical one. To him, the resurrection can come to any man at any time, and consists in being aware of the real meaning of life and alive to its enormous possibilities.' And in 1937 he recalled: 'I have therefore thought that a great deal in this life was a key to the perfect life of heaven. And so

feeling sure I could get these glimpses of what to one was heaven absorbed my attention and caused me to look at things in a special way.'[103] Spencer's tendency to identify completely with his painting and its characters – an attitude which was probably emphasized by the big canvas and limited studio space – is particularly evident in his 1937 account of the picture where he compares the act of painting to a spiritual experience: 'I know the proper place for everything . . . and I experienced a spiritual exultation as I put this here and that there. . . . Sometimes while composing this picture I got into the picture and stood about in different parts of it and . . . continued to compare from where I was standing. . . .'[104] Spencer imparted this exalted religious atmosphere to the row of saints seated along the church wall: their function was to express 'different . . . states of spiritual thinking,'[105] for example, 'contemplation, consideration, pondering, understanding . . . believing.' Theirs was to be the 'chiefest' job of 'thinking.'[106] The others resurrecting were given the simpler task of 'enjoying the peace'; having resurrected from a state of rest they now assumed a new one, 'the lively and productive state of "peace."'[107] In passing from one state to another they are, however, 'at home before they have got right out of their graves,' and are 'enjoying the perfectness of doing nothing.'[108] The blacks, too, are 'respectfully enjoying' a number of tactile activities such as 'Feeling a round stone . . . resting a hand on a many faceted piece of rock . . . playing with sand. . . . Touching the hem of Christ's robe.'[109] Spencer's description of the painting's division into the spiritual activities of the saints and the physical pleasures of the others, helps to explain the early sub-title of the painting,[110] 'An Allegory of the Saving of the Black and White Races: the Instinctive and the Intellectual,' which was never officially used when the picture was exhibited.[111]

One aspect of *The Resurrection* which has not been previously discussed is the underlying sub-theme of Spencer's relationship with his wife Hilda and the consequent presence of a subdued air of sexuality in the painting. Writing in 1939, Spencer described the emergence of this new subject in his work:

Up to and after I had finished the Betrayal

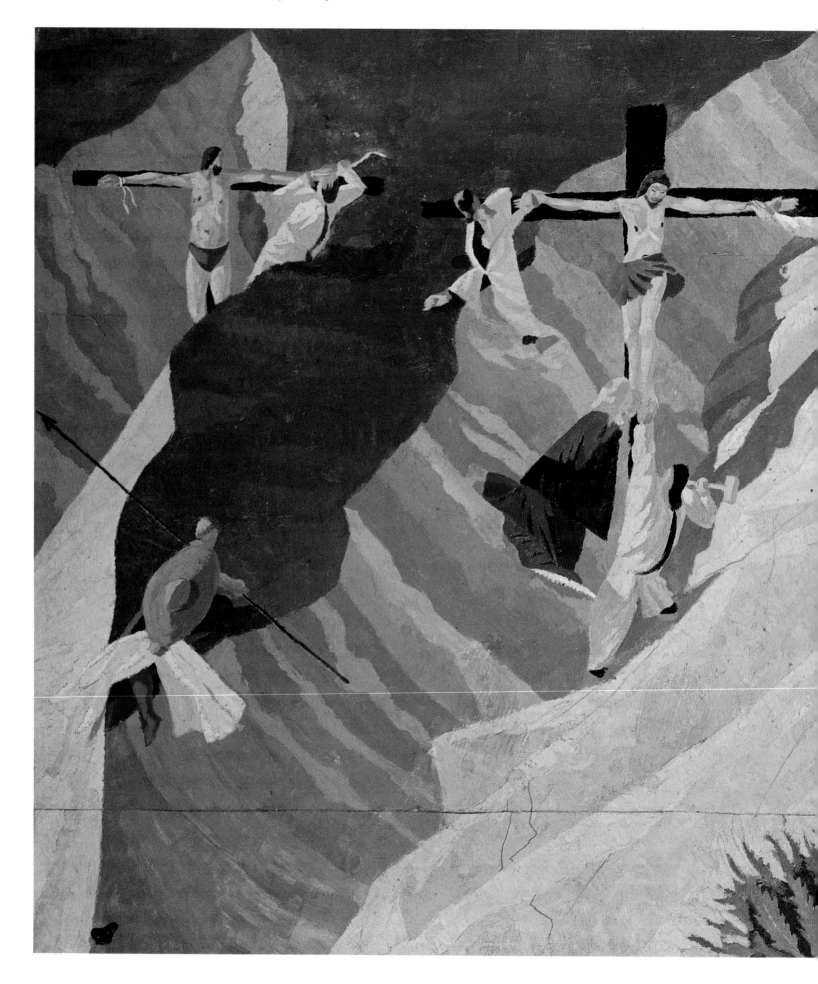

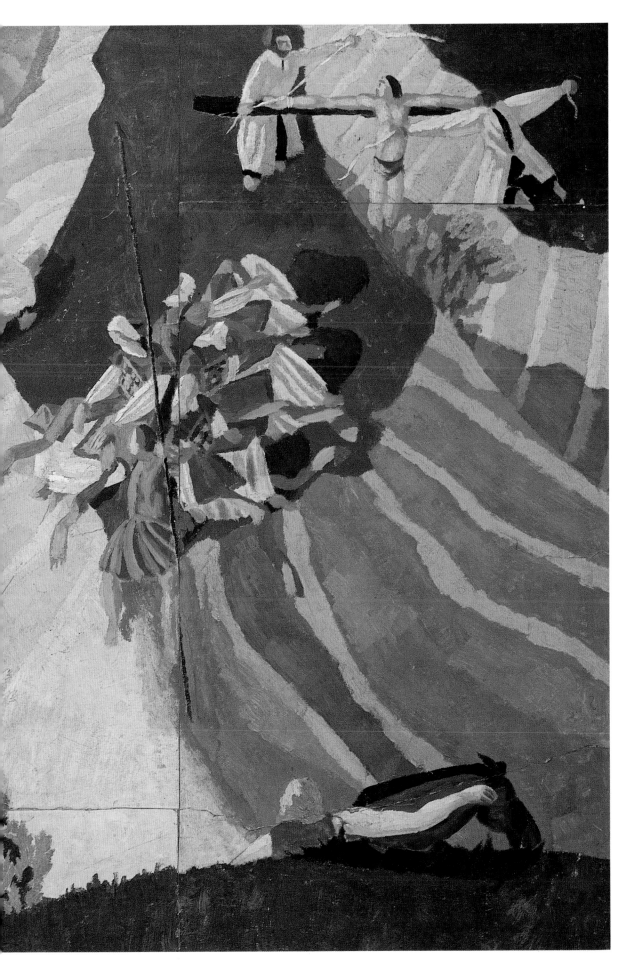

Cat. 77
The Crucifixion
1921

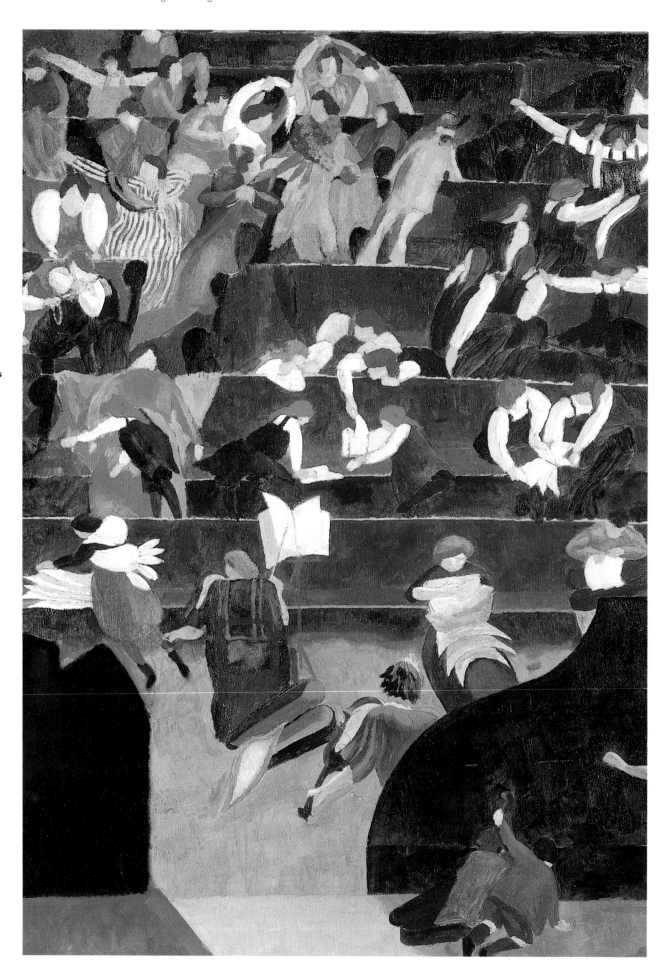

Cat. 80
A Music Lesson at Bedales
1921

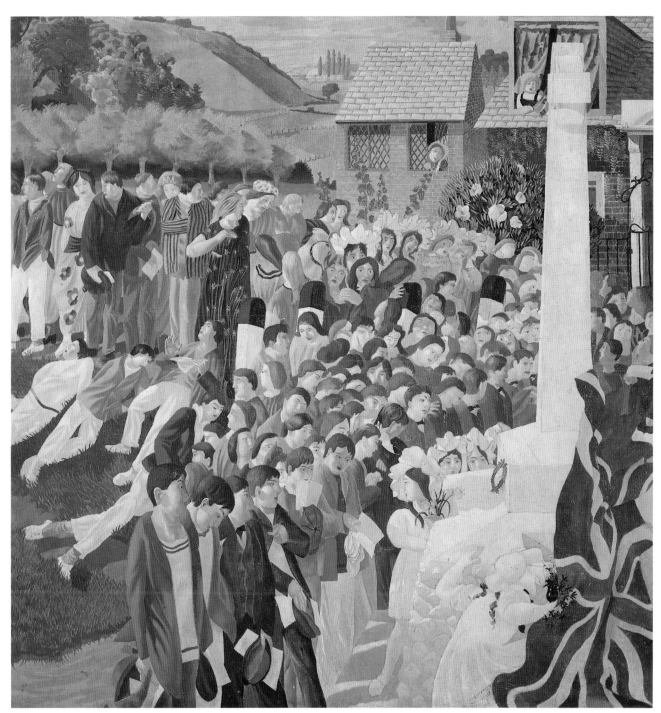

Cat. 81
**Unveiling Cookham War
Memorial**
1922

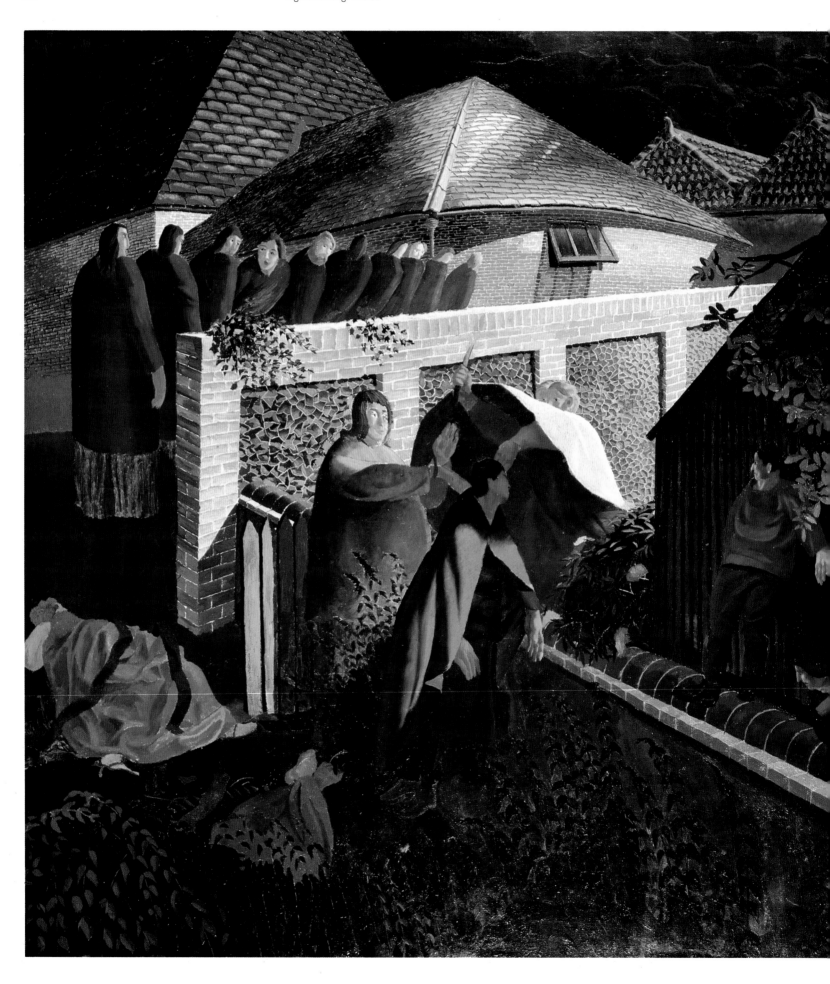

Cat. 91
The Betrayal
(second version)
1922-3

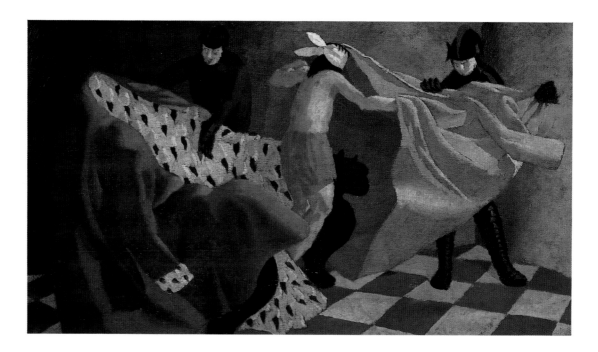

Cat. 93
The Disrobing of Christ
1922

the sexual passion had not entered my work but when I came to painting the Resurrection I noticed them and how they increased the emphasis and profoundness of what I had felt. I felt it in the wish to include myself and Hilda and in the painting of the negro people. The figure getting over the stile and lying in the near tomb is Hilda and the dresses worn by the figure smelling the flower on the left and the black dress worn by the figure on the right are hers.[112]

Spencer felt that his earlier religious works had either been 'innocent' or that sex was 'unconscious' in them.[113] In this sense, *The Resurrection* was a transitional work, in that the sexual element was confined to the simple presence of Spencer and Hilda. Their sexuality is conveyed metaphorically by the 'touching' activities of the Negroes, who seem to fulfil (like Gauguin's natives) the role of free spirits unconstrained by western social conventions. Spencer linked sexuality closely with artistic creativity – it gave him a great feeling of 'stimulation and vitality' – and he felt that this 'new character,' now sexually aware, 'some years' after his marriage (in 1925) began 'to paint my pictures.'[114] This description of the role of sexuality in his creative work explains why Spencer later panicked when he experienced sexual difficulties in his relationship with Patricia Preece.

In February 1927, Spencer used the newly

completed *Resurrection* as the centrepiece for his first one-man exhibition at the Goupil Gallery. Although he had been showing at Goupil's since 1925, the exhibition introduced Spencer to a much wider public, and gave him his first major critical coverage in the press. The exhibition was also a considerable sales success, with thirty-nine paintings and drawings sold, bringing in a total of £1917. 14s. of which Spencer received £1438. 5s. 6d., after a deduction of a 25 per cent commission. This sum included £750 from the purchase of *The Resurrection, Cookham* by the Duveen Paintings Trust for the Tate Gallery.

Critical reaction to the exhibition was generally enthusiastic and occasionally ecstatic, with *The Resurrection* receiving the lion's share of attention. The *Guardian* critic thought it 'one of the few important religious pictures produced in England,'[115] an opinion echoed by Charles Marriott of *The Times*, who described it as 'in all probability . . . the most important picture painted by an English artist in the present century;'[116] and by R.H. Wilenski in the *Evening Standard*: 'the most original and important picture painted since the war,'[117] and P.G. Konody: 'Mr Spencer's Great Resurrection.'[118] Elsewhere the critic for the *Daily Sketch*, under the headline 'A Primitive Artist of Today,' declared *The Resurrection* to be '. . . the most completely satisfactory treatment of such a subject that has ever been executed by a British artist. . . . If Mr Spencer, who is still in his early thirties, had painted nothing else he

Cat. 92
The Robing of Christ
1922

article published in the *Nation and Athenaeum* of 12 March 1927.[124] Here, Fry tried with some success to be fair to Spencer's achievement, while at the same time submitting the paintings to his own theory of aesthetics, with its inherent hostility to subject-matter. Fry saw in Spencer 'a visionary not a visualizer,' and continued:

> Put him before any actual appearance, and he is at a loss to draw from it any but the most banal conclusions. He will make an undistinguished map of a face or a trivial colour harmony of a landscape, without body or consistency. But give him an idea, the odder and more unlikely the better . . . and he will gradually collect from out of the visible world a number of images which have a firm literary context.

would be entitled to rank among the very leaders of modern art.'[119] This near unanimity of critical approval, at least among the dailies, was remarked upon by the writer for the *Daily Express*, who commented: 'Critics of all schools regard it [*The Resurrection*] as a noble religious picture, and as without doubt the greatest achievement by any artist in England since the war.'[120] Among the few negative cases of criticism, the *Birmingham Post*'s comments were typical. Under the heading 'Experimental Work by Mr Stanley Spencer,' the *Post*'s critic attacked the figurative paintings in the Goupil exhibition for following 'a limited convention which permits distortions of the human form and perversions of reality which are often ridiculous, and for which there is no decorative excuse.'[121] He went on to single out *The Resurrection* for 'a want of grace and distinction,' and 'a tendency towards caricature, both of which detract from the persuasiveness of the painting,'[122] all areas in which Spencer was to come under increasing attack in the 1930s, climaxing in 1935 with the dispute which led to his resignation from the Royal Academy.

The attitude to Spencer's exhibition of those English artists who were aligned with contemporary European developments in art was almost certainly unfavourable, and probably echoed the *Nottingham Guardian*'s report that 'Epstein was there [at the Goupil exhibition], fiercely critical.'[123] Their opinion was summed up by Roger Fry in an important

Fry went on to explain his own attitude towards literary art and to Spencer's place in it:

> Mr Spencer is a literary painter, he works by imagery. Our quarrel with such should not be that they are not plastic – they are practising an alternative art – but that, for the most part, their imagery is so dull and inexpressive. That complaint cannot be urged against the Resurrection. . . . It is no perfunctory or sentimental piece of story-telling, but a personal conception carried through with unfailing verve and conviction. And such imagery is not so common but that it should be welcomed even by those who, like myself, find its total effect to be a distinctly unpleasant and disagreeable stimulation.

This last sting in the tail made it clear that even the best of Spencer's work could not fit into the formalist straitjacket of Fry's model of contemporary art, with its concept of successive movements and adamantly Francophile leaning.

Fry's criticism may have received an indirect response in the April *Apollo*,[125] where Spencer's most skilful apologist, John Rothenstein, attacked the 'younger generation of artists' in England for making 'pastiches' or 'mere exercises in the manners of the French masters.' Evidently the considerable critical success of Spencer's work provided Rothenstein with a useful opening through

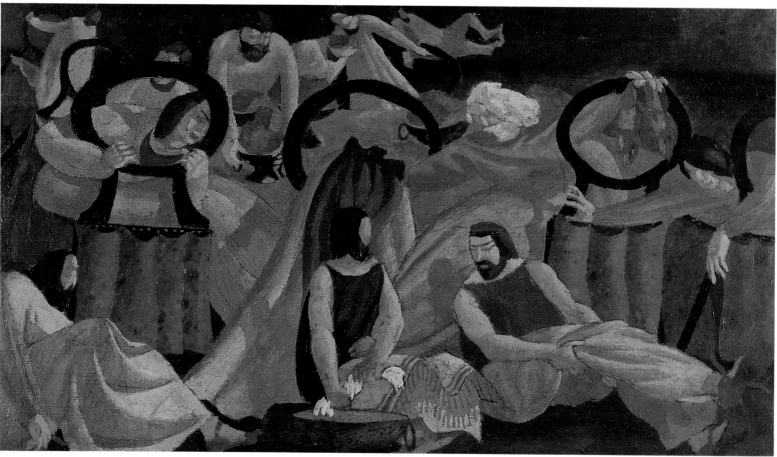

Cat. 94
Washing Peter's Feet
1922

which to attack the French-based aesthetics of Fry, Bell and their followers. Consequently, Rothenstein was able to reaffirm the existence of a viable independent school of painters whose work was firmly rooted in the national artistic tradition. This was particularly appropriate in the centenary year of another English visionary painter, William Blake, an event which was extensively celebrated in 1927.[126] Rothenstein may also have been aware that Fry's influence was losing its momentum along with the popularity of his work. Only a month before, in the March *Apollo*, Fry's painting had been criticized in terms of English versus French schools: 'His best picture here [at the Lefevre Galleries] is "A Farm Close" but the detour via France and Cézanne which the author has made during the last seventeen years seems to have been a waste of time; he could have got there much more directly and rapidly via Cézanne.'[127]

In his article, Rothenstein declared that 'Stanley Spencer is entirely free from this fascination' with French art, and while it was possible to detect 'traces of impressionist influences' in his handling of light and shade, these were of an 'entirely unconscious kind.'

Rothenstein had taken the trouble to interview Spencer and was able to quote him as saying (quite untruthfully) that he knew 'no more than a charwoman' about modern tendencies in English and French art.[128] Building on this statement, Rothenstein produced a picture of an artist whose work was 'an unconscious and essentially indigenous growth,' influenced by the Italian primitives, the Slade School tradition, and the Pre-Raphaelites. In place of 'Gallic brilliance and cosmopolitan scholarliness,' Rothenstein detected 'a singular depth of indigenousness.' He went on: 'He reflects on a smaller scale at a later age the spirit of the country around Cookham, and with all the native profundity and intensity with which the novels of Mr Hardy mirror that greater tract he has rechristened Wessex.'[129]

Most of the critics of Spencer's Goupil exhibition made similar comments about the artist's sources and his peculiar Englishness. A number sought to explain Spencer's evident borrowings from the past as forming part of a cyclical process in art history which made him – paradoxically – modern. Thus, in discussing the Goupil show, 'H.L.C.' in the *Graphic* could declare: 'Art does not progress: it moves in

cycles, and today the archaic realism of Giotto and the vivid concrete dreams of the early German painters have, in some quarters, become the *dernier cri*. Mr Stanley Spencer is modern, quite young and consequently quite old . . . a solemn and fanciful expressionist.'[130] This theory stands quite close to the position of teachers like Henry Tonks, whose approach to art was free of the concept of progress and closer to an 'ahistorical notion of "quality."'[131] For Tonks it was quite acceptable to discuss Manet at the same time as Titian or Michelangelo, and it was this attitude (which clearly affected Spencer's outlook as well) which many critics brought to their reviews of the exhibition. This goes some way to explaining why a painting, which in Fry's eyes was definitely old-fashioned, might in another critic's opinion rank Spencer 'among the very leaders of modern art.'[132]

For a number of critics, this cyclical approach to art helped to explain the new work of Spencer, as well as a number of other artists including Henry Lamb and Richard and Sydney Carline. As early as 1924 C. Lewis Hind, in his book *Landscape Painting*,[133] had remarked that the influence of modern 'isms' was in abeyance: 'Art does not progress,' he wrote, 'it goes in circles. A modified Pre-Raphaelitism is now one of the New Things.'[134] Several critics also linked the renewed interest in Pre-Raphaelitism with the so-called 'primitives,' in this case the early Italian painters, and certain aspects of northern medieval art. Thus the critic for the *Near East*

and India could remark: 'Mr Spencer's exhibition is an excellent index of what the younger school of British artists are aiming at: a kind of revision of the 'Primitive' technique with a strict but unconventional imagination,'[135] while 'J.B.', writing in the *Guardian*, felt that *The Resurrection, Cookham* had 'a native raciness and homely charm . . . in type one may trace [in it] characteristics of early English art, of the art of the "dooms" in Norfolk churches.'[136] He then proceeded to compare it to Walter Greaves's *Hammersmith Bridge*, before declaring that: 'Mr Spencer's picture . . . stands out as a modern and significant work of art, curiously exciting in its energetic decoration and arbitrary selection, yet alive, and informed throughout with the active human expressiveness of a Breughel.'[137]

P.G. Konody was even more emphatic; for him the 'Resurrection was akin in character and intensity to the effect left upon me by my last visit to the Arena chapel in Padua. Mr Spencer seems to me to stand as near to Giotto as it is possible for an artist of the present day.'[138] Elsewhere, the critics sought a more specific grounding for Spencer's work in the British artistic tradition, with the *Daily Chronicle* writer declaring him a 'second Blake,'[139] while the reviewer for *Country Life* compared *The Resurrection* to Holman Hunt's *Light of the World*, to the detriment of the latter which he found to be 'flabby,' with 'little feeling for rhythm of forms or harmony of colour.'[140]

When looked at as a whole it is clear that many of the critics covering the Goupil

Cat. 95
The Last Supper
1922

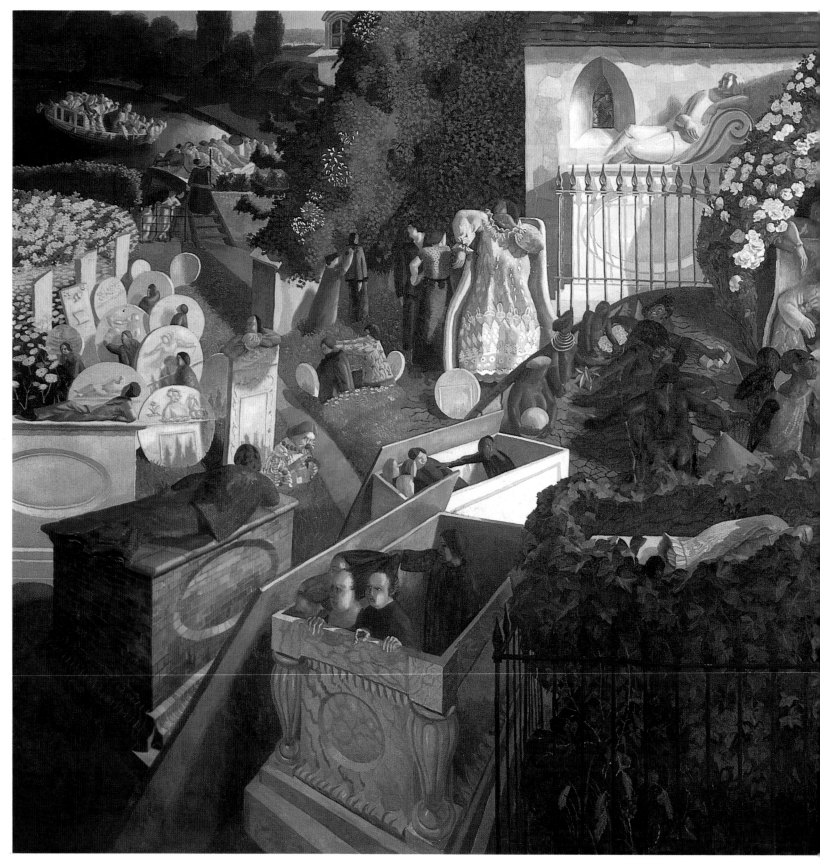

Cat. 116
The Resurrection,
Cookham
1924-6

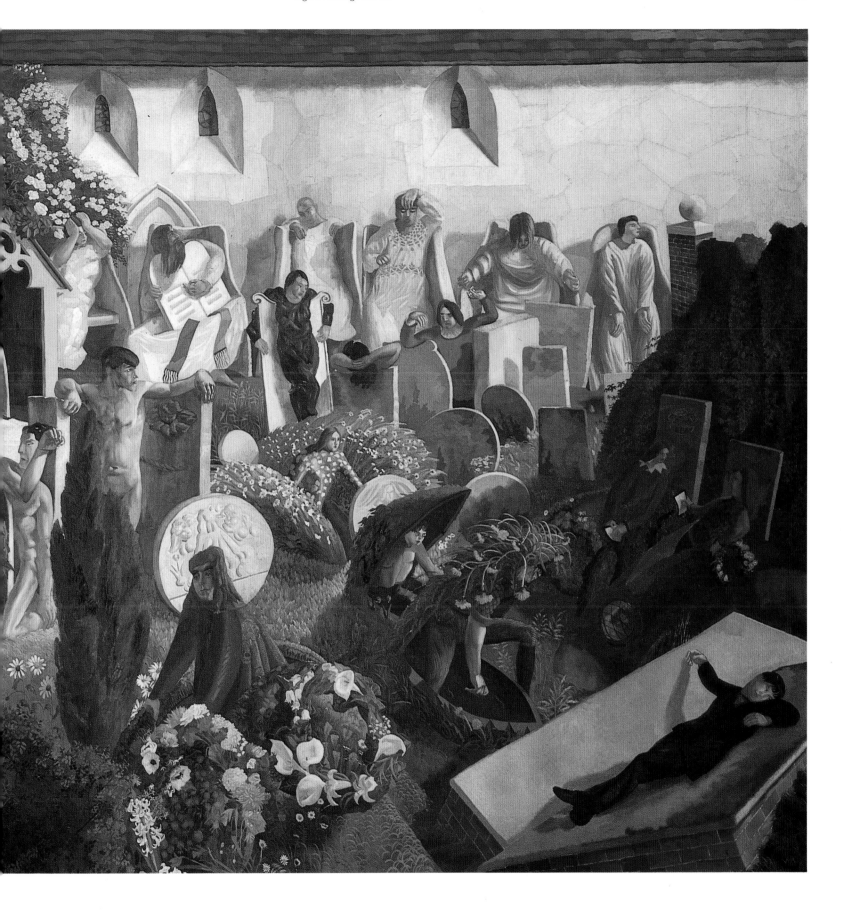

Cat. 118
Soldiers Washing
c.1927

exhibition saw Spencer as part of a new, specifically English, art revival which had its roots planted firmly in the traditions of the Old Masters and their most recent successors – the Pre-Raphaelites. The influence of modernist French art, as championed by Roger Fry, 'the heartless swish-swash of myopic Cézanne disciples' (as the *Morning Post* was to call it in 1930), was to be rivalled and perhaps even replaced once again by a 'national' style.[141] This attitude was put characteristically by the *Daily Express* reviewer in 1929: 'The modern movement in painting in England broadly speaking, derives mainly from two tendencies. . . . There is first of all the influence of the Renaissance and the Primitives filtered partly through the pre-Raphaelites [here he identified Stanley and Gilbert Spencer as the leaders].' The 'other school' followed Cézanne, Duncan Grant, Roger Fry, Paul Nash and Mark Gertler.[142]

Other reviewers, however, while acknowledging Spencer's English and primitive sources, were also alert to his connections with Modernist art. Charles Marriott in *The Times*, for example, having called *The Resurrection* 'English to the bone,' went on to comment: 'What makes it so astonishing is the combination in it of careful detail with modern freedom in the treatment of form. It is as if a Pre-Raphaelite had shaken hands with a cubist.'[143] Marriott had presumably spotted the cubistic treatment of the church wall, and the elevated viewpoint and sharply plunging perspective on the left side of the painting. As his comments followed some very fulsome praise for Spencer's picture, it is evident that he found this particular combination of sources acceptable.[144] The critic for the *Connoisseur*, on the other hand, thought that he had spotted a partially concealed danger which might lead to the trivialization of a noble theme: 'The artist is a modern who seeks to clothe the latest and most advanced ideas in an archaic garb. One feels that the picture though intended to be impressive, has missed its aim, and is less suggestive of the Resurrection than of a nightmare in one of Woolworth's toy bazaars.'[145]

The often favourable reception of Spencer's Goupil Gallery exhibition, and its extensive coverage in the press, make it apparent that – at least in 1927 – the critics were willing to see him as an artist of great potential on the English art scene. As Dennis Farr has pointed

out, nothing very substantial had happened in the eight years since the end of the war to provide a solid grounding for the growth of new art.[146] 'The New Men' (Spencer, Lamb, the brothers Nash, Wyndham Lewis and Roberts) whom a critic had singled out at the *War Painting* exhibition in 1919, had not, with the exceptions of Spencer, and Paul Nash at Dymchurch, produced much important work.[147] Henry Lamb had been a particular disappointment, having retreated to Coombe Bissett in Wiltshire to concentrate on society portraits and the occasional landscape, after receiving poor reviews of his first one-man exhibition at the Leicester Galleries in 1927.[148]

The art doldrums of the twenties also affected Roger Fry's aesthetic of 'significant form,' and as he remarked in the catalogue for the *London Group Retrospective Exhibition* in 1928, Post-Impressionism had begun to revert to more traditional spatial and structural compositions, an influence in part derived from the new formalized naturalism of Derain.[149] In Fry's case, this had led to a dullness in his painting which critics were quick to observe and comment upon (see above). Thus, in 1927, one anonymous viewer had been prompted to remark that 'Mr Fry seems to have lost his Cézanne enthusiasm and acquired none of his own.'[150]

This attitude was still apparent in 1932 when William Rothenstein, writing in *Men and Memories*, bemoaned what he viewed as the decline in English drawing standards. This he attributed to encroaching foreign ideas: '. . . the influence of Continental artists, of Matisse and Picasso especially, has seduced English painters from their old independence. Only a few among the younger painters have kept their birthright, notably Stanley and Gilbert Spencer.'[151] Elsewhere in the book, Rothenstein continued his attack on external influences, criticizing Picasso, 'that sad aesthetic rake,' and calling on 'certain English painters' to be 'more faithless to Cézanne.'[152] On page 219, he ventured a commentary on contemporary English art in which he seemed to have Stanley Spencer (whose *Resurrection* he called 'one of the significant paintings of our time'), Eric Gill, John Nash, Eric Ravilious, Gwen Raverat and Blair Hughes Stanton in mind:[153]

Today, standing aloof from the 'abstract' painters . . . there are a number of young

Cat. 121
Study for the Resurrection of Soldiers, Burghclere
c.1926-7

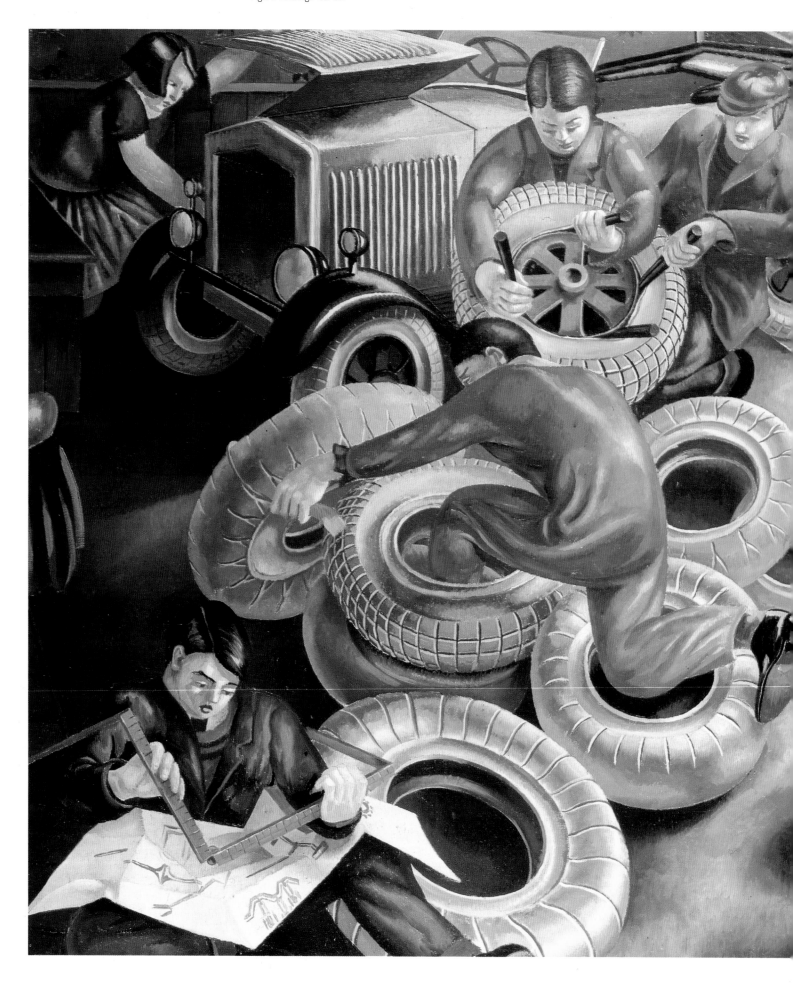

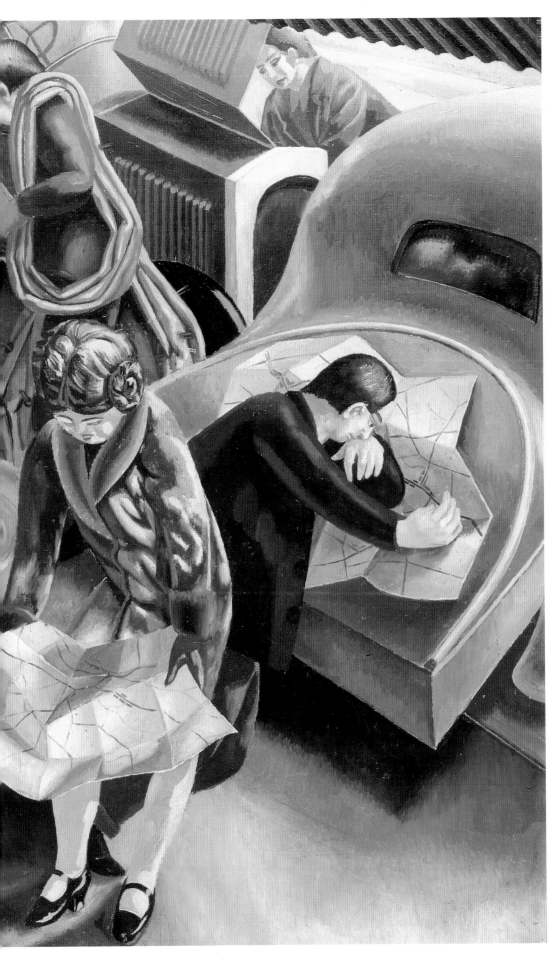

Cat. 128e
The Garage
1929

artists who give fresh and vigorous attention to the life about them. In English painting there is something akin to the provincial flavour of Mark Rutherford's and Thomas Hardy's writing, an imaginative quality set down with reticence, yet by no means lacking in passion.

The popularity of Spencer's work can also be seen in the context, not only of the traditional nationalistic hostility to foreign influences, but also in a growing emphasis on the importance of the English countryside as a repository of all that was good in the national way of life.[154] This attitude can be discerned in books like *Change in the Village* (1912) and *The Wheelwright's Shop* (1923) by George Sturt (1863-1927), and in the works of novelists such as E.M. Forster who, in *Howards End* (1910), commented: 'In these English farms, if anywhere, one might see life steadily and see it whole.'[155] Or D.H. Lawrence on Garsington Manor in 1915: 'Here one feels the real England – this old house, this countryside – so poignantly . . . it is in its way so beautiful, one is tempted to give in, and to stay here, to lapse back into its peaceful beauty . . .'[156] Lawrence's nostalgia for the English landscape was probably heightened, as it was for many others, by the onset of the First World War.

Spencer's own relationship to the southern countryside – his birthplace and whenever possible his home – was impeccable and clearly a source of attraction for his early supporters. For example, his early patron Edward Marsh, the purchaser of *Cookham* (1914; 19), at one time intended to use Spencer as one of the illustrators for his editions of *Georgian Poetry*.[157] Marsh's 'Georgians,' notably Rupert Brooke, were mostly socialists 'of a William Morris Sort,'[158] who believed that the heart of England lay in the countryside, as Brooke made clear in the poem 'The Old Vicarage, Grantchester.'[159]

Other writers and critics were also moved by Spencer's peculiar rural 'Englishness.' In his 1927 *Apollo* article on Spencer, John Rothenstein had identified 'Nature herself and a passionate religious feeling' as the core of the artist's best work.[160] Rothenstein's comparison of Spencer's Cookham to the imaginary Wessex of Thomas Hardy (see above) came perceptively near to the artist's own feelings. Guided perhaps by Marsh

himself, Spencer had read most of the great English poets by the end of the First World War. In a letter written in 1918 to Gwen Raverat while he was on active service, Spencer commented: 'I cannot forget Thomas Hardy. I should love to read his Wessex poems again.' The same letter also contained some other literary opinions written in the same vein. He 'prefers Swinburne to Keats . . . Robert Browning I find hard to read. . . . But when are we going to get a really great poet like Milton?'[161]

In this context, it is easy to see why Spencer's work, and particularly *The Resurrection, Cookham*, proved so popular in 1927. The picture was a statement of Spencer's feelings for Cookham, his friends, and of course his religion. As such it was an appropriately Anglican concept that all the resurrected should appear in an English churchyard (a Spencerian parallel to Brooke's Grantchester), and not in some abstract and alien heaven. In an era when the myth of the rural ideal was gaining power, this might well have been the kind of heaven that many of England's urban majority would prefer to find themselves in. Since the war this luxuriant sense of repose and resurrection would have become considerably more appealing, even urgent, a factor which seems to have been in Spencer's mind when he painted the picture. In an interview with the critic of the *Birmingham Post* at the time of his Goupil exhibition, Spencer recalled: 'I had buried so many people and saw so many dead bodies that I felt that death could not be the end of everything.'[162]

The Goupil exhibition was an important success for Spencer; he had begun to earn an independent living from his art, and his public reputation was greatly enhanced. The critical reception too – at least among the more conservative reviewers – seemed to identify Spencer as the potential leader of a revival based firmly on traditional English artistic values. Indeed Wyndham Lewis's concern, expressed in the X Group catalogue of 1920, that there were some people who wanted to see Pre-Raphaelitism reinstated, now seemed to have some potential for achieving reality.[163] However Spencer apparently had no personal inclination to lead any such movement, and his work was too personal in its vision to provide a major stimulus to other artists;[164] only Mary Bone, among younger

artists, later admitted to working partly under Spencer's influence in the late 1920s.[165]

Spencer was also active in other areas in the early twenties. In 1920 he was one of six artists – including Edward Wadsworth, Albert Rutherston, Jacob Kramer and John and Paul Nash – selected by Sir Michael Sadler to provide sketches for a projected series of large-scale paintings for Leeds Town Hall, on the theme of Industry (35, 36).[166] Following the very visible success of the war artists in recording the Great War for the country, and the subsequent production of numerous monuments commemorating the dead, there was considerable interest in the idea of creating art for public places. Tonks, for example, led his students in a number of mural painting schemes in London,[167] and, starting in 1923, the London Midland and Scottish Railway, quickly followed by the London and North Eastern Railway and the London Underground, began commissioning landscape posters from Royal Academicians to advertise their services.[168] Sadler's programme at Leeds must have called for a similar approach, in this case for Industry; certainly Paul Nash's subjects, *The Canal* and *The Quarry*, adhere to the idea of an industrial landscape.[169] Spencer, on the other hand, was attracted to the relaxed street life of the city slums, which he thought were 'very sad and very wonderful.' His sketches show the narrow streets and alleys of Leeds, with lines of washing blowing in the breeze, and the massive wheels of pithead winding gear in the background over the roofs

(see RA, no. 42); views which both in content and composition are not dissimilar to *Christ's Entry into Jerusalem* (70), and *Christ Carrying the Cross* (38). Although this subject was very much to Spencer's taste, it is unlikely that the slum landscape would have met the approval of Leeds City Council, and in any case the scheme fell through before any choice of artist could be made.

Spencer's final project of the 1920s was a commission from the Empire Marketing Board in 1929 for a poster or series of posters based on the theme of Industry and Peace. Evidently his Goupil success, together with the promising work at Burghclere, had made him well enough known to join other popular artists in the production of large-scale advertising subjects.

Although he was busy with the Burghclere paintings, Spencer responded quickly, producing a series of five paintings (128a-e) comprising a pastiche of ideas in part derived from drawings made at Steep in 1921. The scenes, of a garage, shop, and combined art class and music lesson, were intended to provide a panorama of life, based loosely on the commissioned theme. However, Spencer made no serious attempt to consider the paintings in their public role as posters, and the series was never printed. As in the case of the Steep memorial, he was determined to create only on his own terms, and this damaged his prospects for commissioned work, as it was to do again in the 1930s, when he entered the competition to paint decorations

Two Studies for Sandham Memorial Chapel, 1923. Pencil and sepia wash, each 22 x 28½ in/ 55.9 x 72.4 cm. Cookham, Stanley Spencer Gallery. Photographed by Gilbert Spencer before subsequent damage and fading. (See Bell, RA, no. 82a, b)

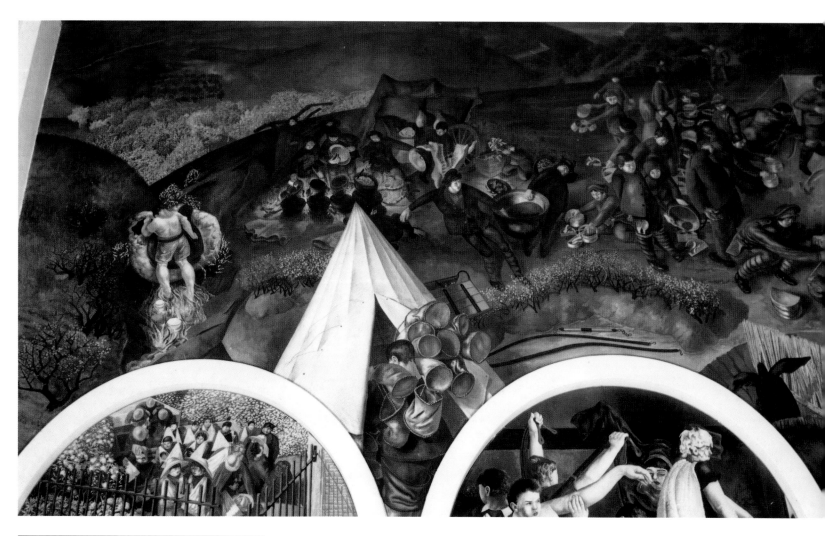

Cat. 130l
The Camp at Karasuli
Burghclere 1930

for the *Queen Mary* (189, 190).

Stylistically, the Empire Marketing Board pictures are close to the Burghclere canvases, with solid tubular figures often nestling comfortably within the womb-like shapes of wicker chairs, car tyres and bolts of cloth. Both the style and subject-matter of the paintings have parallels with William Roberts's art, both men having been drawn to contemporary subjects by their work as war artists. In comparison with other poster scenes of the twenties, Spencer's paintings were rather dark and heavy with a distinctly barrack-room atmosphere; very different from the warm relaxed mood of Adrian Stokes's work for the London, Midland and Scottish Railway, or the Piranesian drama of Frank Brangwyn's Bridge series for the London and North Eastern Railway.[170] Spencer's scenes of contemporary life in the Empire Marketing Board series were to some extent the consequence of his current activity at Burghclere, but they also provided clear evidence that he was well aware of current English figurative art – albeit of the more

restrained type best represented at the Royal Academy summer exhibitions. Spencer's all-inclusive interests also probably took in advertising illustrations of the kind which appeared in *Picture Post* as well as artist-produced posters for London Transport of the type designed by Herbert Budd and others.[171]

Spencer's success at the 1927 Goupil exhibition was soon followed by the even more important achievement of the Sandham Memorial Chapel at Burghclere (130a-s). Ever since his experiences on active service in Bristol and Macedonia, he had retained an idea for a series of war paintings, and in 1921 he made a false start on a scheme commissioned by Muirhead Bone at Steep (RA, no. 64). Later, in 1923, while staying with Henry Lamb in Poole, he produced the definitive drawings (see p.77) which were seen by Louis and Mary Behrend, who at once commissioned him to paint the decorations for the chapel.

The paintings for Burghclere were based on Spencer's recollections of Beaufort Hospital in Bristol, Tweseldown Camp near Aldershot, and

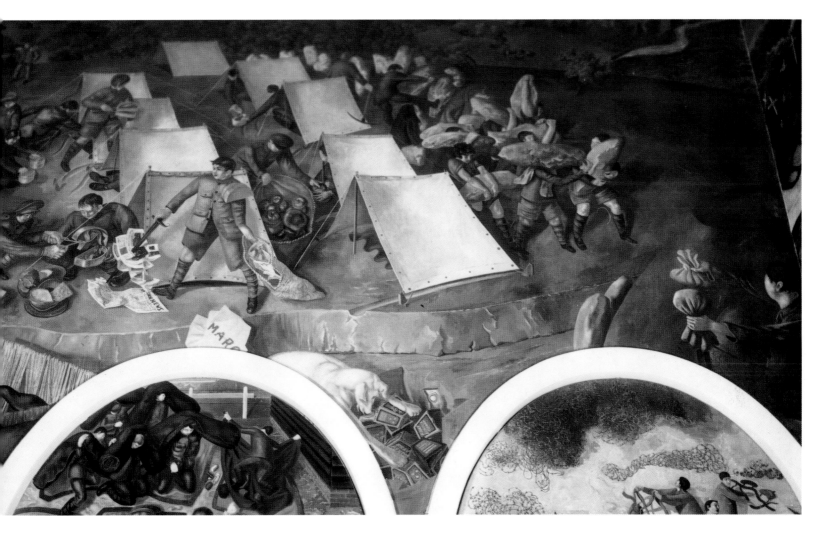

the Macedonian campaign. The artist avoided the more usual military scenes, choosing instead the moments of calm between battle, or the simple everyday activities of the orderlies in Beaufort Hospital. He was inspired in this by a passage from Saint Augustine's *Confessions*, given to him in 1916 by Desmond Chute: '. . . ever busy, yet ever at rest. Gathering yet never needing, bearing, filling, guarding, creating, nourishing, perfecting, seeking though thou hast no lack.'[172] This led Spencer to believe that 'there is something wonderful in hospital life. I think doing dressings when you are allowed to do things in peace and quiet is quite inspiring. The act of doing things . . . is wonderful.'[173] These feelings also spilled over into the domestic activities of camp life in Macedonia. Clearly Spencer had transferred his source of religious pleasure in the places and events of Cookham to his temporary 'homes' in the army. This preoccupation with domestic activities, which is most marked in the Beaufort scenes (e.g., 130 j, p, r), was later, in the 1930s, to become

the central theme of the *Church House* scheme. As Causey has remarked (p. 27), Burghclere demonstrated that Spencer was 'the most skilled designer of figure compositions among English artists of the period.' This is apparent not only in the intensely individualistic side wall paintings, where each subject is defined by its own striking set of patterns and shapes, but also in the three big paintings, *Camp at Karasuli* (130l), *Riverbed at Todorova* (130m), and *The Resurrection of Soldiers* (130h). In the latter, Spencer adopted the traditional division of the painting into three horizontal layers, with Christ enthroned near the top of the composition, but without the inclusion of hell in the lowest register. Here Spencer was probably inspired by Michelangelo's Sistine *Last Judgement*, which is similarly composed of groups of figures, and where the figure of Christ is the same size as the mortals gathered about him. Spencer undoubtedly also looked at Uccello's National Gallery *Rout of San Romano*, where the depth-creating function of the lances and recumbent figures is echoed in the

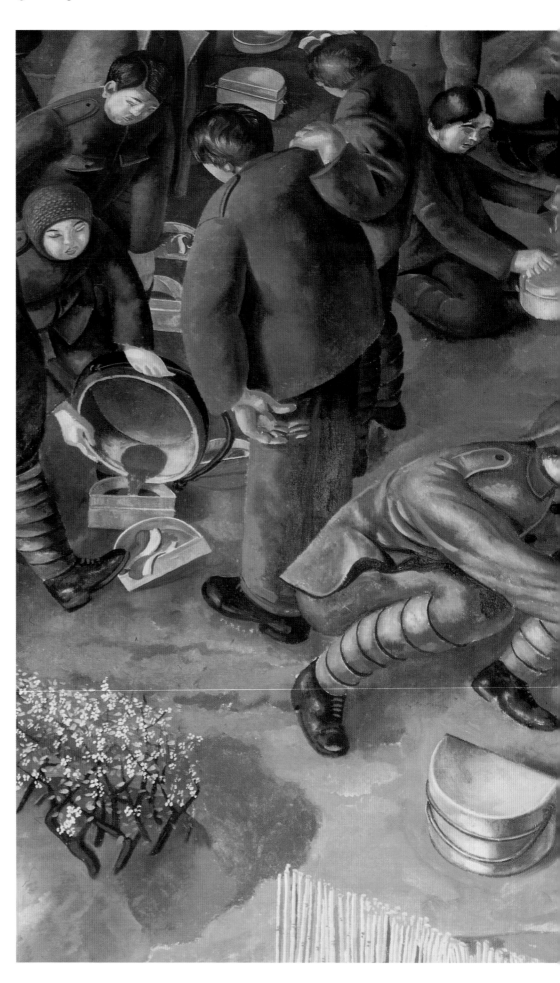

Cat. 1301
The Camp at Karasuli
(detail)
Burghclere 1930

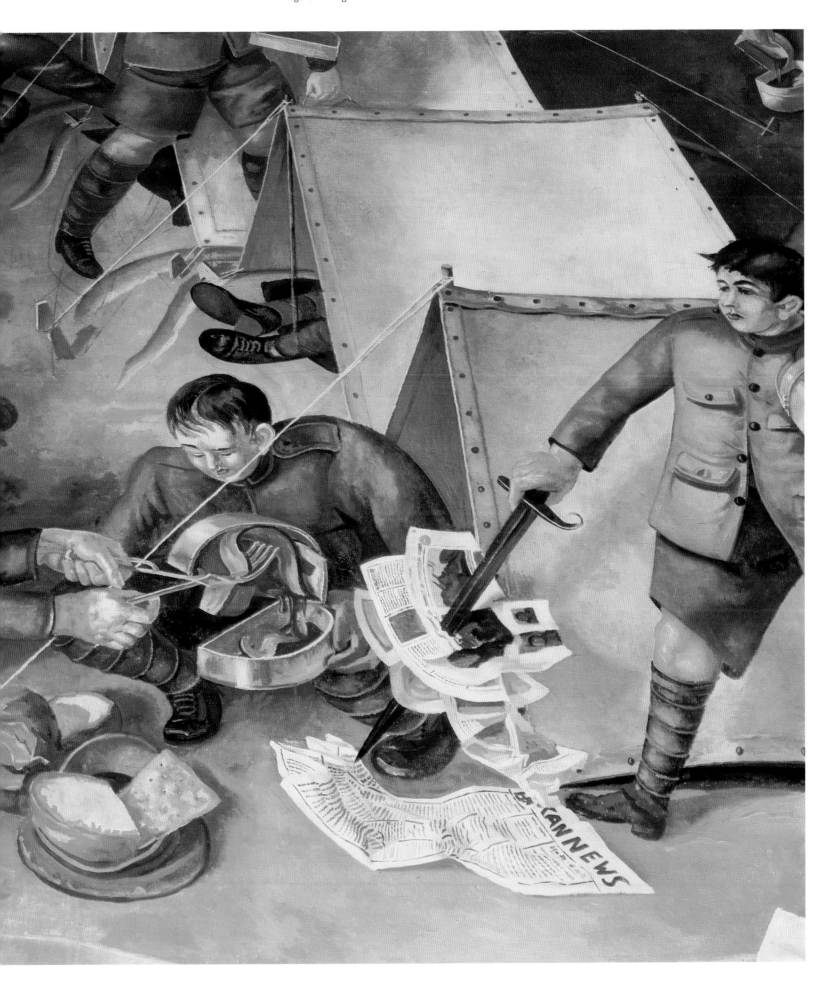

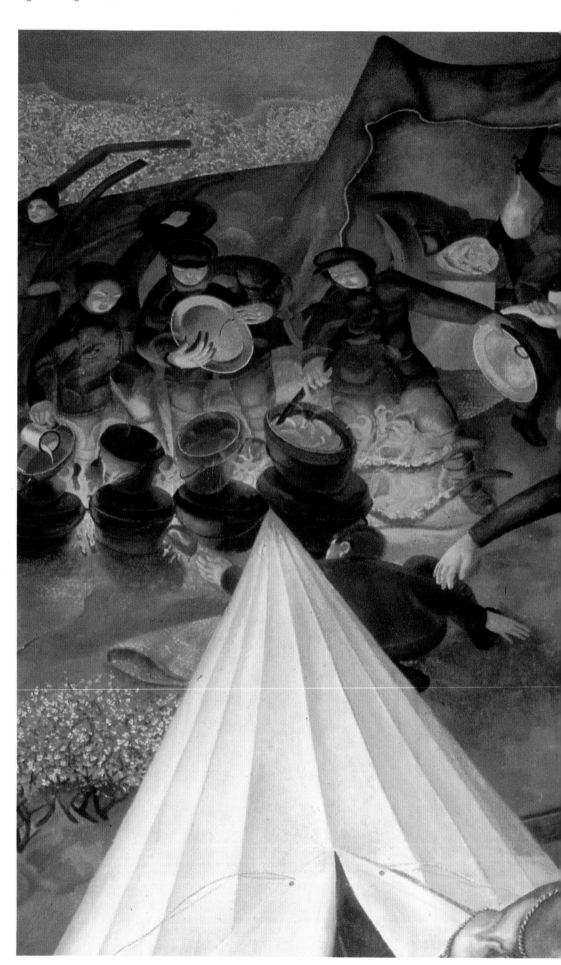

Cat. 1301
The Camp at Karasuli
(detail)
Burghclere 1930

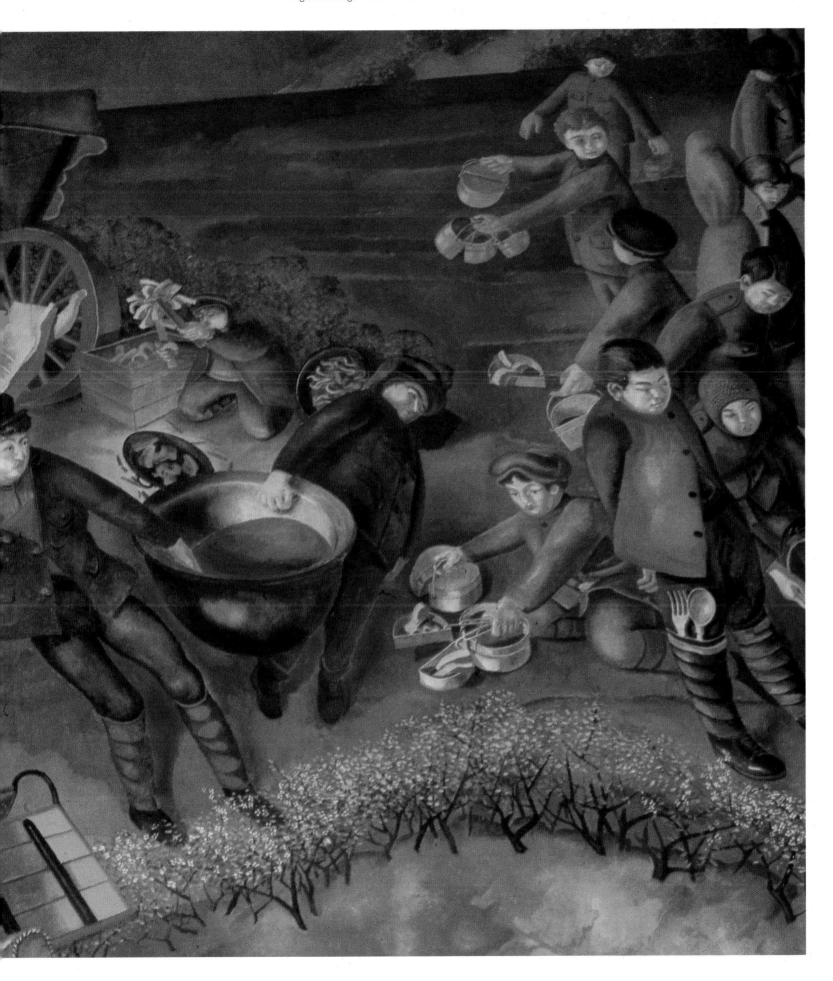

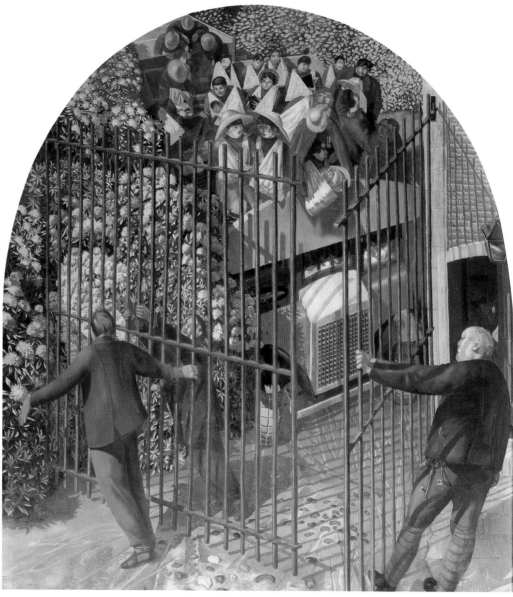

Cat. 130a
**Convoy of Wounded
Soldiers Arriving at
Beaufort Hospital Gates**
Burghclere 1927

Cat. 130b
Scrubbing the Floor
Burghclere 1927

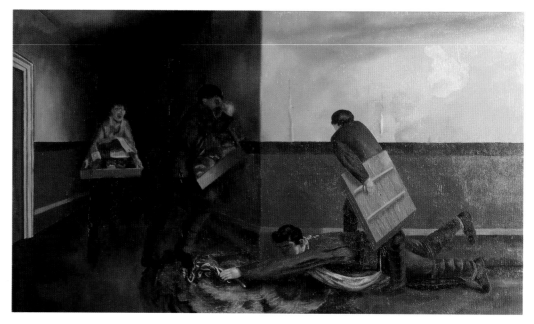

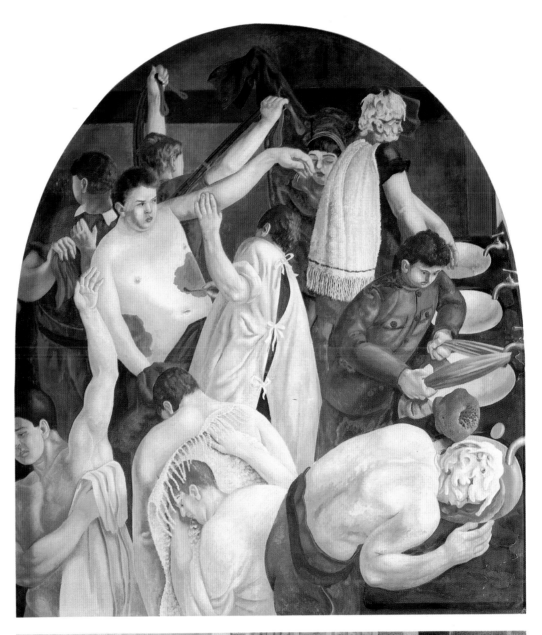

Cat. 130f
Ablutions
Burghclere 1928

Cat. 130c
**Sorting and Moving
Kit Bags**
Burghclere 1927

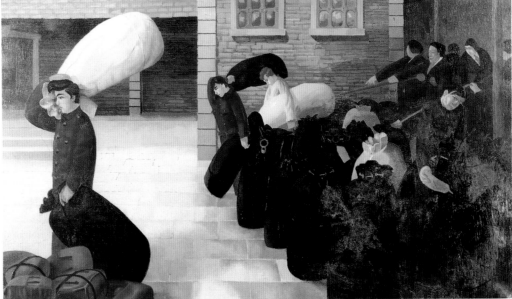

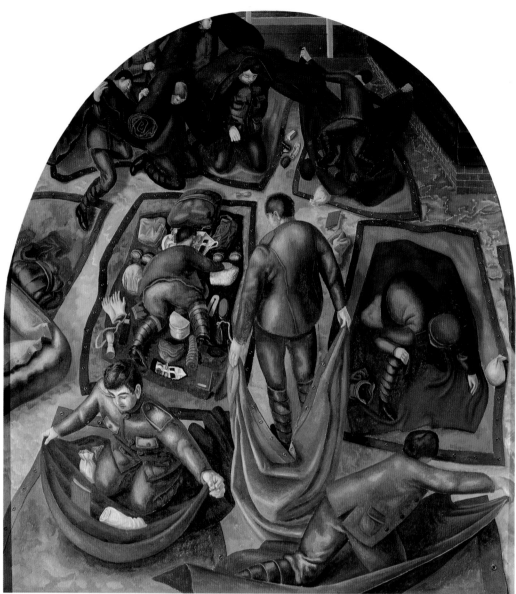

Cat. 130k
Kit Inspection
Burghclere 1930

Cat. 130d
Sorting Laundry
Burghclere 1927

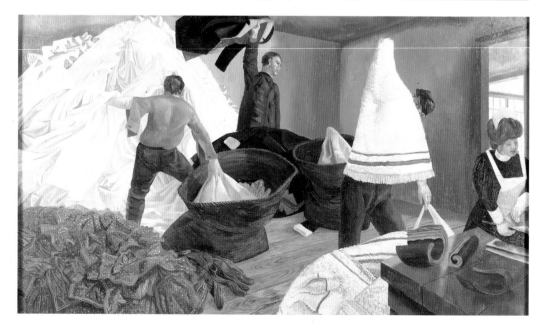

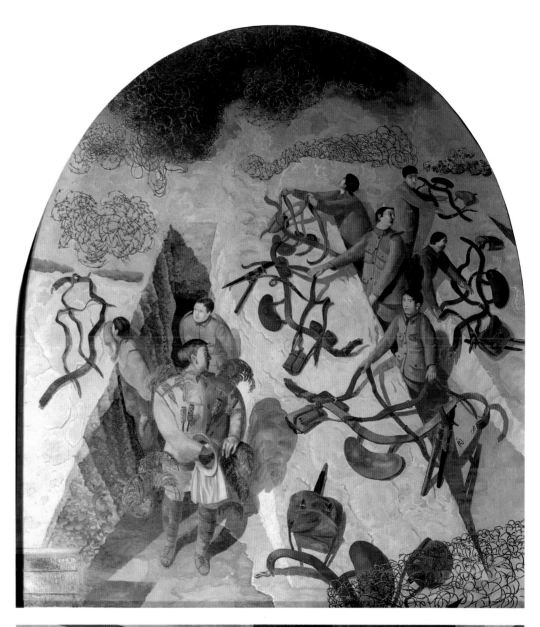

Cat. 130g
Dug-Out or **Stand-To**
Burghclere 1928

Cat. 130e
Filling Tea Urns
Burghclere 1927

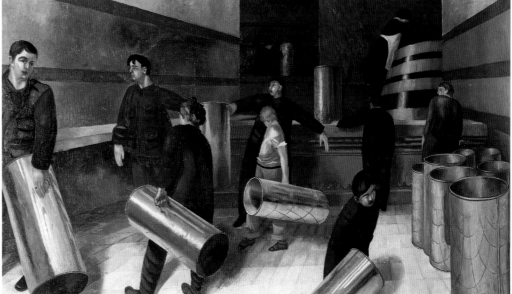

Cat. 130m
Riverbed at Todorova
Burghdere 1930-1

Burghclere work by the white crosses and resurrecting soldiers. The other two big side-wall paintings (130l, m) are equally bold in conception, and are once again probably influenced by Italian painting, this time Lorenzetti's allegory of *Good Government* in the Palazzo Pubblico, Siena, in their elevated viewpoint looking out over a populated countryside.

Critical success for Burghclere came even before the scheme was completed. P.G. Konody, reviewing the designs for the chapel on view at the Goupil Gallery in 1927, declared that 'it promises to be the most remarkable achievement in pictorial decoration ever undertaken by a British artist,'[174] and a stream of visitors to Burghclere, including Arthur Waley the poet, Robert Gathorne-Hardy and the Bloomsburyites, Duncan Grant, Vanessa Bell and the Carringtons, all seem to have been impressed. Many of these had probably been drawn by Roger Fry's grudgingly favourable review of the 1927 Goupil show in the *Nation and Athenaeum* of 12 March 1927.

These early predictions of success were confirmed when the chapel was completed in 1932. Charles Marriott writing for *The Times* declared that 'the century had produced nothing so truly original,'[175] while Sir William Rothenstein felt that: 'To my mind it stands as a great imaginative conception . . . a whole which has both the directness and the complexity of great art.'[176] These comments were supported by Richard Carline's 'New Mural Paintings by Stanley Spencer' in *Studio* of November 1928, and R.H. Wilenski in *English Painting*, published in 1933, where he sought to compare the Burghclere paintings with the way in which Hogarth built up 'incident and specific detail' to reinforce the meaning of the work.[177] This conclusion, while not particularly profound, did provide an alternative to the more usual references to Pre-Raphaelite influences, and helped to place Spencer firmly in the English tradition of narrative and imaginative art.

This critical approval of the chapel survived the rapid decline of Spencer's reputation in the

thirties when his painting underwent a radical
transformation. Indeed Burghclere became
something of an artistic albatross which was
constantly held as an example against his
perceived failure to provide figure paintings
more suited to the public taste. This can be
seen in Eric Newton's book on Spencer in the
Penguin Modern Classics series, published in 1947,
when the artist's popularity was again in the
ascendant.[181] Newton wrote: 'Burghclere is not
Spencer's most perfect creation but it is his
completest,' and he went on to describe the
chapel as a dense but disciplined whole,
combined with 'a kind of universal human
sympathy,'[182] which he implied was lacking in
the later work. These opinions were common
in the thirties, and behind Spencer's defiance of
the Academy in 1935 lay a strong sense of
uncertainty about his work, which rapidly
transformed the initial euphoria over the
success of Burghclere.

Cat. 130m
Riverbed at Todorova
(detail)
Burghclere 1930-1

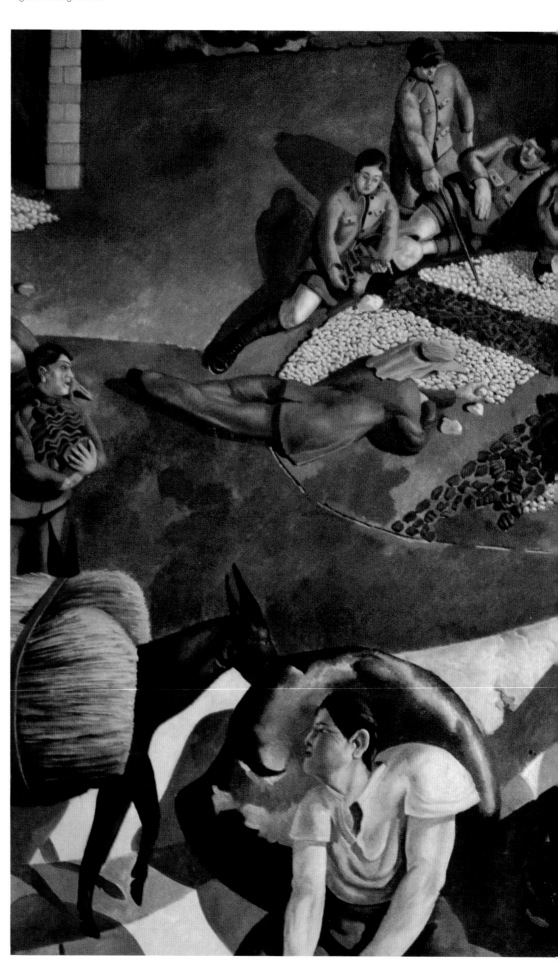

Cat. 130m
Riverbed at Todorova
(detail)
Burghclere 1930-1

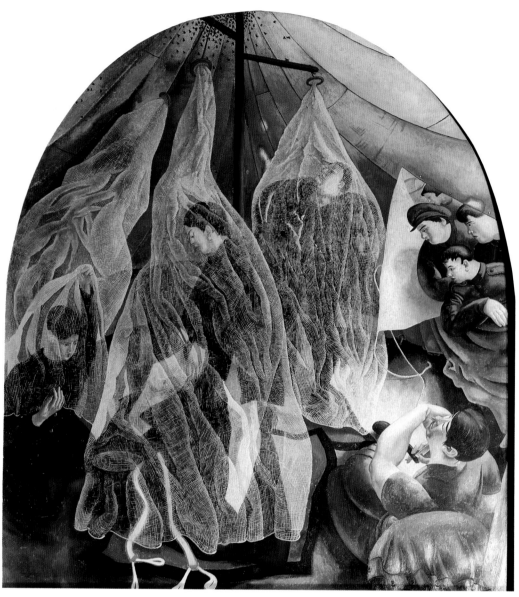

Cat. 130i
Reveille
Burghclere 1929

Cat. 130n
**Patient Suffering from
Frostbite**
Burghclere 1932

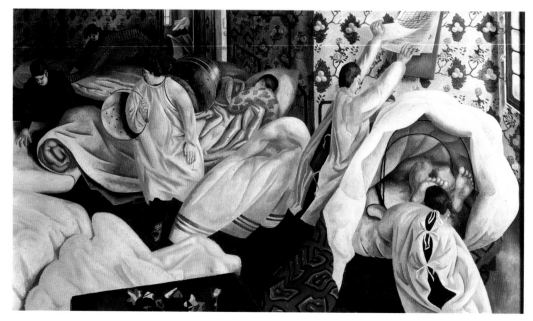

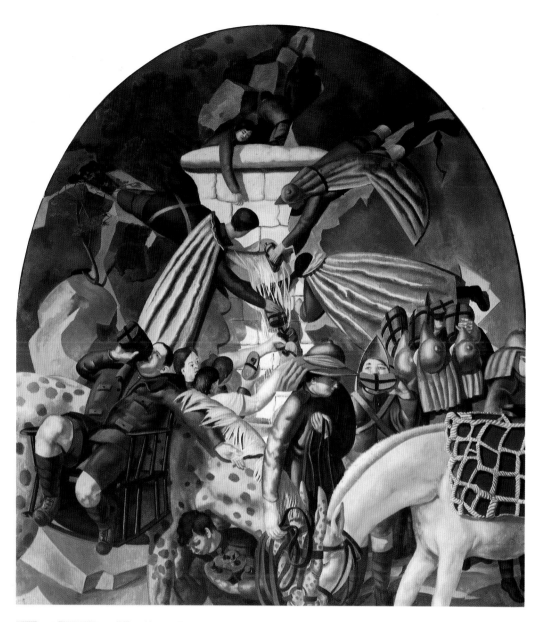

Cat. 130o
**Convoy of Wounded
Men Filling Water-Bottles
at a Stream**
Burghclere 1932

Cat. 130p
Tea in the Hospital Ward
Burghclere 1932

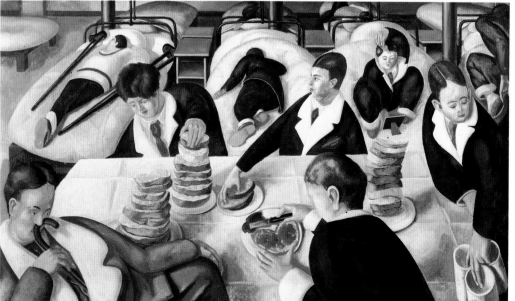

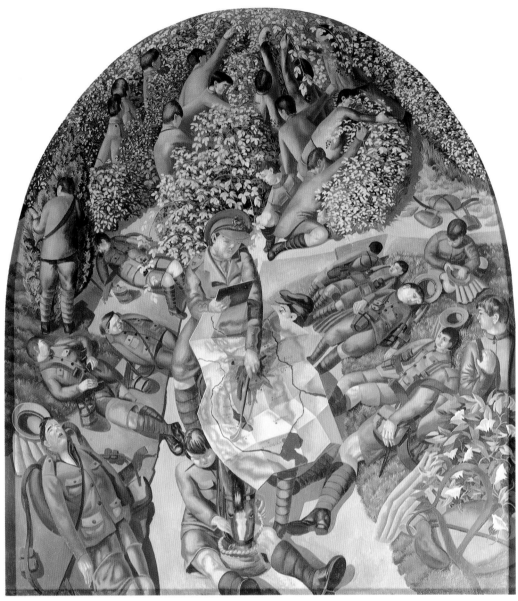

Cat. 130q
Map Reading
Burghclere 1932

Cat. 130r
Bed Making
Burghclere 1932

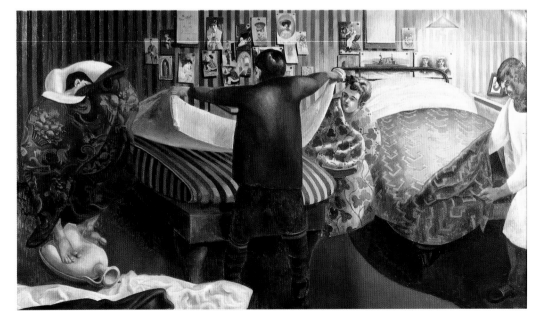

Cat. 130s
Making a Fire Belt
Burghclere 1932

Cat. 130j
Washing Lockers
Burghclere 1929

Cat. 130h
The Resurrection of Soldiers
Burghclere 1928-9

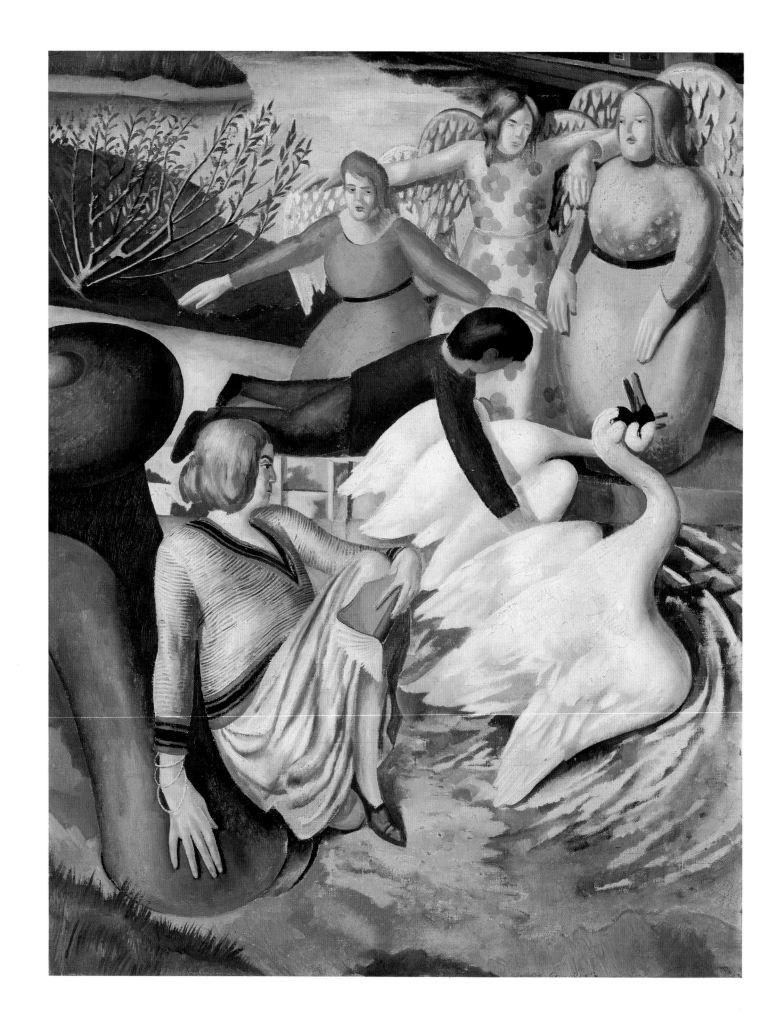

Figure Paintings 1933-45

Cat. 152
Separating Fighting Swans
1933

Spencer moved back to Cookham in December 1931 ten years after he had reluctantly left to pursue his career. The return to the source of his youthful ecstasy must have appeared like the opening of a new and exciting era in his life. Established at Lindworth, a comfortable house situated only fifty metres from his old home,[1] Spencer rapidly completed the last six paintings for Burghclere, which was ready by July 1932, conveniently coinciding with his election as an associate member of the Royal Academy; success must have seemed complete.

There were, however, personal difficulties facing Spencer which were to bring about the collapse of his first marriage and the farce of his second. These brought about a profound alteration of his vision of the world, and radically changed both the subject-matter and style of his painting during the thirties.

Already, in 1918, Spencer had felt the loss of that 'serenity of spirit,' and 'the all pervading joy I felt as a child,'[2] which he blamed on the effects of his arduous war service; a problem compounded by his absence from Cookham and the disintegration of his family life in the twenties.[3] To some extent this was alleviated by his marriage to Hilda Carline in 1925, and the subsequent birth of two daughters, Shirin in 1925 and Unity in 1930. But marriage and its attendant sexual aspect were to alter his life radically as he later made clear when recalling his first meeting with Hilda in 1919: 'I knew that from that day that

what I had always understood in my own mind as being Stanley Spencer and who until then had been the guiding factor was now no longer so. A whole heap of stuff – lust or what you will was sweeping me along helplessly . . . ';[4] and Hilda expressed a similar opinion in the forties when she recalled that marriage, for Spencer, '. . . was like introducing him to a whole new universe . . .' The effect of this on him and his work could not be other than drastic.[5]

Other changes had taken place in Spencer's life as well: during his decade away from Cookham, his idea of the village, the source of all his early imaginative work, had seemed transformed, not only into a spiritual oasis, but into Heaven itself. Burghclere had taken over six years to paint, during which Spencer had made no major studies for new figure paintings, with the possible exception of the Empire Marketing Board commission of 1929 (128).[6] Now, upon his return to Cookham, Spencer sought to re-create his old intense relationship with the village through his marriage (symbolically replacing his old pre-war family life), and his immersion in the atmosphere of the familiar village landscape.

Spencer had always been attracted by large-scale painting, and his attempts to obtain commissions at Leeds, Steep, and Bedales School (80), culminating in the enormous success of Burghclere, are evidence of his determination to find permanent settings for his work.[7] When faced with the problem of how best to celebrate his return to life in

Study for the projected 'Hilda Chapel' in the *Church House* (Tate Gallery Archives, 733.2.430, p.848)

Cookham, Spencer turned again to the idea of a building capable of housing a series of paintings based on a common theme. Critical success at Burghclere; a growing confidence in the handling of large-scale schemes; and the realization that the chapel had given his paintings a unity and coherence not present in his individual paintings, encouraged Spencer to try something more ambitious. As he wrote in 1932, 'I have done a small chapel now I wish to do a house.'[8] From these factors emerged the concept of the *Church House*, a building combining the elements of a church and a house; this, in ever-expanding forms, was to be the intended destination of all the non-commissioned figurative paintings, with the possible exception of the *Port Glasgow Resurrection* series, produced by Spencer right up to his death in 1959.

The existence of the *Church House* idea was known to a number of Spencer's friends as early as the mid-1930s,[9] but the importance of the scheme remained virtually unrecognized until Maurice Collis first read Spencer's collected papers while preparing his biography of the artist in 1960-2.[10] Collis's references to the building were limited, and it was left to Anthony Gormley, again using the Spencer papers (at that time held in University College, London), to produce an excellent outline of the 1930 plans for the *Church House* in his Cambridge BA thesis.[11] Gormley's study, however, did not reveal the full extent of Spencer's plans, and discussion was limited to

the period 1933-9, after which the artist introduced substantial alterations. Other, more recent commentators, notably Robinson and Causey, both make reference to the over-all scheme, but do not consider it in any great detail.[12]

The origins of Spencer's plan for the *Church House* can be found at Burghclere. In the chapel he brought together the minutiae of everyday domestic routine in the army, and combined it with his religious emotions. In 1937 he wrote: 'Since completing Burghclere I have often thought how pleasant it would be if one of the doors of either of the almshouses attached to the chapel could have opened directly into it . . .'[13] This in turn gave rise to the idea of an entirely new building designed to allow both secular and religious paintings to mix freely. 'The secular pictures have religious associations and the religious ones secular associations,' Spencer wrote, 'and just as I do not like the two separated in my work, so neither do I like them separated in what they are meant to epitomise collectively.'[14] The easy balance between religious theme and village setting found in Spencer's pre-1919 work was now to be institutionalized within the imagined form of the *Church House*, and the doctrine he now invented to go with it.

Initially this intended combination of a church and a house looked like an enlarged Burghclere chapel, with a nave ('parish church size') and two attached houses, together with a number of 'little chapels' scattered about nearby.[15] The shape of the church was to be analogous with Cookham and its environs in order to express the 'strange differences in feeling'[16] of the various parts of the village. The nave was to be the 'village street'[17] and the transepts 'two side streets.'[18] The two houses and the chapels could be entered through doorways in the nave, thus imparting the correct blend of secular and religious atmosphere to the visitor. Spencer wisely kept the over-all plan of the *Church House* vague to allow for alterations or additions.[19]

Spencer's wish to build the *Church House* was clearly connected with his continuing admiration for the great painting cycles of the Italian Renaissance. But as Causey has pointed out,[20] Spencer always felt the need to stress the associations between his pictures and the places where they were painted, and he often noted down in his lists the exact part of a

room where he had worked on a canvas.[21] This, in turn, led to the idea that paintings, like people, required 'homes,' where they might be seen in their proper setting and atmosphere. Spencer's strong sense of identity with his pictures and their environment was essentially biographical, and even his earliest figure paintings had gained much of their intensity through the mystery of familiar Cookham places. In the twenties, after Spencer left Cookham, the biographical element was extended to people as well,[22] as he began to deal with the village as a memory rather than as direct experience; and by the time he came to paint Burghclere he was working with events in his life which had occurred over a decade before. In the *Church House* scheme, Spencer wanted to regain the immediacy of the early pictures, by painting scenes from his ongoing life in Cookham;[23] which could then be viewed, as a unity, in a building which duplicated the disposition and atmosphere of the village itself.[24]

During the evolution of the *Church House*, both the ground-plan and the paintings intended for it underwent constant modification, with additional series being added right up to the mid-fifties.[25] In this, the scheme resembled a vast painted auto-

biography, with new chapters constantly being added as Spencer's life unfolded. On its own this aim might have led to confusion, but Spencer adopted a number of specific themes, based on biblical sources, all of which remained essentially unchanged throughout the 'building's' subsequent history. These use Cookham as their setting, and were intended to symbolize his belief in the indivisibility of secular and religious life. As Spencer put it to Hilda in 1947: 'I want to show the relations of the religious life in the secular life, how that [sic] all is one religious life.'[26]

The themes were: *The Pentecost*, *The Marriage at Cana* (382, 385) and *The Baptism* (380) which were included in the all-encompassing theme of the *Last Day* or *Last Judgement*.

In the *Cana* series, Spencer concentrated on the marriage feast, which was both symbolic of the state of marriage and reflected his own preoccupation with the institution.[27] The guests, as Gormley has shown, participate in 'a cycle of life through marriage;'[28] their journey to the ceremony representing their early life to adulthood; and their return from it, married life and the birth of children. This cyclical view of human existence probably reflected Spencer's reading of eastern religions, which also influenced the format of the *Church House* in other ways (see below).

The *Cana* paintings, more than any other group, underwent continuous modification. In the thirties Spencer only painted one part of the marriage feast, *Bridesmaids at Cana*, in 1935 (171), and he did not return to the subject until 1952-3, when he painted *A Servant in the Kitchen Announcing the Miracle* (382) and *Bride and Bridegroom* (385). Of these, the first two are intensely domestic, behind-the-scenes, impressions of the wedding; while the last is really a celebration of Spencer's spiritual marriage to Hilda after her death in 1950. In the remaining paintings Spencer concentrated on the theme of married life, a subject which interested him more and more, as he became preoccupied with sexuality and the concept of a polygamous marriage to Hilda and his new friend Patricia Preece.

These began with the relatively sedate *Domestic Scenes* of 1935-6 (191-200), painted for his one-man show at Tooth's in 1936, and showing Spencer with Hilda and the two children, as the Cana families going to bed (198) or dressing for the marriage feast (195).

Study for the projected 'Elsie Chapel' in the *Church House* (Tate Gallery Archives, 733.2.430, p.843)

In 1937-8 Spencer added the more overtly sexual images of the Beatitudes of Love (274a-j), usually involving a man and woman in a state of passionate excitement, and containing no obvious reference to the Cana theme. Finally, in 1937-40 came the idea of chapels dedicated to the five women in Spencer's life: Hilda, Patricia Preece, Elsie, Daphne Charlton and Charlotte Murray.[29] By this time the original religious concept of the Cana series had been almost entirely transformed into a secular one.[30]

Of the other series, The Pentecost remained virtually unpainted or with its theme submerged in other paintings belonging to the scheme. Originally the scene in the upper-room was to be the central image, with the Cookham malthouses (the site of the 1920 Last Supper) as the setting. The second part of the conception, the seventy-five disciples dispersed into the world to proselytize, was interpreted by Spencer as the blessing of everyday life, in this case by visiting the villagers and taking part in Cookham life.[31] Only one painting, Christ in Cookham (1952; 378), was made expressly for this series, but the presence of 'disciples' or 'visitors' in paintings such as Promenade of Women (1938; 246) and A Village in Heaven (1937; 228) – one a Cana painting, the other belonging to the Last Judgement series – points to an attempt by Spencer to integrate two apparently incompatible themes. This confused approach, when added to the already obscure doctrine of the Church House, made Spencer's ideas even less accessible to his public.[32]

The third in the series, The Baptism (380), was a more successful attempt to interlock the Church House themes, but was equally closed to a traditional biblical interpretation. Essentially, The Baptism was part of the life cycle of Cana. People who have attended the Baptism, as in Girls Returning from a Bathe (1936; 202), travel on to the wedding feast. The setting for The Baptism is the Odney pool at Cookham where Spencer had bathed as a boy. Here Saint John performs the ceremony, watched idly by bathing Cookhamites reclining on the river-bank. The absence of any overt religious reference in either Girls Returning from a Bathe or Sunbathers at Odney (182; the only other completed work in the series) helps to explain the confused response with which they were greeted, as well as showing how far Spencer

had drifted from the pre-1919 balance of religious and secular feelings, exemplified by Zacharias and Elizabeth (16) and The Nativity (11).

All three of the Church House series were brought together under the unifying umbrella of the Last Day or Last Judgement. Spencer's interest in the theme had of course been a long one, beginning with The Resurrection of the Good and the Bad (23) in 1914 and culminating in his two masterpieces, The Resurrection, Cookham (116) and The Resurrection of Soldiers (130h) at Burghclere. As in these earlier paintings this was to be no orthodox Last Judgement; instead the whole of Cookham would be quietly transformed into the Heaven so clearly predicted in the 1926 Resurrection. The event was to be no more disturbing than a bank holiday or Cookham Regatta, and the inhabitants were to emerge on to the streets as in Promenade of Women (246), to rejoice in their new-found freedom.

What differed in Spencer's conception of the Church House was his inability to contain the idea within a single painting. As Elizabeth Rothenstein commented of the 1926 Resurrection: ' . . . [it] was from a sort of infinity into the finite, from peace into the chaos of common life.'[33] Now, in the thirties, Spencer's desire to leave no part of life untouched by God's grace meant that the potential impact of the Resurrection was dissipated and trivialized until it became almost unrecognizable.[34] This fascination with detail meant that Spencer never came to paint an effective central Resurrection for the series, and similarly left other important altarpieces like The Apotheosis of Hilda (450) and Christ Preaching at Cookham Regatta (448) substantially incomplete.[35]

Of the few paintings that were completed for the Last Day,[36] the majority were intended for the 'street scenes' in the 'nave' of the Church House, showing the village of Cookham 'liberated' by the second coming. Among the earliest of these were paintings with semi-independent themes like Sarah Tubb and the Heavenly Visitors (1933; 151) and Separating Fighting Swans (1933; 152), to be followed in 1934-5 by the extraordinary Turkish Window (162) and Love Among the Nations (172) representing the international contingent at the Last Day, a party of whom had already appeared in the 1926 Resurrection. In 1937-8 Spencer expanded this series with a number of other frieze-like paintings, A Village in Heaven (228), Love on the

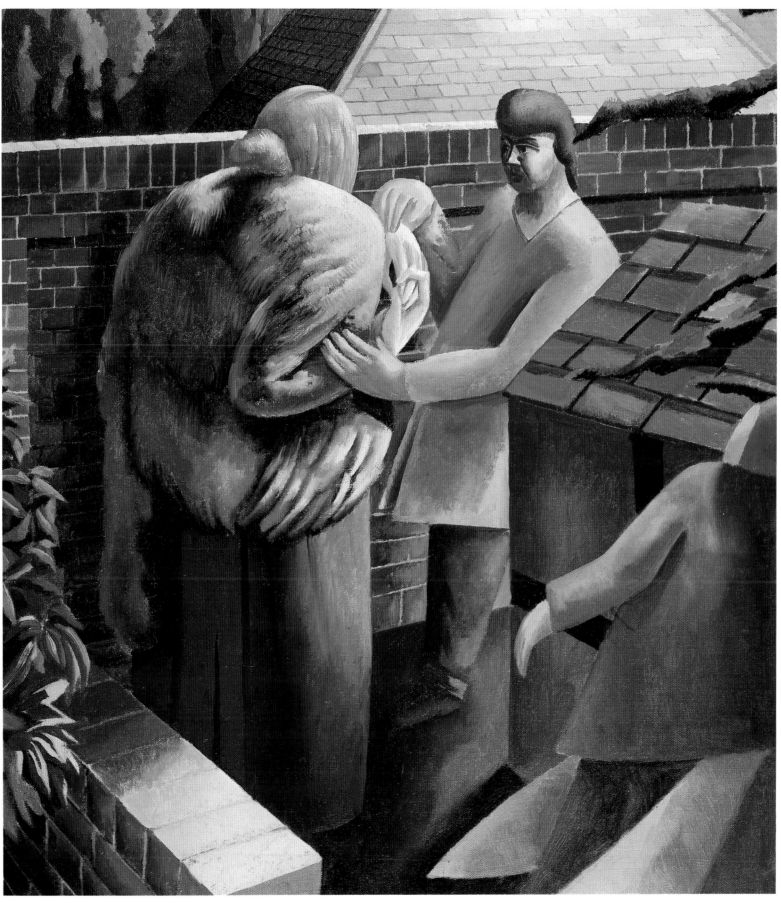

Cat. 145
The Meeting
1933

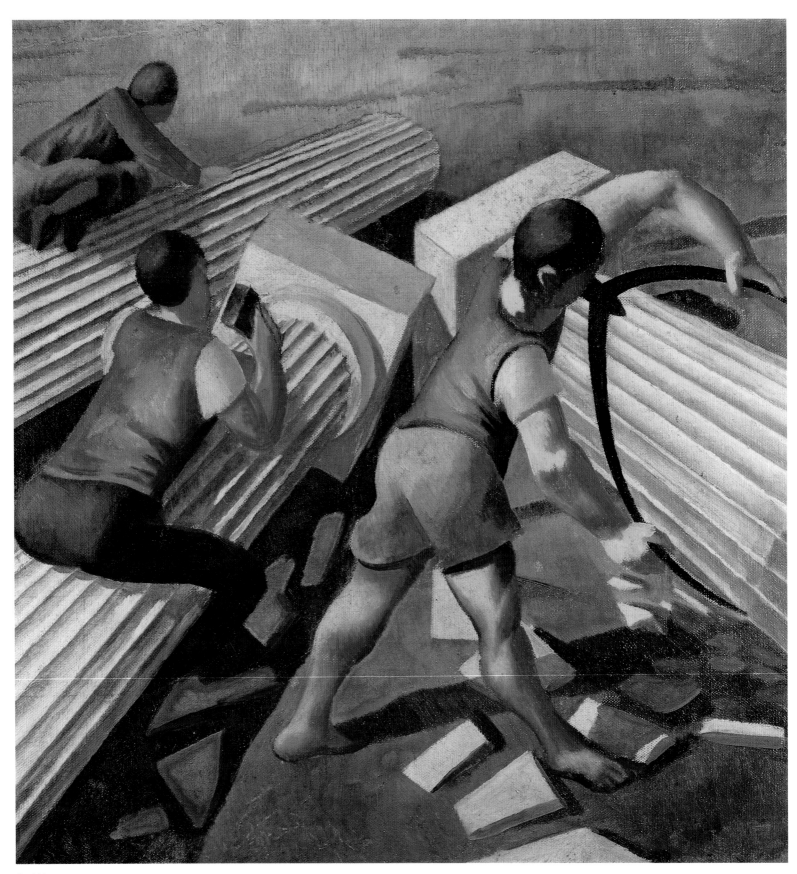

Cat. 146
**Making Columns for the
Tower of Babel**
1933

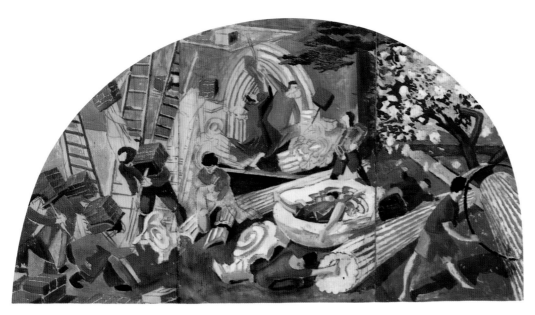

Cat. 147
**Builders of the Tower
of Babel**
1933

Moor (415), and *Promenade of Women* (246), all
of which developed the theme of liberated
sexuality first clearly stated in *The Turkish
Window*. After 1938, Spencer moved away from
Cookham, and the *Resurrection* paintings, some
half-finished, were abandoned until after the
war, leaving the project in unrecognizable
fragments.[37]

As Gormley observed,[38] Spencer's main
difficulty was the problem of finding a suitable
patron willing to build the *Church House*. At
Burghclere the quality of Spencer's work owed
much to the Behrends' financial backing which
enabled him to paint without distraction. In
the thirties, without any immediate possibility
of support, he was forced to create the series
'in fragments and sell them as easel pictures.'[39]
Consequently, the sense of coherence, so
apparent at Burghclere, was lost and the
paintings dispersed without any real possibility
of retrieval. This in turn caused Spencer to lose
confidence; and baffled friends, critics and
public alike, who were confused by icon-
ographically obscure paintings whose meaning
was only really apparent when they were seen
together. In this situation, faced with growing
personal and financial difficulties, Spencer
himself was forced to admit that many of the
paintings were 'not so good.'[40] Despite this, he
continued to paint pictures for the house and
develop new series; less, perhaps, because he
thought that a real building might be forth-
coming, than because he needed the coherence
and continuity offered by his house in the air,
even when they were lacking in his real life.

After 1931 Spencer devoted most of his

energies to working on subjects related to the
Church House scheme; particularly during the
years 1932-9, when personal difficulties made
the imaginative world of his art easier to face
than the reality of his day-to-day existence. As
he was to write in the late thirties: 'My desire
to paint pictures is caused by my being unable
or not being capable of fulfilling my desires in
life itself.'[41] Spencer tried to combine the joy
of spiritual and domestic life with Hilda and
his overwhelming and frustrated sexual desire
for his new friend Patricia Preece. As a
consequence the religious elements of the
Church House were soon submerged in a welter
of sexual imagery, as Spencer sought to
reconcile his sexual desires with his religious
feelings.

During the early 1930s Spencer concentrated
on the large drawing series which he later
used for the major *Church House* paintings,
begun in 1935, and including *Love Among the
Nations* (172) and *Love on the Moor* (415).[42] In
another move, he broke with the Goupil
Gallery in 1932 (where Marchant the owner
had recently died), and joined Arthur Tooth
and Sons Ltd. Dudley Tooth was an astute
dealer who at once began an aggressive
campaign to promote Spencer's art, offering
him a one-man exhibition for 1933 and
arranging to send paintings to the annual
Royal Academy exhibitions. From a
commercial point of view, Tooth preferred
Spencer's popular landscape and still-life
paintings, but he also spent considerable time
and effort selling the increasingly 'difficult'
figurative work.

Spencer's early paintings from this time
express his attempts to retrieve the 'Cookham'
atmosphere of his pre-war works, and to
integrate it with his new life in the village.
The most important influence on him was his
growing attraction for Patricia Preece. They
had first met in a teashop in Cookham in
1929, and had kept in contact until Spencer
returned to the village, when their friendship
became increasingly intimate. Preece was an
artist on the fringe of the Bloomsbury Group,
and she impressed Spencer with her social
connections and her sophistication, both of
which he found missing in Hilda.[44] After his
success at the 1927 Goupil exhibition and at
Burghclere, Spencer seems to have felt the
need to play the 'great' artist and Preece must
have appeared an excellent potential partner.[45]

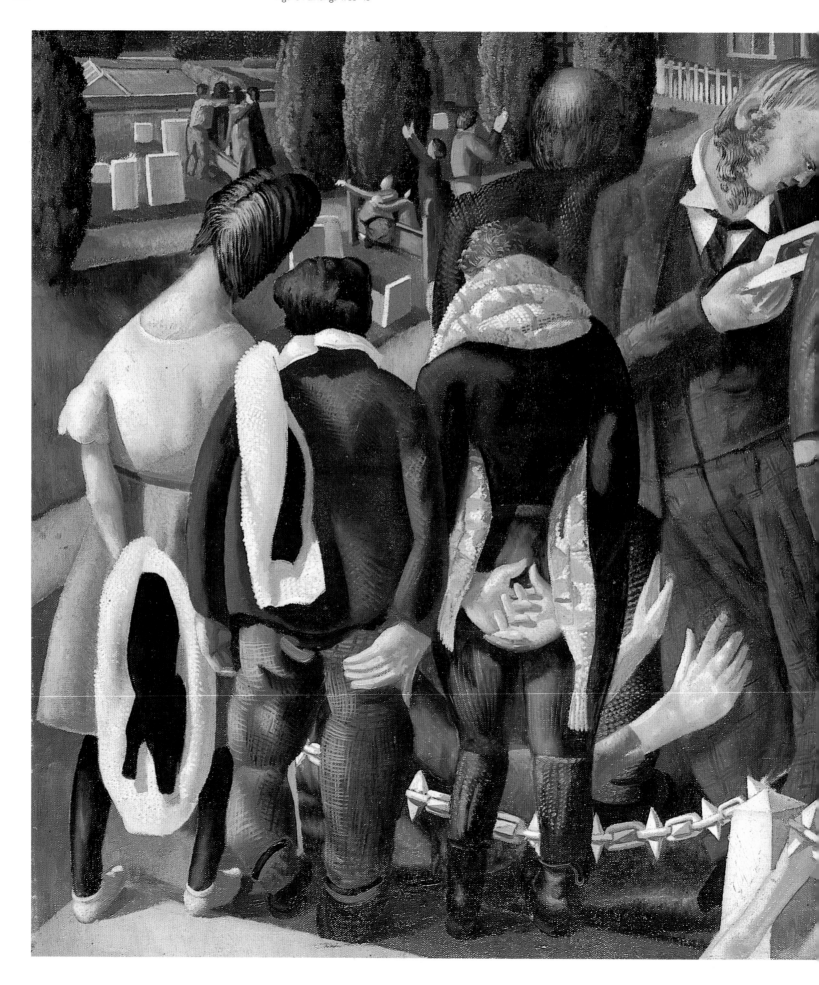

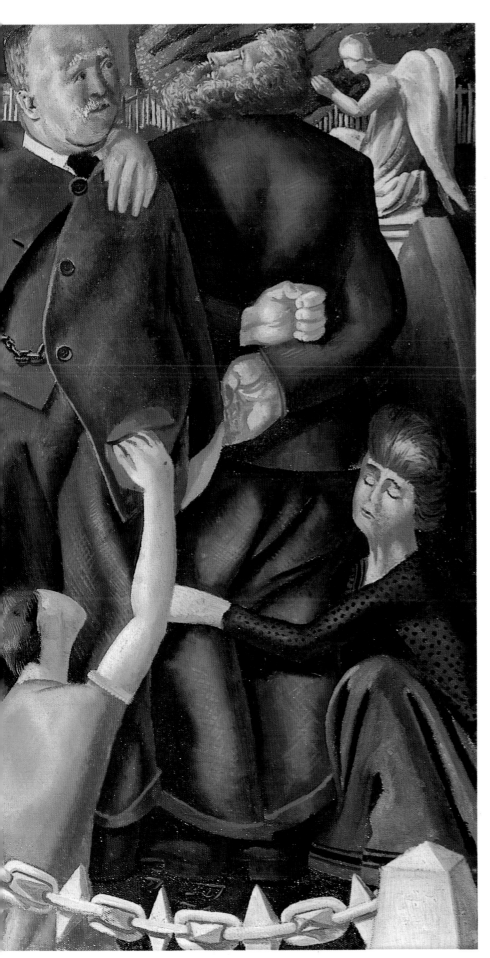

Cat. 150
Parents Resurrecting
1933

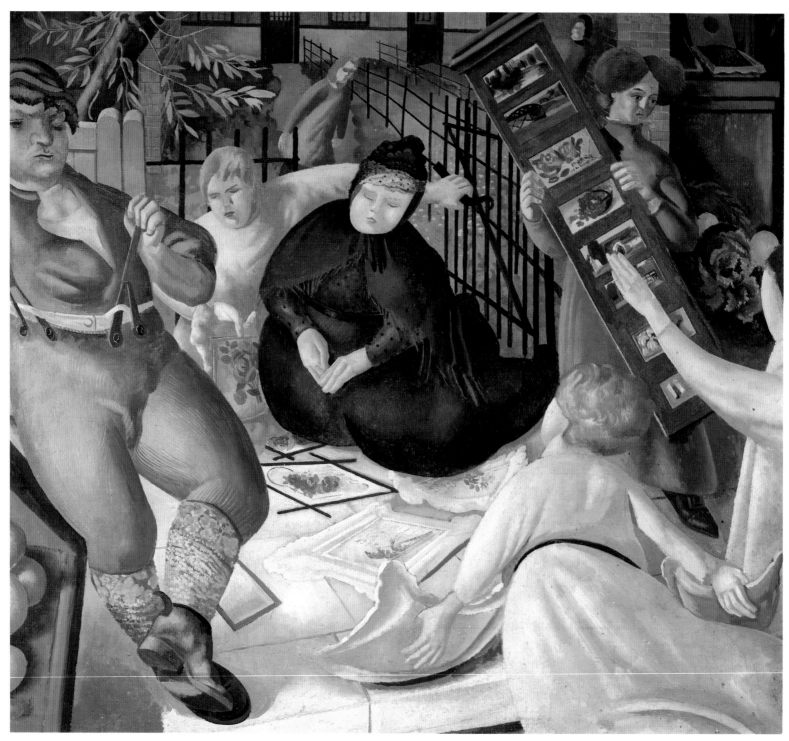

Cat. 151
**Sarah Tubb and the
Heavenly Visitors**
1933

Cat. 153
Villagers and Saints
1933

Spencer's frantic courtship of Preece, and his obsessive sexual desire for her, began to dominate both his life and painting. This in turn affected the concept of the *Church House*, which gradually lost its more conventional religious aspects, and increasingly came to reflect the dramas of Spencer's own private life. As his frustrations and difficulties grew, so the scheme became more important, both as a justification for his actions and as a means of fulfilling them vicariously.

These concerns first became apparent in *The Meeting* (145) and *Separating Fighting Swans* (152), both of 1933. In *The Meeting*, celebrating Spencer's first encounter with Patricia Preece, the couple meet in the alley beside Fernlea, which had been an old haunt of his youth, and therefore steeped in friendly associations. Spencer was trying to create an invisible seam between his early life and the present: as he commented in 1937, the painting 'was an attempt to do something which had the atmosphere I used to feel before the war, but it does not go far enough.'[46] Patricia holds a swan under her arm, probably as Gormley observed (p. 17), a reference to *Swan Upping* (27) a painting which linked pre- and post-war experiences.[47]

The theme is continued in *Separating Fighting Swans* where a diminutive Spencer parts two swans before an admiring Patricia, who leans against a suggestively phallic bollard, the first of a whole series of subliminal sexual objects appearing in Spencer's paintings of the thirties.[48] Again Spencer described the picture

in terms of the reconciliation of the two stages of his life, and of the introduction of Preece into both his life and the private world of his imagination: '[it is] an effort to combine an incident in my life, with a person in my life, and a place in Cookham, and a religious atmosphere.'[49]

In the same year Spencer also painted *Parents Resurrecting* (150) and *Villagers and Saints* (153), the first two works to have direct connections with the *Church House* scheme. Of these, *Parents Resurrecting* was to be a crossroads between the *Baptism*, *The Last Judgement* and *Cana* themes; with the children coming from Odney pool and pausing to watch their grandparents returning to life in Cookham churchyard, before hurrying on to the wedding feast. As yet *The Resurrection* had not spilled out on to the streets of Cookham. In *Villagers and Saints*, Spencer continued the *Last Day* theme, with the events now expanded to encompass the whole village. Here the 'Judge' and his followers arrive at the back-door, almost like the milkman, 'to find us'[50] on the Day of Judgement, 'in our own domestic circumstances;' the emphasis being placed on the everyday nature of the event, symbolized by the blessings bestowed on the rag and bone man, and the young Spencer boys playing marbles.[51] Both works were intended as part of the aisle wall 'street' paintings, and were to be linked by long narrow canvases such as *Promenade of Women* (246) and *A Village in Heaven* (228).[52]

During the years 1934-5, Spencer was also engaged in painting two of the long thin

Cat. 162
The Turkish Window
1934

pictures intended to hang on the aisle walls of the *Church House: The Turkish Window* (162) and *Love Among the Nations* (172). These paintings represented a continuation of the theme of peace found in the Burghclere murals; a state now brought about by means of love-making, which, Spencer believed, would break down the social and religious barriers between nations and individuals. As he wrote later: 'During the war, I felt the only way to end the ghastly experience would be if everyone suddenly decided to indulge in every degree and form of sexual love, carnal love, bestiality, anything you like to call it. These are the joyful inheritances of mankind.'[53] This idea was now doubly attractive as Spencer had fallen in love with Preece and was besieging her for sexual favours. Unwilling to leave Hilda, he now saw his wartime fantasy of free love as a means of solving the dilemma of his personal life – he would live with both women.

In the combined *Love Among the Nations* and *Turkish Window*, Spencer showed men and women of different races, avidly engaged in fondling and investigating one another with an easy familiarity usually reserved for private life. Here, however, 'love breaks down barriers,'[54] and all inhibitions are swept away in the joy of discovery. Spencer had earlier assigned a group of coloured people to a corner of the 1926 *Resurrection*, but now they are given a whole *Church House* street to themselves. In 1935 he called the painting 'a memento of my visits to Mostar and Sarajevo [in 1922] and my feelings for the east generally,'[55] but this theme is already overlaid by his growing preoccupation with sexuality and the

justification of his affair with Preece.

Spencer's belief in the power of love to 'break down barriers' received much of its support from an idiosyncratic reading of eastern religions, in particular Buddhism, Hinduism, Taoism and Mohammedanism, to which he had been introduced at the Carlines' in the 1920s.[56] It was at this time that he read Sir Edwin Arnold's *Light of Asia*, a poem about Buddha which gave a generalized idea of the attributes of harmony and understanding central to the Buddhist religion.[57] Spencer was also attracted to the Hindu religion, with its goal of Moksha (similar to Nirvana) or freedom; although his interest seems to have been concentrated on the third goal of a balanced life, Kama, often mistakenly associated in the West with purely carnal pleasures. Spencer also knew of Taoism by the thirties, including the writing of Tao Te Ching.[58] Both Buddhism and Taoism were antithetical to the Western concept of duality, and therefore provided an important justification for the kind of freedom which Spencer was seeking in the thirties. As he declared: 'all concepts of good or bad, ugly or beautiful are just objects in the way of revelation.'[59] His interest in Islam was less strong (it probably appeared too punitive to him) but the Islamic acceptance of polygamy was obviously attractive to Spencer, who was contemplating making both Patricia and Hilda his wives.[60] Spencer was able to connect these ideas to the Western tradition through his reading of another eccentric religious artist and thinker, William Blake: 'The attractive thing about Blake,' Spencer wrote 'is that God is found everywhere at all times,'[61] a

Cat. 156
Souvenir of Switzerland
1933-4

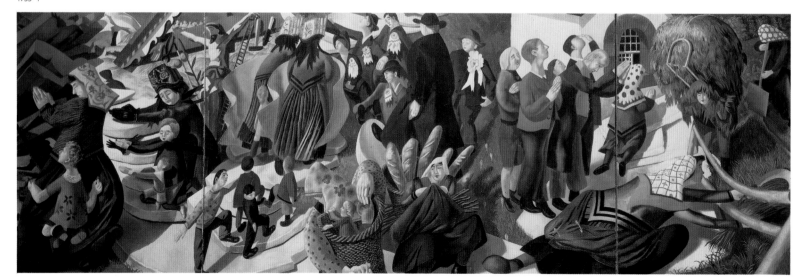

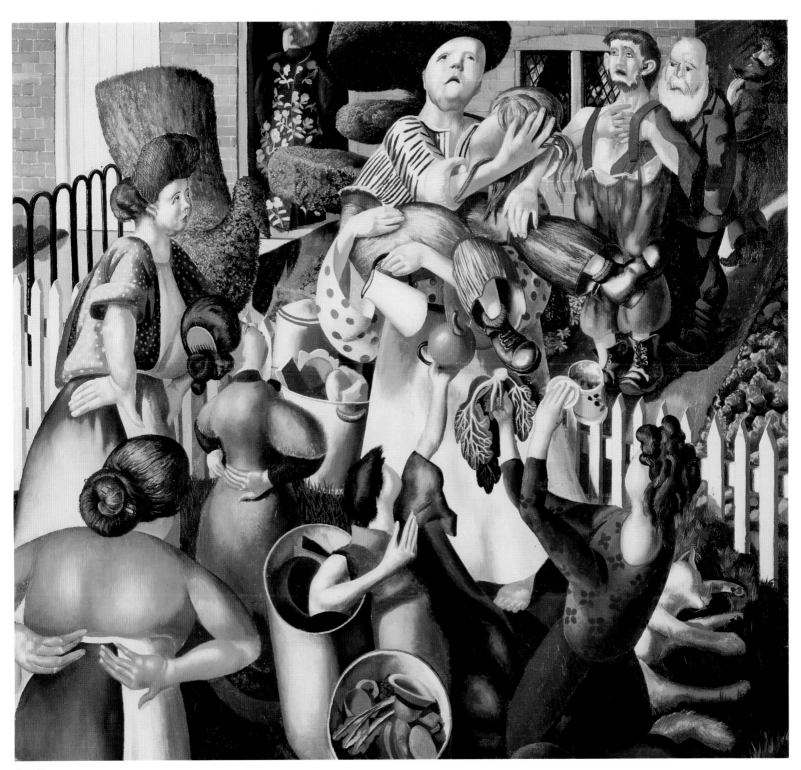

Cat. 163
The Dustman or **The Lovers**
1934

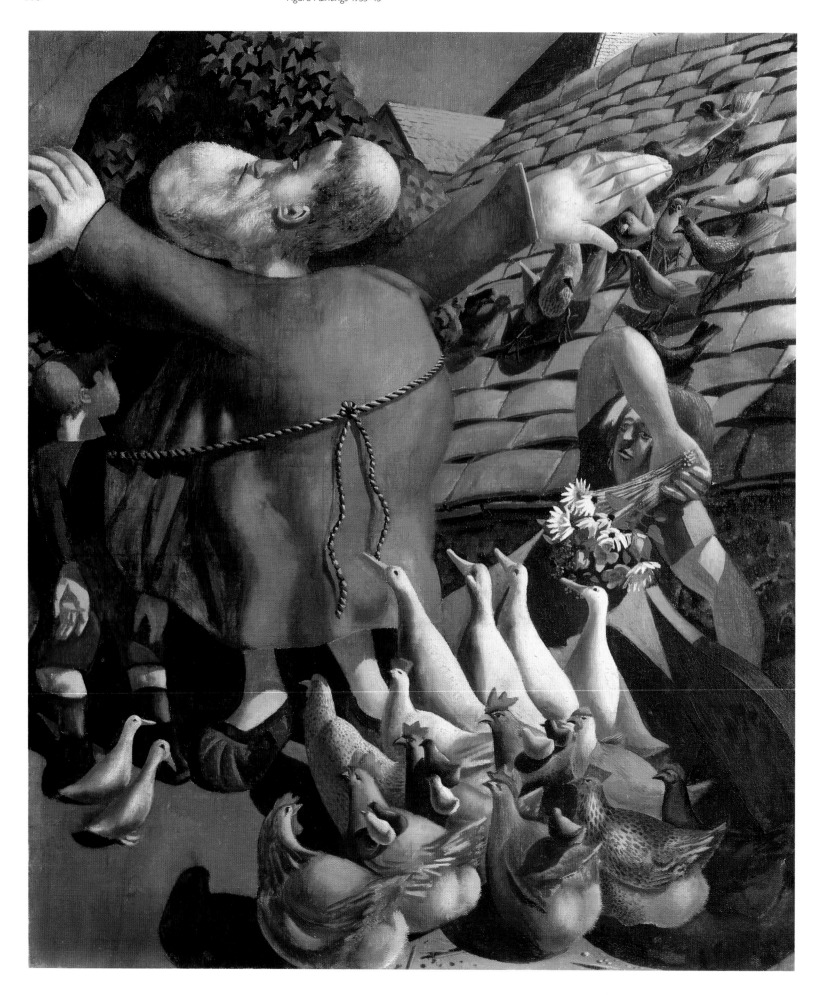

concept which fitted in well with Spencer's reading of the all-pervading nature of Eastern religions, and which is reflected in his idea of the Last Day.

Together with the doctrinal aspects of oriental religion, Spencer's painting was also directly influenced by its art. In 1922 Spencer bought a book on Indian sculpture in Munich[62] and this was supplemented by the plates in his *Wonders of the World*, and the Carlines' extensive art library. As he told Hilda: 'I often think of us looking at the books on Indian sculpture. They seem to give me longings greater than those inspired by the Bible.'[63] In 1932 Spencer made a long drawing of his life on 'seven inch high' paper (now lost) which 'was to be a sort of life of Buddha study,'[64] presumably based on the Borobadur frieze. From this statement it is clear that Spencer conceived of the *Church House* in terms of a mixture of Christian and Eastern religious ideas, which also extended into the design and physical layout of the paintings. Thus the friezes of the Buddhist and Hindu temples of Asia and India are probably the source of the long nave and aisle scenes in the *Church House*; and may explain Spencer's move towards continuous bands of paintings, and away from the centralized Western format of most of his earlier work. This is apparent in *Love Among the Nations* (once intended to be much longer) and in later paintings including *Promenade of Women* and *A Village in Heaven*, and would also account for the numerous figures and their repetitive poses which occur in these larger works.

Spencer also seems to have taken the erotic entwined figures to be found on temples like the Khajuraho complex in India as the basis for the lovers in *Love Among the Nations* and the *Beatitudes of Love* (274); and although he normally avoided the extremes of nudity and copulation found in Indian sculpture, for example in the Mithuna couple from Khajuraho, the barely concealed sexual arousal of the man in *Beatitude 4, Passion or Desire* (1937; 274d) is, in my opinion, Spencer's deliberate Cookham equivalent.[65] Moreover, the wonderfully relaxed public sensuality of the Indian sculptures must have helped reinforce Spencer's belief that 'desire is the essence of all that is holy.'[66] Compositionally, too, the flattened frontality of the *Beatitudes* couples, their interwoven forms, and their total spiritual and physical absorption in one another

(similar to the state of Moksha), closely paralleled their more elegant Indian equivalents.

Spencer's interest in sexual freedom is to be found in the work of several other English artists, notably D.H. Lawrence and Eric Gill. There is no evidence that Spencer met Lawrence, but they shared mutual friends in Lady Ottoline Morrell and Mark Gertler, and, if they did not meet, certainly heard of one another. Robinson (1979, p. 53) has pointed out Lawrence's emphasis on the importance of sensual experience in life, and his suggestions of the expressive force with which primitive carvings might release purely physical feelings without the interference of intellectual justification. Lawrence also took these ideas up in his own paintings, which Spencer might have seen in the exhibition at Dorothy Warren's gallery in London in April 1928.[67] These paintings included a number of works such as *The Lizard*, *Under the Haystack* and *The Mango Tree*, showing naked men and women engaged in various forms of sexual activity, in an atmosphere of total 'primitive' abandonment, and without reference to traditional Western themes.[68] This closely parallels Spencer's own insistence on sexual freedom, not only in the *Church House* paintings, but also in his explicit portraits of Patricia Preece.[69]

Eric Gill's interest in sexuality was even nearer to Spencer's, as he had a powerful belief in the close identification of physical love with the spiritual experience of his Catholic faith. In his *Autobiography*, first published in 1940, Gill repeatedly emphasized his conception of the central role played by love-making: 'I became a catholic because I fell in love with the truth. And love is an experience. I saw, I heard, I felt, I tasted, I touched. And that is what lovers do.' And elsewhere: 'just as physical love is the centre of our life as man and woman, so the Holy Mass is the centre of our life as Christians.'[70] Gill also closely identified the experience of creating art, as Spencer did, with the ecstasy of sexual union, defining his carvings for the façade of the London Underground headquarters as 'attempts at making love;'[71] and recalled the experience of watching his calligraphy teacher Edward Johnston draw 'as the thrill and trembling of the heart which otherwise I can only remember having had when first I touched her body.'[72] Like Spencer, Gill respected the Eastern

Cat. 164
Saint Francis and the Birds
1935

overleaf

Cat. 168
Workmen in the House
1935

Cat. 169
The Builders
1935

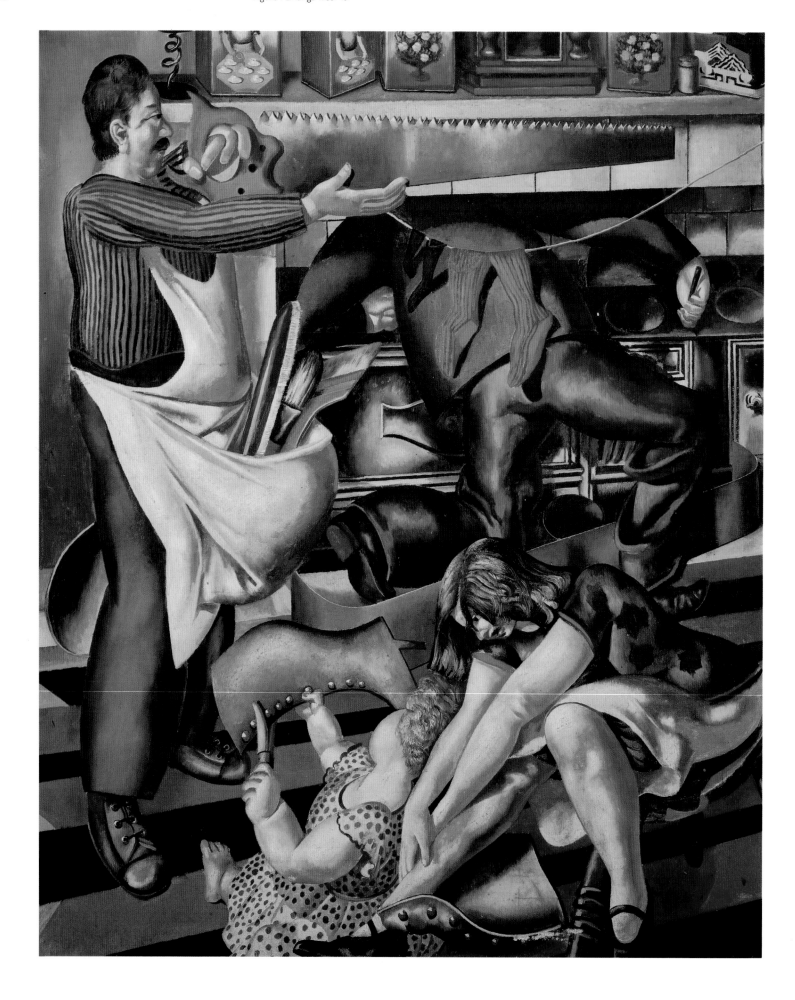

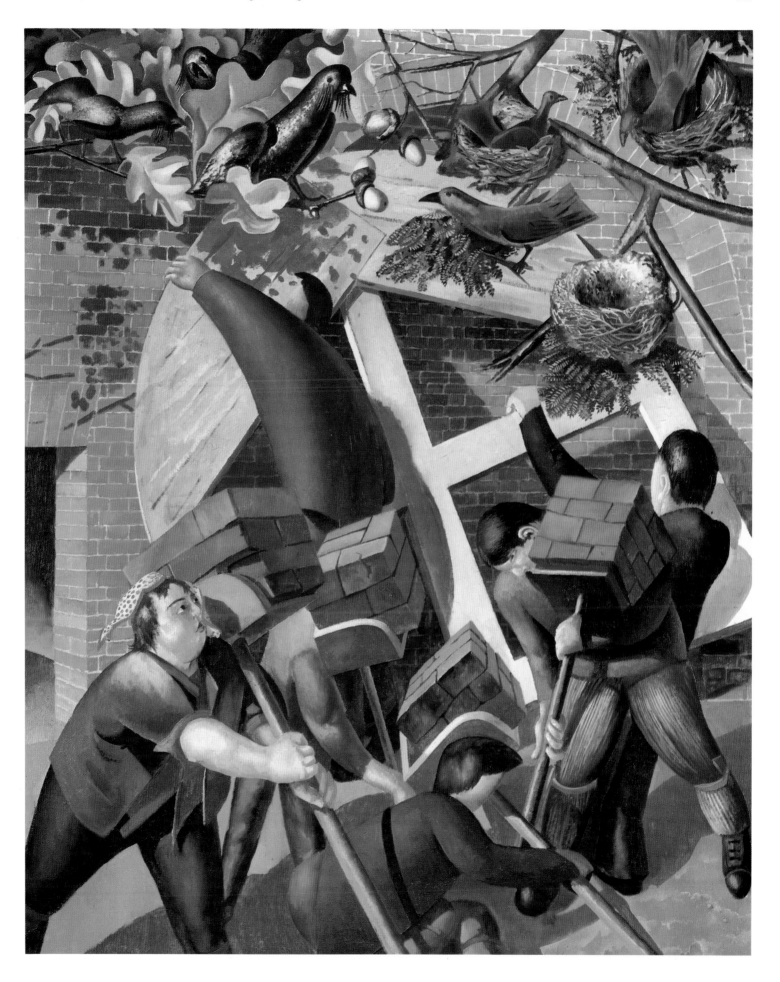

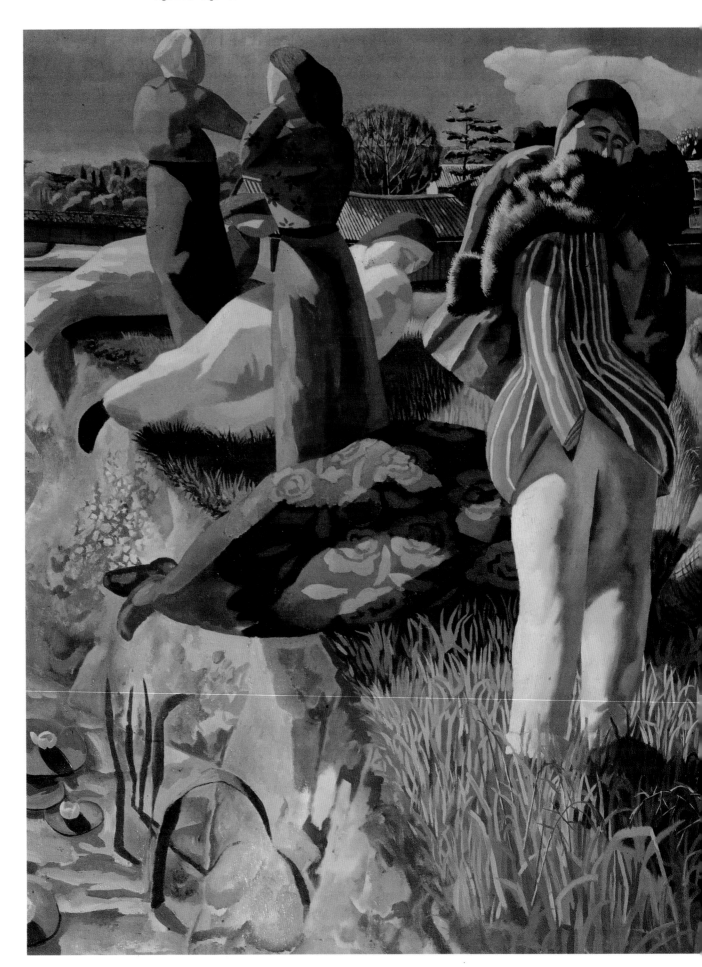

Cat. 170
By the River
1935

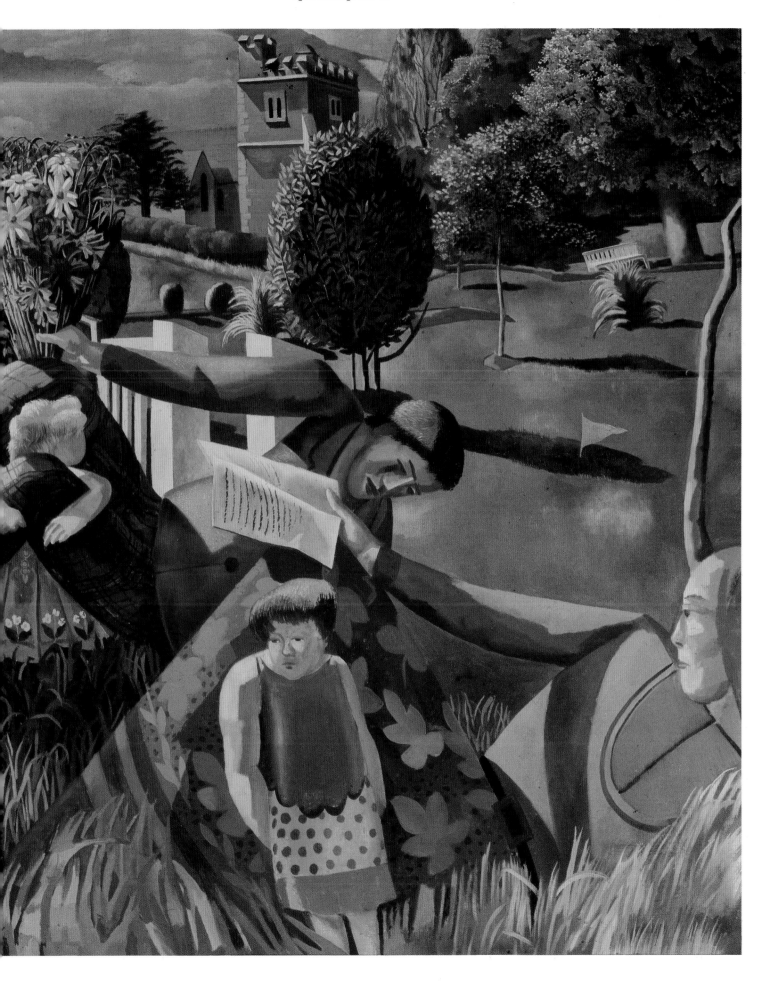

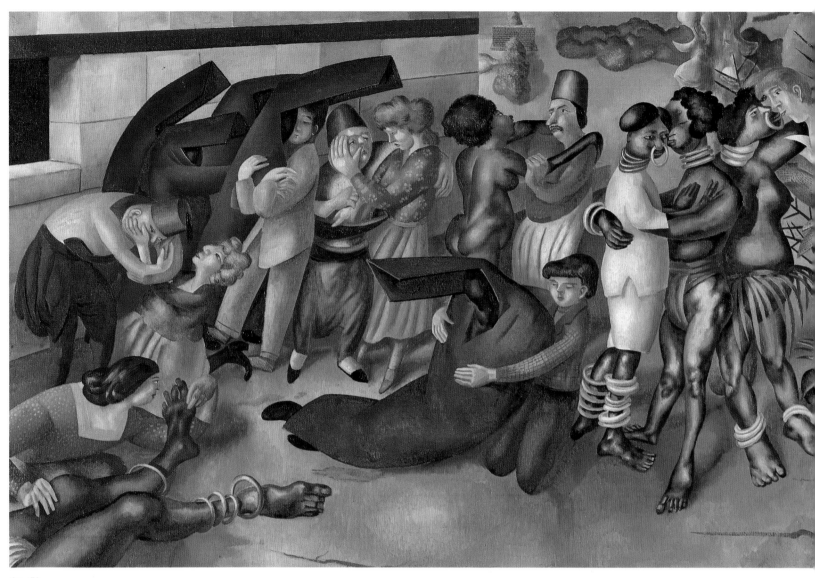

Cat. 172
Love Among the Nations
1935

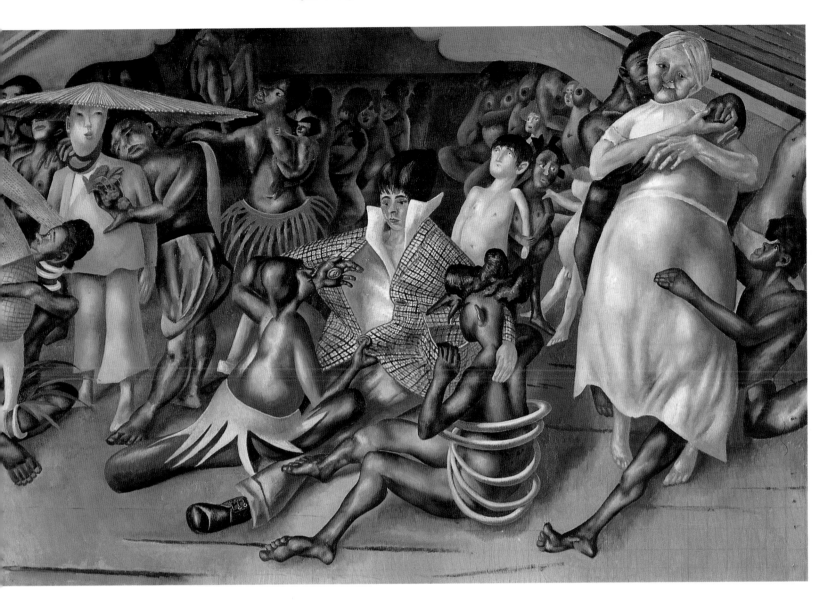

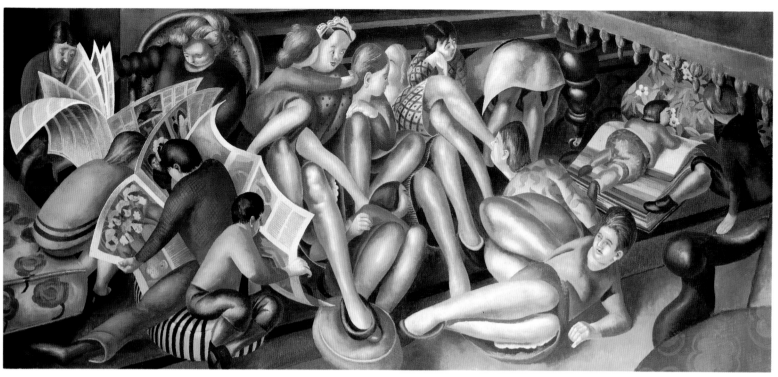

Cat. 171
Bridesmaids at Cana
1935

religions, and permitted the explicitness of Buddhist and Hindu art to enter his own work, for example in the form of the sensuous figure of a naked girl, which was the centrepiece of his design for a headstone for the grave of Alice Jameson in 1933.[73] Unlike Spencer in the thirties, however, Gill did not permit sexuality to become a substitute for religion, considering it instead a foretaste of the greater joy of Heaven itself.

In 1935 Spencer was also involved in his famous clash with the Royal Academy. All the paintings sent by Tooth's on his behalf to the Summer Exhibition of 1934 had been accepted and the extensive press coverage was generally enthusiastic. Comments such as 'Stanley Spencer's Year' and 'Stanley Spencer's Academy,'[74] were common; and Douglas Goldring in the Studio was optimistic that along with the work of Sickert and John, Spencer's paintings might help to enliven the general mediocrity of the Academy exhibitions.[75] Only the Times reviewer introduced a note of warning about possible future difficulties with the Academy. He advised visitors to the Summer Exhibition to study Spencer's paintings carefully: '. . . because it is reasonably certain that in fifty years time he will be recognized as one of the very few contemporary painters who have really counted in the history of English art.' But he

pointed out: 'that Mr Spencer is as unwelcome to contemporary aesthetic opinion as he is likely to be a stumbling block to the general public . . . Like all originals Mr Spencer is a disconcerting artist, and neither illustratively nor formally is his meaning always clear.'[76]

Given the considerable critical enthusiasm of 1934, Spencer might reasonably have expected a favourable reaction to the five new paintings submitted to the hanging committee the following year;[77] particularly as a comparatively 'difficult' work, Parents Resurrecting (150), had been accepted without comment the previous year. In the event, however, the committee chose only three paintings, rejecting Saint Francis and the Birds (164) and The Dustman or The Lovers (163). Sickert's large portrait of Lord Beaverbrook was also refused, apparently through shortage of space. But while Sickert accepted the decision without complaint,[78] Spencer was furious, particularly as the letter of rejection also conveyed the committee's opinion that they 'did not think these works of advantage to your reputation.'[79] To Spencer this implied the Academy's right to dictate what he should paint. After a short delay he replied to Lamb's letter on 23 April,[80] demanding that the Academy allow him to withdraw the remaining paintings from the exhibition; and because 'it is very unlikely that I shall ever paint differently,' proffered his resignation.[81]

By now the dispute was public property and the Academy's letter appeared in *The Times*, accompanied by Spencer's counter-statement.[82] In accordance with a regulation of the Academy, artists could not withdraw their work from the exhibition once it had been selected for hanging. Spencer tried to get around this rule as Tooth now planned to put all five pictures on show at Bruton Street.[83] On 26 April he told *The Times* that he had asked the Academy 'as a favour to remove my pictures,' which he 'intended to exhibit . . . elsewhere.' At the same time he emphasized that he did 'not want the Academy to do me any harm nor do I wish the Academy any harm.' In an interview with *The Times* on the same day, however, Sir William Llewellyn PRA repeated the Academy's refusal 'to make any alteration in the rules,' but added in a conciliatory gesture that 'we are pleased to have the three [accepted] pictures.' Spencer's response, the text of which was published in *The Times*,[84] came the following day. He now made his resignation 'final' and warned the Academy that they were 'showing these three pictures against my express wish.' He went on: 'If by doing this you wish to show me you can have what pictures of mine you like and not those you do not like, I will take care you never have another picture of mine as long as I am alive.'

Cat. 182
Sunbathers at Odney
1935

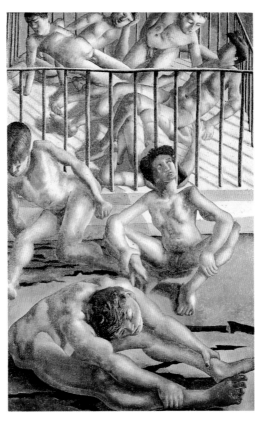

In the meantime the rejected pictures were retrieved and quickly put on display at Tooth's; an astute move by Dudley Tooth, who evidently made use of the Academy fiasco to further public debate, and promote sales of Spencer's work.

The reasons for Spencer's rejection from the Academy have been variously explained: Causey (p. 28) suspected ill-will over his critical success in 1934; Collis, on the other hand, considered the rejected works to be 'too undiluted Spencer'[85] for the taste of the Academy hanging committee. Both of these opinions are generally correct,[86] but the decision also reflected the over-all policy of the Academy, which Sir William Llewellyn PRA found it necessary to restate in a short article for the June 1935 *Studio*.[87] The Academy, he declared 'must keep in mind, besides the interests of connoisseurs, the comprehension of the ordinary visitor, who seeks a ready means of forming a ready taste in contemporary art;' as well as providing 'a fairly balanced and attractive view' of the year's art; and it must also function as 'a steadying influence on the exuberance or haste of innovators.' Presented in this way the Academy's position sounded like a ready recipe for mediocrity and malaise. Spencer's position was suspect in all the areas mentioned by Llewellyn, particularly the last, where, lumped with John, Sickert and Epstein, he was a particularly vulnerable target for reactionary elements both outside and within the Academy.[88] The year 1935 may also have been particularly sensitive for the hanging committee, as the King's Silver Jubilee fell on 6 May, two days after the Academy *Summer Exhibition* opened. Consequently, the Royal Family were the subject of a disproportionate number of paintings in the exhibition, and the committee probably paid particular attention to the choice of works which they deemed 'appropriate' to the occasion.

Critical response to the Academy controversy was mixed, and the subsequent reviews indicate that the row over Spencer's rejected pictures also provided an occasion for various parties to attack or defend the position taken by the Royal Academy regarding contemporary art.

Most of Spencer's detractors objected to his work on the grounds of unsuitability, unacceptable distortion, or even the mental instability of the artist. As early as 1915, P.G.

Konody had criticized *The Centurion's Servant* (21)
– then on show at the NEAC – for being 'too
obviously intended to shock or mystify the
spectator.'[89] Now the charge was levelled
again, with the added objection that Spencer's
work was distorted and even – in the case of
Saint Francis and the Birds – blasphemous. The
Continental Daily Mail, for example, referring to
'warped art' and 'repellent shapes', went on:
'Let us ask ourselves. "Are the two rejected
Stanley Spencers good art?" The answer must
be an emphatic "No", and the public will
certainly not quarrel with the decision of the
Royal Academy.'[90]

The reviewer proceeded to attack *Saint Francis
and the Birds* and *The Dustman or The Lovers* for the:

> . . . disproportionate cranium and stone-like
> beard [of Saint Francis, which] assume the
> grottesque [sic] appearance belonging to
> one of the ugliest fishes, the hammer-head
> shark. Mr Spencer's St. Francis is a caricature
> which passes the bounds of good taste,
> [and] which is equally poor in drawing,
> design and composition. [*The Dustman or The
> Lovers*] is covered with an inextricable
> muddle of repellent shapes. We are taken
> beyond the frontier of reason into a world
> of madness and nightmares.[91]

The accusation of mental instability was also
taken up by the *Field* which felt that Spencer's
representation of Saint Francis as 'a distorted
doll,' was 'a fault not of the painter's hand,
but of his head and heart.'[92] Other critics
lamented that Spencer had the talent to join
the academic fold if only he were prepared to
paint in the naturalistic manner then confined
to his landscapes and portraits, a point that
was expressed by Frank Rutter writing for the
Sunday Times, who remarked: 'If Mr Spencer
were content to paint the normal appearance
of nature – as he can do to perfection when he
chooses – the present situation would never
have arisen.'[93] This opinion was repeated in *The
Times*,[94] whose critic remarked: 'Last year it was
said in these columns that Mr Spencer at the
Academy was rather like John Bunyan at a
meeting of the Society of Dilettanti. The
comparison was only too true, and the
reluctant conclusion this year . . . is that the
RA is no place for Mr Stanley Spencer.'

The reviewer went on to identify the work
of Sickert and John as representing 'the

extreme limits in what is possible in the range
of Academic sympathy.' He continued: 'With
Mr Spencer the case is quite different. His
work is evidently conceived as it is executed,
with an intensity of vision that might be called
abnormal [but] His Workers . . . and Builders
. . . are particularly welcome, because they
show his immediate translation into form of
the facts of common things.'

Spencer's supporters, on the other hand,
tended to avoid the ticklish matter of pictorial
distortion and concentrated their attack instead
on the conservatism of the Academy hanging
committee. The *Spectator* reporter, for example,
while accepting the rejection of *The Dustman or
The Lovers* as a 'justified decision,' felt that
'Once more the Royal Academy is being made
to appear in a reactionary light,'[95] an opinion
which was supported by the *Manchester Guardian
Weekly*, whose critic considered the Academy
decision a 'serious mistake.'[96] The continued
poor quality of the Summer Exhibitions left
the Royal Academy vulnerable to attack, and a
good deal of support for Spencer came from
critics who were not necessarily enthusiastic
about his work. The *Northern Daily Despatch*, for
example, was more incensed by: '. . . the
dozens of dreary works that make this jubilee
academy representative of every other annual
show since the accession of King George, but
not any better.'[97]

The longest and most considered discussion
of the Academy controversy came from D.S.
MacColl,[98] who published an essay entitled
'Super and Sub Realism, Mr Spencer and the
Academy,' in the *Nineteenth Century and After* for
June 1935.[99] MacColl was by no means an
enthusiast for all forms of advanced art – as a
sharp exchange of letters with G.B. Shaw in
1916 had shown[100] – but he defended Spencer
vigorously: 'This year two pictures, no more
Spencerian than those accepted, have been
thrown out under a plea of "standards,"
"suitability," and even "discipline": smarting
under the snub, the painter has resigned and is
lost to the Academy. There could be no more
luckless sin of committee.' He continued:
'Here was a painter elected in the full
knowledge of his "queerness" – one who
might be described as in some respects a
village simpleton, but waywardly and
genuinely inspired; at a time when any
tincture of genius in painting is rare he has
been admitted for what he was, and has

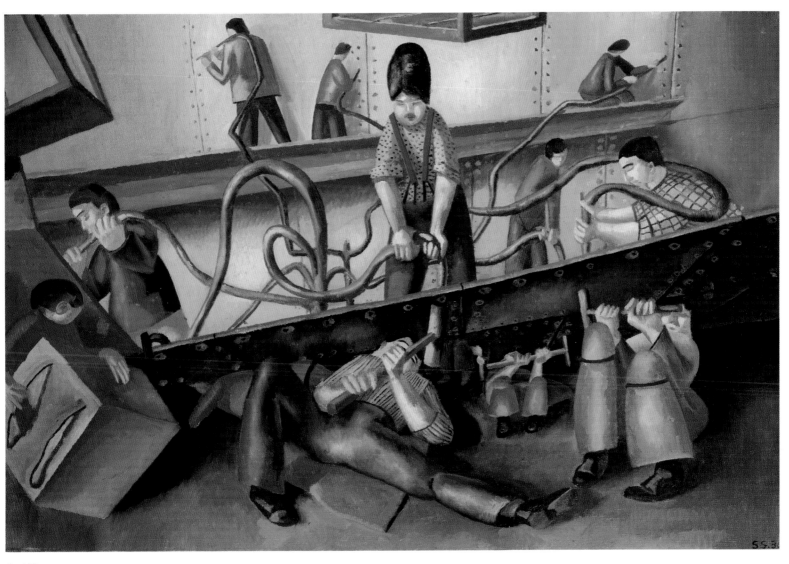

Cat. 190
Riveters
1936

given to last year's exhibition its chief, however disputed distinction.' MacColl went on to attack the type of artist admired by those critics who were in favour of the existing Academy status quo.[101] The work of these artists – or 'Sub Realists' – he claimed, suffered from 'poor visibility, low blood-pressure and lack of visual vigour.' By contrast the 'Super Realists' – and here he included Spencer – were 'visionary as well as visual, [they] see in one way or another violently or strangely . . . under whose contemplation the form transforms, swells or deflates . . . is given the freedom, even the irrationality of dreams . . .'

In contrast to the majority of paintings at the Summer Exhibition which were 'drenched in the jam of sentiment,' MacColl felt that Spencer's *Saint Francis and the Birds*, was 'more like Giotto's stout friar than are the senti-mentalised figures of non-Catholic fancy.'

MacColl's article was timely, but the damage was already done and Spencer undoubtedly lost a good deal of public support, as well as disappointing a number of former friends in the art world. Earlier, in May 1935, when the Academy row was still continuing, Henry Tonks had written to MacColl expressing his doubts about Spencer's new work: 'Spencer as I knew him ever so many years ago was a real spiritual Artist, inspired as he told me by some influence coming into him from something beyond himself, if he was without this guide he did not paint so well, he was speaking of his "resurrection" which I much liked though F. Brown hated it. Now I fear this guide is not so attentive.'[102]

Tonks's opinion was repeated by Fred Brown, also in a letter to MacColl, in which he lamented that enough unpleasant things were happening in the world without the added presence of ugly art:

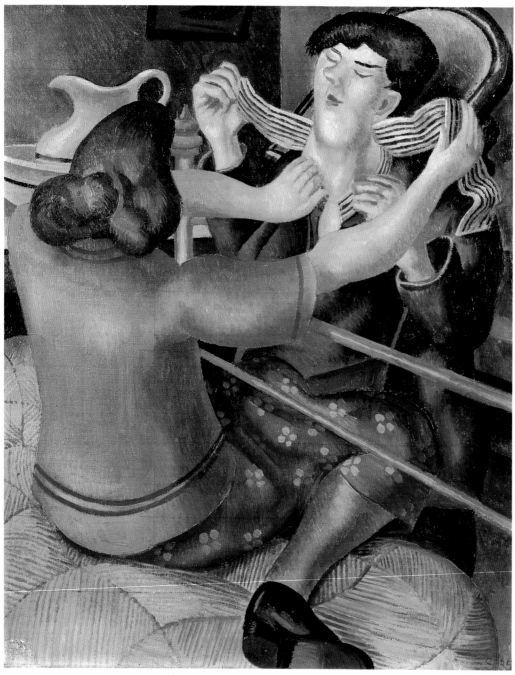

Cat. 191
Taking off Collar or
Buttoning the Collar
1935

Cat. 193
On the Landing or
Looking at a Drawing
1936

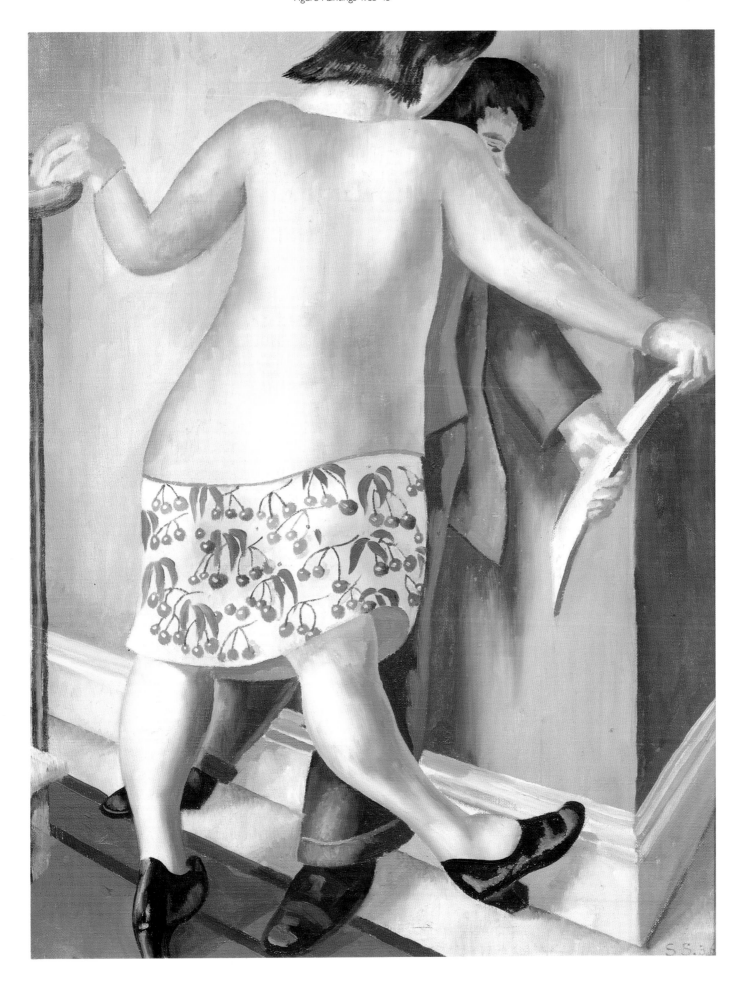

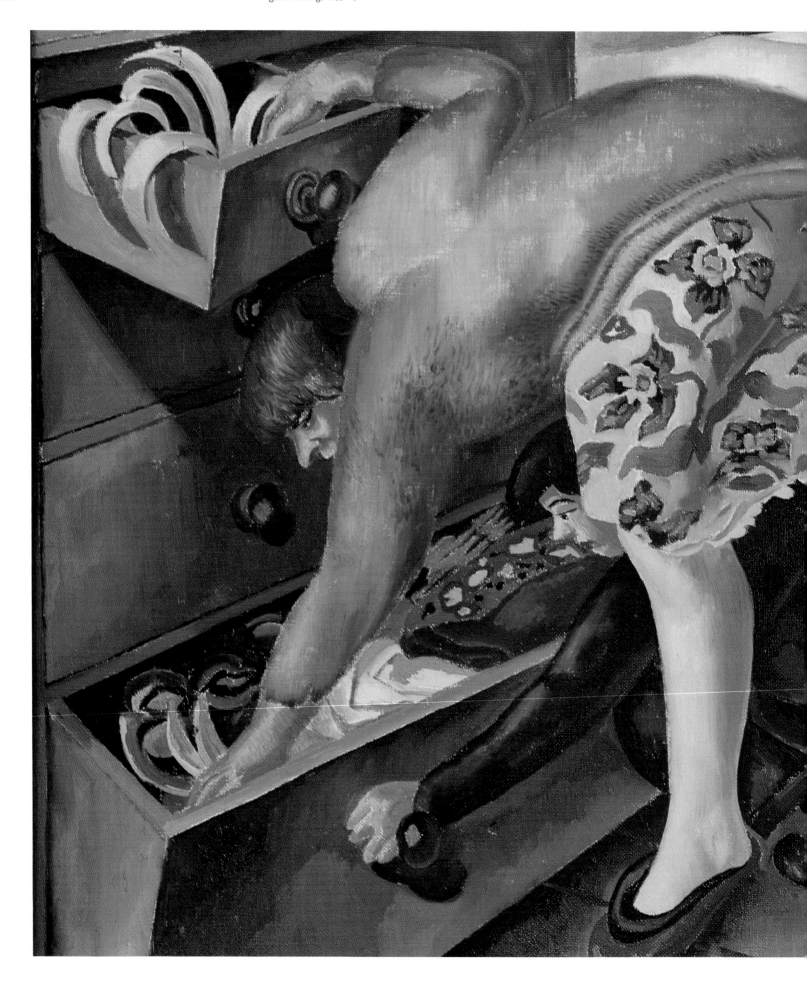

Cat. 192
At the Chest of Drawers
1936

overleaf

Cat. 194
Choosing a Petticoat
1936

Cat. 195
Choosing a Dress
1936

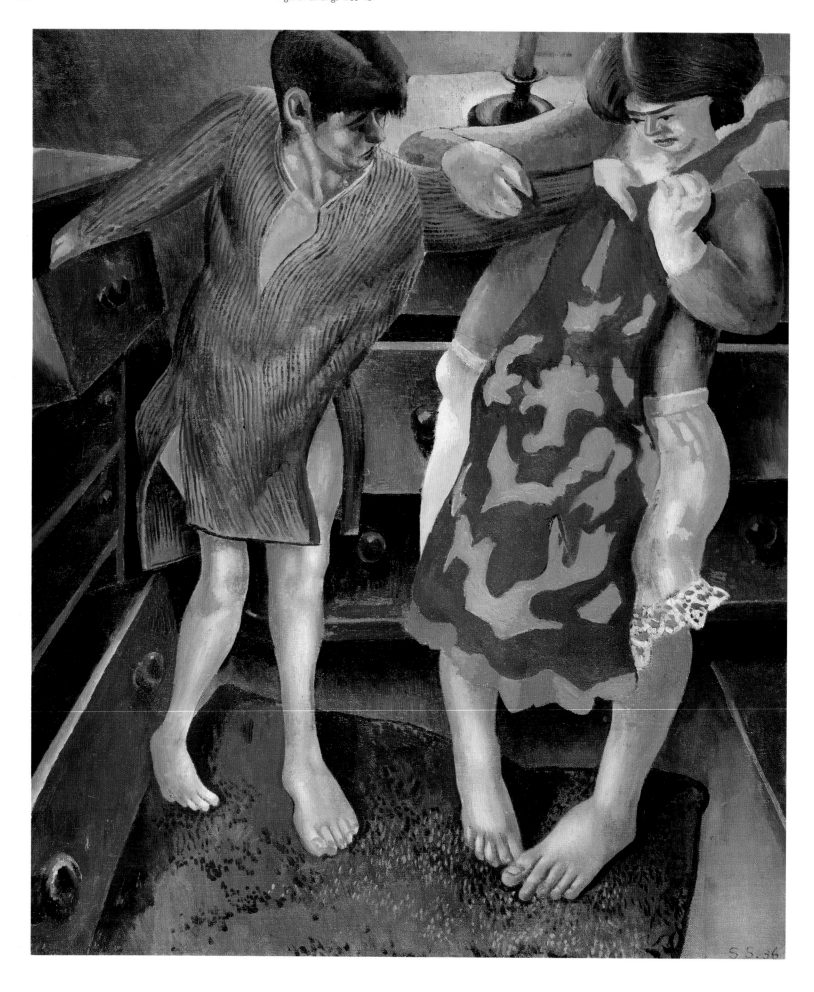

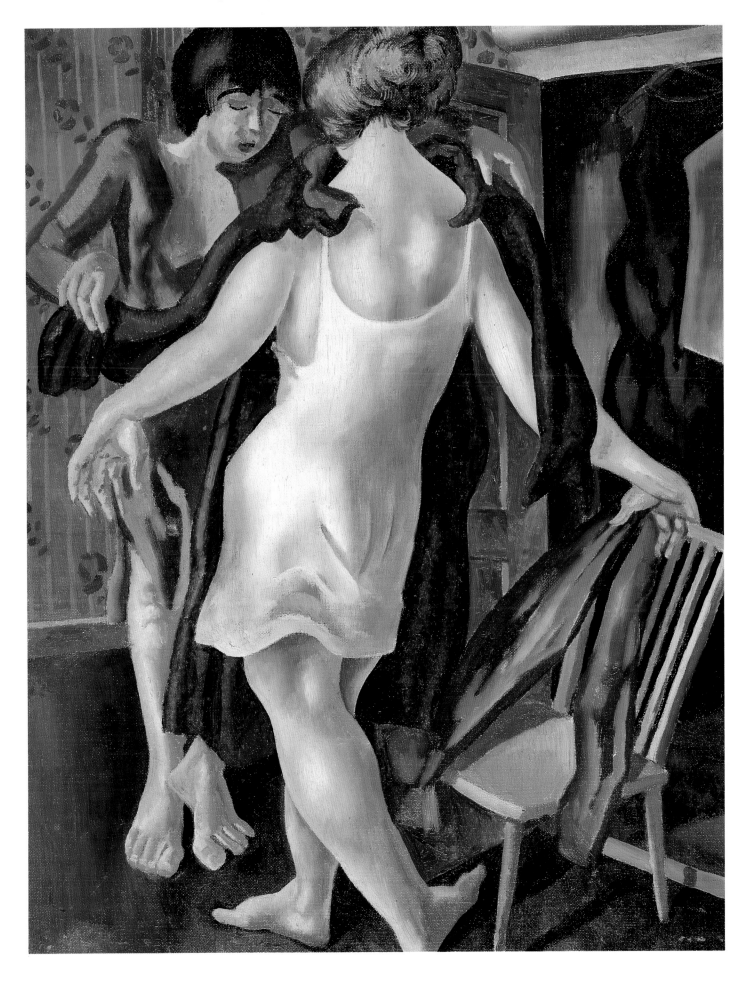

Cat. 198
Going to Bed
1936

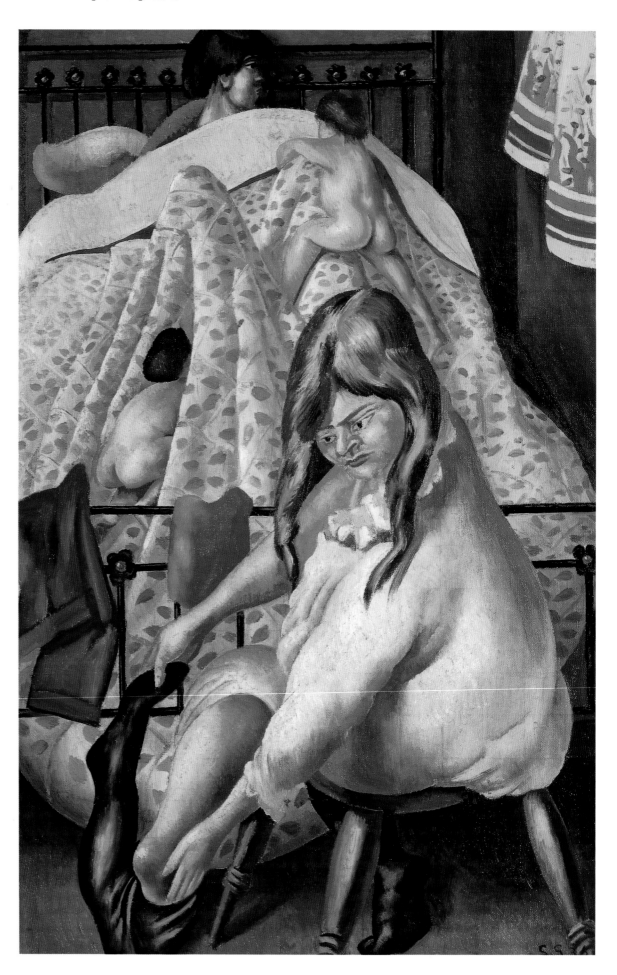

Cat. 200
Dusting Shelves
1936

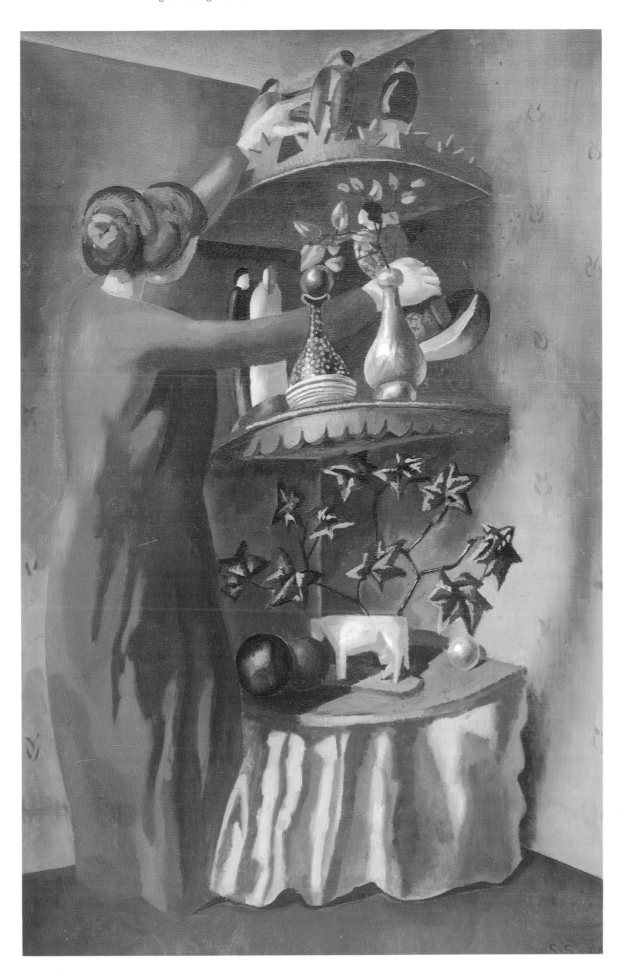

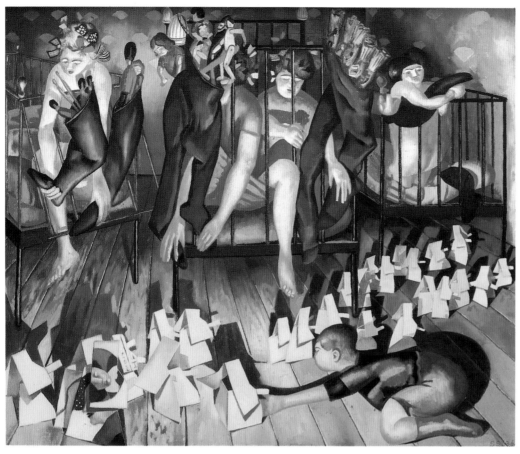

Cat. 197
The Nursery, or
Christmas Stockings
1936

The smaller of the two, 'St Francis
Preaching to the Birds', strikes one straight
away as unusually rich in colour and
pattern . . . it is all tremendously alive and
exciting, and even if the Saint is rather
reminiscent of Humpty Dumpty he is none
the less real for that. He is far nearer to
mother earth and the kindly human
mysticism of St Francis than any dignified
lay figure striking the apropriate rhetorical
gesture could be.

His reaction to *The Dustman or The Lovers* was
equally enthusiastic:

This sort of patchy, illogical vividness
is one which the material eye alone can
never capture, but which the inward
eye of memory can sometimes present to
us with bomb-like force just when we
least expect it. To experience such inward
flashes is common enough, but to be
able to capture them and fix them for ever
on canvas is the gift of genius.[104]

Other reviewers also took pains to be serious
about Spencer's work, and the *Sunday Graphic*
even interviewed Hilda, who explained
the original source of *Saint Francis and the Birds*
in a 'farmyard scene,' and then went on to
defend the painting and its design: 'The size
and weight of St Francis is quite essential
[she told the *Graphic*], and if any one were to
experiment by putting a narrower or taller
figure in place of the one there, they would
find that the whole picture went to pieces.'[105]

Spencer's reaction to the Academy
controversy shows how vulnerable he was to
any form of criticism. Although Robinson
(1979, p. 42) thought that he enjoyed the
dispute, this was certainly far from the case.
Evidence for this can be found in his letters to
the Academy, which contained numerous
repetitions and grammatical errors typical of
Spencer's writing style under stress.[106]
Furthermore, rejection of *Saint Francis* and *The
Dustman*, meant that there was little hope of the
more overtly sexual or distorted works being
exhibited in the future. Faced with the hostility
of the Academy, and Tooth's reluctance to
show the 'difficult' figure paintings, Spencer
must have realized that there was now little
chance of finding a patron to build the *Church
House*. Consequently, Spencer's insistence on

I am told and read something of the great
adulation paid to Spencer by writers in the
press and that he sells all his work. There
are some who profess to see some spiritual
and moral revelation in his work; to me it
seems not only monstrous but absolutely
stupid and incompetent or wilfully perverse
. . . it would seem that too often, an easy
or early success is in weak natures very
harmful and finally ruinous of all that was
promising in them.[103]

Brown had also got hold of some gossip about
Spencer's private life which – as it probably
did in other cases – caused him to lower his
opinion of the artist even further.

The bad press which Spencer's paintings
received in the Academy dispute was
somewhat alleviated by the critical reception of
his rejected works when they were put on
show at Tooth's. When viewed separately from
the question of Spencer's eligibility for
membership of the Academy, some writers
took more care in considering the paintings on
their individual merits. One particularly
favourable review by 'N' was published by
the *Guardian*:

complete artistic freedom seemed threatened, while his already ambivalent position between the Academy and the avant-garde now served to further isolate him.[107]

In retrospect, the rejection of *Saint Francis* (164) must be seen against Spencer's growing use of expressive distortion, with the ungainly bulk of the saint further exaggerated by his jointless arms and paddle-like hands and feet. The personal allusions to Spencer's family (the saint is Mr Spencer in his dressing-gown); to Hilda, holding a bunch of flowers on the right; and to the artist himself (at left) were now too obscure for a public more accustomed to flashy portraits, and the frothy nudity of paintings like Russell Flint's 1935 Academy offering, the *Judgement of Paris*.

The other two Spencer figure paintings accepted by the Academy, *The Builders* (169) and *Workmen in the House* (168) were the result of a commission by a builder. Both works reveal Spencer's growing interest in domestic subjects, and retain much of the figure style and centralized compositional format of the Burghclere paintings. Unlike *Saint Francis* there is a minimum of distortion, either because Spencer was uninspired by the commission, or because he felt that a safe painting was needed to secure the work. Although the subject-matter of these paintings is typically autobiographical, they are not dissimilar to the numerous paintings of 'modern' subjects which could be found at the Academy, or in the pages of the *Studio* — for example, *The Family* (1932), by Fleetwood Walker; J.W. Tucker's *Hiking* (1932); or Lancelot M. Glasson's *The Young Rower* (1932).[108] These were painted in a hard simplified style, which fitted in well with the bright colours, curved forms and geometric fabrics of Art Deco interior design.[109] While Spencer did not draw directly from this style it clearly affected his approach to modern subjects, and it was interesting to see how well *Workmen in the House* blended with the other realist paintings in *The Thirties* exhibition at the Hayward Gallery in 1979/80.

The paintings of the early thirties show Spencer leaving behind the artistic influences of the twenties, and moving towards a style increasingly dictated by his own needs and emotions. However, despite Richard Carline's belief to the contrary,[110] Spencer continued to be interested in, and influenced by, contemporary art. Notwithstanding his relative isolation in Cookham, Spencer maintained intermittent contact with Nevinson and Roberts; [111] and he remained on friendly terms with Gertler, telling Christopher Hassall in 1954: 'I have always been an admirer of Gertler's work and we were always good friends from 1914 to the end.'[112] These connections are reflected in the bulky rounded figures with exaggerated tubular limbs, which appeared in Spencer's paintings of contemporary subjects during the late twenties, notably in the Empire Marketing Board series (128a-e), and at *Burghclere*; and they were firmly established in imaginative works like *Sarah Tubb and the Heavenly Visitors* (151) and *Separating Fighting Swans* (152) by 1932-3. This style has some parallels with William Roberts, who had developed his distinctive urban realist paintings under the influence of Leger about 1928, the same year that Spencer received the Empire Marketing Board. commission.[113] As Causey observed (p. 30), Roberts had also been interested in early Italian art at the Slade School.

On rare occasions in the thirties Spencer also seems to have glanced in the direction of Cubism, perhaps influenced by Gertler's conversion in the late nineteen-twenties. This can be seen in the two dimensional, patterned figure, and oddly juxtaposed head of the seated woman in an unusual painting of 1935, *By the River* (170). However, this style is confined to the figure and is not carried through into the landscape which is purely Spencerian. In the thirties Gertler's attention shifted to Picasso's Neo-Classical phase, and his adoption of large, well-rounded figures in paintings like *The Mandolinist*[114] has parallels with Spencer's work; for example, the characters of Sarah Tubb and her shifty son in *Sarah Tubb and the Heavenly Visitors*.

Spencer's other form of contact with the art world came through the *Studio*, which, according to Gilbert Spencer and Richard Carline, he read throughout his career.[115] During the thirties the *Studio* concentrated mainly on figurative art, and only rarely made excursions into Cubism or abstract paintings.[116] Instead, Spencer's own preoccupation with figurative work would have been reinforced by articles on the American realist painters, such as 'A Gallery of American Painting' by Margaret Breuning,[117] containing reproductions of work by Curry, Luks, Henri, Kent, Benton, Billings

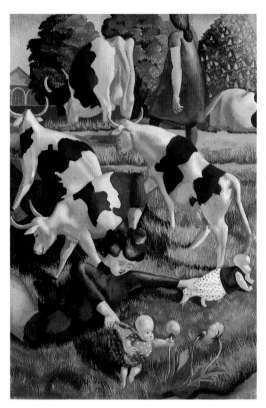

Cat. 201
Cows at Cookham
1936

and Marsh, and a whole article devoted to Benton's murals, in the April *Studio* for 1931.[118] The working-class subjects and deliberate ugliness of these painters have similarities to Spencer's own works,[119] particularly commission pictures, such as the EMB series, the 'Cunarder' studies, *Shipbuilding* (189) and *Riveters* (190) and the Port Glasgow shipbuilding paintings. Benton's murals were also a possible additional influence on Spencer's long *Church House* paintings,[120] in his frequent use of crowds of rough unidealized people in small-town settings. Benton's figure style, too, with its disjointed and strangely animated forms, resembles Spencer's own painting, notably the *Adorations* (226, 227) and *Beatitudes of Love* (1937-8; 274).[121]

Finally, Spencer could also see a reasonable range of contemporary art on his numerous visits to Tooth's. Dudley Tooth had established a highly successful gallery in the thirties, and dealt in the work of prominent figurative artists, including Sickert, Augustus John, Matthew Smith, the Nash brothers, and a number of British surrealists including Tristram Hillier.[122] Spencer's resignation from the Academy highlighted his growing isolation as an artist, both from the avant-garde and from the conservative circles which had originally admitted him to the institution in 1932.[123] Having lost the main forum for exhibiting his figurative paintings,[124] Spencer was now forced to rely solely on Tooth's for both sales and exhibitions. Tooth had tried hard to sell the figure paintings; Beddington-Behrens had paid £150 for *Sarah Tubb* and £75 for *The Meeting* (145), but these prices compared poorly with the £100 paid by J. Spedan Lewis for *The Angel, Cookham Churchyard* (148), a modest landscape which took considerably less time and effort to paint.[125] Recognizing this, and probably urged on by Tooth, Spencer decided in 1934 'to do smaller imaginative works to try and interest people in my work.'[126]

These were the *Domestic Scenes* (191-200), probably drawn in 1934-5, but not begun on canvas until the summer of 1935, after the Academy débâcle, and with the promise of an exhibition at Tooth's (in 1936) in mind.[127] The main theme of the series was Spencer's experience of married life with Hilda at Chapel View, Burghclere,[128] a period which he saw in retrospect as one of perfect marital harmony. Writing in 1937 he recalled that the paintings represented 'the special joy and significance'[129] of household routine: 'Half the meaning of life, is in my case what the husband and wife situation can produce.'[130] Ironically, these paintings were produced at the same time as Spencer was trying to divorce Hilda and marry Patricia Preece;[131] an irony which shows him seeking to represent perfection in his art, even when it was impossible to achieve in real life. As I have pointed out in the RA catalogue (p. 142), this phase of his work begins the progressive idealization of Hilda, and the removal of her image from the trivialization of domestic conflict. With Hilda now living mainly in London, Spencer could turn to the imaginary world of the paintings, where her awkward personality could be made to conform with his own needs.

Compositionally, paintings such as *On the Landing* or *Looking at a Drawing* (193) and *At the Chest of Drawers* (192) show Spencer's use of a new structural device; with the two central figures (Spencer with Elsie or Hilda) balanced and interlocking, symbolizing the inseparability of their love for one another. As Gormley points out (p. 22), Spencer literally tries to make Hilda 'fit' him; and her exaggerated size, looming above him, indicates her importance in his life, both as a domestic and a sexual partner. Spencer's own boyish appearance, common in his paintings after c.1927, points to another ambiguity in their relationship: Spencer seems to have subconsciously viewed Hilda, not only as a wife, but also as a mother figure, a pseudo-oedipal personality who would give unquestioning support to his activities.[132]

The *Domestic Scenes* show the pleasures of home life, but they are also charged with sexual tension, not only in *Going to Bed* (198) but also in *Looking at a Drawing* or *At the Chest of Drawers* where the interlocking figures convey strong sexual attraction as they press up against each other. As yet, however, this tension is contained within a domestic setting: when Spencer returned to the subject after he had divorced Hilda and married Patricia in 1937, domesticity was replaced by more overtly sexual treatments.

Spencer's production during the later 1930s was dominated by two series of paintings: the so-called *Adorations* and the *Beatitudes of Love* . Both were the product of Spencer's new

circumstances in 1937: having divorced Hilda, he wrote of his idea of a polygamous arrangement: 'I wish to have another wife [Patricia] in addition to the one I at present possess [Hilda] and get divorced and remarry so that I may possess two wives.'[133] Hilda's refusal to go along with this proposal, and Patricia's rejection of him after their marriage when on their 'honeymoon' in St Ives,[134] left him without either woman. Spencer was isolated, without the bedrock support of Hilda, or the physical satisfaction of Patricia; moreover, he was now deeply in debt.[135] Placed in this difficult, even traumatic, situation, Spencer turned to his paintings for comfort and solutions.

During the ensuing two years, living in a virtual state of limbo, Spencer's figure paintings lost their earlier recognizable personalities, who were replaced by mainly anonymous 'guest characters.'[136] As he told Hilda: 'My longing for you was becoming dispersed in a polygamous sort of way.'[137] In the *Adorations* series, painted in 1937, Spencer revived the theme of free love first expressed in *Love on the Moor* (415) and *Love Among the Nations* (172), although the Dionysian revelry of the earlier works is now more muted.[138]

All the paintings belonged to the *Pentecost* and *Last Day* themes, with the disciples

spreading through the streets of Cookham bringing redemption to the villagers. Freed from the restraints of the old-world morality, everyone is free to make love as their fancy takes them. The joy of the experience is intense, and mirrors Spencer's own frustrations and desires. In *Adoration of Old Men* (227), for example, a young girl 'is almost fainting with the joy at the thought of being alone with [an old man];'[139] and of *Adoration of Girls* (226) he wrote: '. . . it is a painting I longed to do . . . I love each girl in the picture and painted them with passion.'[140] The appearance of young children coming from school, in *Adoration of Old Men* and *A Village in Heaven* (228), probably symbolizes their advancement towards sexual knowledge (something Spencer had come to regrettably late in life); and, further, connects the paintings with the *Cana* cycle, now revised to lay more emphasis on sex as a central life-force.[141]

Spencer carried his sexually oriented philosophy to one further extreme in *Sunflower and Dog Worship* (1937; 245). Here he extended his belief in the universality of sex to include animals and plants, an idea already alluded to in the cow-woman image in *Love on the Moor*, and perhaps inspired by the frequent appearance of animals in Indian temple sculpture. In the painting a 'husband and wife' make love to the sunflowers,[142] and a party of men and women reach over the wall to fondle the visibly aroused dogs. Spencer later told the owner, Wilfrid Evill, that the people within the enclosure (a kind of reconstituted garden of Eden) had accepted his doctrine of free love, while those on the outside were as yet unconverted.[143] The constant emphasis on the group experience of sex throughout the *Adoration* series was probably tied to Spencer's own exhibitionistic tendencies: 'I usually feel a great inspiration towards sexual performance when in public and among people,' he wrote in 1938,[144] shortly after the completion of the series.

Despite the absence of any obvious reference to religion in the *Adoration* paintings, Spencer still meant them to be as profoundly religious as *The Resurrection, Cookham*, or any of the other early biblical works. Here, though, sexuality and religion shared an identical ecstasy. In 1937 he wrote:

It is a mistake to suppose that because my

Cat. 203
Crossing the Road
1936

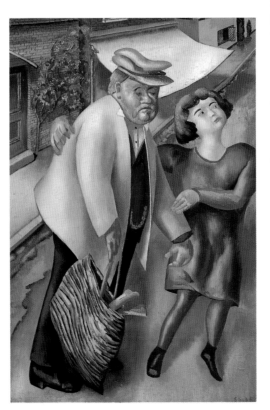

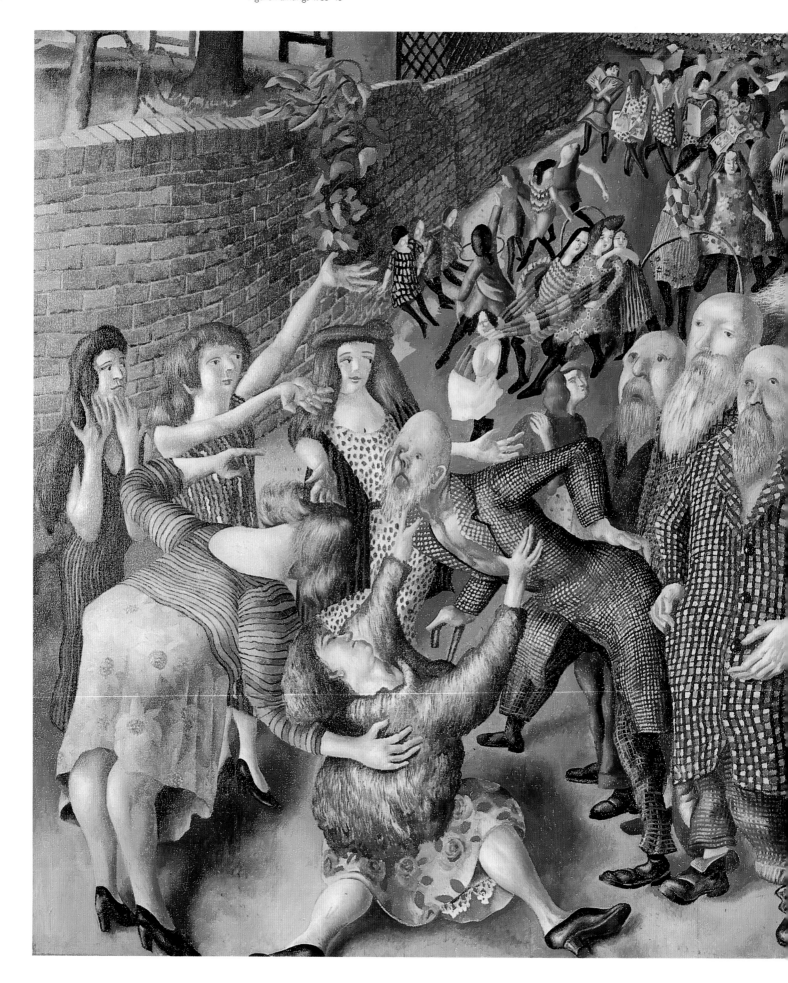

Cat. 227
Adoration of Old Men
1937

Cat. 228
A Village in Heaven
1937

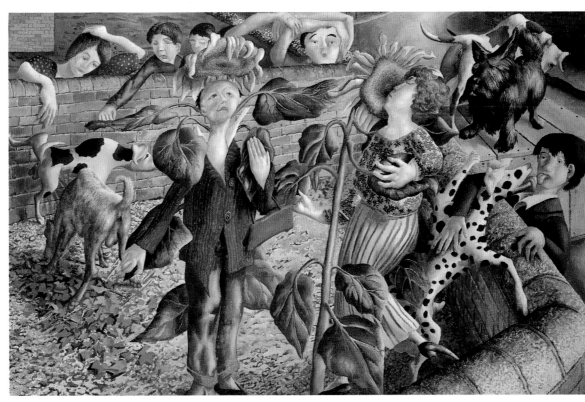

Cat. 245
Sunflower and Dog Worship
1937

Cat. 230
The Village Lovers
c.1937

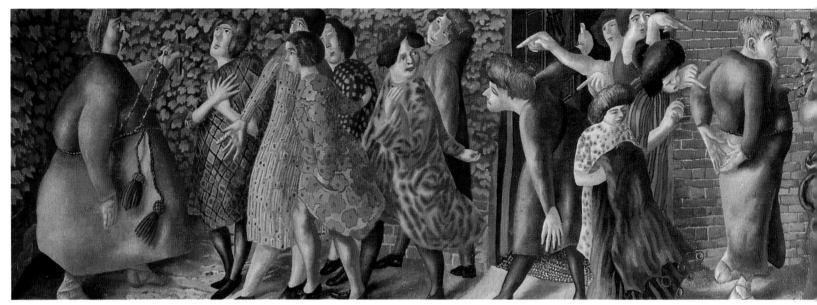

Cat. 246
Promenade of Women
1938

recent pictures have a lean and emphatic relationship to sexual love that they are for that reason not spiritual and not religious. . . There is no difference in the child's sense of wonder when it wonders what is over a wall and a man's sense of wonder when he wonders what is under a woman's clothes. I can feel reverence in the contemplation of Christ on the Cross and I can feel reverence through sexual desire for a woman walking down the street.[145]

To Spencer, both sex and God 'evoke a sense of thankfulness and joy and an equally urgent wish in both cases to be eloquent and to excel in expressiveness.'[146]

Spencer's view was Blakeian, a question of innocence and experience. In the pre-sexual period before his marriage to Hilda in 1925, his work was stimulated purely by 'what an innocent state could supply,'[147] that is biblical themes set in a Cookham landscape. Having married, however, and become 'dependent on sexuality,' he now found that 'so much of what now is meaning to me is closely associated with [sex],' that he had 'difficulty now in getting back to that period.' In order to bring about a reconciliation of these two stages, 'of innocence and experience,' Spencer sought 'a connection,' and found it in the relationship between 'those things which moved me as a child [for example, the bellrope which hung at the end of his nursery bed] and what stimulates me now.' He could thus draw together the strands of his private

and religious beliefs while at the same time justifying the exaggerated role played by sexuality in the paintings of the thirties.

These ideas applied, too, to Spencer's other 1937-8 series, the *Beatitudes of Love* (274a-j), a title which he also occasionally used for the *Adoration* paintings. These works, like the earlier *Domestic Scenes* which they superficially resemble, belonged to the *Cana* series and were intended to hang in small rooms opening off the side aisles of the *Church House*.

At first sight the paintings marked a return to the less crowded compositions of the *Domestic Scenes*, but the earlier homely atmosphere was absent, replaced by a mood of extreme sexual tension and masochistic longing. Rejected by both Hilda and Patricia, Spencer was now living on his own in a state of deep depression and sexual frustration. In this condition he retreated deeper than ever before into the world of his paintings, where he sought to re-establish the connections denied him in real life. As he recalled in 1940: 'In these drawings [the Beatitudes] I had a desire to make some real contact; to win something for myself from the person. It made them seem less remote and less nothing to do with me.'[148] Spencer made this feeling more real by introducing himself into the painting as a kind of proxy character: 'These people are me really . . . only I make it other people as much as I can so as to be able to project my feeling into some visible image I can have in front of me.'[149] Spencer had always produced his best work in a state similar to religious

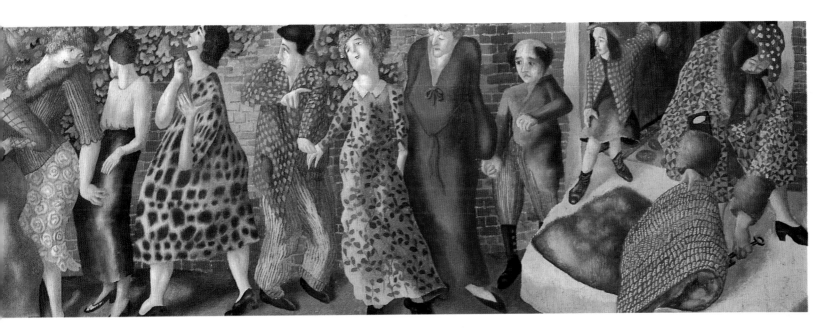

ecstasy, but by the late thirties this had changed to sexual longing. When drawing Daphne Charlton c.1939, he had felt that 'I drew them [her portraits] anticipating a sexual affair . . . that is the state I like to draw in.'[150] It was in an extreme form of this condition that Spencer came to paint the *Beatitudes of Love*.

For the paintings, Spencer invented fictional characters with names and occupations, such as the 'servant girl and husband' in *Romantic Meeting* (274g), 'cowman and wife' in *Consciousness* (274f) and 'Charley and Bertha' in *Passion or Desire* (274d). He also wrote long and tedious erotic accounts of their sexual activities. These stories appear next to Spencer's notebook descriptions of the paintings, and were either intended for his own private use, or for inclusion as texts, along with the paintings in the *Beatitudes* chapel. Although Gormley's discussion (p. 29) mentions the paintings' invented characters, he failed to note that most of the pictures also clearly represent Spencer himself, usually in the company of one or other of his women friends: Patricia in *Passion or Desire* (274d) and *Worship* (274h), and both Patricia and Hilda in the lost drawing for *Seeing* (274c) where all three join hands on top of a large double bed. In *Passion or Desire* a diminutive Spencer, visibly aroused, clutches Patricia's arm and gazes imploringly into her eyes, while she stares indifferently out of the painting; and in *Worship* he reappears as a kneeling supplicant bringing gifts to Patricia and a bevy of elegant women. From this

evidence it is clear that the *Beatitudes* had a dual meaning for Spencer: firstly as fictional erotica, and secondly as the deeply private expression of his frustrated desires for Patricia and Hilda.

A further aspect which distinguishes the *Beatitudes* from Spencer's other paintings was the almost total absence of recognizable settings. As Gormley concluded (p. 30), Spencer was preoccupied with the 'dramatic situation,' to the exclusion of an environment for his characters: but this absence of a recognizable setting, which had been so crucial to his other paintings, indicates too that his vision was becoming separated from its usual path, and the results were claustrophobic and lacking in the bucolic, Breughel-like carnival atmosphere of the *Adoration* series. This tension also led Spencer to extremes of distortion and ugliness, notably in *Romantic Meeting* (274g), where the lumpy figures are absurdly elongated, or *Contemplation* (274e), where the woman's hands have become giant claws.

The odd subject-matter and disturbing appearance of the *Beatitudes* and *Adoration* series served to separate Spencer further from his public. When shown one of the *Beatitudes* at Tooth's, Eddie Marsh (by now an old Spencer supporter) reacted with horror: 'It fogged his monocle,' Spencer recalled afterwards, '"Oh Stanley, are people really like that?" I said: "What's the matter with them? They are all right aren't they?" "Terrible, terrible, Stanley." Poor Eddie.'[151] Adverse criticism also affected sales at Tooth's, and precipitated Spencer into his foolish deal with Zwemmer, in which,

Cat. 274d
Beatitude 4:
Passion or Desire
1938

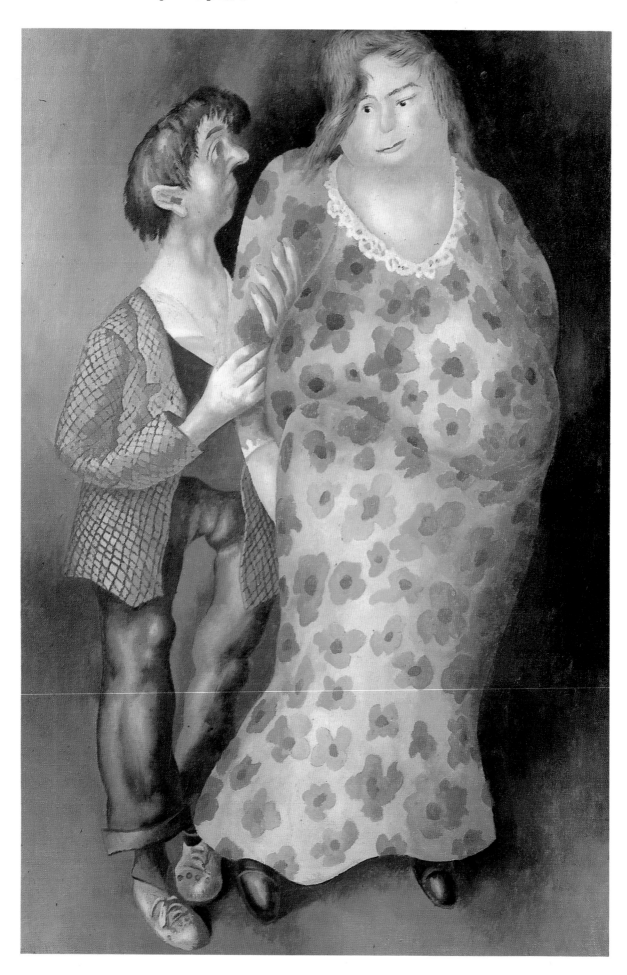

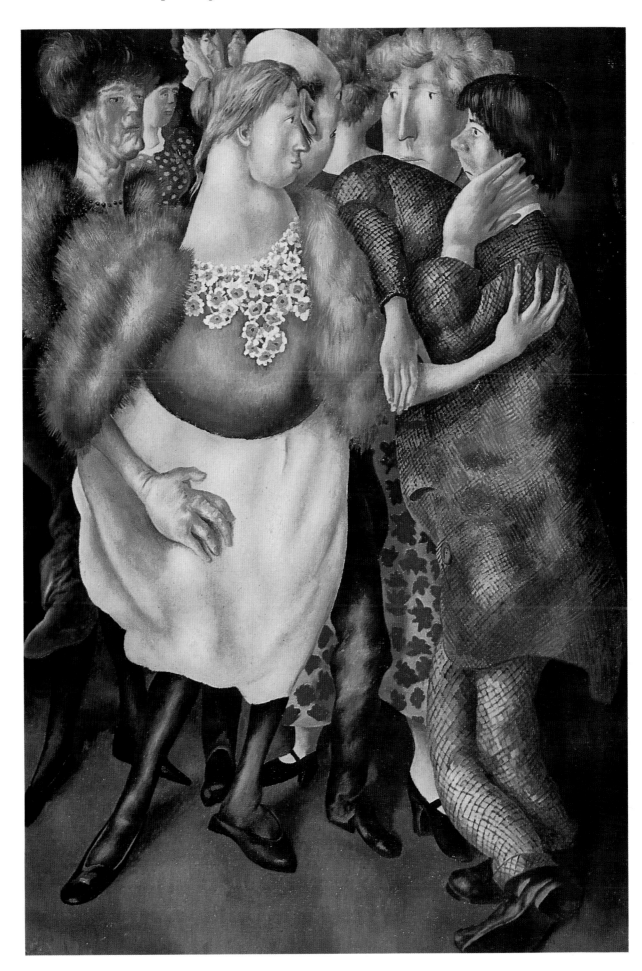

Cat. 274e
**Beatitude 5:
Contemplation**
1938

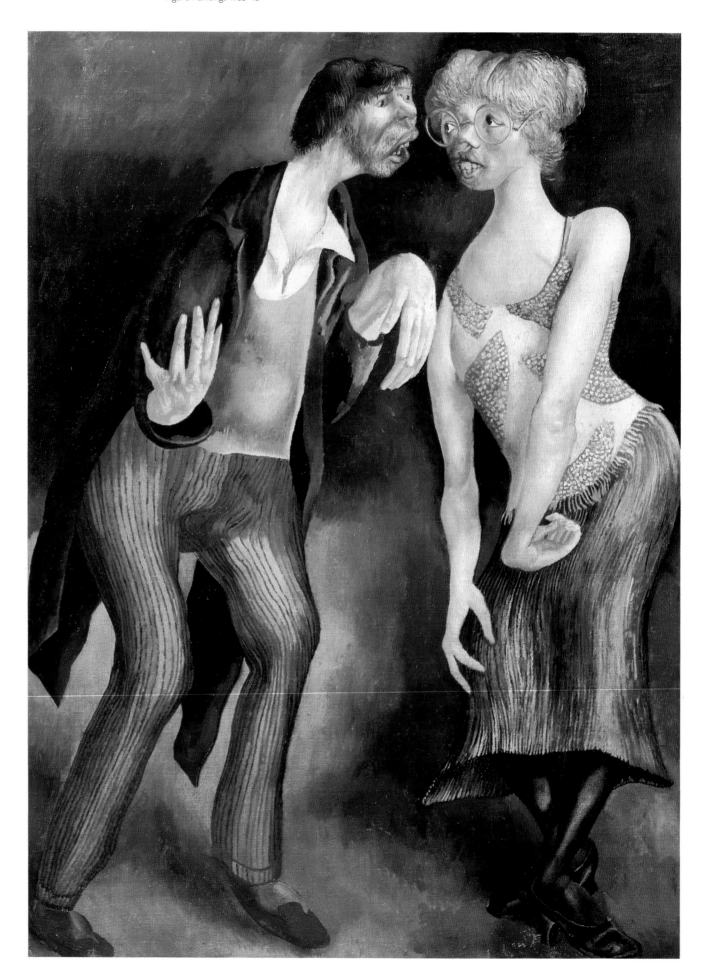

Cat. 274f
**Beatitude 6:
Consciousness**
1938

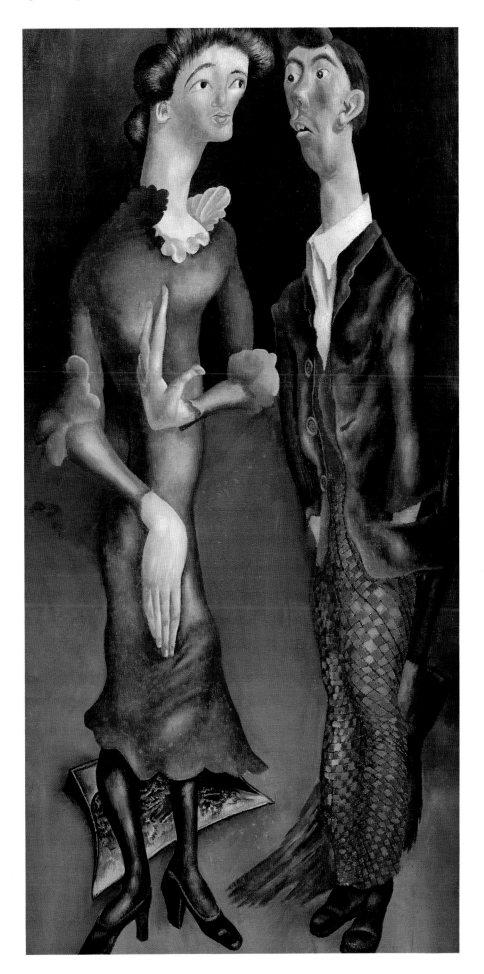

Cat. 274g
**Beatitude 7:
Romantic Meeting**
1938

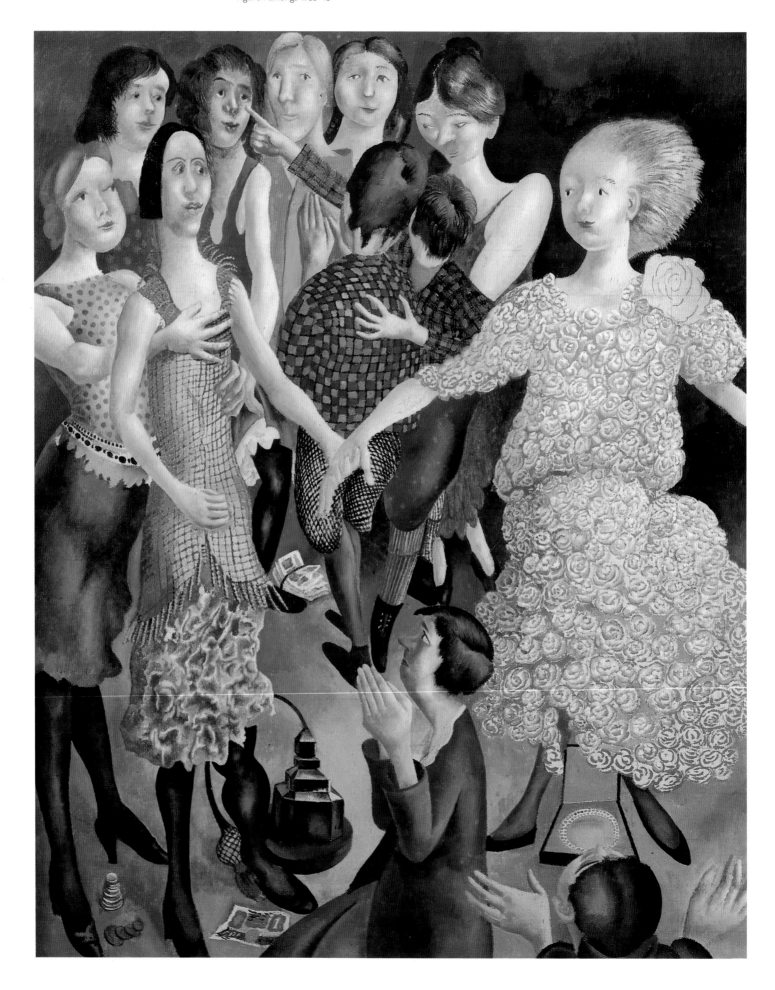

among other things, Zwemmer bought *Adoration of Girls* for £20, a derisory sum compared to the £150 valuation put on it by Tooth's later, in July 1938. Indeed only Wilfrid Evill, Spencer's solicitor, was a consistent and enthusiastic buyer of his work during the thirties, amassing a number of important works including *The Village Lovers* (230), *Worship* and *Double Nude Portrait* (225).

Spencer's own reaction to the criticism of distortion in his paintings was to deny that he had ever deliberately intended to depart from natural appearances – indeed he sometimes refused to admit that his pictures were distorted at all. In c.1957 he stated flatly: 'I do not distort deliberately. I have no intention or wish to distort. For a very good reason . . I am always at normal appearance.'[152]

Spencer then went on to explain in a roundabout way that his paintings were the product of a powerful inner need 'that is not covered by any immediate object I see.' This 'need' or 'longing' was 'proof of the existence of what I long for;' and Spencer felt convinced that the final realization of this idea was 'something akin to what it would be like to perform a miracle.' In short, Spencer was trying to explain that the 'need' generated by the workings of his imagination was the reality which he sought to put down on canvas. Consequently, the distortion which some people claimed to detect in his work was the product of their inability to 'see' the pictures as the product of his imaginative life.

Elsewhere, Spencer emphasized that the distortions were not a deliberate stylistic ploy, but emerged quite accidentally in the compositions directly from his subconscious. In a letter to a friend, Olive, he complained that R.H. Wilenski had called the distortions 'deliberate':

> He was confusing me with the modern painters who departed from normal appearances and did so on purpose. . . But the reason why I might make an arm . . . miles longer than an actual human being's arm would be for a completely different reason. . . In my too long arm the departure was not intended or deliberate or wished for and caused consternation in me when after I had done it I realized 'the mistake.'[153]

Spencer then went on to explain that he did not correct the 'mistake' because 'making it the correct length would ruin the design.' It was, he declared, the product of 'the fullest extent of my inspirational powers at the time of the conception . . . of the idea.'

Spencer's defence of the imaginative distortion in his paintings was also closely linked to the question of beauty in art. This was particularly relevant to the *Beatitudes of Love*, which were about as far away from the conventional ideal as it was possible to be. At some time in the 1940s, Spencer wrote an important response to a 'Mr Bradbury' who had apparently criticized the *Beatitudes* on the grounds of ugliness.[154] In his letter Spencer emphasized that the outward appearance of beauty did not concern him: 'I am unaware of any classified distinctions regarding what is or is not beautiful,' he wrote, 'it is the inward joy and emotion alone [which] directs me.' The beauty of the relationship, he went on, lay in the mutual pleasure of the *Beatitudes* couples in one another: 'The thing that has given me the wish to do these paintings is when I contemplate how meaningful and wonderful is the relationship of two ordinary people.'

This relationship reached its peak in the couples' mutual sexual attraction, which in Spencer's description is made to sound like a form of spiritual ecstasy: 'The final and crowning experience of these various couples' feelings will be expressed in carnal desire.' It was this inner awareness, Spencer explained, which constituted real beauty, no matter what they looked like to other people: 'In their appearance these couples might not conform to what ever might be the conventionally supposed canons of beauty, but to me in expressing the miraculous wonder in their awareness of each other they express the beauty of that meaning.'

In this description, Spencer simply substituted sexuality for the Christian belief in inner spiritual beauty; giving in the process a clear sense of the continuity between his youthful Christian views and his later belief in the powers of sex.

On another level, Spencer was also probably doing some special pleading on behalf of the less attractive people of the world. In 1979, Richard Carline informed me that Spencer was very sensitive about his small size and scruffy schoolboy appearance, which was often remarked upon by the press.[155] Neither Hilda

Cat. 274h
Beatitude 8:
Worship
1938

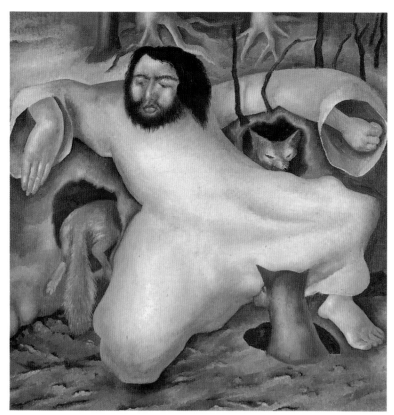

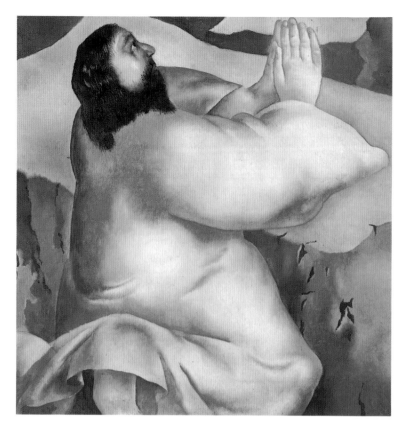

Cat. 283a
Christ in the Wilderness:
The Foxes have Holes
1939

Cat. 283b
Christ in the Wilderness:
He Departed into a
Mountain to Pray
1939

nor Patricia was particularly good looking in the conventional sense, indeed Spencer seems to have been attracted by plain or ugly people of the type who populate the *Adoration* series and *Love on the Moor*.[156] Spencer therefore created a world where these people might succeed without any hindrance, as well as a doctrine to justify it. As he wrote to 'Mr Bradbury': 'That these people may not be everybody's cup of tea is not important . . . but that they are each other's does. What ever [sic] they look like they are all in all of each other's lives.'[157]

The *Beatitudes* were the last major painted series concerned solely with sex within the *Church House* scheme. Faced with the opposition of his public and his dealer, Spencer clearly realized that these paintings were too obscure to be successful. On a personal level, too, the intensity of feeling in the *Beatitudes* was too great to sustain for a long period. When Spencer returned to the *Church House* theme in 1940, sex had resumed its background role in paintings once again devoted to domesticity.

During the thirties Spencer held only one major exhibition in Britain, his one-man show at Tooth's of 25 June to 18 July 1936. Dudley Tooth had originally proposed an exhibition in 1932 when Spencer had suggested including a

number of the movable works from Burghclere;[158] however, the Behrends had objected, and the show, now minus the chapel paintings, was put off to November 1933.[159] Then in March Spencer wrote cancelling his submission to the Royal Academy, asking Tooth if he could not 'sell what you can of mine privately without my having an exhibition in November,' and explaining that having to hurry his work had 'been such a painful experience that I feel . . . I can't bear it any more.'[160] The pressure of producing work to order, so different from his usual habit of working when the spirit moved him, was too much for Spencer and Tooth advised him to paint at his own pace.

In the following year Spencer agreed to show at the Academy, and even suggested a small exhibition of his drawings of 'heads'[161] at Tooth's. Dudley Tooth agreed, but Spencer abruptly cancelled the arrangement, citing as his reason the cost of catalogues and framing charged to him by the gallery.[162] Spencer's behaviour was extremely awkward for Tooth, who tried other means of publicly exhibiting the paintings, such as loaning works to public galleries in 1934-5,[163] and in the early and late thirties arranging for Spencer to exhibit at the Venice Biennale.[164] One reason for Spencer's

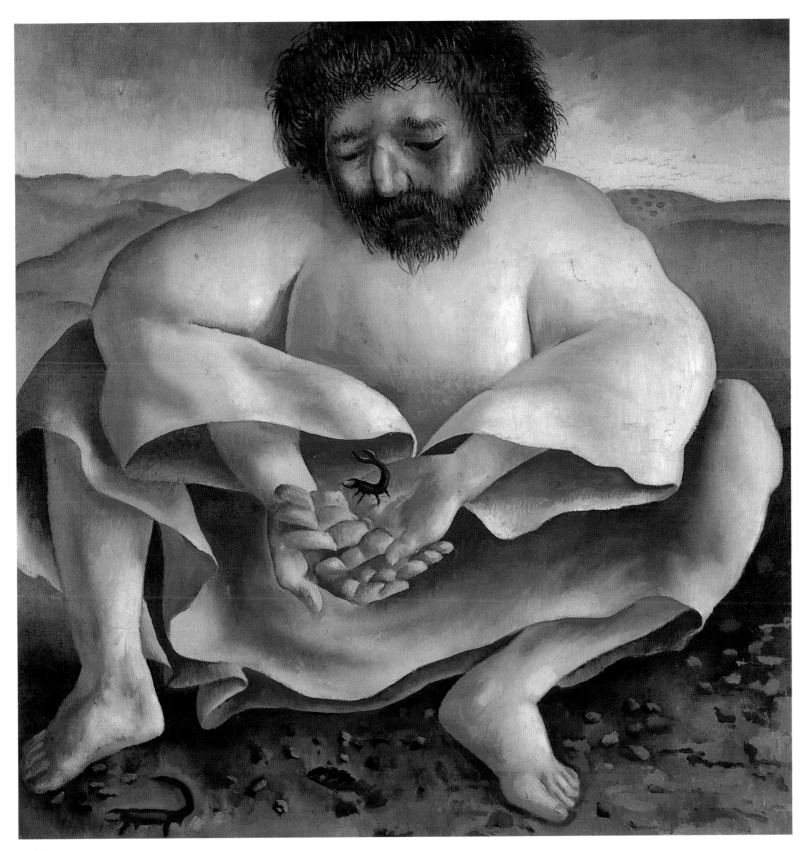

Cat. 283c
Christ in the Wilderness:
The Scorpion
1939

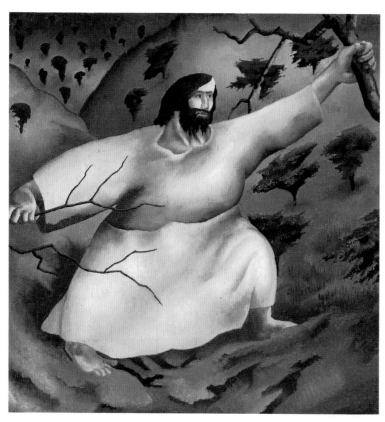

Cat. 283f
**Christ in the Wilderness:
Driven by the Spirit into
the Wilderness**
1943

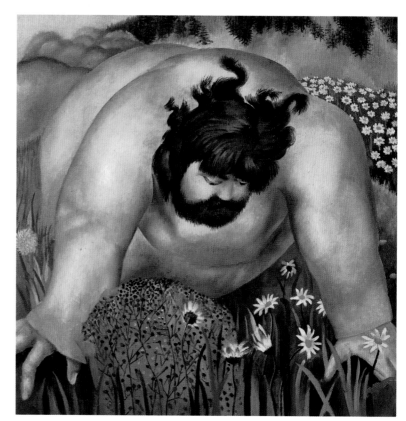

Cat. 283d
**Christ in the Wilderness:
Consider the Lilies**
1939

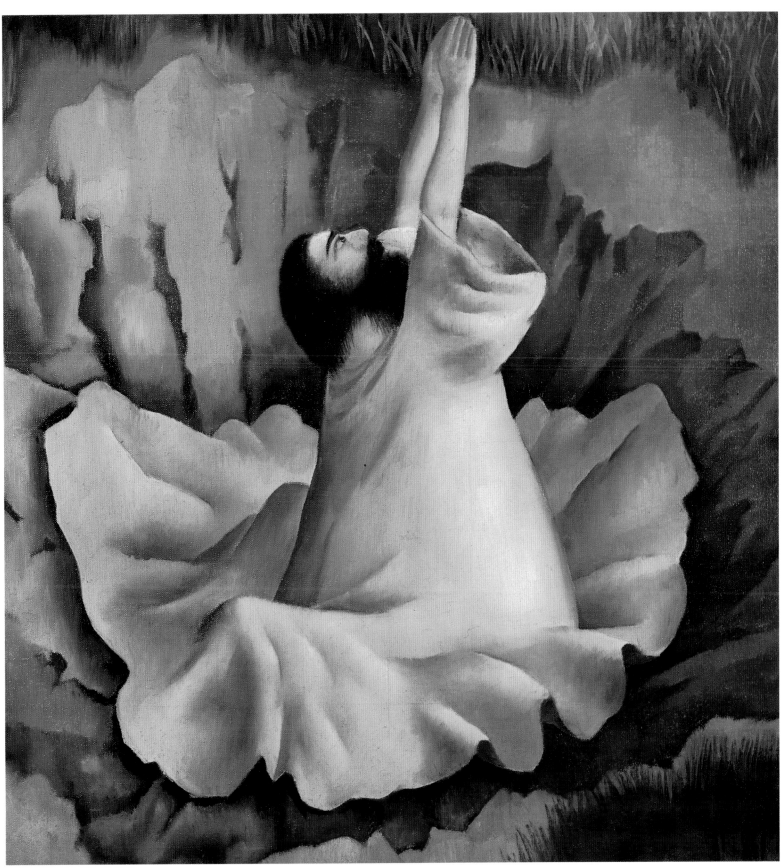

Cat. 283e
**Christ in the Wilderness:
Rising from Sleep in the
Morning**
1940

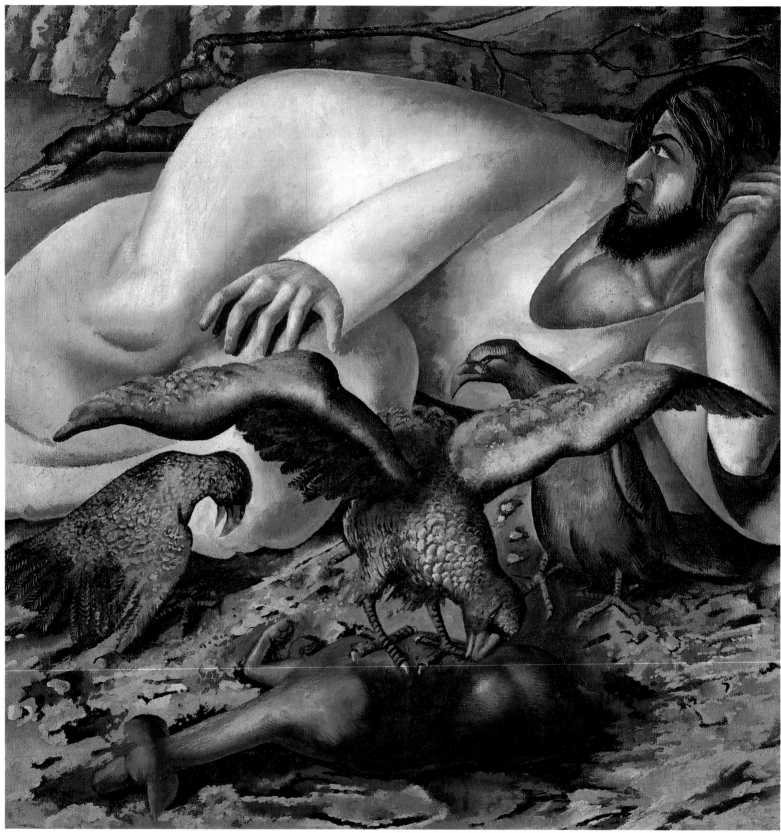

Cat. 283g
Christ in the Wilderness:
The Eagles
1943

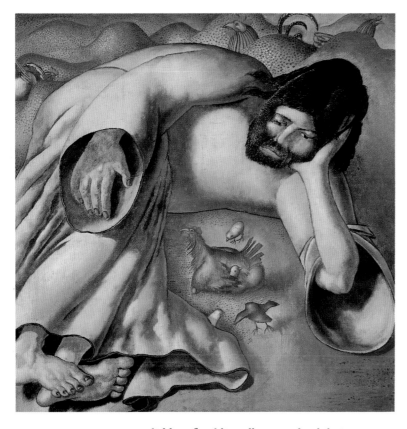

Cat. 283h
**Christ in the Wilderness:
The Hen**
*c.*1954

collection – was acceptable to the critics in a way that *Saint Francis and the Birds* and the *Dustman* or *The Lovers* were not. Consequently, some writers proved willing to pay serious attention once again to Spencer's figurative work.

At least two critics, those of *Truth* and the *Christian Science Monitor*, felt that the exhibition was 'the most important "one man show" of the season,'[167] and 'the most notable exhibition of the moment'[168] – this despite the concurrent exhibition of the work of Salvador Dali in London.[169] Others returned to the line of discussion taken by reviewers of the 1927 Goupil Gallery exhibition, by linking Spencer with his English predecessors. The critic for the *Scotsman* was the most insistent, comparing Spencer to 'the tradition of British Pre-Raphaelitism . . . the poetic naturalistic kind of Hunt, Brown and the younger Millais', as well as Hogarth and Madox Brown.[170] These comments were repeated by Frank Rutter writing in the *Sunday Times* who compared Spencer to Hogarth;[171] and the *Guardian* critic who admired the artist's 'Pre-Raphaelite honesty,'[172] declaring: 'The fact still remains Stanley Spencer can paint a motor-tyre or a laburnum tree or an iron bedstead in a way that makes one catch one's breath with a shock of delight.'[173]

For the most part attention was concentrated on the *Domestic Scenes* which Spencer had planned as the centrepiece of the exhibition. Here the reception was mainly favourable perhaps because these comparatively uncomplicated compositions seemed, at least on the surface, to be absorbed in the celebration of simple everyday activities. The anonymous writer for the *Christian Science Monitor* made this clear in his discussion of *Crossing the Road* (no. 5 in the exhibition):

> It is in these little incidents of daily life . . . that Stanley Spencer rises to his highest points of inspiration, for when he attempts a larger subject as in 'Humanity' [*Love Among the Nations*, no. 21 in the exhibition], he is less successful, not only losing clarity in the design but being discouraged to the point of pessimism in his emotional outlook.[174]

This misreading of 'Humanity' – which was essentially an optimistic anti-war painting – points to the continuing difficulty experienced by critics in interpreting Spencer's large figure

dislike of public galleries and exhibitions was his belief that institutions ignored or misunderstood his work; a feeling reinforced by their evident preference for landscapes, and Tooth's own doubts over the figure paintings. Also, Spencer had growing financial difficulties which came to a head in December 1935, when he begged Tooth to 'sell a landscape of mine for *any price* before Christmas.'[165]

When Spencer finally agreed to an exhibition at Tooth's in 1936, the show was based on a mixture of small figure paintings usually known as the *Domestic Scenes*, and a number of landscapes and still lifes, a total of twenty-nine pictures. The exhibition was a great success, and Tooth's sold seventeen paintings while the show was up, and a further three subsequently. Altogether Tooth realized £1825. 10s., less £608. 10s. commission, £112. 5s. 6d. for framing and photography, and £700 cash advanced, leaving Spencer with a total profit of £414. 14s. 6d.[166]

The 1936 Tooth exhibition received a considerable amount of critical attention which, now that the Academy furore had died down, was once again firmly concentrated on the work itself. From the tone of the reviews, it is apparent that the careful mixture of landscapes and domestic subjects chosen by Tooth – a thoroughly non-controversial

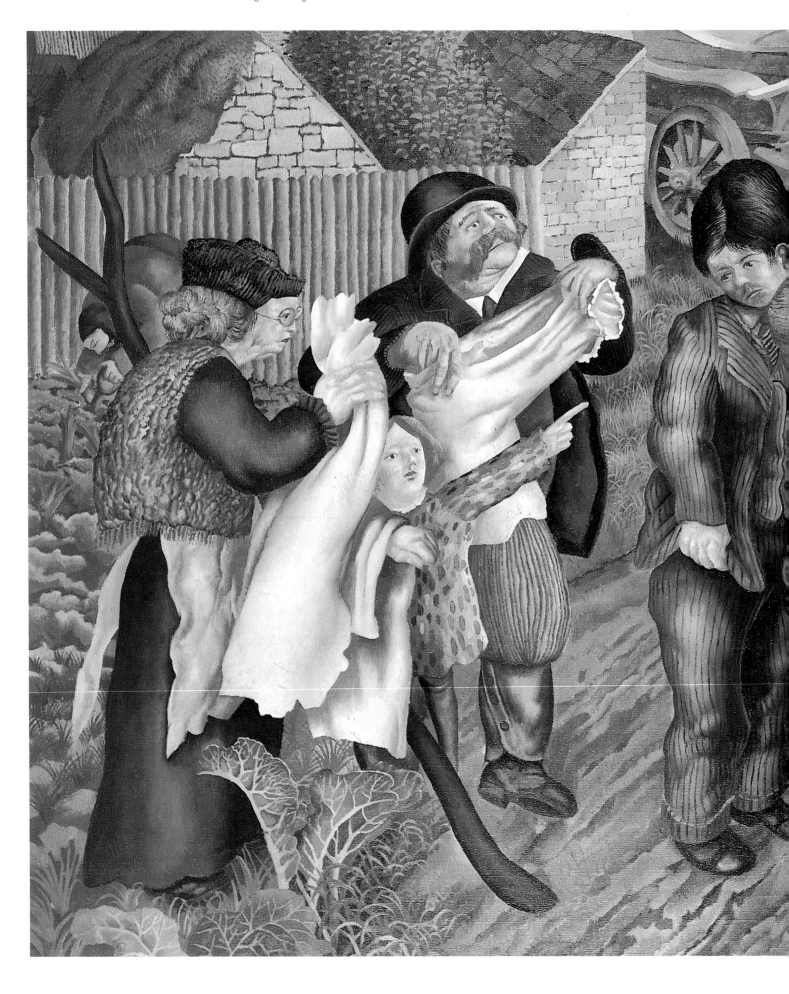

Cat. 292
Village Life, Gloucestershire
1940

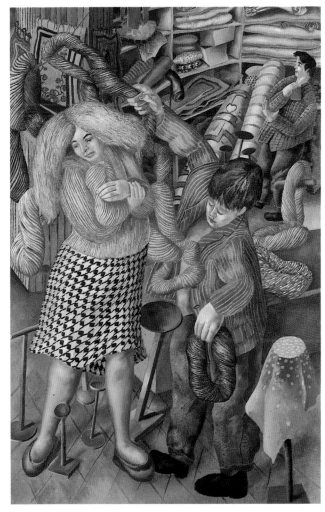

Cat. 287
The Woolshop
1939

paintings with their elaborate composition and obscure subject-matter. Moreover, there is no evidence that Dudley Tooth made any serious attempt to explain the paintings to the critics, indeed it was he who suggested the title 'Humanity', presumably to obscure the meaning which was more obviously stated in Spencer's own choice – *Love Among the Nations*. Spencer himself does not appear to have been interviewed by the critics, who probably remained ignorant of the *Church House* and the Cana theme linking the *Domestic Scenes*.

Other critics enlarged on the analogy to Hogarth and Ford Madox Brown: T.W. Earp felt that the *Domestic Scenes*:

> might be small-town conversation pieces were it not for the gesture and expression that the figures display. Their action is vested in a sense of looming crisis, and traced with such care, as though the incident itself, and not only its presentation, held some meaning for the artist . . . this quality is that he communicates his ardour and reveals what is ordinary attraction.[175]

While Earp's perceptive piece came close to identifying the central though hidden meaning in the series, Anthony Blunt, writing for the *Spectator*, sought to explain another aspect of the paintings – what he called their 'disagreeableness' – by invoking wider external influences: 'Except for a few unimportant canvases like *Laburnum* . . . the paintings at Tooth are rather disagreeable. But they are intensely serious and intensely real, and since at the moment serious reality [probably a reference to the rise of German fascism] is rather unpleasant, the disagreeableness of the paintings is inevitable.'[176]

Not surprisingly, there were also hostile critics of Spencer's work, although even the sharpest, in the August edition of *Apollo*, was prepared to admit that 'Stanley Spencer is a genius' if 'an abnormal one;'[177] a view whose latter part was to be resurrected in the press once more in 1950 by Sir Alfred Munnings (see Ch. 4).[178] Elsewhere more specific critical discussion centred on Spencer's figure style (one of the main centres of debate in the Academy dispute the previous year), and the modest distortions of form which occurred in the *Domestic Scenes* and 'Humanity'. *Cavalcade*, for example, in an article entitled 'Spencerisms'

commented: 'In these pictures a cartoonist could raise equal mirth with a black line. Spencer adds brilliant colour, to animate the cartoon and to establish the piquant grotesqueness of his figures.'[179] The *Daily Mail* reviewer was equally offended by the 'horrid articulated dolls,' while preferring the *Self-Portrait* (no. 25 in the exhibition), which also received general approval from the other reviewers.[180]

The success of the exhibition in terms of both sales and critical comment revealed Spencer's potential popularity as a painter not only of landscapes, but also of the more restrained figure paintings of the type represented by the *Domestic Scenes*. The favourable reception of the latter can be tied not only to their lack of distortion and more comprehensible imagery, but also to their general connections to the popular simplified realism of artists like William Roberts, and the smooth-surfaced 'modern' style of numerous Royal Academy exhibitors like Dod and Ernest Procter.[181] Dod Procter, in particular, had made a considerable reputation for herself at the Royal Academy, beginning in 1927 with *Morning* (Tate Gallery) which was named 'Painting of the Year' and purchased for the nation by the *Daily Mail*.[182] Her style was characterized by Anthony Bertram in 1929 as 'Rubens . . . modified by the Cubist vision,' a description which was not dissimilar to that used by the critics for Spencer's 1924-6 *Resurrection, Cookham*.[183] Unlike most of Spencer's work, however, Procter's compositions and subject-matter were usually traditional enough to avoid serious criticism. By 1936, Spencer was already too tied up with the ever-expanding *Church House* scheme, and his growing obsession with the power of sexuality, to consider conforming to a style which was readily acceptable in Academic or critical circles.

In retrospect it is evident that the 1936 exhibition was both a triumph for Dudley Tooth's hard-headed business sense and the result of Spencer's short-lived willingness to produce 'acceptable' pictures in the face of potential public objections to the more distorted and sexually explicit work. Unfortunately, Spencer's personal crises over the next few years prevented any repetition of the 1936 success, and it was not until the 1942 exhibition at the Leicester Galleries that he was

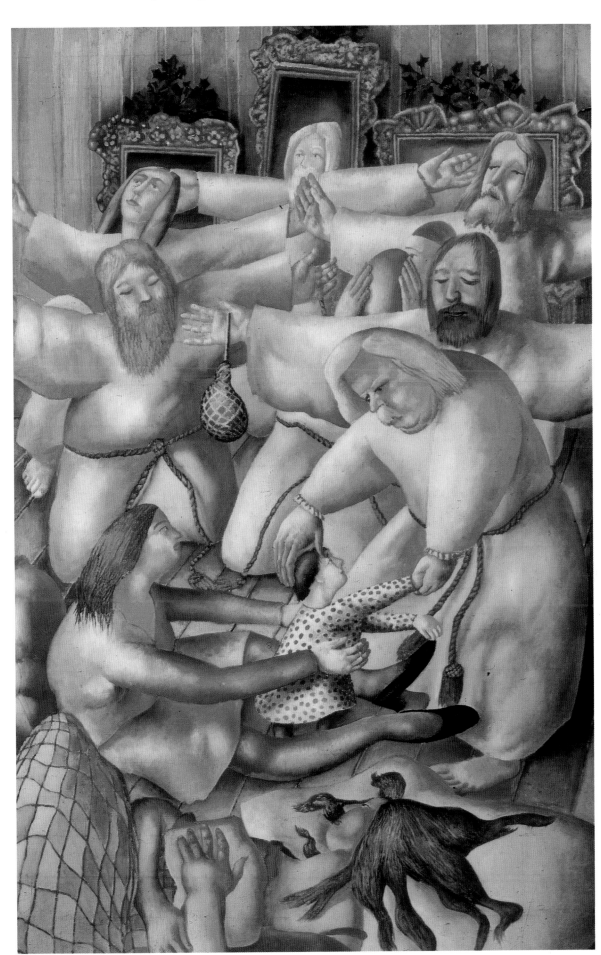

Cat. 298
**The Coming of the Wise
Men (The Nativity)**
1940

prepared to bring his work before the public again.[184] In the meantime he attempted to maintain a precarious – and often damaging – balance between the large-scale production of landscapes for easy sale, and figure paintings, which sold slowly, if at all, for the *Church House*.

Spencer did this in the face of strong pressure from Dudley Tooth who wanted him to exhibit work as frequently as possible. This resulted in several confrontations between the artist and his dealer, including one in December 1936, when Tooth made some harsh comments about Spencer's erratic attitude to exhibiting, and ended with an ultimatum calling on him to co-operate or face the consequences.[185] After this the dealer/artist relationship was somewhat smoother, although Spencer continued to tolerate dealers only out of necessity, complaining in 1940 that: 'A dealer is a kind of undertaker who wafts my work from me,' adding, 'I wish I had never let any work of mine out of my hands.'[186] Spencer's resistance to the idea of exhibiting his paintings as widely and as frequently as possible was clearly one of the reasons why his work tended to slip out of the public eye after the successes of the 1927 Goupil exhibition, the publicity surrounding Burghclere, and the 1934 Royal Academy showing. For some artists this reluctance might have seemed to be a form of professional suicide, but Spencer was not just being awkward, and from his comments it is evident that he was engaged in a desperate battle to preserve something of his imaginative equilibrium – in the face of the not inconsiderable commercial demands placed on him by Tooth, and his own financial difficulties.[187]

Spencer left Cookham in October 1938, staying at first with John and Elizabeth Rothenstein at 5 Fellows Road, Swiss Cottage, before moving into a rented room a short distance away at 188 Adelaide Road.[188] By this time he was badly depressed and probably on the verge of a nervous breakdown. Faced with the failure of his second marriage, and the unsaleability of the *Adoration* and *Beatitudes* pictures, Spencer chose to go into retreat.[189] During his stay he produced the *Christ in the Wilderness* series (283), inspired by quotations from the New Testament.

In the *Wilderness* paintings, Spencer temporarily abandoned the emphasis on

sexuality which had dominated the work of the previous seven years, and returned once more to the religious subject-matter of the early 1920s paintings. Gormley (pp. 41-2) saw this as Spencer's 'final admission' that he was unable to unite the religious and secular elements in his art, but he was able to make further, if less extreme, attempts in later paintings, based on the *Scrapbook* drawings begun in 1939-40 (287).

Spencer was happiest on his own surrounded by the imaginary world of his art and writings, and his stay at Adelaide Road provided a form of self-therapy which broke the tension of his recent existence in Cookham. 'After sweeping the floor and dusting a bit,' he wrote, 'I would sit down on one of the two chairs and look at the floor. Oh, the joy of just that.'[190] Within this context the *Wilderness* paintings show Spencer seeking to re-establish, through Christ, his belief in man's oneness with the world. Christ is presented as if he were 'a pebble' or 'both sides of a mountain;' and the form of his body and clothing often merges delicately with the shape of the ground, as in *Rising from Sleep in the Morning* (283e), where the composition assumes the shape of a lotus blossom. In other works, like *The Foxes Have Holes* (283a) or *The Eagles* (283g), Christ associates with wild animals in the same way that men,[191] beasts and gods mingle in Hindu and Buddhist temple sculpture.[192]

Spencer clearly took great pleasure in his isolated life in Adelaide Road, and there is a strong sense that he closely identified with Christ's own experience in the wilderness. Writing in his notebook in December 1938, he sounded very much like a Christian or Hindu hermit experiencing the joy brought about by contemplative isolation: 'O that I could write only and solely of this moment in this room this afternoon. It would suit me if I felt able to never stir again from just what I am doing now. All that I have been and done before I came to live here, would be an intrusion.'[193]

In 1940 Spencer painted *The Coming of the Wise Men* (298) which, together with *The Woolshop* (287) and *Village Life, Gloucestershire* (292), indicated a slight shift away from the extreme tensions of his earlier work towards a calmer, less sexually charged atmosphere. While the painting still belongs to *The Last Day* or *Last Judgement* scheme for the *Church House*, it also looks back to Spencer's family experiences

Cat. 324
Gardening
1945

Cat. 328a
Caulking
1940

Cat. 328i
**Shipbuilding on the Clyde:
Furnaces**
1946

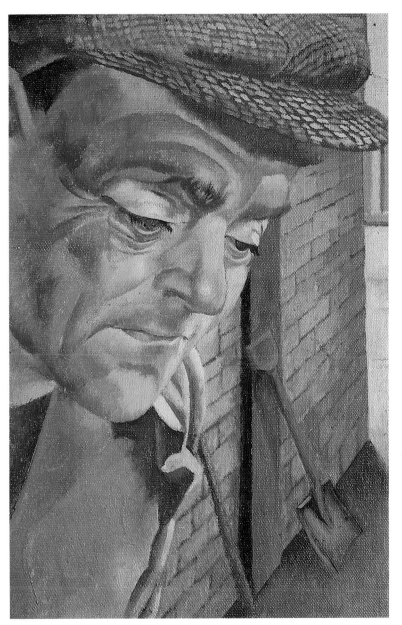

Cat. 328j
The Furnace Man
c.1945-50

was delighted to find precisely the kind of atmosphere of homeliness and activity which best suited his temperament. 'People generally make a home for themselves,' he wrote, 'wherever they are, and whatever their work, which enables the important human element to reach into and pervade in the form of mysterious atmospheres . . . the most ordinary procedures of work and place.'[194]

Typically, Spencer chose to paint a large commemorative series of pictures of the shipyards (328) rather than the smaller individual works envisaged by the WAAC. 'I like the theme to be continuous,' he told Dickey, the official in charge of the war artists, 'and not absolutely cut off by item, as the continuous character helps to preserve the impressions one gets in the shipyard itself by wandering about among the varied happenings.' Instead of depicting the more dramatic moments at a shipyard, such as launchings and their attendant ceremonies, Spencer showed the crowded everyday events of shipbuilding with men working under the vessels, keels, and in the surrounding workshops. In each case (e.g. 328b), the communal activities of the workers are mixed with the individual, and some men are shown absorbed in their own tasks of welding or painting; while others are drawn together around the large abstract shapes of metal plates (328b, c, f), like the disciples at some extraordinary Last Supper.

In the earlier paintings (328a, b) Spencer showed his subjects viewed from above and isolated by the geometric shapes created by the parts of the ship, the masts, bilges, keel plates or ventilators. This effect is reduced in the later works (328f, g, h), by a diminution in the scale of the figures, and by the proliferation in the numbers of objects which crowd every available space on the canvas.

in Cookham and a less turbulent time in his life before the personal crises of the thirties. The painting therefore suggests not only the artist's more relaxed state of mind in 1940, but also a conscious attempt to revive the clarity of his earlier artistic vision through reference to a childhood memory. In one sense the painting, a Nativity scene, is probably also symbolic of Spencer's own wish to bring about a new era in his own life and work after his period of exile at 188 Adelaide Road.

By the end of 1939 Spencer had recovered his equilibrium enough to accept a commission from the War Artists' Advisory Committee (WAAC), obtained for him by Dudley Tooth, to paint a series of pictures of shipyards in Scotland. On visiting Lithgow's yards in Port Glasgow in May 1940, Spencer

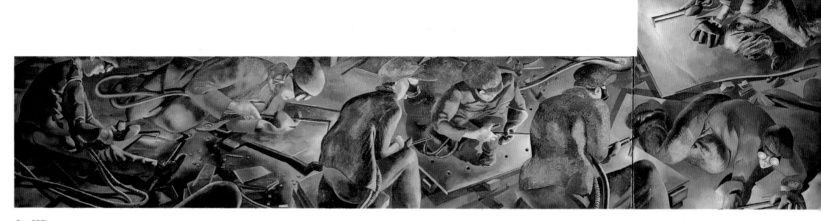

Cat. 328b
Shipbuilding on the Clyde:
Burners
1940

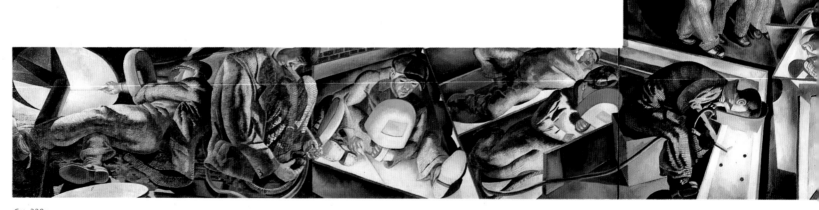

Cat. 328c
Shipbuilding on the Clyde:
Welders
1941

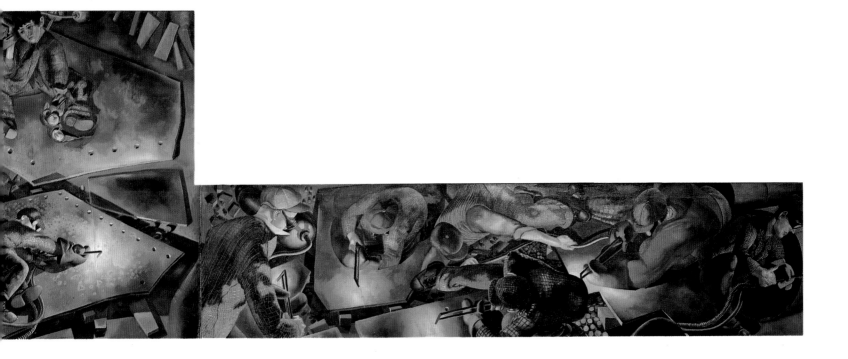

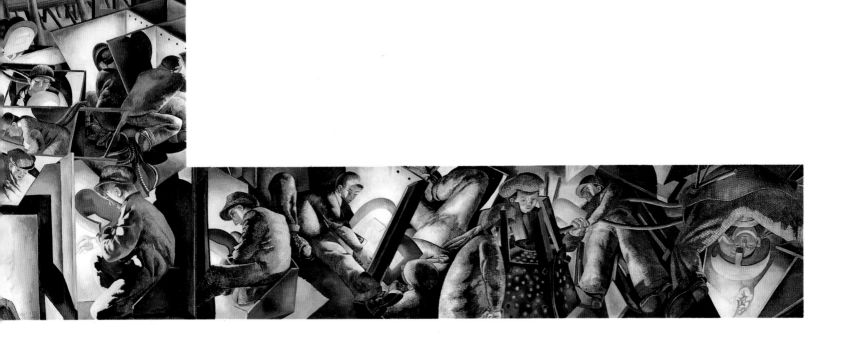

Cat. 328c
**Shipbuilding on the Clyde:
Welders**
(detail of right-hand section)
1941

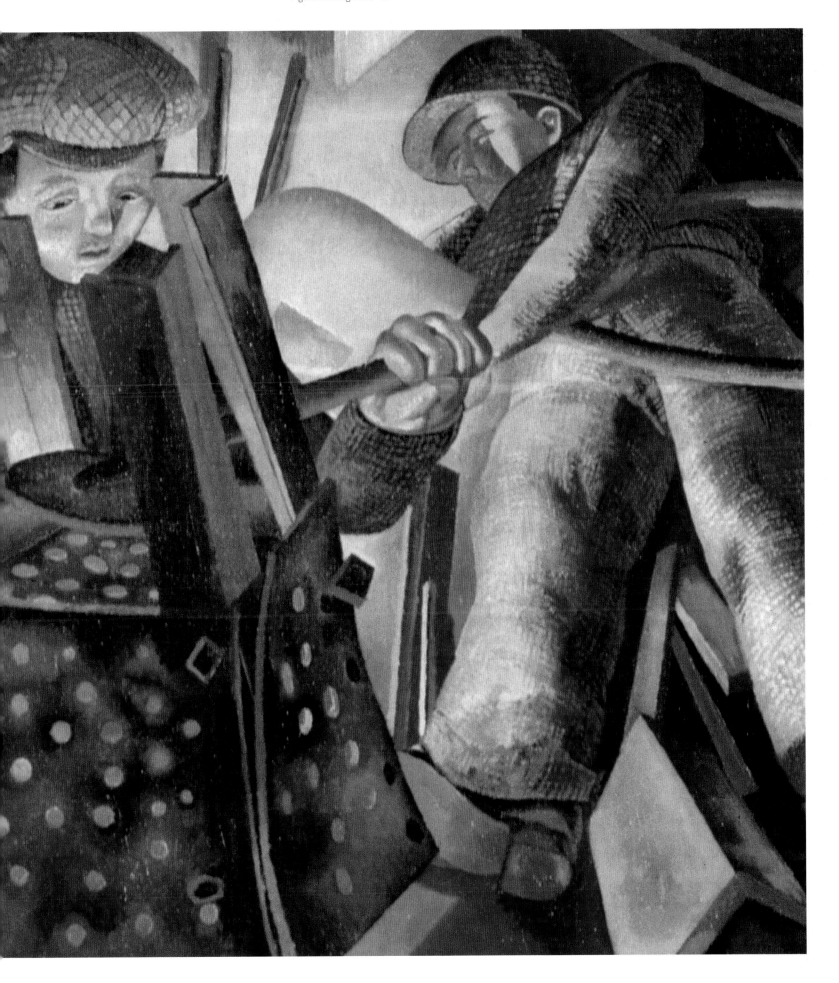

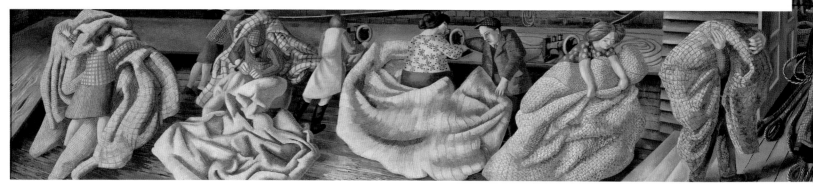

Cat. 328g
Shipbuilding on the Clyde:
Riggers
1943

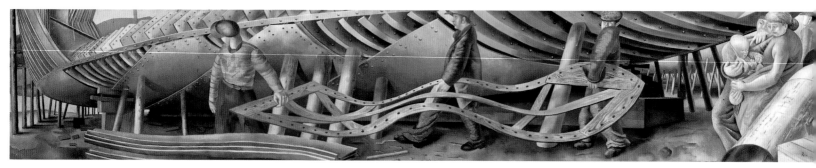

Cat. 328e
Shipbuilding on the Clyde:
The Template
1942

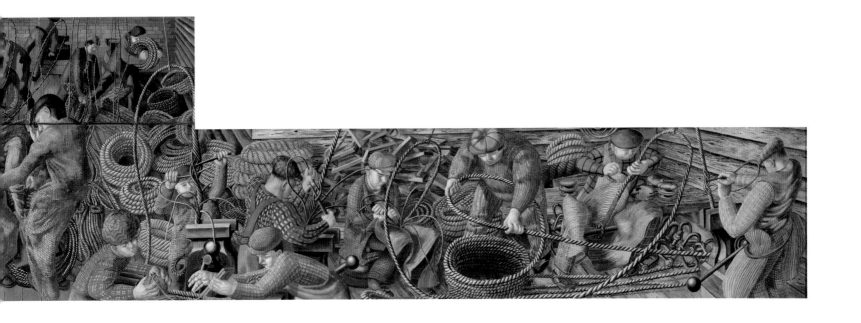

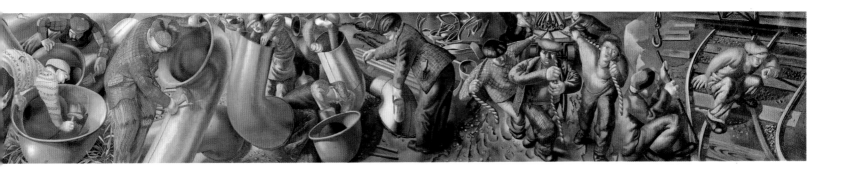

overleaf

(left) Cat. 328g *(right) Cat. 328e*
Shipbuilders on the Clyde: **Shipbuilders on the Clyde:**
Riggers **The Template**
(detail of central section) 1943 (detail) 1942

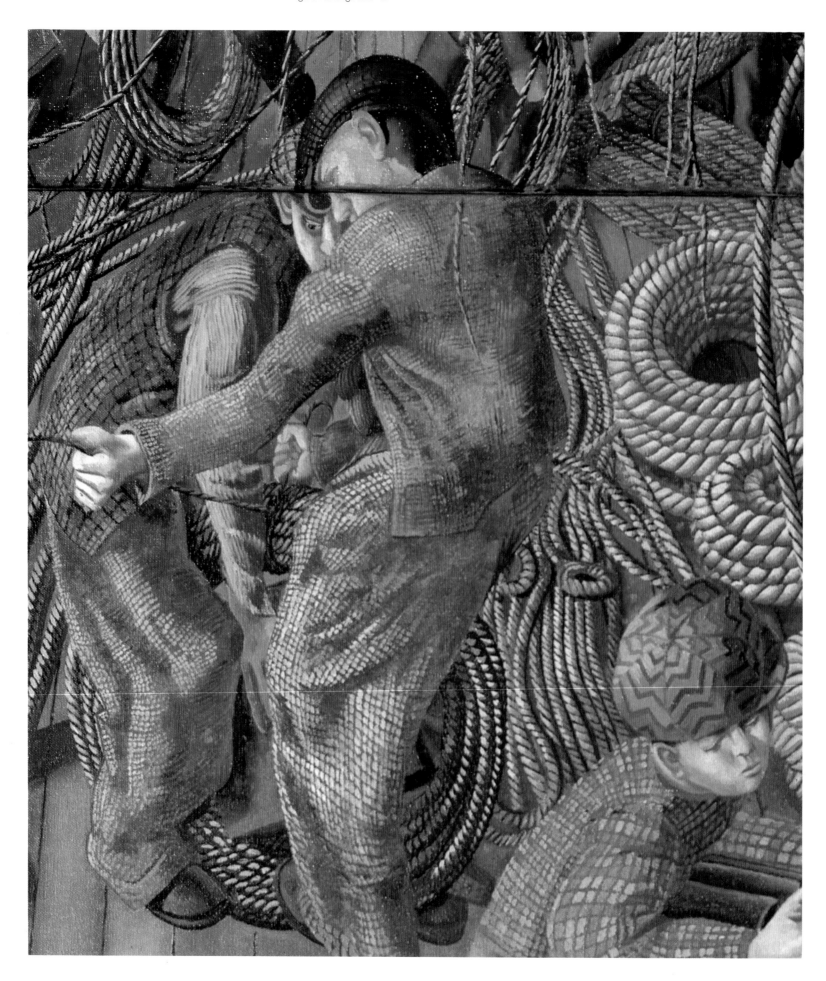

Cat. 328h
Shipbuilding on the Clyde:
Plumbers
1944-5

Cat. 328d
Shipbuilding on the Clyde:
Riveters
1941

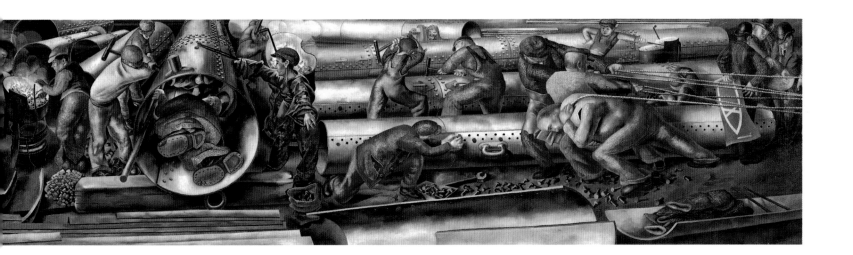

Cat. 328d
**Shipbuilding on the Clyde:
Riveters**
(detail) 1941

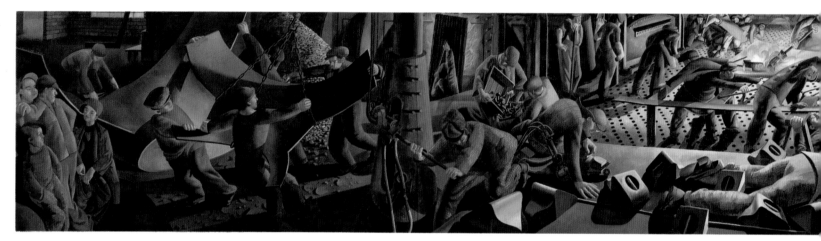

Cat. 328f
Shipbuilding on the Clyde:
Bending the Keel Plate
1943

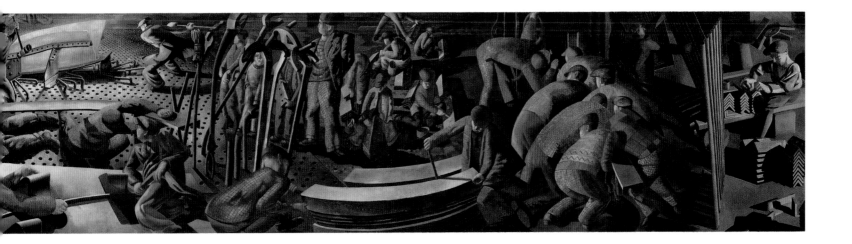

overleaf

Cat. 328f
**Shipbuilders on the Clyde:
Bending the Keel Plate**
(detail) 1943

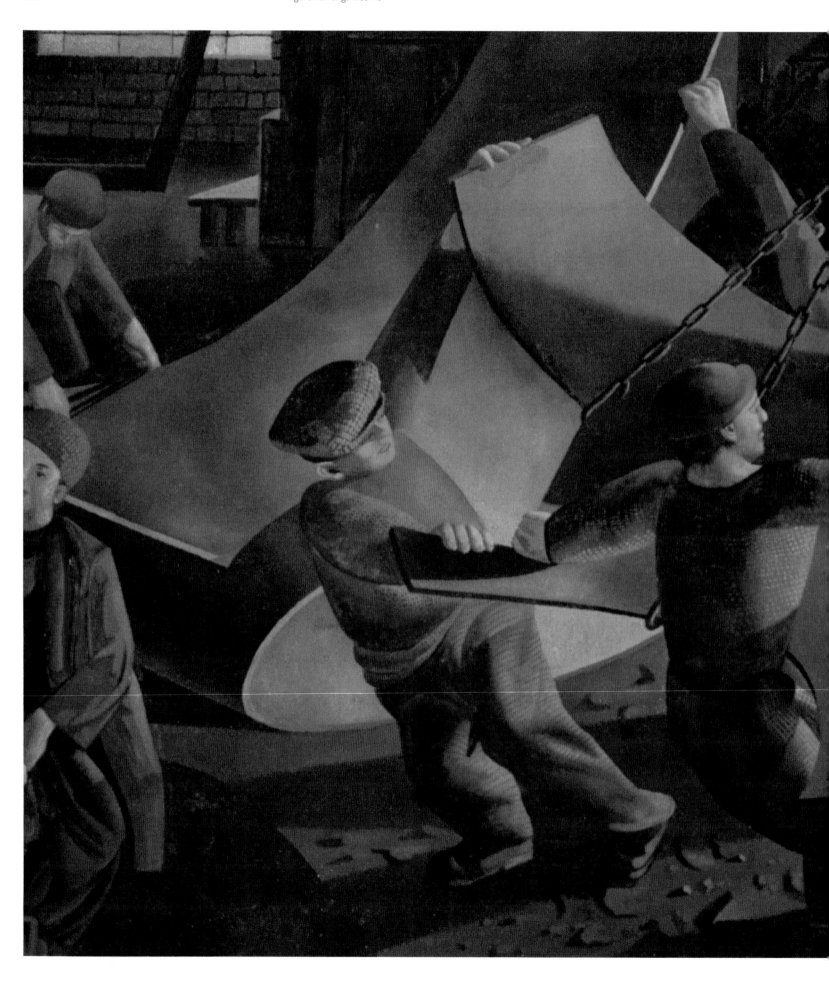

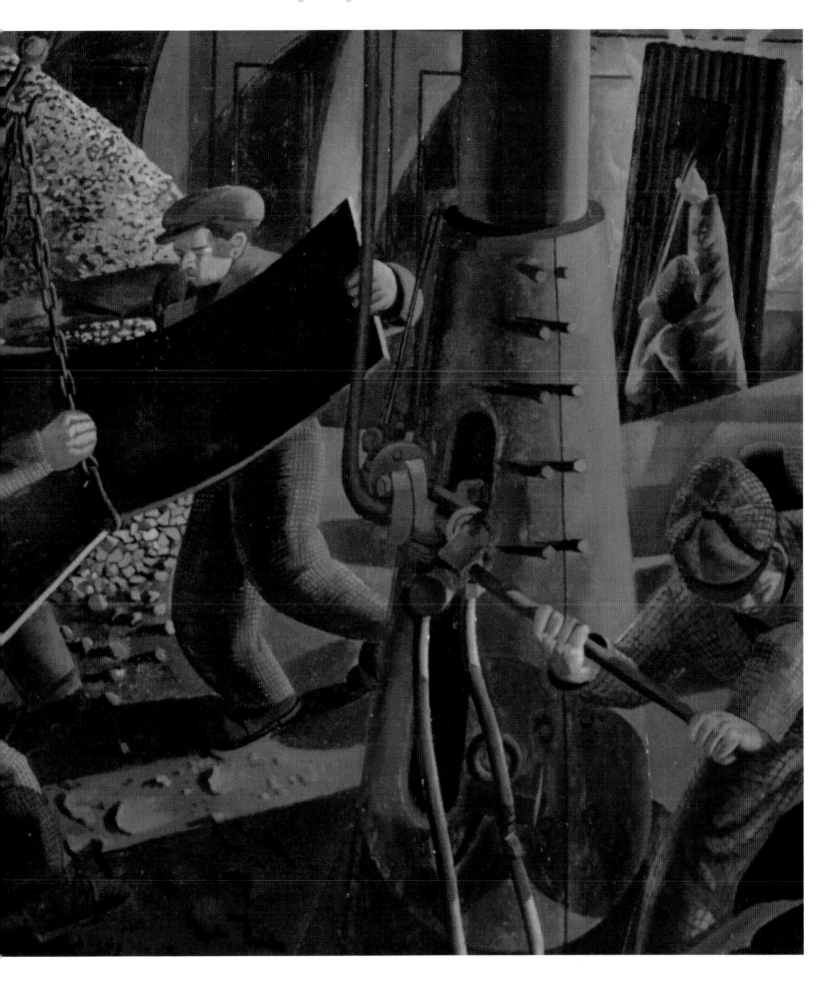

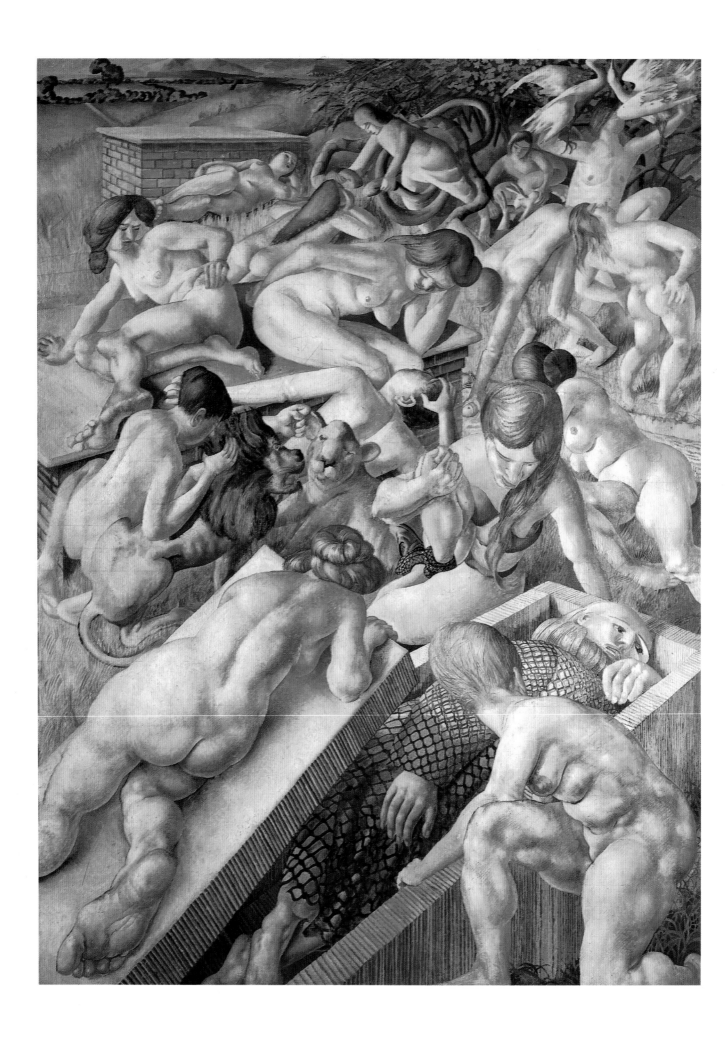

Figure Paintings 1946-59

Spencer's position at the end of the war was very different from his isolated situation six years before at Adelaide Road. The success of the *Shipbuilding* series, which had been exhibited and publicized widely, finally re-established his reputation, which had declined so abruptly after the Royal Academy fiasco of 1935.[1] Moreover, his earlier overriding concern with overt sexual imagery was now more relaxed, and again firmly placed within the religious context of new series like the *Port Glasgow Resurrection* paintings begun in 1944-5.

These developments were probably due, at least in part, to the strong sense of community life that he had found in the Port Glasgow shipyard workers' homes, and which replaced his disintegrated pre-war dream of an ideal life in Cookham. His friendship with the Jungian psychoanalyst, Dr Karl Abenheimer, whom he met at Graham Murray's flat in Glasgow, also helped him solve some of his more intractable personal difficulties.[2] According to Murray, Spencer was in a poor psychological state when they first met in Glasgow, and the artist agreed to undergo analysis with Abenheimer, as well as providing him with a brief jumbled written statement of his feelings. When Spencer returned to Cookham, another psychoanalyst, a friend of Abenheimer's who lived in the village, also helped him. Later, Charlotte Murray introduced Spencer to a London psychiatrist, Dr Israel, who subsequently saw him professionally from

time to time until his death in 1959. According to Murray these sessions considerably alleviated Spencer's problems (particularly the sexual ones), and were an important contributing factor to his post-war emotional well-being.

The new, less controversial paintings which resulted promised to be more readily saleable, and this, combined with the skilful promotion and financial management of Dudley Tooth, gradually provided a new economic security which Spencer had not seen since the early thirties.[3] However, it is undeniable that while the stream of ideas for new painting series continued unabated, the quality of execution in the new pictures was sometimes below that of much of his pre-war painting: the paint surface is often flat and mechanical, the figures bland and anonymous and their gestures repetitive and rhetorical. This was partly because Spencer constantly expanded projects and set himself impossible goals.[4] By 1945 he had lost much of his former enthusiasm for the act of painting itself: instead he expressed a preference for writing about his work.[5] Finally, his growing popularity led to constant requests for portrait and landscape commissions, surprisingly few of which he was prepared to turn down, even when they interfered with his major figurative work.[6]

The first product of Spencer's new peace of mind, *The Resurrection, Port Glasgow* series (358) was conceived and mainly drawn in Glasgow during the war, as part of the *Scrapbook* studies, which also provided compositions for

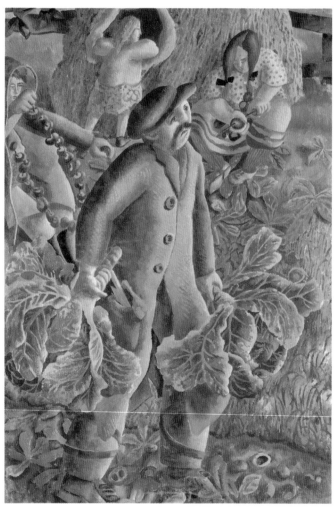

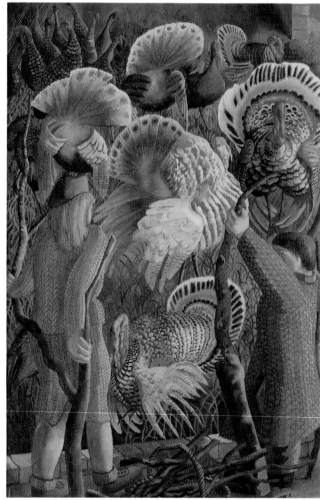

Cat. 347
Chestnuts
1949(?)

Cat. 332
Turkeys
1946

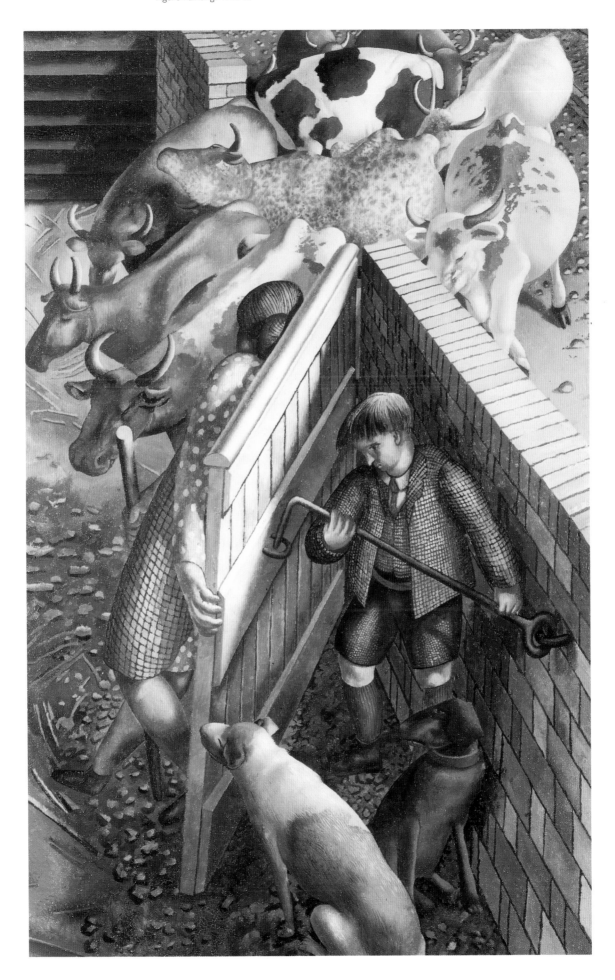

Cat. 352
The Farm Gate
1950

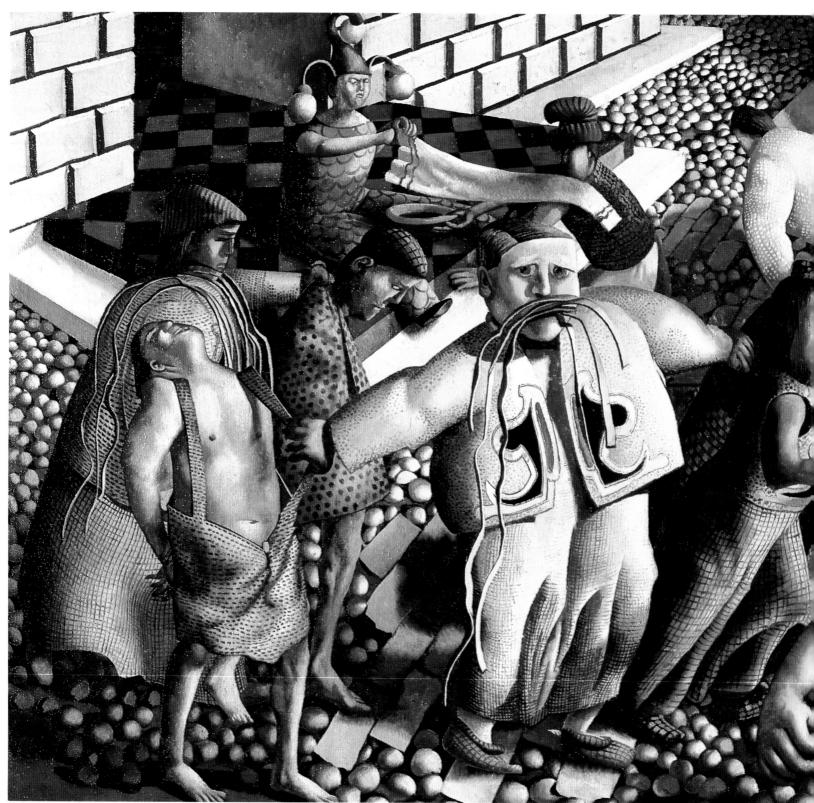

Cat. 356
Christ Delivered to the People
1950

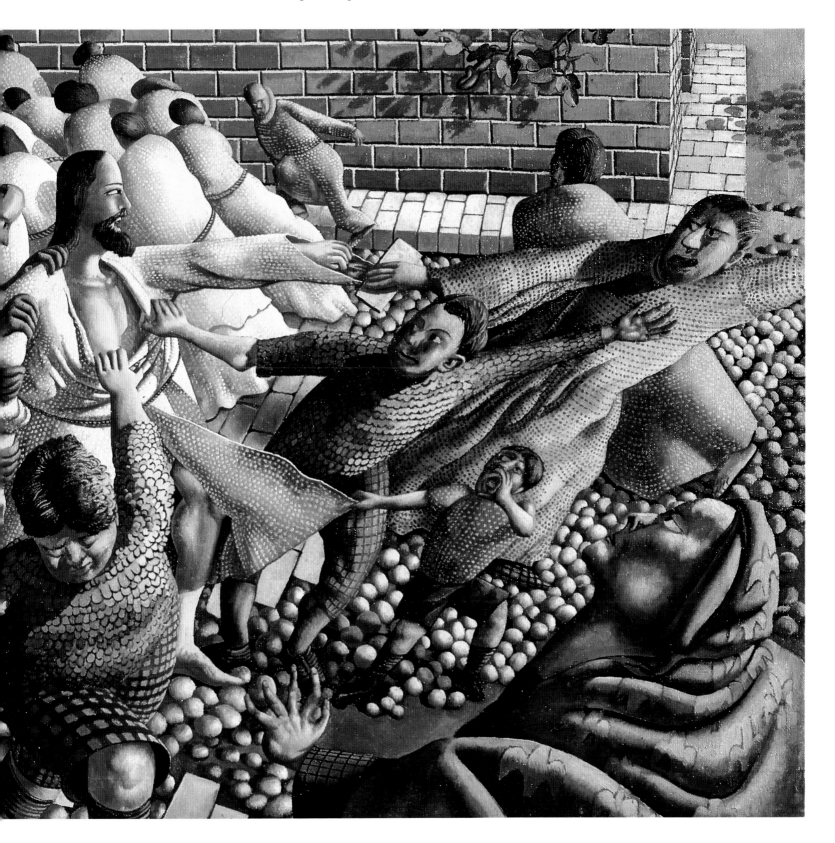

numerous other paintings during the fifties. Characteristically, the original idea was for a vast 15-metre-long canvas, but logistical difficulties forced a compromise in which the composition was broken down into a number of smaller parts with *The Resurrection, Port Glasgow* (358i), *The Hill of Zion* (358e) and *Angels of the Apocalypse* (358h) forming a loosely related group which retained some of the scale (7 metres) of the original conception.[7]

The series marked a return to the theme of the 1926 *Resurrection, Cookham*, with the hilltop cemetery above Port Glasgow replacing the village churchyard as the scene of the Second Coming. Spencer had discovered the site on his night-time rambles through the town, and immediately identified with the atmosphere of spiritual calm which he found similar to the graveyard in Cookham. As he wrote, 'there is an unidentified not-yet-come-to-earth-Port-Glasgow epitomising something I hope to find and arrive at . . .'[8] Clearly, Spencer's childhood fascination with being able to leave his home (and now his lodgings at Glencairn) and in a few steps arrive in an other-worldly atmosphere had not left him.

Spencer's ambitious scheme for the *Resurrection* series resulted in a sharp exchange of letters with Dudley Tooth over the paintings' intended subject-matter. This correspondence throws an interesting light on the way Tooth attempted to manipulate Spencer's output, while the artist, for his part, produced a lengthy defence of his approach to imaginative figure painting.

The discussion was prompted by a number of letters written by Spencer between May and October 1944 from his lodgings, in which he described the series in considerable detail.[9] In one of these he also asked Tooth not to exhibit any of the paintings until the series was completed, thereby discounting the possibility that they could be sold quickly.[10] By late November, Tooth, apparently alarmed by the growing size of the scheme, and probably fearing that Spencer was embarking on another unsaleable figure series, wrote to Spencer outlining his concerns:

Whether [you paint] one large three feet high by forty feet long or five separate pictures, unless you eliminate the 'elements

Cat. 358e
The Resurrection: The Hill of Zion
1946

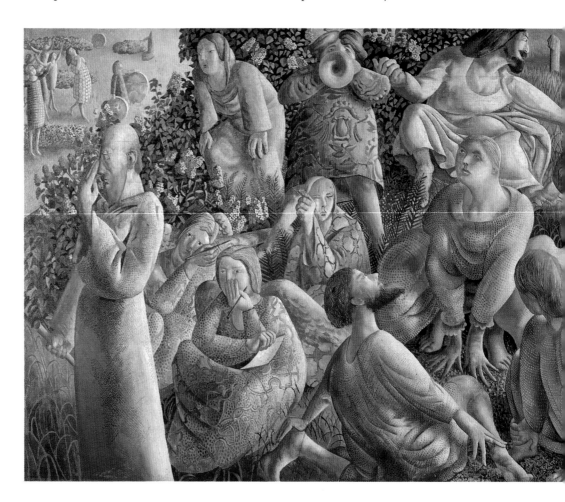

which people object to' in your recent work, I can see little hope of the pictures helping to reduce your debts. May I see the compositions before you start to paint? If you would paint religious pictures without any element of sex creeping in, I would rather have them than landscapes. There was nothing to offend people in the 'Christ in the Wilderness' series. However you must do what your inner feelings dictate.[11]

Tooth was writing in response to a long letter written on 27 October 1944, in which Spencer expressed his apprehension over the form the new series might take:[12]

I can give no guarantee [Spencer wrote] and scarcely any hope that I could or would do a figure picture that would meet with the kind of approval . . . that was accorded to my early religious paintings. There is something in my figure pictures religious ones as well that I do nowadays that seems to put people off. Personally I love these pictures and I am only mentioning something I have observed in other people's feelings . . . I sold only those Wilderness paintings at the 1942 [Leicester Galleries] show I had. I think *all* the other figure paintings were unsold and all the compositions [drawings] were unsold. In 1938 I had to paint 31 landscapes, with my best foot forward in each one.

He went on to explain that his various *Resurrection* paintings were the product of his 'associations' with the places and people he had encountered during his life. In the case of the Port Glasgow paintings, however, he identified a new difficulty:

The 'trouble' in this last one is that as it is a more 'personal' Resurrection subject, and naturally includes a lot of my varied feelings and wishes, I am so afraid that as there has been already shown such a dislike . . . for the figure pictures I have done since 1937 that herein also . . . in these pictures . . . [they] might see or find things of like nature that they disliked for some reason.

Spencer ended on a falteringly belligerent note:

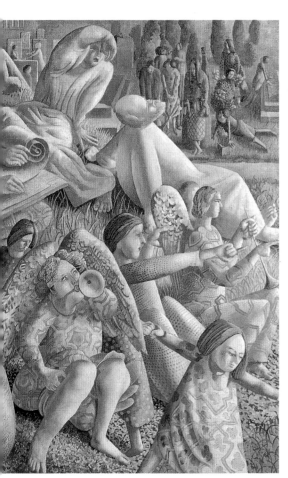

Cat. 358h
Angels of the Apocalypse
1949

Cat. 358d
The Resurrection:
Reunion
1945

'I don't bother about peoples likes . . . but without this explanation you might be supposing that if I do a religious . . . picture that there will in consequence be an elimination of what people are objecting to in my work.'

It was almost certainly Spencer's evident nervousness over the reception of the new *Resurrection* paintings which persuaded Tooth to make a serious effort to persuade him to reduce the awkward aspects of his works along the lines of the *Christ in the Wilderness* series. In this sense Tooth's letter of 27 November is a splendid example of a dealer working with a 'difficult' artist: presenting Spencer with all the attendant problems of his proposed course of action, but still leaving him with the possibility of following his 'inner feelings' – and their possible consequences.

Unfortunately, there is little direct evidence to show how Spencer responded to Tooth's letter. However, by 27 January 1945 he had shown his dealer some drawing studies for the series, and Tooth encouraged him to continue working on them: 'I am sure that they will be much wanted and appreciated and I am looking forward to seeing the first two or three canvases.'[13]

An examination of the *Resurrection* paintings also indicates that Spencer clearly avoided any overt sexual references in the series, as well as the uncomfortable distortions which made the characters in the *Beatitudes of Love* so 'ugly.' Moreover, although Spencer had called the compositions 'more personal,' there are few direct references to his intimate friends in the paintings, with the exception of *The Resurrection, Port Glasgow*, where he and Hilda kneel in the middle, and Charlotte Murray (his Glasgow friend) is helped out of a large grave on the right; Spencer and Hilda are also shown embracing in *Reunion* (358d). None of these characters is mentioned by name in Spencer's commentary written for Wilenski's book on the series, and the personal references remained as a strictly private iconography for the artist and his closest friends.[14]

The tendency towards anonymity in Spencer's paintings has already been noted in the multiple-figure pictures of the thirties like *Promenade of Women*. In the *Resurrection* series, Spencer continued this development, replacing the recognizable characters of *The Resurrection, Cookham*, with odd-looking people who demonstrate their emotions using extravagant gestures reminiscent of an over-elaborate Italian Quattrocento deposition: 'children squat and hold onto the railing . . . a husband greets his wife,'[15] a 'still living mother'[16] welcomes her newly resurrected child, and others raise their arms rhythmically in celebration or stretch them out to yawn. This effect was further emphasized by the puppet-like spherical heads (they look like Raggedy Annes) and tubby bodies of the figures, particularly in *The Resurrection, Port Glasgow*. Such stylized repetition of gesture and form again owes something to Spencer's interest in Indian temple sculpture, where figures also enact ritual movements in a religious context.

In 1944 Spencer explained to Dudley Tooth that 'the main trend' in the series was 'towards expressing the fulfillment and realization of this present lives [sic] hopes and wishes. This causes the joy expressed at the Resurrection to be something felt and shared between the resurrecting people and shown in their meeting again.'[17] This he contrasted with *The Resurrection, Cookham*, where, 'the governing factor was the resurrected ones consciousness of God. So they stand or lie or sit about in that state of mixed peace and wonder.'

When the paintings were exhibited at the Royal Academy the critics also attacked the *Resurrection* paintings for weaknesses in both colour and design. Here the main target was *The Resurrection, Port Glasgow* (358i) with its rather obvious symmetry and odd, lumpy figures, whose clothing was derived from knitwear and fashion advertisements.[18] In the 1926 *Resurrection* Spencer had employed an elevated viewpoint to provide a comfortable and uncluttered setting for the Resurrection to take place. This device is repeated in the *Port Glasgow* version, but now the landscape background is eliminated, and the resulting shallow space is packed with figures whose activities are as repetitive as the commentary which Spencer wrote to accompany the illustrations in Wilenski's book on the *Port Glasgow* series. The colour in *The Resurrection, Port Glasgow* and *The Hill of Zion* (358e) also has a pale, greenish-grey over-all tinge which lacks the richness of the 1926 *Resurrection*, and contributes to a crowded airless impression, particularly on the larger canvas. Absent, too, is the obvious pleasure with which Spencer handled paint in his earlier works, and the picture surface is uniformly flat and evenly brushed.

The artist seated in front of
The Resurrection, Port Glasgow
(358i), c.1950

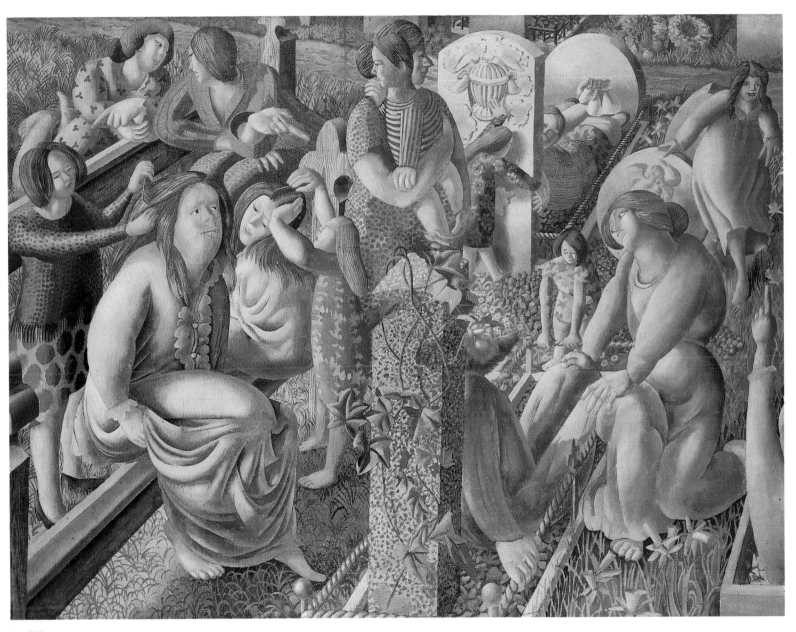

Cat. 358a
**The Resurrection:
Tidying**
1945

In the smaller *Resurrection* paintings most of these problems are less apparent, although criticism has tended to bracket them with *The Resurrection, Port Glasgow*, probably because its presence in the Tate Gallery makes it the most accessible of the series. The compositions are taken from the beautiful *Scrapbook* drawings, and retain a coherence through the parallel lines of gravestones and converging paths which is absent from the more scattered grouping of the big painting. The action is also less frantic, and some of the old sense of calm and pleasure found in Spencer's earlier compositions reappears in paintings like *Tidying* (358a) and *Waking Up* (358c) with their languid figures disposed comfortably on a Pre-Raphaelite carpet of flowers or autumn leaves.

Colour, too, is more intense, with the dense herbage creating a brightly coloured backdrop against which the resurrecting figures are set as in a Renaissance tapestry.[19] Evidently Spencer lavished more care on these smaller paintings, which undoubtedly benefited from the highly finished state of the *Scrapbook* drawings. *The Resurrection, Port Glasgow*, on the other hand, he had first been forced to mutilate into three separate parts, and then later to augment with an extra section while the canvas was partly painted.

In looking at the Port Glasgow *Resurrection* paintings as a series it becomes apparent that they do not work when hung together, a point driven home by the 1980 exhibition at the Royal Academy. The clumsy triple-tier

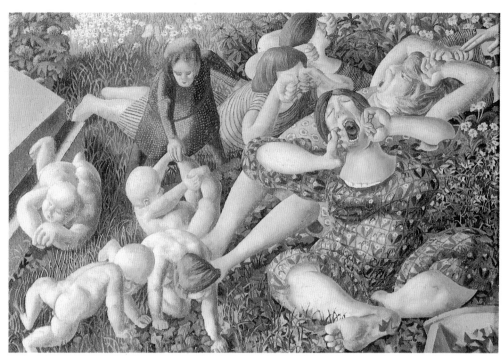

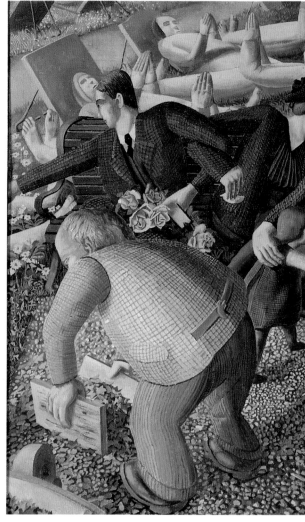

Cat. 358c
The Resurrection:
Waking up
1945

'wedding cake' conception of *The Resurrection, Port Glasgow*, *Hill of Zion*, and *Angels of the Apocalypse* (358h) failed because Spencer 'lost heart' over their disjointed appearance;[20] while the smaller paintings, with the exception of *The Resurrection with the Raising of Jairus's Daughter* (358g), simply repeat the Resurrection theme with some minor thematic variations. Viewed separately, however, these small, comparatively intimate works do seem to show Spencer making a serious effort to continue with the revived qualities of colour and composition he had re-established in the best of the *Shipbuilding* paintings.

Spencer's completion of the last *Resurrection* paintings in 1950 coincided with his return to the Royal Academy, where he was elected RA, as well as being created a CBE in the New Year's honours list. His reinstatement to the Academy, apparently at his own request, once again indicates the equilibrium which had returned to his life since the end of the war.[21]

More importantly, it was a reaffirmation of his essentially conservative position on matters of modern art. While the critical reception for Spencer's first showing of paintings at the Royal Academy Summer Exhibition, and his concurrent one-man exhibition at Tooth's, was divided in its opinions, his public popularity, and subsequently his sales, increased rapidly. This success was assured by Tooth's skilful promotion of his work, and by the large number of middle-class collectors – particularly in the Cookham-Maidenhead area – who created a healthy demand for his portraits, landscapes and even the larger figure paintings. This group, which included families like the Shiels, the Martineaus and the Metzs (as well as the patronage of Lord Astor, then living at Cliveden), was essentially conservative in taste, and took pleasure in the idea of patronizing an artist[22] whose distinctly 'local' flavour was fully in accordance with their own particular conception of English rural life.[23]

atmosphere, and the critical reception of his work recalled the enthusiasm of his Academy showing in 1934. W.T. Oliver of the *Yorkshire Post* even went so far as to call it 'Mr Spencer's year . . .';[25] while the *Daily Mirror* ('Man with Tombs returns in triumph'),[26] and the *Morning Advertiser* ('"Rebel" RA attracts the crowds')[27] recalled the controversial nature of Spencer's career. It was also a good financial year for exhibitors at the Summer Exhibition, and the *Evening Standard* for August, under the headline 'Painters sell more,' reported that Spencer was the 'best seller' with total sales of £3750 from four pictures, £2000 of which was for *The Resurrection, Port Glasgow*, purchased by the Tate Gallery.[28]

Spencer's controversial work clearly made good copy and there were numerous interviews accompanied by photographs of the artist scattered throughout the press.[29] However, there were plenty of serious reviews as well, which provide the first major critical assessment of Spencer's work since his 1936 one-man exhibition at Tooth's. For the most part these comments were favourable, with the *Daily Telegraph* critic calling *The Resurrection, Port Glasgow* the 'Picture of the Year,'[30] and H. Swaffer of the *Daily Herald*, writing under the heading 'Artist Triumphs after 15 years,' concluding his piece with the ringing declaration − 'indeed it is his year.'[31] The *Guardian* critic was also impressed by 'the tremendous singleness of purpose which is Stanley Spencer's greatest gift.'[32]

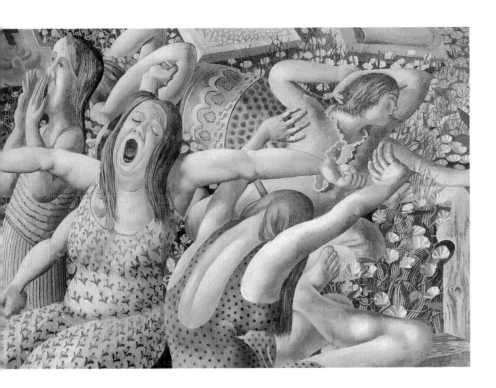

During the 1950s, Spencer rarely had problems selling his work to this market, and the numerous paintings which Tooth sent to the Academy summer shows were almost invariably bought at the exhibition.

Spencer's return to the Royal Academy in 1950 was one sign of the gradual liberalization of that institution which took place under the new President Sir Gerald Kelly, who had replaced the arch-traditionalist Sir Alfred Munnings when he retired the previous year. Apart from the extensive press commentary on Spencer's own work at the 1950 Summer Exhibition, a number of critics noted with pleasure the more open attitude of the Academy that year; most seeming to agree with the critic of the *Guardian* that, in readmitting artists like Spencer and John, the '. . . Academy [is] beginning to move in the right way.'[24]

Undoubtedly Spencer's own return was an important contribution to this optimistic

Not unnaturally, most critical attention was reserved for the five big *Resurrection* paintings, and in particular *The Resurrection, Port Glasgow*, which invited comparison with the equally large *Resurrection, Cookham* (1924-6), hanging in the Tate Gallery. In keeping with the earlier press criticism of the twenties and thirties, most writers were impressed by the scale of Spencer's work, and the single-minded intensity of his approach to painting. The critic for the *Illustrated London News*, for example, felt that: 'There is no doubt that this important series of paintings, on which he has been engaged from 1945-50, will rouse great discussion and should be studied with attention.'[33] This opinion was repeated by W.T. Oliver in the *Yorkshire Post*, who felt that the *Resurrection* series 'lifts this year's exhibition on to a new plane from that of its recent predecessors.'[34] Oliver also returned to the

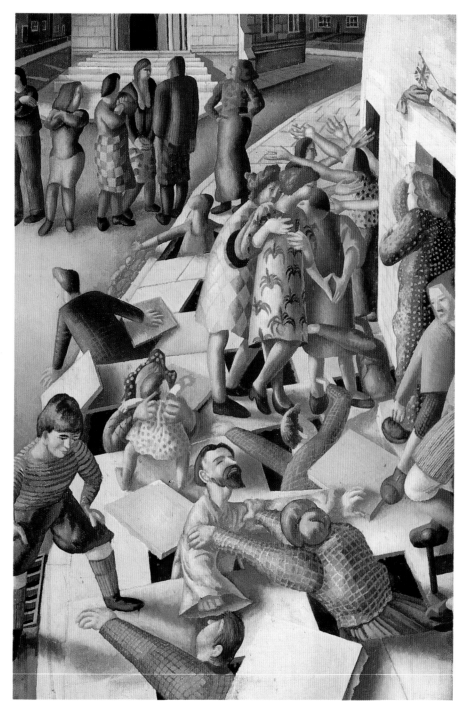

Cat. 358g
**The Resurrection with the
Raising of Jairus's Daughter**
1947

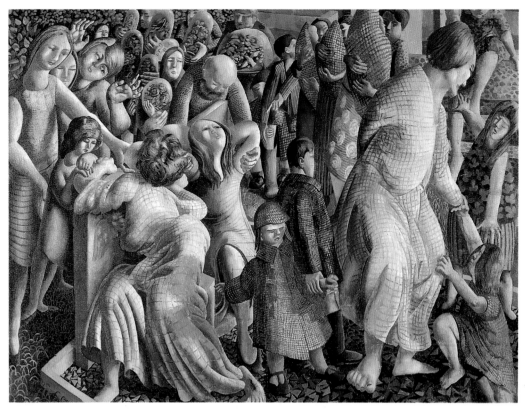

Cat. 358b
The Resurrection:
Reunion of Families
1945

fill an enormous canvas without giving the impression that a sketch has been enlarged. It has to be big in order to do justice to its context.[37]

Newton's article, coming as it did just over a week after the private view and the first reviews, may well have represented an attempt to defend Spencer's work against certain specific criticisms. As in 1935-6 several critics had found Spencer's expressive distortion and overcrowded canvases too extreme to be acceptable (see Ch. 3). *The Times* writer,[38] for example, found it 'impossible to find any focus or systematic emphasis in the picture [*The Resurrection*]'; while the *Morning Advertiser*[39] found it 'crowded,' and 'so unorthodox and so wildly fantastic an interpretation of so serious a subject,' that it 'may be found repellant [sic] as well as bewildering.' Indeed the *Advertiser's* critic found it 'a relief' to turn to Spencer's landscape *Garden Path, Cookham Rise* which was also hung in the exhibition.

Inevitably some writers looked back to *The Resurrection, Cookham*, both as a measure of the artist's current standing and a reference to the time when Spencer's paintings were relatively 'distortion' free. The verdict from the *Guardian* critic on no less than two occasions (29.4.50, 4.5.50) was that the 1926 work was 'the better picture.' This opinion was later repeated by Basil Taylor writing in the *New Statesman*[40] who found that '. . . the later work . . . grotesquely, if unconsciously parodies the earlier.' He went on to state his position:

often repeated theme of Spencer as eccentric outsider, commenting that: 'the force and conviction of these works spring from the wonderful simplicity of heart of the man who painted them. Stanley Spencer has the outlook of a genuine primitive . . .'[35]

This concept was given a slightly different twist by the *Sunday Times* critic who on 30 April called Spencer 'the last of the medieval artists,' thereby seeking to explain the isolated nature of his talent.

Among enthusiasts for Spencer's work the most eloquent was Eric Newton whose review in the *Sunday Times* set out to explain the merits of *The Resurrection, Port Glasgow* to 'the crowds who passed in front of it . . . [but] failed to realise that they were in the presence of a great work of art.'[36] Newton found the *Resurrection* paintings:

> . . . almost intolerably charged with visual detail and symbolic meaning.
>
> It is only when one realizes that this mass of detail is fused together by an intense emotional temperature that the pictures begin to be cumulatively impressive and one is forced to acknowledge that behind the naivete and the quaintness is an imaginative pressure more sustained than any other British artist. That is why he can

> Spencer never corrects nature's organic disorder with any constructive geometry. His portraits, drawings and paintings are uncomfortably physical, and at the same time empty of any sensuousness. Every accident of form and texture is followed and represented by a mealy paint, coldly handled, and every oddity becomes more intense, more important by reason of its literalism.

Taylor's opinion is generally representative of the critical objections to Spencer's work found in the 1950 press coverage of the Academy and Tooth exhibitions; although there were some writers who found the artist's approach to be very effective. A. Clutton Brock in *The Times*, for example, overcame his doubts and

declared: 'But the artist does undeniably succeed in communicating the excitement that the theme has so evidently aroused in his own mind . . . and he uses distortion very effectively in *Love Letters* [359] to make the spectator unavoidably and vividly conscious of the physical presence of two most unattractive figures.'[41]

Of all the critics who reappraised Spencer's art at this time, the most interesting was Spencer's contemporary, P. Wyndham Lewis, who wrote a carefully considered review for the *Listener* of 18 May 1950, in which he sought to sum up Spencer's career, as well as commenting on his 'Britishness' and the aspects of 'quaintness' and primitivism which had both attracted and repelled other critics:

> This is a great opportunity to discuss Spencer's art in general. His work could come from no country except Britain. No harm in that: but it is by no means the best work done here. That Spencer is not the Royal Academician's cup of tea must also be said . . . the typical contemporary painter finds it impossible to think so highly of this work, and his reasons may I think be fairly summarized as follows . . . Spencer, it is felt, is careless of paint. His painting is the negation of quality. It is quantitative. He is endlessly repetitive. One thinks that he could turn out a thousand figures as easily as a hundred . . . In his multi-figured composition the detail . . . is a convention poor in form, illustrational. The colour is drab . . . There is still his 'quaintness' to be considered. It is English art studentish: it is the diluted 'primitivism' of the school 'Sketch Club.' His naivety is painful, like the oppressive archness of a self-conscious little girl. For all this I respect Spencer. Were he to paint the figures in his compositions as carefully as his excellent Self-Portrait at Tooth's all would be well. He inhabits a different world from the potboiler. He has a visionary gift after all.

It is evident from this review that Lewis disliked Spencer's work and yet respected the skill and professionalism with which he approached the business of painting. In expressing a preference for the *Self-Portrait* (342) Lewis reiterated the widely held opinion that Spencer would be a better artist if he concentrated on working from life, as well as paying more attention to the handling of paint. There were, of course, questions which had been raised before, and there is no

Cat. 358f
The Resurrection: Rejoicing
1947

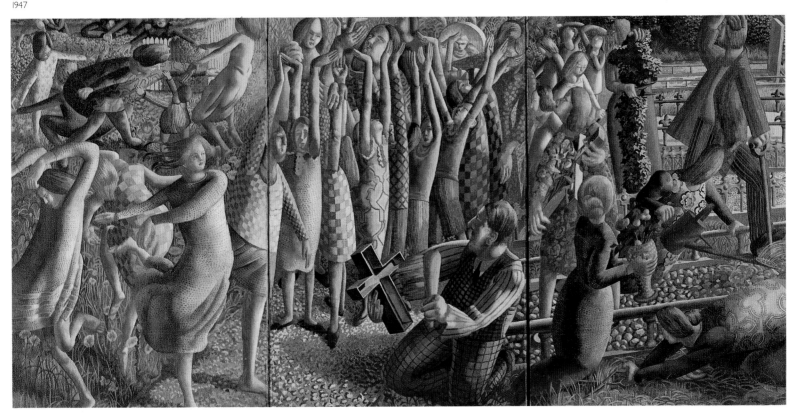

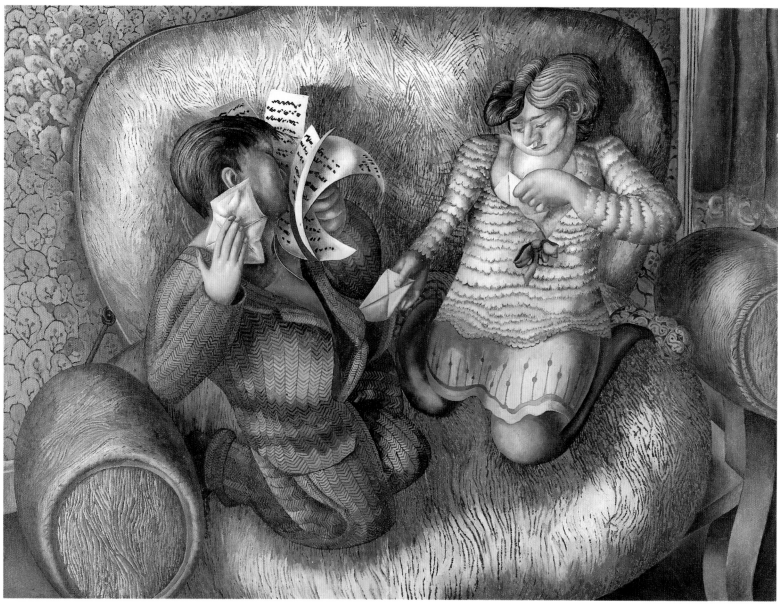

Cat. 359
Love Letters
1950

evidence that Spencer made any modifications as a consequence; or as a reaction to recent developments in contemporary art.

However, the reception of Spencer's work at Tooth's and the Royal Academy once again points to his awkward position – not a member of the avant-garde, yet not quite of the establishment either – despite the exhibitions and honours which came in considerable numbers between 1945 and his death.

This ambiguity – so perceptively identified by Wyndham Lewis – is similarly found in the public response to Spencer's work, where it can best be studied in the heated debate which appeared in the correspondence columns of the *Daily Telegraph* between July and September 1950, after the Chantrey Fund Committee

purchased *The Resurrection, Port Glasgow* for the Tate Gallery. The exchange was in part prompted by the ex-PRA Sir Alfred Munnings, who used the occasion to attack the 'hoodoo jargon' of Modernism, while challenging anyone 'to deny the fact that the so-called "Resurrection" picture is intentionally abnormal.'[42] Munnings compared the painting unfavourably with an equally large 'yet normal' nineteenth-century work – the *Cuirassiers at Reichschaffen* (Versailles Museum) – by the French artist Morot.[43]

Evidently Munnings saw the return of Spencer and Augustus John to the Academy as a sign that Modernism was making inroads into an institution which he still saw as the upholder of true English artistic traditions. There was also the question of how the

Chantrey Committee should disburse their funds, and Munnings may well have felt that their choice was a slap in the face for the older established academicians like himself.[44] His attitude was echoed by a number of correspondents who used the occasion of the Chantrey purchase to suggest that the public was being deceived by 'precious art boys' who indulged in 'boosting' modern art for profit.[45] A number were also in agreement that 'modern art' would soon be recognized 'for what it really is – philistinism.'[46] Support for The Resurrection, on the other hand, tended to concentrate on its 'profound and imaginative qualities,'[47] while avoiding discussion of the wider aspects of so-called Modernism; a recognition, perhaps, by the better informed that Spencer was hardly in the forefront of the avant-garde by 1950.[48]

Indeed, Spencer was beginning to look even more provincial to some artists and critics who were drawn by the increasing internationalism of Modernism promoted by the United States after the end of the war. As Juliet Steyn has pointed out,[49] this influence was quickly absorbed by some artistic circles in Britain, prompting Patrick Heron to write in 1956: 'We shall watch New York as eagerly as Paris for new developments . . . your school comes as the most vigorous movement we have seen since the war.'[50] The influence of the New York painters, and the resulting emphasis on formalism and the surface quality of paint, affected even those British artists like Peter de Francia, Peter Coker, Frank Auerbach, John Bratby and Lucian Freud who remained committed to figurative painting; but left Spencer's thin dry paint surfaces even less popular with Modernist critics.[51]

Support for a realistic style with national roots came in fact from conservative collectors (like Spencer's Berkshire circle of friends); and, more surprisingly, a communist critic like Roy Watkinson in the Daily Worker, and John Berger who wrote sympathetic criticism of Spencer's work in the New Statesman (20.2.54). The communist position was summed up by R. Turner, writing on 'Britain's Cultural Heritage' in Arena (1951, p. 46), where he queried the inroads of 'American' formalism into British art: 'It can be seen that there is a great national heritage of art with the tradition of realism and the search for truth. When came the break with this tradition and the turn towards formalism and cosmopolitanism?'[52]

In the same year that Spencer returned to the academic fold Hilda died of cancer. Spencer had been optimistically planning remarriage but this hope was now cut short. In its place he developed an idea of spiritual union with Hilda in which she acted as a supportive ideal companion, or even an alter-ego, while he continued to write her the voluminous confessional letters which had been a feature of their earlier separations. In death Hilda's awkward personality became more manageable and easier to love and she soon assumed a madonna-like sanctity in Spencer's imagination which was to continue for the remainder of his life. In effect Hilda had joined the pantheon of personalities, both real and imagined, which populated the private world of his paintings.[53]

The principal effect of Hilda's death was to prompt a resurgence of Spencer's interest in the Church House. The Resurrection, Port Glasgow paintings had not been assigned a specific place in the scheme, perhaps indicating a temporary loss of interest in the idea. Now, however, Spencer revived the project, finishing old canvases from 1936 like From Up the Rise (416) and Love on the Moor (415), in which Hilda's effigy dominates the crowd of lovers on Cookham Moor, as well as developing a whole series of new ideas based on the Scrapbook drawings.

It is probable that Spencer always intended the majority of these drawings to be designs for the Church House; indeed, they provided a means of continuing the development of his plans, while his main efforts were concentrated on the Shipbuilding series. But it was not until 6 November 1948 that he clarified his intentions in a letter to his Glasgow friend, Charlotte Murray, which contained a new series of diagrams of the Church House.[54] These show a series of 'Chapels' dedicated to the important women in his life, Hilda, Daphne Charlton, Patricia, Elsie the maid, and Charlotte Murray, better known as 'Madam X' from Glasgow. Of these the Patricia 'memorial' was the smallest and consisted largely of nudes from the thirties.[55] The remainder, with a few exceptions, are taken from the Scrapbook studies, the compendium of drawings which Spencer had made in four cheap 'Derwent' scrapbooks during 1939-45, in anticipation of the time

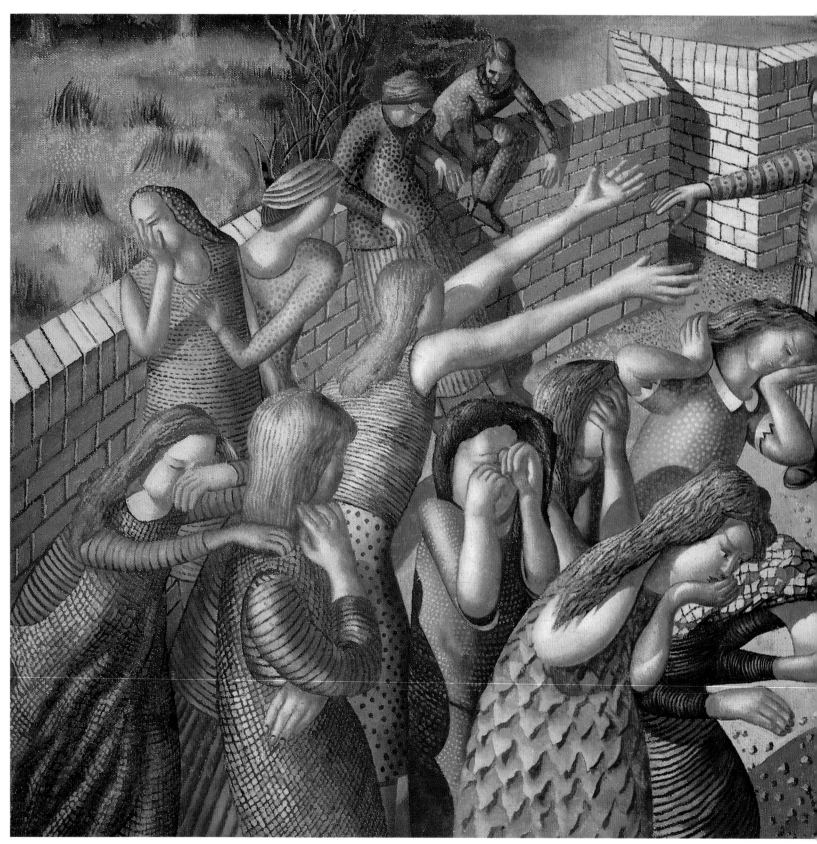

Cat. 360
The Daughters of Jerusalem
1951

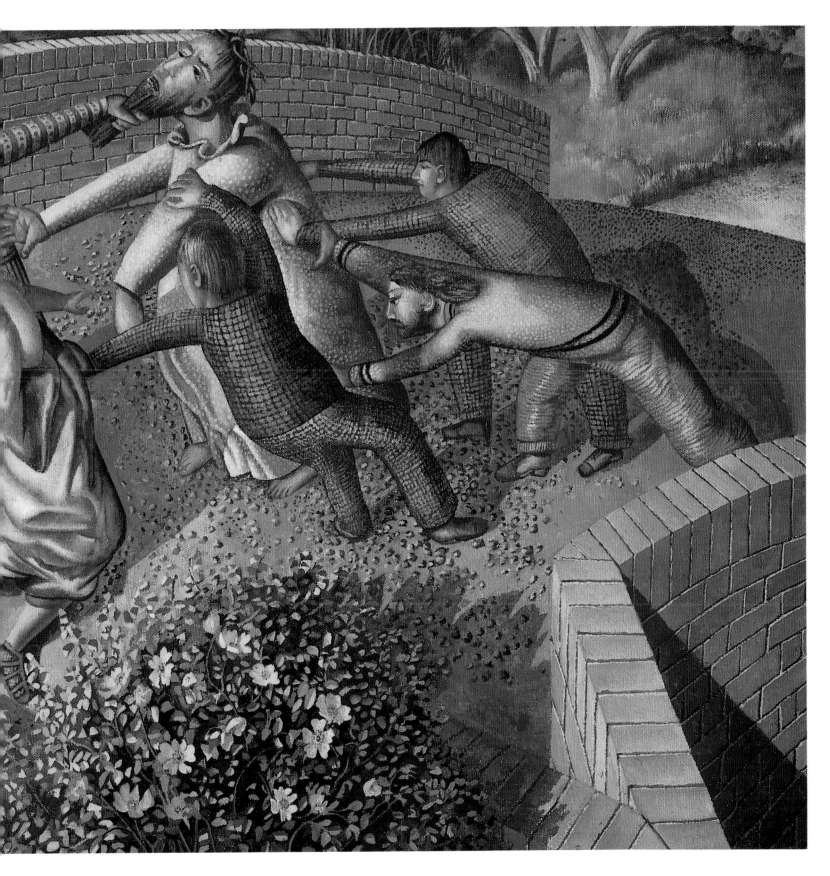

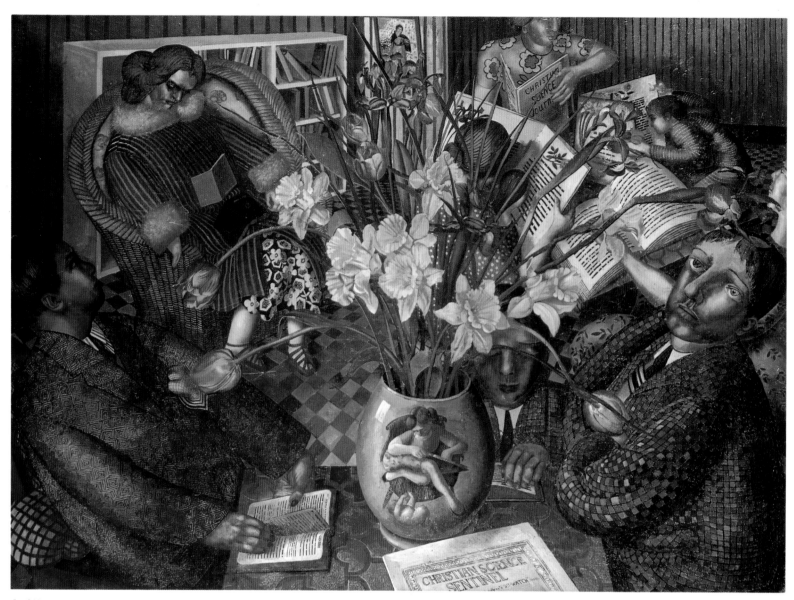

Cat. 361
Silent Prayer
1951

when he could return to the *Church House* scheme. These drawings concentrate on Hilda, Elsie and Daphne and there is no surviving indication of the format for Mrs Murray's 'Chapel.'[56] Understandably Spencer concentrated his energies on the Hilda Chapel, although even here very few of the scenes were actually completed. The theme is the already well-worn one of their marriage, a number of the proposed pictures being little more than variations of the 1935-6 *Domestic Scenes*.[57] Spencer began at the altar (or in this case the fireplace) end, for which he completed the large central mantelpiece scene of *Love Letters* (1950; 359), which shows Spencer and Hilda seated on a large, ugly brown sofa, exchanging letters, their favourite form of communication. Their love for each other is confirmed by the way Hilda draws the letters from her bosom, while Spencer presses the pages to his face as if to inhale her thoughts. He also painted *Hilda Welcomed* (1953; 384) and *Hilda and I at Burghclere* (1955; 414) which were to hang on the side walls, together with a number of planned compositions showing himself with Hilda on their favourite territory in Hampstead, the scene of their early courtship and marriage.[58] Of these only *Me and Hilda, Downshire Hill* (449) was begun, but all the drawing studies show an urgently attentive Spencer paying court to the large, awkward figure of Hilda as she lurches forcefully about her business. The masochistic elements found in the *Beatitudes of Love* are absent, but Spencer still assigns to himself the submissive role of the thirties paintings. These they resemble compositionally, in their concern with interwoven pairs of figures, without, however, achieving the same psychological tension through distortion as paintings like *At the Chest of Drawers* (192) or *On the Landing* (193). In the absence of the extraordinary emotions which had been the driving force behind his pre-war paintings, Spencer's art relaxes, and the subjects become increasingly anecdotal and diffuse in meaning. Frequently Spencer seems to have chosen the composition for its emotional significance rather than for any artistic value, and many of the most impressive *Scrapbook* drawings, for example L51 and L95a, remained unused.

In 1954-5 Spencer added three other works to the *Hilda Memorial*: *Hilda and I at Pond Street* (391), *Hilda and I at Burghclere* (414) and *Hilda with Bluebells* (402). Of these the second continues the theme of domestic life at Burghclere, begun in the thirties with *Workmen in the House* (168) but now painted in the disparate patterns characteristic of the fifties, and most evident in the extraordinary three-dimensional design of the rug. *Hilda with Bluebells*, on the other hand, is a poignant testimony to Spencer's love for his wife, with a wistful Hilda contemplating the spring flowers like a Flemish madonna before a vase of lilies. This painting is not derived from any of the *Scrapbook* drawings, and is the only work completed for the lower register or 'predella' of the Hilda 'Chapel.'

At the same time that Spencer was involved in a return to the *Church House* he was also at work on a number of independent paintings. Some, like *The Farm Gate* (352) and *The Dustbin, Cookham* (1956; 422), were what Robinson (1979, p. 74) has called his 'public' works, pictures which were not redolent with meaning, for example, to the *Church House* series, and which were 'safe' subjects for exhibition at the Academy. Others, like the small-scale Life of Christ paintings, appear to have been an attempt to revive the Quattrocento-like directness and simplicity of the similar series of the twenties. Of these, *Christ Rising from the Tomb* (1954; 395) and *The Deposition and the Rolling Away of the Stone* (1956; 424), each of which has its own predella in a division of the main canvas, are the best examples of Spencer's continuing interest in a conventional interpretation of the Bible, alongside his own eccentric creation in the form of the *Church House*.

A further development after the war was the emergence of a form of overt violence in a number of his religious paintings. Previously most unpleasant elements had been eliminated, even from scenes of the *Betrayal* (91) and the *Resurrection*.[59] Now, however, almost as though released from the terrible tension of his life over the past fifteen years, Spencer produced two fine paintings in quick succession, *Christ Delivered to the People* (1950; 356) and *The Daughters of Jerusalem* (1951; 360), both showing Christ being viciously abused by his detractors. In the *Daughters of Jerusalem* the horror of the event is softened somewhat by the weeping women, but the other painting is unremittingly harsh both emotionally and visually in the clear cold light which falls upon the scene; an effect emphasized by the billiard-ball-shaped cobbles

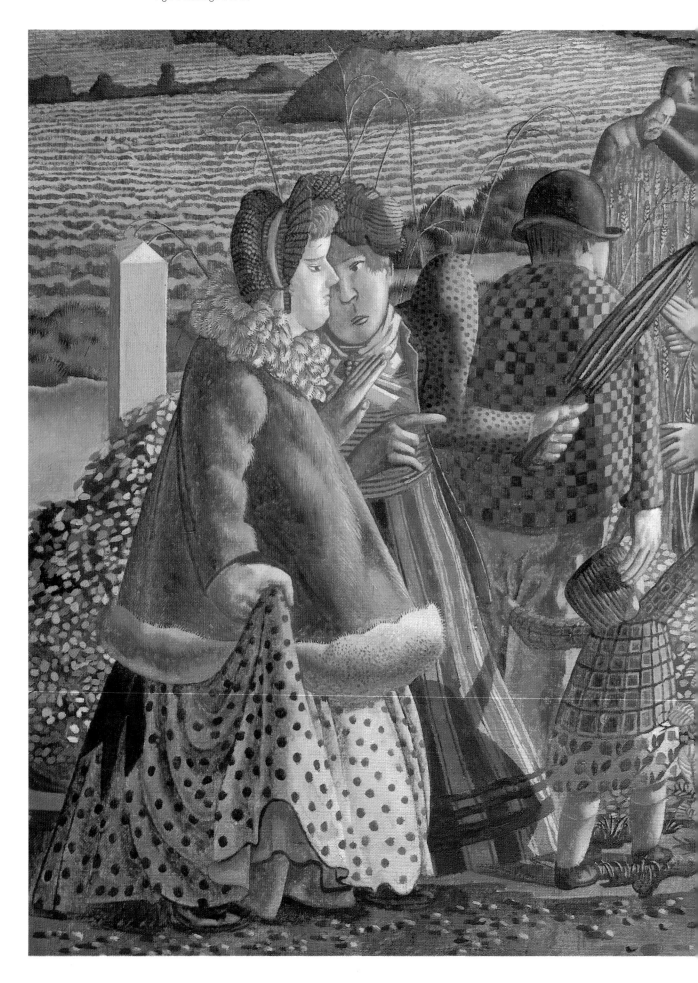

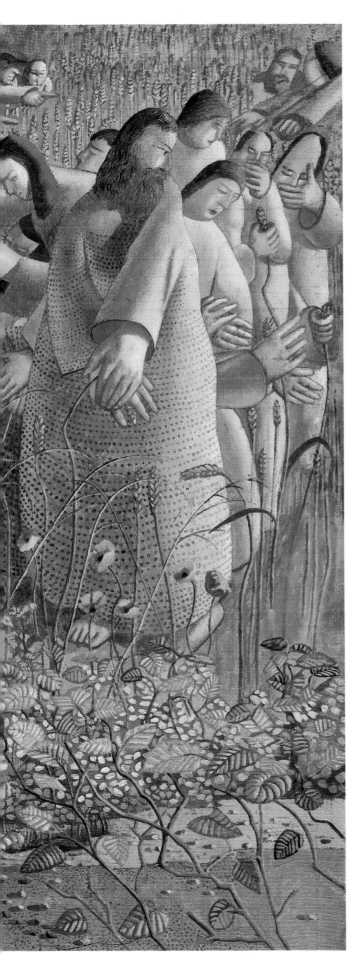

Cat. 373
The Sabbath Breakers
1952

Cat. 378
Christ in Cookham
1952

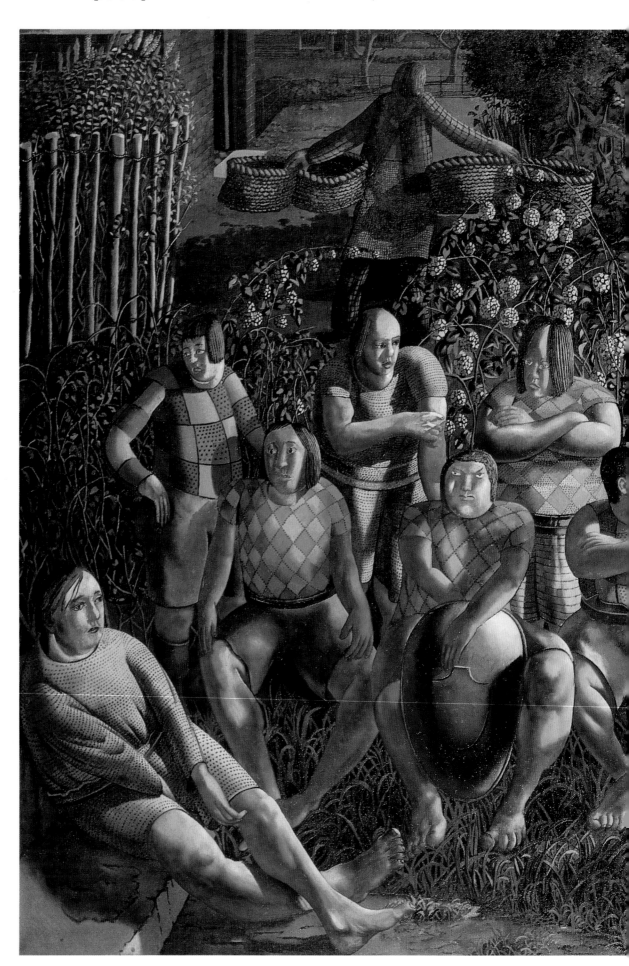

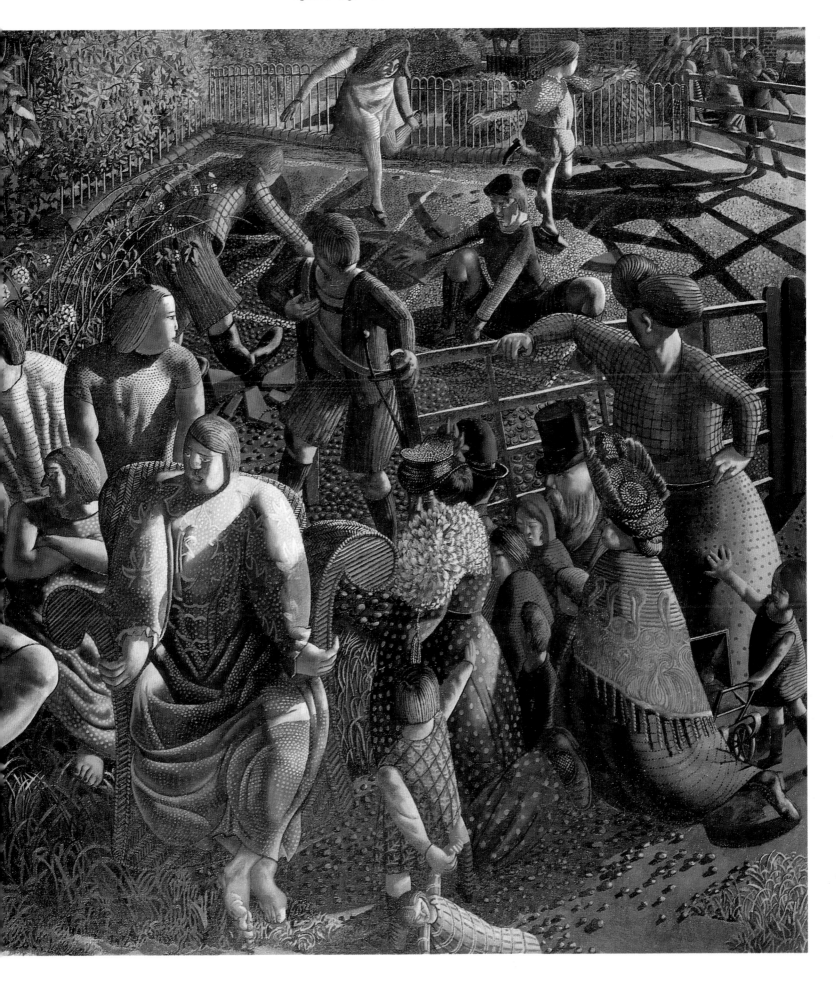

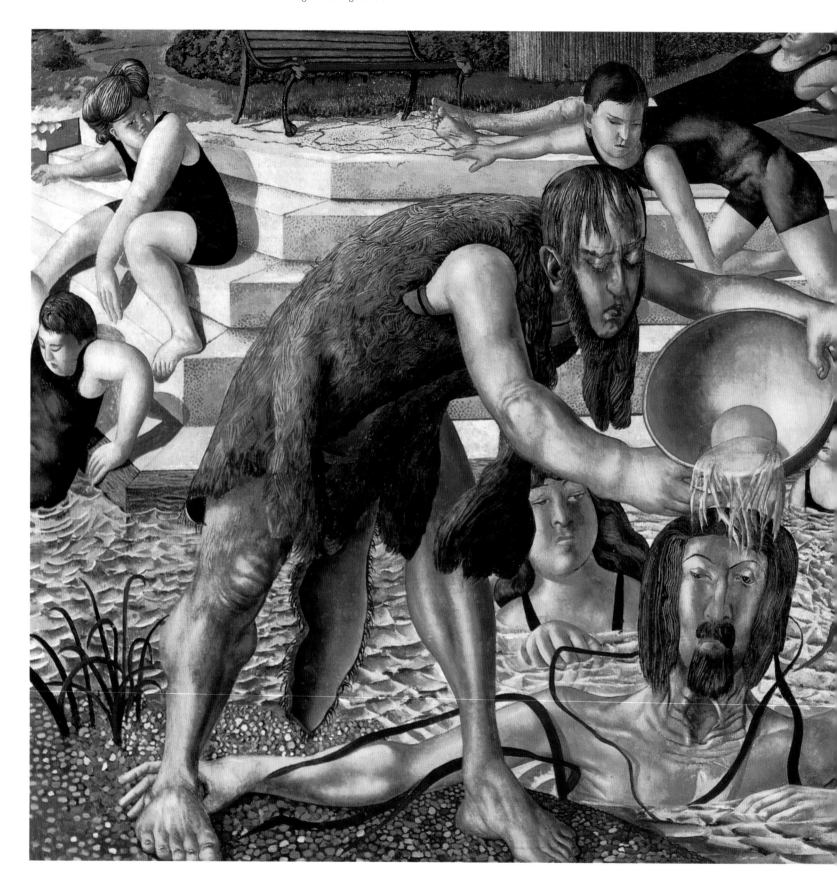

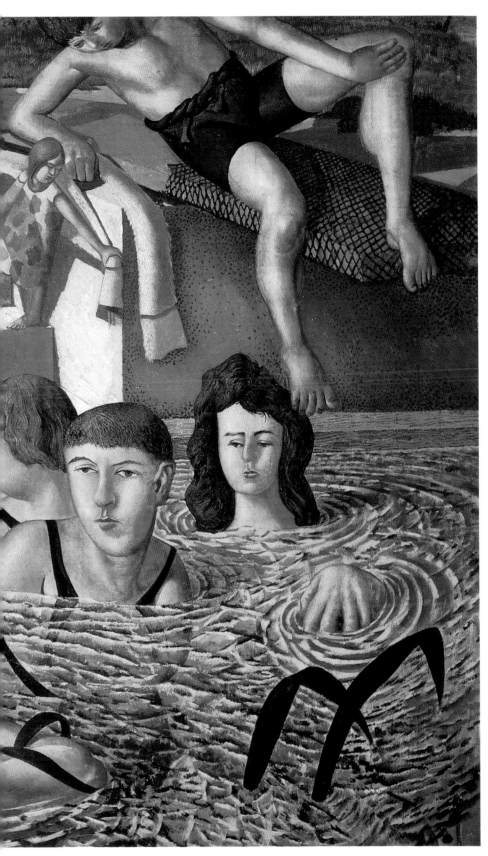

Cat. 380
The Baptism
1952

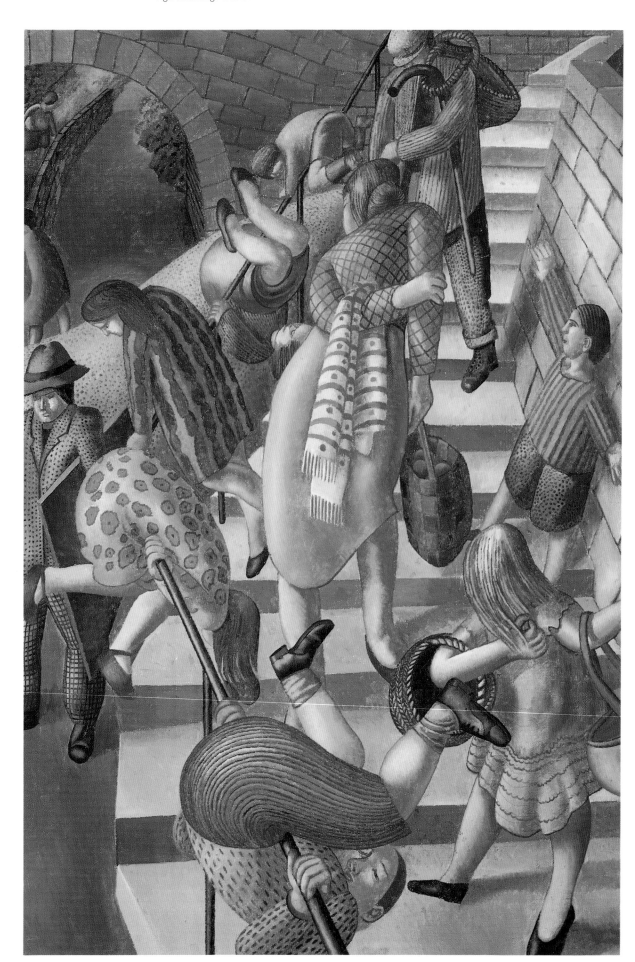

Cat. 381
The Glen, Port Glasgow
1952

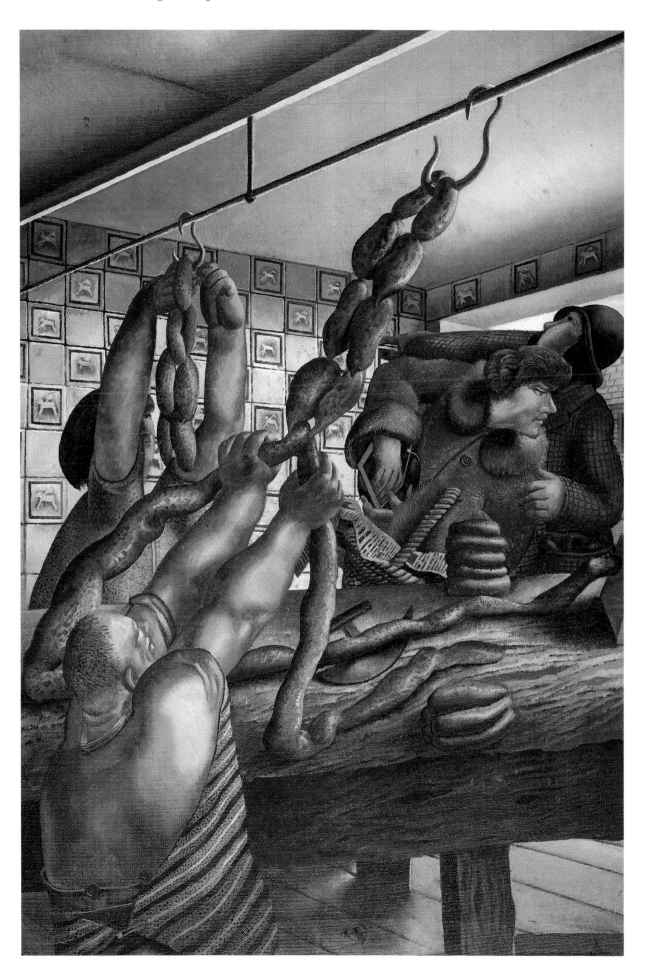

Cat. 363
The Sausage Shop
1951

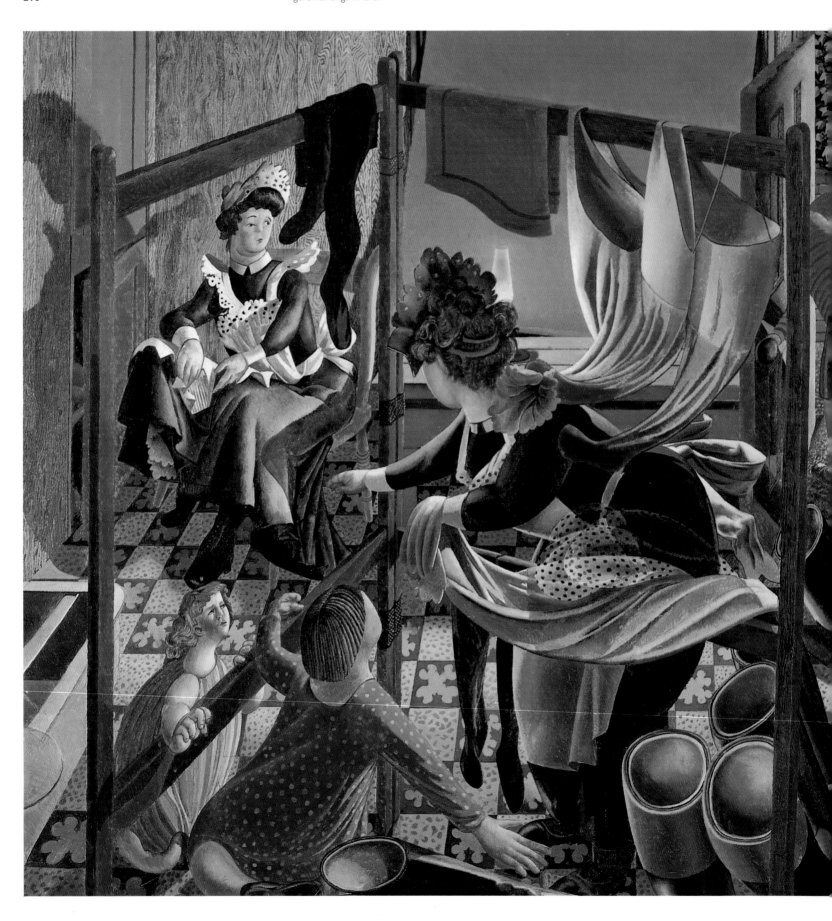

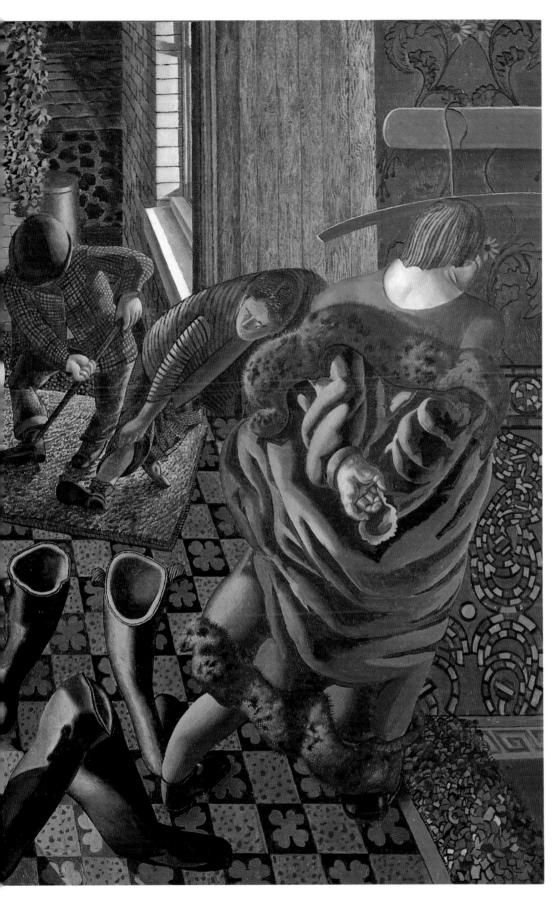

Cat. 382
**The Marriage at Cana:
A Servant in the Kitchen
Announcing the Miracle**
1952-3

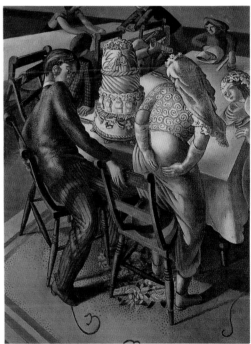

Cat. 385
**The Marriage at Cana:
Bride and Bridegroom**
1953

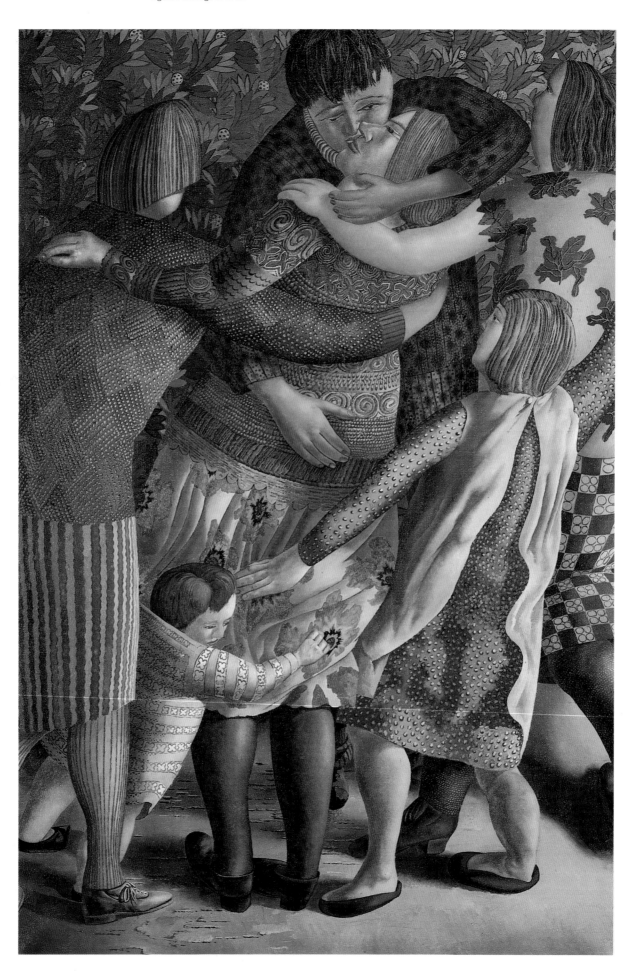

Cat. 384
Hilda Welcomed
1953

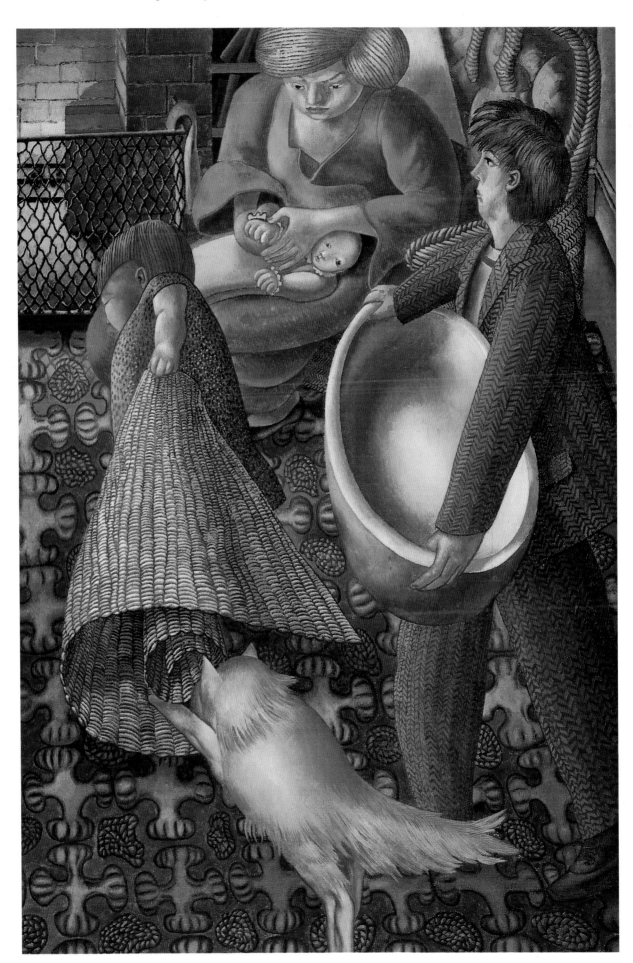

Cat. 414
Hilda and I at Burghclere
1955

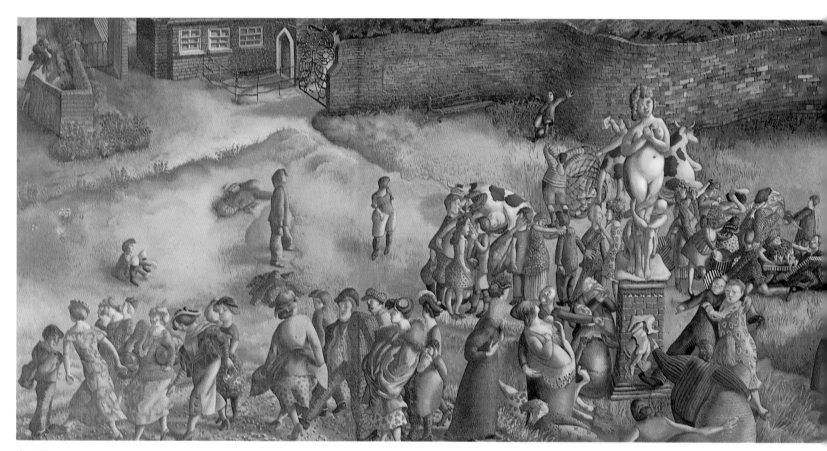

Cat. 415
Love on the Moor
1937-55

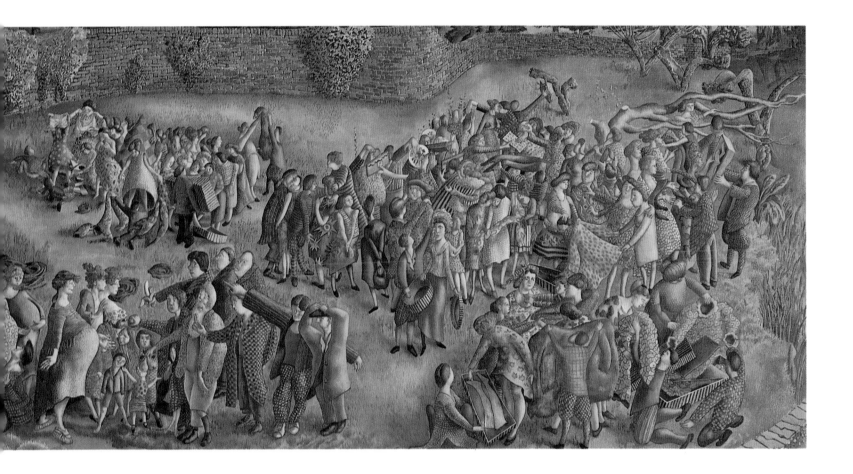

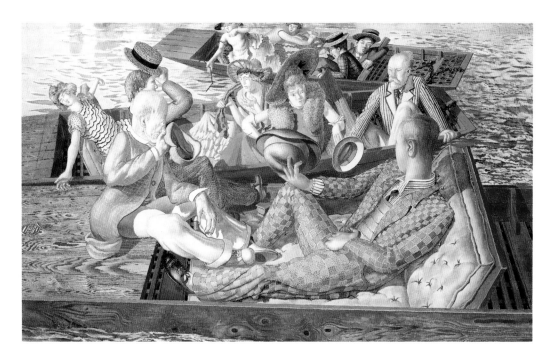

Cat. 383
Christ Preaching at Cookham Regatta: Punts Meeting
1953

which create an almost physical sense of discomfort.

Strangely, neither painting has received any attention in the literature, and no comment survives by Spencer, so any discussion of their meaning for the artist can only be conjecture. However, given that Spencer closely identified with Christ when painting the *Wilderness* series (283) at 188 Adelaide Road in 1939, it seems reasonable to see these two paintings as an additional reflection of his own experiences before the war. He must also have been acutely aware of the irony in having left Cookham as a social outcast in 1938, only to be welcomed back after the war as a great artist and a near-mythological personality by the same society. Spencer gave an inkling of these feelings in 1958 when he told the boys of Aldenham School that he had depicted the men nailing Christ to the cross in *The Crucifixion* (441) as brewers 'because it is your Governors and you, who are still nailing Christ to the cross.'[60]

Despite the already labyrinthine dimensions of the *Church House*, Spencer added yet another series to the scheme during the fifties, *Christ Preaching at Cookham Regatta* (383). Typically, the idea had occurred to him some time before in the 'late twenties' when he had made a small drawing of Christ preaching from the Cookham horse-ferry barge, which stands out in the river surrounded by punts filled with smartly dressed visitors to the regatta.[61] This first drawing was 'not satisfactory' and Spencer

did not return to the idea until 1938 when he did four additional drawings in an exercise book. Again, however, the idea remained unrealized until c.1949, when Spencer once more got out the 1938 studies and began painting the series that occupied him until his death.[62]

The series fitted easily into the flexible design of the *Church House*, where Christ's presence in Cookham could be explained in the general context of the Last Day, with He and the disciples descending on Cookham to give their blessing. Here Cookham Regatta could assume the wider character of the celebrations surrounding the Resurrection, now expanded to include not only the villagers, but also smartly dressed visitors down from London for the day. In keeping with many of Spencer's other major themes the *Regatta* idea was also connected with memories of his early life in Cookham. In 1953 he told Hilda that he could not afford to punt as a youth and so could only participate as an eager onlooker.[63] Consequently, the idea of going on the river became a tantalizing one, which could be reached only through his paintings.[64] The experience of the regatta was also important to Spencer because it represented a recognizable highlight of his childhood, a festival which punctuated the year with a regularity which must have further reinforced his sense of the unique experience of village life. This is made clear in Gilbert Spencer's delightful account of the regatta, in which he

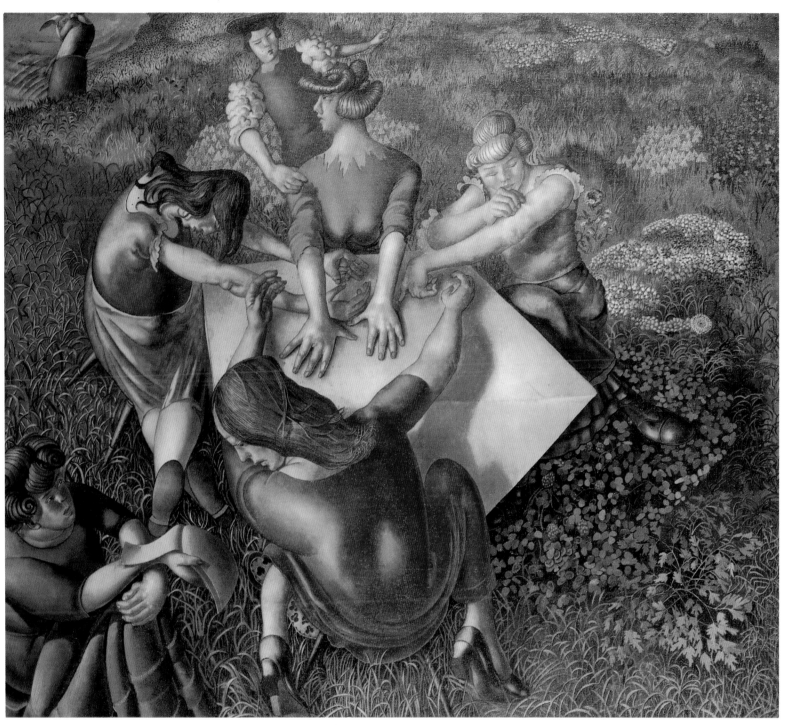

Cat. 386
**Christ Preaching at
Cookham Regatta:
Girls Listening**
1953

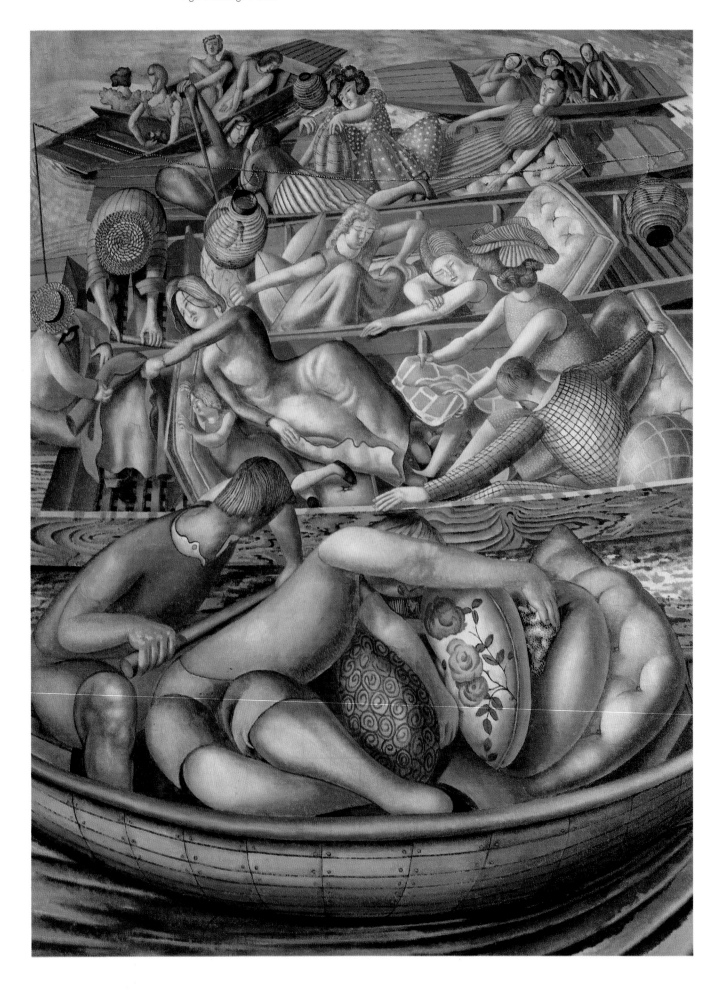

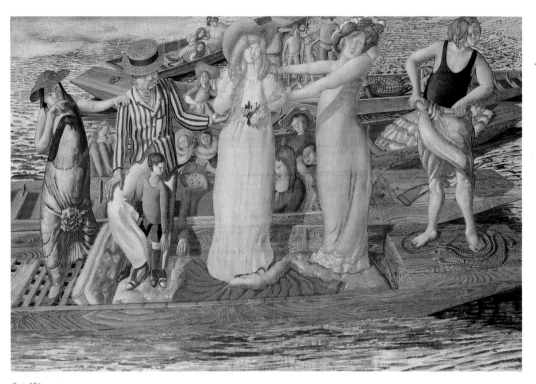

Cat. 401
**Christ Preaching at
Cookham Regatta:
Listening from Punts**
1954

Cat. 413
**Christ Preaching at
Cookham Regatta:
Conversation between
Punts**
1955

describes how the young Spencer boys watched from the bridge as their brother Will and the village choir serenaded the punters by the light of Chinese lanterns from moorings by the Ferry Hotel.[65] This magical event provided Spencer with the central scene, with Christ and the disciples replacing the singers on the horse-ferry. The festively dressed onlookers in their Edwardian clothes exactly match those described in Gilbert's account.

Beginning in 1949, Spencer struggled to bring coherence to his scheme, which at the outset consisted of sixty-eight imperial-size drawings in red conté showing episodes from the regatta. At the outset the main scene showed Christ, viewed from above and surrounded by a star-shaped array of punts. This remained until at least 1954, when continued difficulties with the composition, and the need to reduce the size of the main painting, brought about a change in design: the viewpoint was moved round from the Ferry lawn to Cookham Bridge, so that Christ is now seen from the side, facing towards the lawn which is on the right.

This composition was the one finally used by Spencer in the big 5.5-metre-long canvas, *Christ Preaching at Cookham Regatta* (448). In the earlier drawings Spencer seems to have worked towards an upright canvas, somewhat like *Furnaces* in the *Shipbuilding* series, which also employs a star-shaped composition. At this

stage the painting was probably intended as a central 'altarpiece' (like *Furnaces*) surrounded by a predella of smaller paintings. The reversion to the present shape was apparently necessitated by Spencer's decision to include as many episodes from the *conté* drawings as possible, even to the extent of duplicating other paintings in the series, notably *Conversation Between Punts* (413). This would have ensured that the most important compositions for the series were kept together in one painting even if the other smaller works were sold separately. The direct consequence of this decision was to move away from the centralized coherence of the early studies, replacing it with a sprawling composition full of separate episodes which was not unlike that of *The Resurrection, Port Glasgow*. Christ on the horse-ferry is now moved back into the central distance and reduced to the scale of the tiny figure in *The Resurrection of Soldiers* at Burghclere. His role of central character is now replaced in the foreground by the large figure of Mr Turk, the Cookham boatman.

In the other smaller paintings for the series Spencer often virtually ignored the religious aspect of *Christ Preaching at Cookham Regatta*, concentrating instead on re-creating the atmosphere of an Edwardian social occasion. As Gilbert Spencer recalled, these events always emphasized class distinctions, with the different ranks collecting in their respective places to gossip on the river or eat their picnics on the banks.[66] Spencer made this clear by contrasting the lavish dress and elaborate courtesies of the wealthy, in *Punts Meeting* (383) and *Listening from Punts* (401), with the commonplace appearance and activities of the 'barmaids' in *Girls Listening* (386) and *Punts by the River* (443). Spencer's sympathies with the lower classes and their more relaxed way of life is emphasized by the way the girls have hitched up their dresses to be more comfortable in *Punts by the River*, so that their figures are all curves, loose-jointed in their ease. By comparison, the men in *Punts Meeting* perform a marionette-like formal dance of greeting, and the easy intimacy of the other party is missing. Spencer generally felt more at home in the company of women, particularly in the years after the war, and the preponderance of women in the working-class regatta parties is very noticeable. Significantly, the only man in *Punts by the River* is an

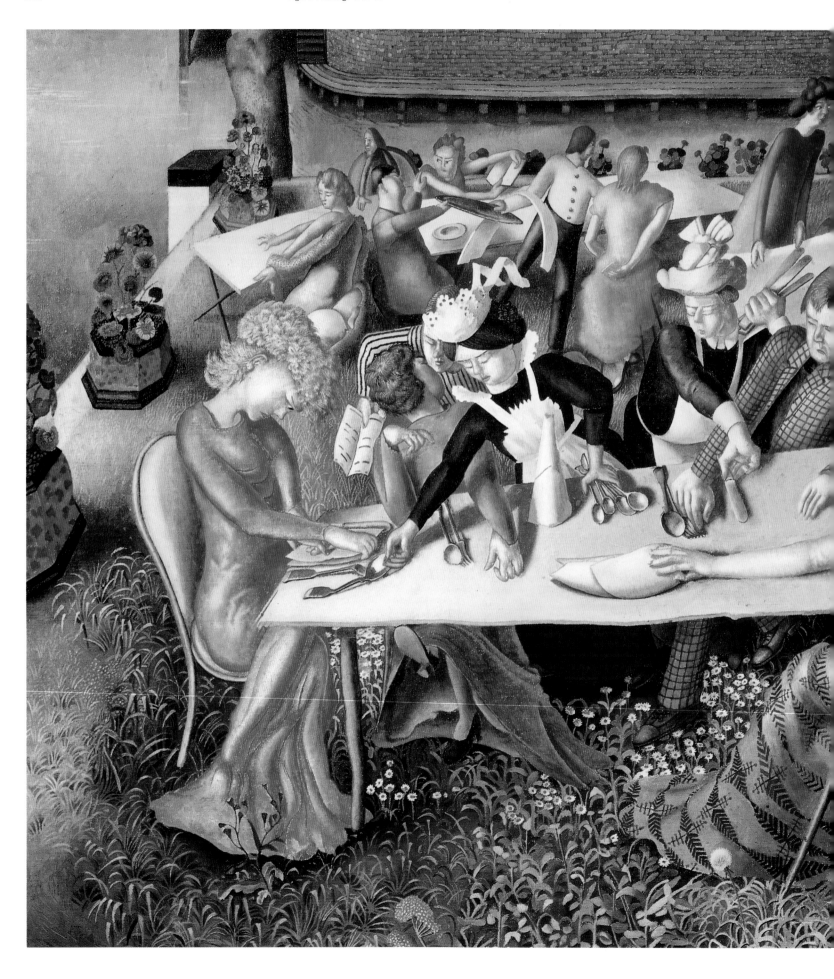

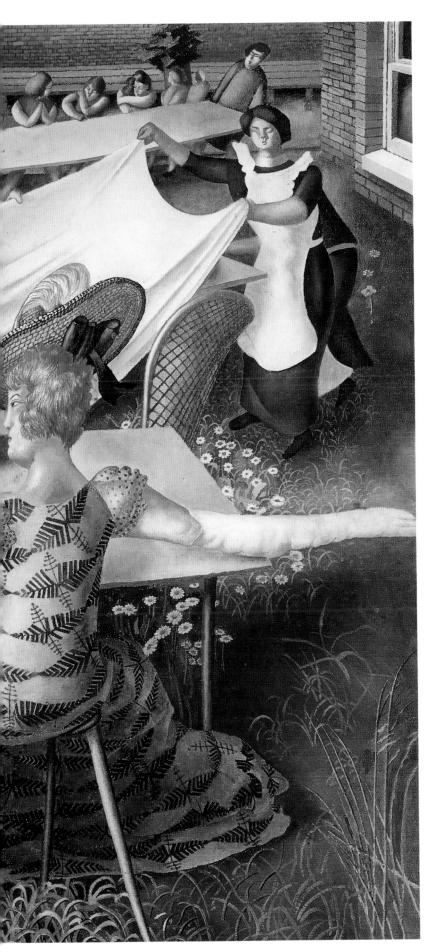

Cat. 425
**Christ Preaching at
Cookham Regatta:
Dinner on the Hotel Lawn**
1957

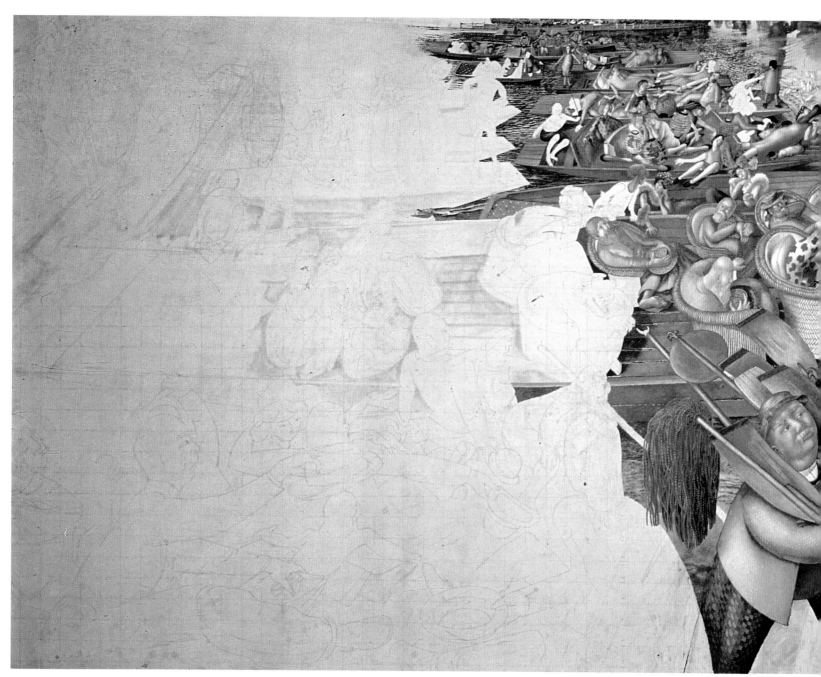

Cat 448
Christ Preaching at
Cookham Regatta
Unfinished

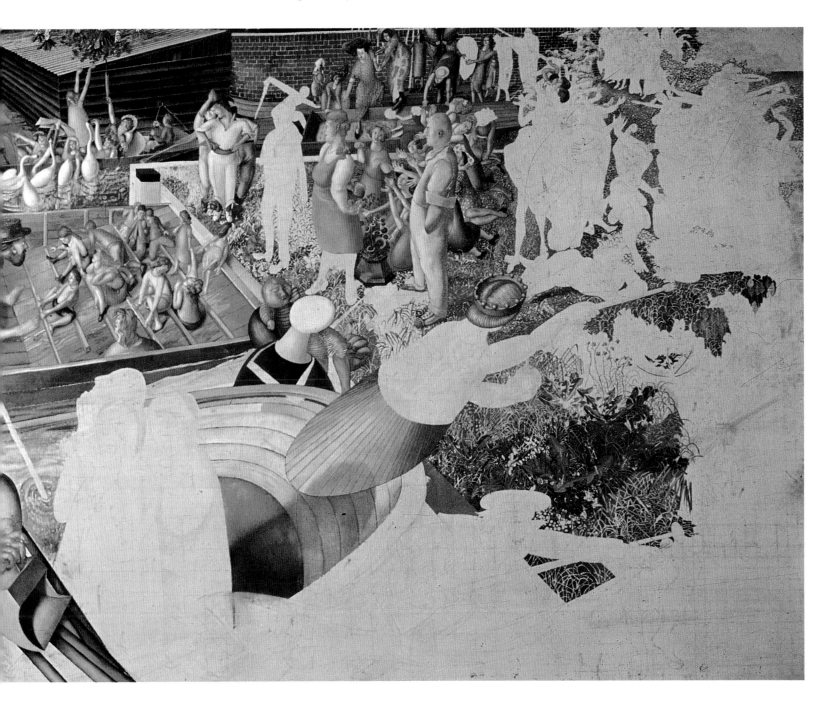

Cat. 422
The Dustbin, Cookham
1956

Cat. 434
At the Piano
1957-8

idealistically well-built version of the artist himself, playing the role of admirer.

Unfortunately Spencer left no clear written commentaries on the *Regatta* paintings, and his rare references usually point to this depiction of events as a compendium of the incidental and mundane. On one occasion, however, Spencer informed Geoffrey Robinson that the girl dressed in red at the centre of *Listening from Punts* was a 'fallen woman unmasked by her companions and brought before Christ for judgement.'[67] If this is the case, then Spencer presumably intended that she should be forgiven, and the hypocrisy of her accusers exposed. This view of society's censorious attitude would be comparable with Spencer's statement to the boys of Aldenham School about the continued crucifixion of Christ by society. The painting may also contain a comment on his own treatment by the villagers during his relationship with Patricia Preece. Whatever the exact meaning, Spencer does seem to have felt secure enough to take a crack at his detractors in his last years, as well as making generous amends for his own attacks on supporters like Henry Lamb in the twenties.[68]

To begin with, Spencer planned to hang the smaller *Regatta* paintings on the nave walls of the *Church House*, flanking the big canvas of

Christ Preaching at Cookham Regatta. In choosing the compositions, however, he paid relatively little attention to the way the various scenes would work together, and no two canvases are exactly the same size or shape, while the scale of the figures differs widely.[69] That Dudley Tooth sold the paintings quickly, and as far abroad as Australia, indicates that, even in his improved financial state, Spencer was forced to sell where he could and thus break up a scheme which was of major importance to the revised post-war *Church House* plans.[70] The apparently absurd return to large, over-ambitious paintings like *Christ Preaching* (448) or *Hampstead Heath Litter* (450) was in fact an attempt to preserve the most important elements of each scheme in one indivisible work, whose statement would be as complete as that summation of his early career, *The Resurrection, Cookham*.

In 1954 Spencer added a new painting to the Hilda 'Chapel' called *Hampstead Heath Litter* (450) which was to be the centrepiece of the 'Hampstead Life' section of the room.[71] The picture is approximately the same size as *Christ Preaching at Cookham Regatta*, and represents another example of the progressive deification of Hilda which took place after her death. Spencer had proposed marriage to her by the pond in the Vale of Health, Hampstead, and in the new painting he sought to re-create their relationship by making it '. . . a manifestation of the joy of our united souls . . . a kind of Vale of Health paradise or heaven,' in which he appears 'worshipping Hilda as a "votive offering."'[72] Spencer and Hilda are shown no less than four times; Hilda, in her state of 'being with God,' reads the letters which he pens while seated beside her. Around them, parties of young women search through litter bins for old love-letters of the kind he had written while first living at Burghclere in 1927.[73] Others, wearing paper streamers and blowing on party whistles, dance before Hilda in a kind of Dionysian celebration of her large awkward beauty, as she sprawls comfortably on a park bench. Again the theme of the holy and the mundane are brought comfortably together, prompting Spencer to ask 'Can God have created in the manner of a Borough Council?'[74]

Spencer arranged the various Hildas and her attendant celebrants in clumps, viewed from an elevated viewpoint against the landscape. This

Cat. 427
The Bathing Pool, Dogs
1957

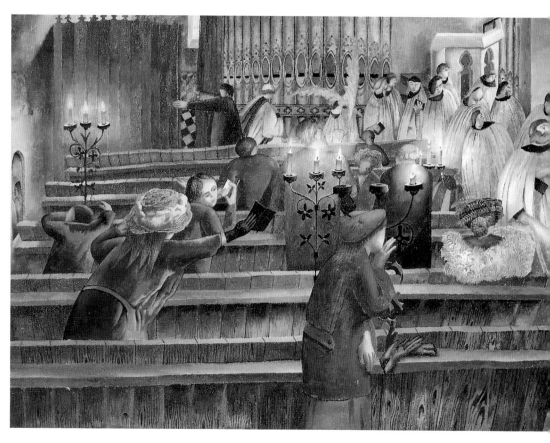

Cat. 420
In Church
1956

idea he adopted from a photograph of a queen white ant and accompanying workers found in a book called *Wonders of Animal Life*, probably also the source for a 1938 drawing study for *Christ Preaching at Cookham Regatta* which he described as 'crab-like'.[75] The peculiarity of such an idea again points to the extraordinary originality of Spencer's imagination, as well as to what John Berger in the *New Statesman* for 20 February 1954, called his 'oddness;' a combination which always prevented wholehearted enthusiasm for his work among both critics and the public.

In 1958, through the good offices of his friend Jack Martineau, Spencer was commissioned to paint a *Crucifixion* (441) for Aldenham School, the educational establishment of the Brewers' Company.[76] The subject had occurred from time to time in his drawings, notably in the *Scrapbook* composition of 1947 (Leder 137), but he now took the opportunity to rework the idea completely.[77] In the painting which resulted, Spencer transformed the relative calm of the 1921 *Crucifixion* (76), and the stiff symmetrical composition of the 1947 drawing, into a dynamic scene of startling cruelty. The picture was inspired by a mound of rubble from pipe repairs in Cookham High Street, which is transformed

into a Calvary, level with the upper windows of the neighbouring houses, from which their inhabitants gaze. The crosses are arranged in a circle or 'coffin' shape with Christ, seen from behind, facing the abuse of one of the thieves, and the sadistic pleasure of the executioners driving home the nails with demonic fury.[78] Spencer took the traditional contemplative image of the Crucifixion and reversed the scene, so that the worshipper is invited to experience the full force of this verbal and physical assault from the victim's point of view. This very disturbing painting is clearly related to *The Daughters of Jerusalem* (1951; 360) and *Christ Delivered to the People* (1950; 356), which are also concerned with the individual's persecution at the hands of the mob. Again in the *Crucifixion* the impression is reinforced that Spencer closely identified with Christ's suffering, a theme first implicit in the *Christ in the Wilderness* series (283) painted at a moment of extreme isolation at 188 Adelaide Road in 1939.

The *Crucifixion* was the last major painting which Spencer completed before his death, but the extraordinary composition, and the evident care with which it was painted, were not always repeated in the other late paintings.[79] Much of his time was taken up instead with landscape and portrait work, and

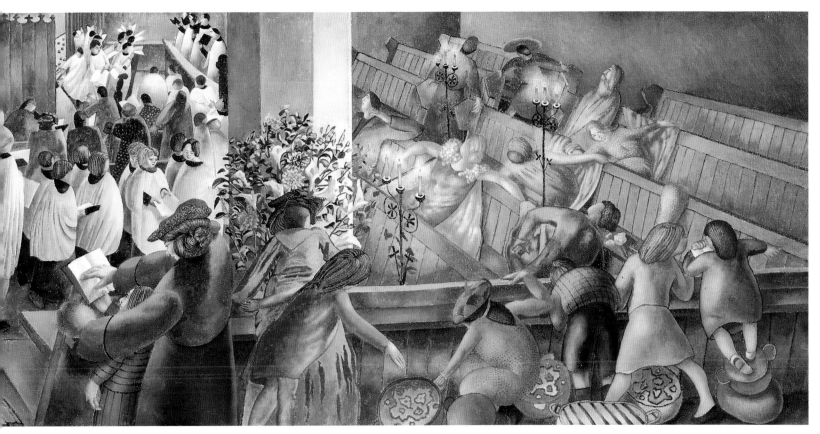

Cat. 442
In Church
1958

his two major projects, *Hampstead Heath Litter* and *Christ Preaching at Cookham Regatta*, were only worked on intermittently. Since moving into Cliveden View in 1944, Spencer was also faced with a severe shortage of space, and the large canvases had to be pinned up around three or four walls of his tiny workroom before painting could begin.[81] It was only after his first operation for cancer of the colon in December 1958, and his return to Fernlea in May 1959 with a guaranteed income from Lord Astor, that Spencer was able to concentrate on *Christ Preaching* in the slightly larger front room where the Spencer family had celebrated Christmas when he was a boy.[80]

Apart from the two large paintings and the Aldenham commission, Spencer painted only two other figure paintings in the years 1958-9. These were the tiny *Saint Peter Escaping from Prison* (1958; 440), a continuation of the small-scale religious series last worked on in 1955;[82] and *The Glove Shop* (444), one of the *Shop* series for the *Church House*, painted during April and May 1959.[83] During the remainder of this period he was frequently away from home working on portrait commissions, for example painting Mary Cartwright, Mistress of Girton, in 1958 (436) or staying with friends like the Morrells, the Martineaus, or Joyce Smith in Dewsbury.[84]

Indeed his increasing fame, and a shower of public honours, culminating in a knighthood in 1958, undoubtedly distracted him from painting, and contributed to his failure to complete the *Regatta* and Hilda series. However, success did mean the return of a reasonable income. In November 1957 he was £500 in credit at Tooth's, as well accumulating as an additional £1000 for income-tax payments; and his return to a more 'acceptable' manner of painting meant higher prices, £650 each for the *Glasgow Resurrection* triptychs, and £300 for *Wisteria at Englefield* (394), a comparatively modest landscape of the kind that had usually sold before the war for about half that sum. Sales too were assisted by the big Leeds and Tate exhibitions, of 1947 and 1955, as well as yearly showings at the Royal Academy summer exhibitions.

In the autumn of 1959, however, the cancer whose growth had been arrested by the earlier operation began to spread again, and this time it proved to be too extensive to be operable. In November Spencer was taken to the Canadian War Memorial Hospital where he died shortly afterwards.

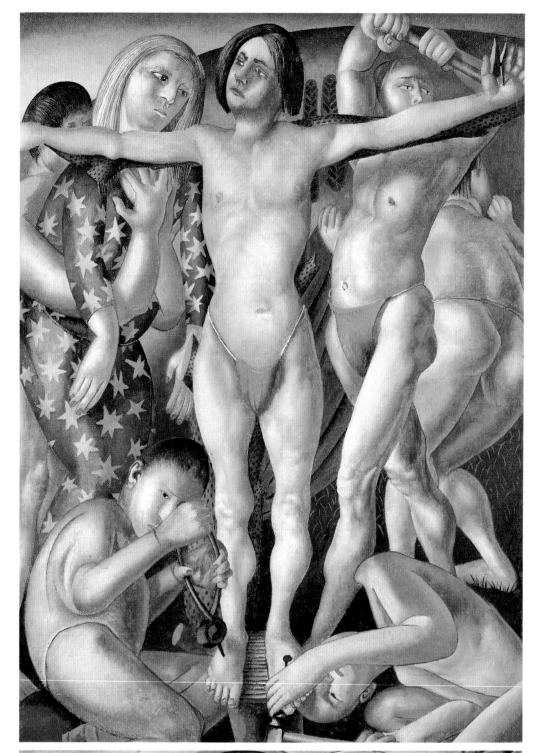

Cat. 424
**The Deposition and the
Rolling away of the Stone**
1956

Cat. 441
The Crucifixion
1958

Cat. 450
Hampstead Heath Litter
or The Apotheosis of Hilda
1959 (unfinished)

Cat. 449
Me and Hilda, Downshire Hill
Unfinished

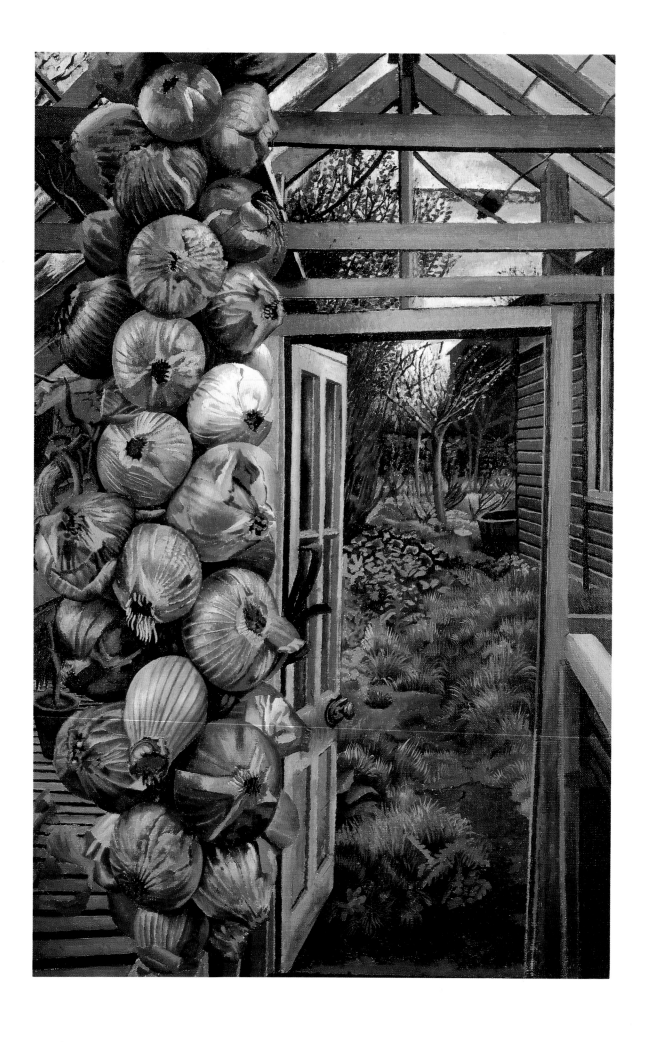

Landscape Paintings

Cat. 243
Greenhouse and Garden
1937

The position of landscape painting in Stanley Spencer's œuvre has presented particular difficulties for recent criticism. On the one hand, there is the clear evidence of Spencer's success in terms of public sales and popularity, as well as the obvious partiality of many of the contemporary critics for these less controversial subjects. On the other hand, Spencer's well-known position, that landscape was merely an obstacle to his concentration on figurative work, has generally been accepted by recent biographers and critics writing since his death.[1] Academic criticism has for the most part ignored the landscape paintings mainly, perhaps, because it was felt that any judgement of his achievement must be founded upon the works which the artist himself felt to be central to his career.[2] As a consequence, Spencer's landscapes have received praise for their undoubted quality, but only glancing attention has been paid to their sources, development and purchasers. In this chapter I hope to be able to redress this imbalance and to provide a clearer indication not only of Spencer's approach to the genre but also of the critical reception of the landscapes, especially in the 1920s and 1930s.

Spencer's earliest landscapes, like his figurative works, were deeply rooted in his youthful experience of Cookham. In Fernlea there were a number of views of the village painted by the local artists William Bailey and Fred Walker, as well as a reproduction of Millais's *Ophelia* in which the lush foliage must

have reminded Spencer of the water meadows around Cookham.[3] These examples, together with Dorothy Bailey's tuition, must have provided a useful stimulus, for in the years between 1905 and 1909 there are a number of pen and ink studies of subjects such as *Meadow, Willow, Stream and Footbridge* (1905) and *In Mr Bailey's Yard* (1905), that are clearly drawn from life.[4] Spencer also copied a number of illustrations from Helen Stratton's edition of Hans Andersen and E.H. New's plates for Gilbert White's *Natural History of Selborne*.[5] The latter were particularly important for Spencer as they provided him with a clearer sense of how to give form to his own as yet incomplete feelings about Cookham. Thus, following New's illustrations of birds, he was 'inspired to draw a dead thrush,' which he 'felt' to be 'part of the [Fernlea] garden.'[6] From this modest beginning, Spencer expanded his view of the village with a drawing of *Sandall's Cottage* (whereabouts unknown), before going on to draw 'other houses' inspired by 'sitting among the hollyhocks and runner beans.'[7] These studies included *Liza's Cottage* (c.1907) and *Swift's Cottage* (c.1907), as well as neighbourhood subjects like *Widbroke Common* and *Cockmarsh from the Hill* (both 1906-7), both scenes which he would return to paint in future years.

This stream of landscapes lessened considerably after Spencer entered Maidenhead Technical School in 1907, and during his stay there he recorded only four landscape studies,[8] most of his work being imaginative figure compositions. Given the opportunity to draw

Cat. 51
At Bourne End
1920

Cat. 67
The Quarry Woods, Cookham
1920

from the cast or the model, Spencer chose to concentrate on figures, often combining them with familiar settings (also used in drawings) in works such as *Dot in Strand Meadow* and *Dot as Melancholia in Strand Meadow*, a site which he had drawn before in 1907.[9]

At the Slade, Spencer continued the practice of making landscape studies of the Cookham neighbourhood, as well as painting four water-colours of Clayhidon, Devon, on a previously unremarked visit there in 1911.[10] Some of the Cookham views were made in anticipation or preparation for figure paintings; *Two Girls and a Beehive* (4) being accompanied by no less than three views of the setting of Mill Lane, and *Zacharias and Elizabeth* by two further studies, one of which (15) was his first true landscape oil painting.[11]

Nearly all Spencer's landscape studies from the Slade period have vanished; however, *Cookham* (1914; 19), the earliest surviving pure independent landscape picture, is painted directly from nature in sharply lit clear colours, and reveals the same interest in Pre-Raphaelite painting that infects his contemporary figure pictures, notably *The Nativity* and *Zacharias and Elizabeth*.[12] Spencer's use of an elevated viewpoint that looks past a lush foreground of highly detailed foliage and down to a distant horizon, was also a favourite compositional device of the Pre-Raphaelite painters: for example, Holman Hunt's *Our English Coasts* (1852; Tate Gallery) and Madox Brown's *An English Autumn Afternoon* (Birmingham City Art Gallery). Spencer would have known about the Pre-Raphaelites through his brother Will, who had visited Holman Hunt in his studio, and his own Gowans and Grey book on Rossetti which he acquired in 1913.[13] In the immediate pre-war years, the Post-Impressionist influences which affected figure paintings such as *Apple Gatherers* (12) and *Mending Cowls* (26) hardly touched Spencer's landscape work, which, like that of his brother Gilbert, remained rooted in the English tradition.[14]

The hiatus caused by the First World War prevented Spencer from proceeding any further with his landscapes, although a tiny and previously unremarked sketchbook of his journey back from Macedonia shows the artist recording the scenery, either in minute topographical detail, or in imitation of the wash technique of Claude Lorrain. This passing interest in Claude almost certainly came from

the Gowans and Grey book sent to him in Macedonia by Florence Image, and is reflected in studies like that on page 33 of the sketchbook, which shows a view of the mountainous landscape round Delphi.[15] Something of the flavour found in these landscapes can also be observed in the studies which Spencer subsequently made immediately after the war in connection with his war artist's commission, notably *Travoys along Sedemli Ravine* (1919; IWM) and *Wounded Being Carried by Mules in Macedonia* (c.1918; IWM). After completing *Travoys* in 1919, however, Spencer turned to painting landscape on a far more extensive basis than his sporadic pre-war activities in the genre.

The earliest of these were a series of small panel paintings of the Thames at Bourne End, made while Spencer was staying with the Slessers, and in the intervals between work on the larger figurative canvases. After the smooth, carefully crafted quality of *Cookham*, these new works appear very raw, with coarse parallel brushstrokes defining the salient details, and a few broad areas of flattish colour, ranging from pale grey to khaki, establishing the simplified shapes of the landscape, as in *Bourne End, Looking Towards Marlow* (1920; 53).

At this time Spencer was already established as a regular visitor to the Carline circle in Hampstead, and it was probably through his association with this group that he became more closely involved with landscape subjects. George Carline had been painting landscapes since the 1880s, and the rest of the family (with the exception of Ann who only began to paint in 1927) were all engaged in one form or another with the subject. Even the recent war paintings of Richard and Sydney had been deeply concerned with the landscape settings for their military subjects, as had the work of their friends Paul and John Nash.[16] At irregular intervals the Carlines would sally forth on painting expeditions (indeed George died on one to Assisi in 1920), accompanied by other members of the circle. On occasion, Spencer joined these parties, as he reported to William Rothenstein in April 1920:

I am staying at Seaford [in Sussex] with the Carlines . . . such a delightful holiday. . . . Yesterday we all went out onto the downs and did paintings. The 'artists' were: Mr Carline (the father of the flock), Hilda,

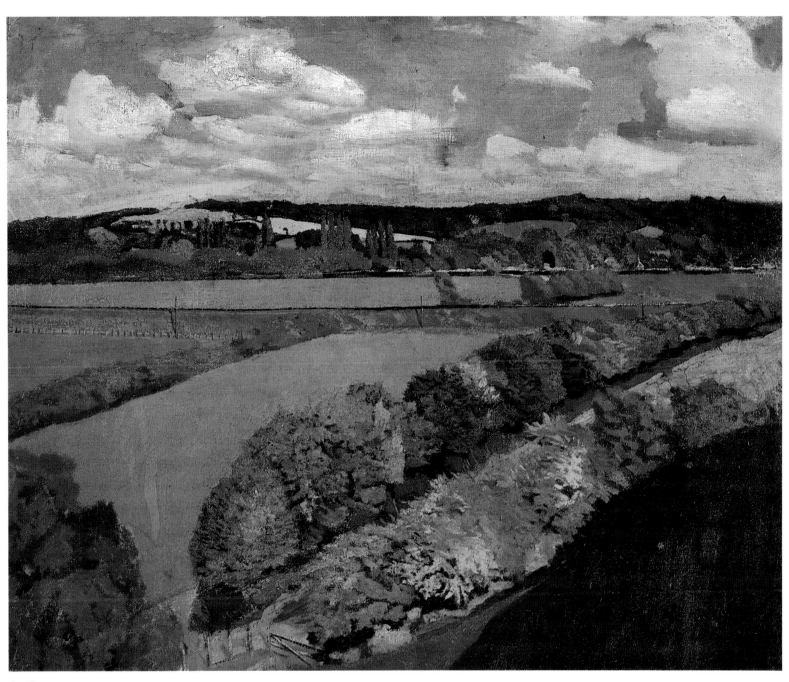

Cat. 19
Cookham
1914

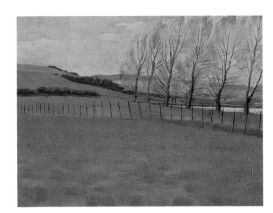

Cat. 55
Cockmarsh
1920

Cat. 58
Durweston Hills
1920

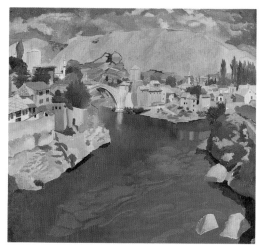

Cat. 88
River Nareta, Mostar
1922

Cat. 82
Sarajevo, Bosnia
1922

Cat. 62
The Mill, Durweston
1920

Cat. 86
Sarajevo
1922

Cat. 89
Ragusa (Dubrovnik)
1922

Sydney and Richard Carline and Gilbert and Stanley Spencer. We did the paintings first and set them in a row in a dear old barn and admired them for all we were worth because you see there was no one else to do so.[17]

Unfortunately, the Seaford paintings have since disappeared, but it seems very likely that they were similar to the Cookham and Bourne End landscapes of the same year.

Spencer's close connections with the Carline circle at this time had brought him back into contact with the London Group, to which both Richard and Sydney Carline were elected in 1920; and the Nash brothers, in particular John, who was a good friend of Gilbert's.[18] Spencer had been elected to the London Group in March 1914 (Japp, Gertler, Paul Nash, Roberts, William Rothenstein and J.S. Currie were rejected at the same meeting), but he never showed with them or participated in their meetings. In the early post-war period, however, he met members of the group like Ginner at Downshire Hill, where they were fairly frequent visitors.[19]

Other members of the Carline circle were also influenced by certain aspects of Post-Impressionism: Hilda Carline's paintings still exhibited the Gauguinesque landscape Symbolism first revealed in *Return to the Farm, Wangford, Suffolk* (1918, private collection), and this now emerged in a slightly less expressionistic form in *Melancholy in a Country Garden* (1921, private collection), which showed the artist's mother, viewed from behind, standing in a garden full of abundant summer growth and gazing through an open gate.[20] Paul Nash, too, was involved in landscapes with Symbolist qualities (see Causey, pp. 88-9), and these, in the form of the Dymchurch paintings, seem to have briefly influenced Richard Carline, particularly in *The Jetty, Seaford* (Tate Gallery) of 1920.[21]

Among this group, Spencer's own work relates most closely to that of John Nash, his brother Gilbert, Henry Lamb and Sydney Carline, all artists who tempered their interest in Post-Impressionism with the traditional English approach to direct observation from nature.[22] Like John Nash, Spencer appears to have varied his treatment of landscape between

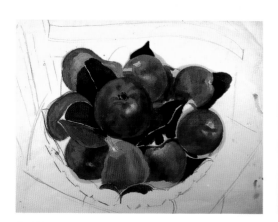

Cat. 98
**Apples and Pears on
a Chair**
c.1920s

Cat. 97
Still Life
1923

a slightly abstracted but naturalistic approach as in *Cookham*, and the strong abstract forms of *Bourne End, Looking Towards Marlow* (1920; 53). In Nash's work a similar approach can be seen in two paintings of 1918: *Cornfields, Wiston, Suffolk*, where the tendency towards abstraction in the curving lines of the field boundaries contrasts with the naturalistic corn stooks and farmworkers; and *The Cornfield* (Tate Gallery), where the composition is controlled by the interlocking planes and masses, while the paint surface is emphasized by subtle variations in texture.[23]

At this time the quality of brushwork in Spencer's landscapes is rough and occasionally even crude, in sharp contrast to his pre-war approach in *Cookham*. To some extent this may have been the result of a change in the support as Spencer had begun to employ small wooden panels for his landscape work in 1920, probably because their small size and robust construction made them easier to use outdoors. However, he also exploited the unprepared woodgrain in the process of forming the composition. For example, in *Bourne End, Looking Towards Marlow* the vertical lines of the grain set against a grey background give the impression of a rainy day. Elsewhere, Spencer even left small portions of the wood

panel showing between the roughly laid-in areas of paint as in *Bourne End, Buckinghamshire* (1920; 52).

While the composition of the small landscapes of 1920-1 is close to the work of John Nash and Gilbert, Spencer may have looked to other sources as well for his new approach to landscape. In the immediate post-war period he was particularly close to Henry Lamb, and this had brought him into contact again with Augustus John.[24] Spencer stayed with the Johns at Alderney Manor, and in June 1920 invited Augustus and Dorelia to his birthday party at the Slessers.[25] John had been using small wooden panels for some of his landscape and figurative work since before the war, notably at Rhyd-y-fen with J.D. Innes in 1911, and Spencer could well have seen some of these in London or at John's studio. There is also evidence that Spencer was influenced by Augustus John's technique, notably the rough, unprepared wood surface, the broad flattish areas of colour and a less radical variation of the scumbled brushstroke. Space, too, was organized in simplified planes, as in John's *Dorelia with Three Children* (1910), but his palette, although generally lighter than the pre-war one, did not have the same Fauvist intensity as John's.[26]

Cat. 101
The Roundabout
1923

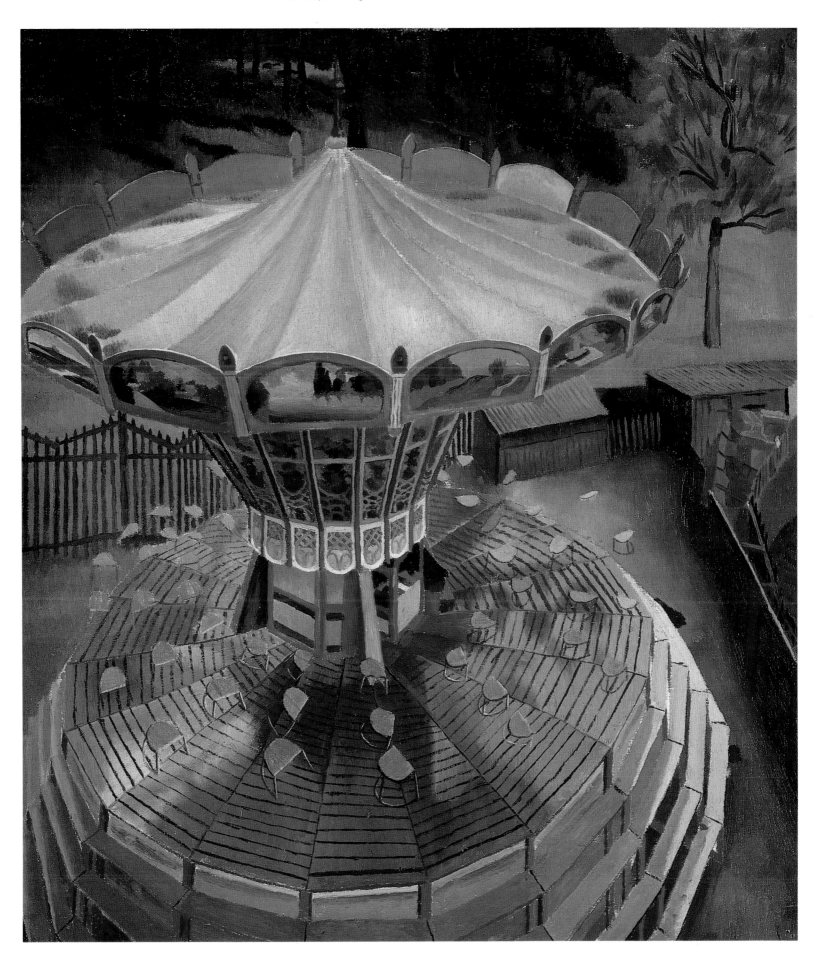

In the summer of 1920 Spencer produced his most sustained landscape series to date when he accompanied Gilbert on a painting expedition to Durweston in Dorset. Here they were joined each day by Henry Lamb who had rented a makeshift studio nearby in Stourpaine in order to complete his last war painting, *Advanced Dressing Station on the Struma* (1916; Manchester City Art Galleries). The stay in Dorset precipitated a crisis for Spencer, who found himself in competition with his brother, whose considerable experience of landscape painting clearly unnerved him. At the same time Spencer was also forced to reconsider his attitude towards landscape work and its place in his career; his uncertainties in this regard being reflected in the nine Dorset landscapes, most of which differ slightly from each other in style.

In a revealing discourse on landscape written on 16 January 1948, following a long commentary concerning 'My Feelings about Anna Karenina,'[27] Spencer recalled that his rivalry with Gilbert reached back before the war and had in part been responsible for his initially taking up landscape painting. As he put it, two early drawings — *Elms* and *Bellrope* were caused 'by competitious [sic] copy of brother,' and 'hence the first two landscapes.'[28] These were followed by 'a third,' *Cockmarsh* (actually *Cookham*), intended as a rival to Gilbert's *Widbrook Common*.[29]

After the war Spencer again reverted to landscape because he 'felt crushed by the war' (what he called 'war depression'), 'and by the wonder of my brother's work.'[30] This attitude continued on their expedition to Dorset, and when the three artists set up their easels together Spencer's competitive side was stirred once again — 'I felt a challenge', he recalled in 1948.[31]

Apart from this sibling rivalry Spencer also faced a number of practical decisions about his career which related directly to the whole business of landscape painting. From his experience in Dorset he drew two conclusions about the future: first 'that [in order] to earn I had to do them [landscapes],' and second that in landscape and portraiture: 'I had no wish or intention ever to be fully expressive by means of painting an object in front of me.'[32] Spencer was probably encouraged in this decision by the ready market for his own landscapes (the Behrends quickly bought three Dorset pictures)

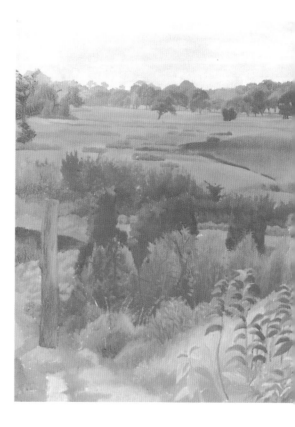

as well as the considerable success of Gilbert's sales, including the purchase of *Sash's Meadow, Cookham* (Tate Gallery) by the National Gallery in 1919, and a financially rewarding one-man exhibition at the Goupil Gallery in 1923, which consisted mainly of landscapes.

Spencer's attitude to landscape also extended to his feelings about Cookham and the choice of an appropriate way to render them in paint — here again his relationship with Gilbert played a part. 'Cookham was for you, as it was for me,' Spencer later wrote to his brother, 'We both had identical sympathies but a different sort of approach.'[33] And in 1958 Spencer wrote in the introduction to his exhibition in Cookham Church: 'While I have a certain respect for my landscapes I was never able to express in this form the meaning that was to be found in Cookham. It was when I painted what I had imagined that I came nearer the feeling that Cookham had for me.'[34] In quoting this passage in his autobiography Gilbert was able to draw his own conclusion on the matter: 'Now surrounded . . . at my retrospective with landscapes such as 'Sash's Meadow" spelling out my love for the Berkshire countryside, our "different sort of approach" was made manifest.'[35] In 1929, however, Gilbert was not so sanguine, declaring angrily to Richard Carline: 'If Stan

Cat. 114
Tree and Chicken Coops, Wangford
1926

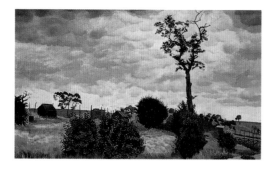

Cat. 106
Turkeys
1925

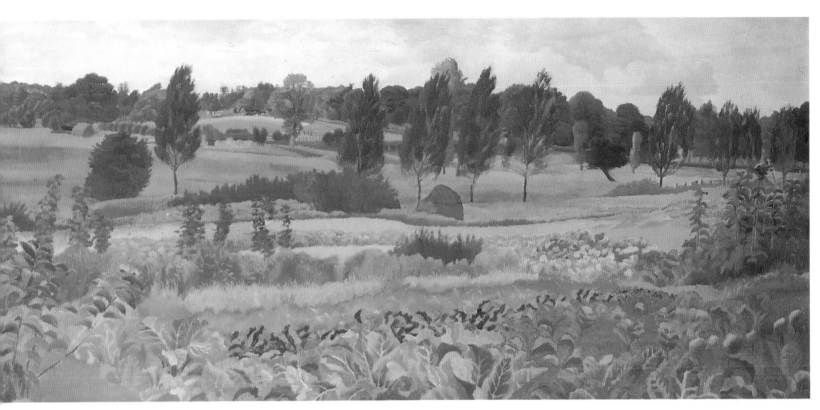

Cat. 103
**Near Southwold,
Suffolk**
1924

thinks that by painting Cookham at both ends he has shut me out he is doomed to disappointment, I have got postcards of Cookham here and am now "throwing up" a couple from them for the Goupil.'[36]

In Dorset in 1920, however, Stanley Spencer was still struggling with the problem of painting a landscape directly from nature. That this proved awkward is very clear from his irritable recollections written in 1948. It is apparent that his main difficulties centred upon the time it took him to complete a picture, and his insistence that it should reflect the scene before him. With an imaginative painting, time had not been a problem, but when the subject was a constantly changing landscape (as in *Landscape with Cultivator* (1920; 61), where the cornfield was cut and stacked as he worked, 733.10.143), everything had to be laboriously repainted.

If Spencer had been willing to work from drawings and not from nature, as Harold Gilman had recommended to John Nash, his landscape production might have taken quite a different turn.[37] Consequently, as he told Gilbert in 1949, 'Because of not understanding or liking this kind of work [landscape] and being unable in any way to find *myself* in it . . . I can do no good work "hence my failure."'[38] In these circumstances landscape was a lifeless

mechanical chore. It was only in figurative paintings, where the characters acted out the workings of Spencer's imagination, that landscape reassumed a dramatic role, as it does in *Zacharias and Elizabeth* (16) or *Love on the Moor* (415). In pictures like these the landscape acquired a poetic intensity rarely found in the pure landscape. Here, the essential relationship between place and imagination — the key to Spencer's creativity — is clearly apparent in his description of the early wash drawing *Jacob and Esau* (1910-11; Tate Gallery) which was 'done near Cliveden . . . just before getting there we used to sit in among some felled trees and there while I thought out something Syd [his brother] would read about Jacob and Esau or — the song of Solomon. The land seen at the back of my figures of Jacob and Esau . . . is what we gazed out at as we sat.'[39]

Despite his misgivings, Spencer worked hard at Durweston and the nine paintings which he produced there show him moving away from the more roughly painted Bourne End works, towards a style once again based upon the careful observation of nature which was to become the hallmark of his mature paintings of the mid-1920s. Spencer's work was now closer to Gilbert and Lamb's more traditional approach to landscape,[40] particularly in *Durweston, Thatched Cottages* (64), but his taste

Cat. 139
**The Blacksmith's Yard,
Cookham**
1932

Cat. 119
The Cultivator
1927

Cat. 132
Cottages at Burghclere
1930

Cat. 140
Villas at Cookham
c.1932

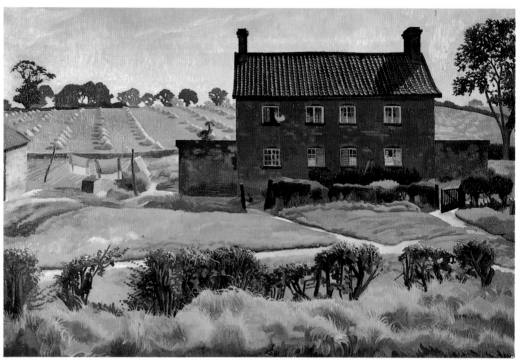

Cat. 126
**The Tarry Stone,
Cookham**
1929

Cat. 112
**The Red House,
Wangford**
1926

could still be eclectic: in *The Mill, Durweston* (62)
the repeated patterns of the lock and the
millhouse windows have a distinctly Cubist
form, whose effect is enhanced by the
over-all greyish tonality. Elsewhere, in *Durweston
with Harrow* (61) and *Farm in Dorset* (59), and
like the slightly later *Quarry Woods, Cookham*
(1920-1; 67), the narrow foreground curving
fields, heavy massing of trees and the blond
tonality recall John Nash's work.[41]

Both Spencers, John Nash, Sydney Carline
and Henry Lamb all shared quite similar
attitudes to the painting of the English
landscape.[42] Through their association with
the Camden Town and London Groups, they
had developed an interest in prosaic subjects,
painted with what soon became a minimum
of reference to current artistic styles, and
composed from a careful observation of the
southern English countryside.[43] All five artists
also centred themselves in or near the country
whenever they could: Spencer at Cookham
and Wangford, Lamb at Stourpaine and
Coombe Bissett, Gilbert at Garsington,
Sydney Carline in Oxford, and John Nash in
Gloucestershire and later East Anglia.

Another factor which also linked the group
was the minimal way in which their painting
styles altered after the mid-1920s. This was
particularly evident in the work of Nash,
whose style was set as early as 1918; and
Spencer, who had established the basis of

his manner at Durweston and who rarely
changed it substantially after c.1925.[44] These
similarities between the painters were soon
recognized by the critics, and the commentator
for the *Scotsman* writing on Sydney Carline's
landscapes, then on view in the *Young Artists
Exhibition* in 1929, remarked: 'He may be said
to belong to the school of the Spencers and
Henry Lamb — a school which is peculiarly
English. His landscapes are tender and sweet
in colour, without ever descending into the
pretty. They are kept from this by a certain
bareness and severity in design. . . .'[45] Unlike
Nash, Sydney Carline and to some extent
Henry Lamb, however, Spencer was
determined not to be drawn into painting
landscapes to the detriment of his figurative
work, and if some critics saw in this group
of artists an incipient school of English
landscape painting, he was by no means a
willing participant.

Despite his disagreeable experience at
Durweston, Spencer continued to paint
landscapes when the opportunity arose, usually
when he was away from his studio on visits to
Seaford, Coggeshall, or Lady Ottoline Morrell's
at Garsington. These paintings show a new
assurance, both in their composition and in
their use of colour to establish form and
depth. Although Spencer was still occasionally
dependent on outside influences, for example
Paul Nash for the open foreground and dark

massing of trees in *The Quarry Woods, Cookham*, he also began, in this same painting, to establish the compositional format which was to remain the mainstay of his landscape *oeuvre* up until his death in 1959. This consisted of a foreground filled with foliage beyond which, after a narrow intervening space, the view pulled sharply back into the distance, in this case to a row of farm buildings with hills beyond. This provided a solution to the empty foregrounds of a number of his earlier works, as well as allowing him to give a conspicuous place to foliage, which he painted with brilliant facility in such figure paintings as *The Nativity* and *The Resurrection of the Good and the Bad*. Once again Spencer's approach was probably inspired by Pre-Raphaelite examples.[46]

In July 1922 Spencer joined the Carline family on an extended painting trip to Yugoslavia.[47] Spencer had been 'inspired' while painting with the Carlines at Seaford in 1920 and, being at a loose end after the collapse of the Steep scheme, he found this a convenient moment to join the party.[48] In addition he must have felt that a spell of landscape painting would provide a useful income now that he was no longer living with his patrons the Slessers and Bones.[49]

Once in Yugoslavia, Spencer joined the Carlines in painting from sight in the towns and countryside. The landscapes which resulted

(82-90) show his new confidence in handling landscape composition. In his paintings Spencer returned to the paler colours of his recent figure paintings, notably *Christ's Entry into Jerusalem* (1921; 70) and *Bond's Steam Launch* (1920; 40), using clear greys, buffs, olive greens and a soft pinky-beige. Consequently, the paintings present a unified appearance, where each area of colour is clearly defined and not muddied, as was the case in the earlier Durweston works. Spencer also temporarily altered his composition, on this occasion using a vertical or square format which enabled him to accommodate the distant views and abrupt mountain slopes of the Yugoslavian countryside.[50]

During the early twenties Spencer's landscapes sold steadily to Henry Lamb, Edward Marsh, Sir Michael Sadler, and the Slessers and Behrends, patrons of his figurative painting who were already familiar with his work. Prices of the earliest pictures were not recorded, but by 1923 when Spencer began to exhibit at the Goupil Gallery he was able to sell *The Roundabout* (101) to Sir Michael Sadler for the substantial sum of £40, the same price paid by Lamb for *The Centurion's Servant* before the war.[51]

The publication in 1924 of Wilenski's monograph, which included illustrations of nine landscapes out of a total of thirty-five paintings and drawings, probably widened

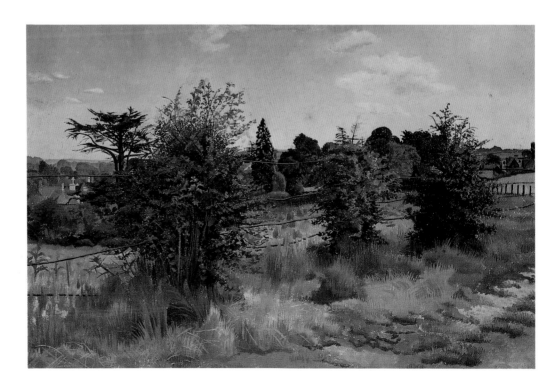

Cat. 141
Terry's Lane, Cookham
c.1932

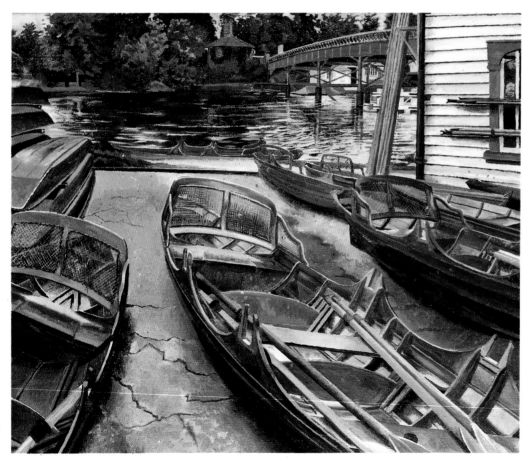

Cat. 134
Turk's Boatyard, Cookham
1930

Cat. 210
**Boatbuilder's Yard,
Cookham**
1936

Cat. 144
**Swiss Skittle Alley:
Saas Fee**
1933

Cat. 148
**The Angel,
Cookham Churchyard**
1933

Cat. 143
Alpine Landscape
1933

Cat. 157
Landscape, Burghclere
1933-4

Cat. 149
Gypsophila
1933

Cat. 159
Rowborough, Cookham
1934

Cat. 173
Pound Field, Cookham
1935

Cat. 179
Zermatt
1935

Cat. 177
Cookham Lock
1935

Cat. 180
Clipped Yews
1935

Cat. 205
Flowering Artichokes
1936

Cat. 175
Madonna Lilies, Cookham
1935

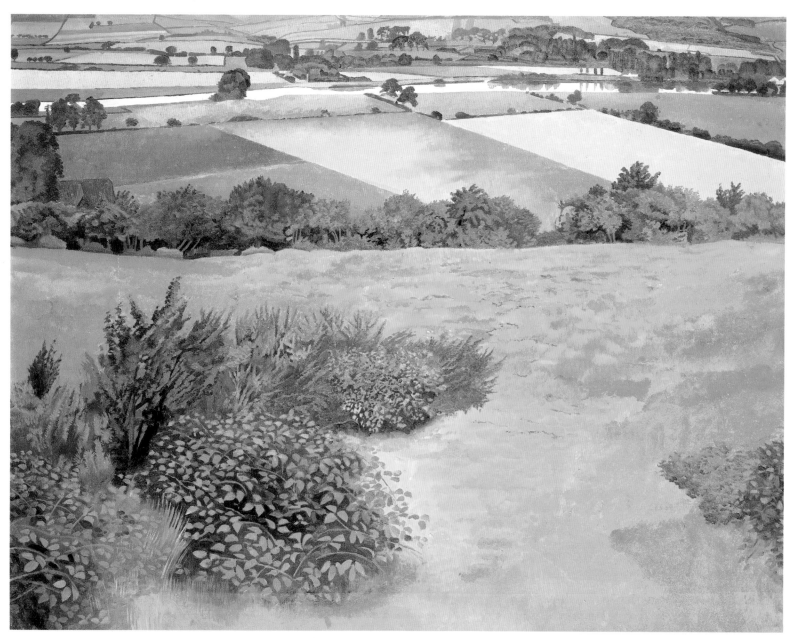

Cat. 176
Cockmarsh Hill, Cookham
1935

public appreciation for this type of subject beyond Spencer's immediate circle of admirers.[52] This became evident at the 1927 Goupil exhibition where Spencer showed twelve (and possibly fifteen) landscapes, many of which were sold to new collectors, like C.F.A. Evelyn, P. Tudor-Hart and Lynda Grier, who had no particular interest in his figurative work.[53] As a result, Spencer's collecting public was considerably broadened and he was no longer dependent on the small network of friends, collectors and fellow artists who had supported him since his Slade School days.

In all, Spencer sold eleven out of the twelve landscapes and still lifes listed in the exhibition catalogue, for prices ranging from 25 guineas for *Lake of Scutaria, Montenegro* (90) to £65. 5s. for *Stinging Nettles* (109); this compared well with the sum of 50 guineas paid by Captain Ernest Duveen for *Soldiers Washing* (118), and £68. 5s. for *Joachim Among the Shepherds* (14), a pre-war work bought by Lady Ottoline Morrell.

This success was repeated in the following years, with *Near Halifax* (124) going for £35 at the 1928 Goupil salon and *The Cultivator* (119) for £55 at the Spring Exhibition of Modern Art in 1929, where it was bought by Lynda Grier.[54] In 1931, despite the depression, prices increased with the sale of *Turk's Boatyard, Cookham* (134) for £63, probably because of the

prestigious purchase of *Cottages at Burghclere* (131) by the Fitzwilliam Museum from the Goupil salon the year before; and in 1933, the last year that Spencer exhibited work with Goupil's, the relatively dull *Barley Hill* (136) fetched £65, probably reflecting Dudley Tooth's new, inflated pricing policy.[55]

The growing popularity of Spencer's landscapes was further enhanced by the generally favourable reaction of the critics: at the Goupil exhibition most attention was directed to *The Resurrection, Cookham*, but the *Near East and India*[56] felt that *The Source of the Buna, Mostar* (87) 'has a striking unit of design, and is pleasingly coloured,' while the *Yorkshire Post* found Marsh's *Cookham* 'beautiful.'[57] The critic of the *Birmingham Post* was more rigorous, commenting: 'In his landscapes his inclination is towards a photographic realism which at its best is satisfying in its fidelity to nature . . . and at its worst, open to serious criticism because it becomes unimaginative and commonplace . . . nothing but a matter of fact statement of obvious things, without inspiration and mechanically exact.'[58] This apt criticism, which seems to have been aimed mainly at the later landscapes, points not only to the reason for Spencer's popular success as a landscape painter, through his accurate portrayal of familiar intimate English settings,

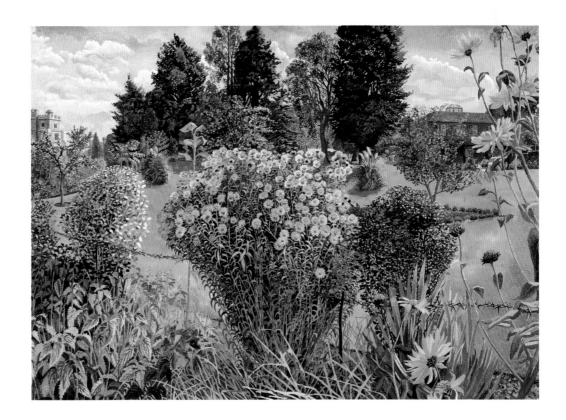

Cat. 207
Bellrope Meadow
1936

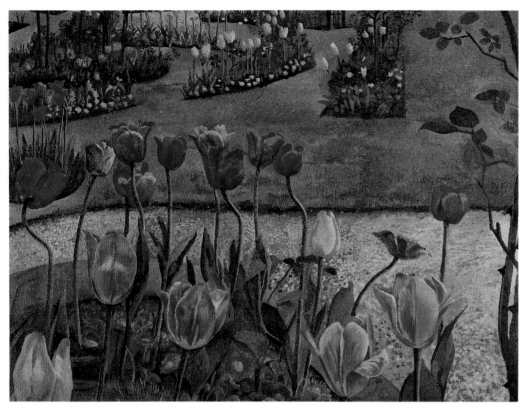

Cat. 211
Tulip Beds
1936

Cat. 208
Gardens in the Pound, Cookham
1936

Wangford in the summer of 1926, when he painted several substantial views of the village and surrounding countryside. Despite his sales successes he still agonized over painting them; in a letter to Desmond Chute in 1927 about *Stinging Nettles* he mused: 'It is strange that I feel so "lonely" when I draw from nature, but it is because no sort of spiritual activity comes into the business at all.'[61] Although he 'felt something growing inside me' as a result of painting *Stinging Nettles*, nevertheless he usually found landscapes 'dull and empty,' devoid of the spiritual exaltation of 'a resurrection or a visitation' which had 'something marvellous' about it.[62] This 'unevenness' between the two types of subject-matter left Spencer feeling 'dubious of myself altogether' as he felt that both should move him equally.[63]

Spencer's letter to Chute revealed both his intellectual puzzlement over his landscape problems and a determination to find at least some satisfaction in these paintings. He actually achieved this more often than he cared to admit, most notably in the mature culmination of the twenties, *Cottages at Burghclere* (132), painted in 1930. Here he was able to suggest an extraordinary balance between the neatly trimmed and cultivated cottage gardens and the aggressive tangle of brambles and weeds that press against the rickety fence and lopsided gates; a mixture of nature and civilization that is also described vividly in Hardy's Wessex novels. In this painting Spencer achieved an intense naïve identity with every detail of the picture in a manner that closely resembles the atmosphere of his figure paintings.

A new stage in Spencer's landscape painting came in October 1932, when he transferred from Goupil's (where Marchant had recently died) to Arthur Tooth and Sons in Bruton Street. Dudley Tooth first approached Spencer in a letter dated 6 March, when he asked the artist to join the gallery, offering as 'bait' a one-man exhibition.[64] Spencer agreed and informed Mrs Marchant of his intention to transfer to Tooth's in October,[65] the agreement being finalized in November.[66]

Spencer's arrangement with Goupil's seems to have been a loose one, but Dudley Tooth preferred a more commercial approach, insisting that all potential purchasers be referred to the gallery and that work be circulated to other dealers to 'widen the market.'[67] Early pressure

but also to the relative lack of later critical interest in his landscape work. For his approach to landscapes must have seemed (by 1924 anyway) to have withdrawn from contemporary development, most notably the more obvious Modernism of Nash's Dymchurch paintings or his Surrealist landscapes of the late twenties.[59] Significantly, the last major reference to Spencer's landscapes in connection with the modern movement occurred in 1930, when *The Times* critic described *Cottages at Burghclere* as 'the work of a Pre-Raphaelite who has looked at Cézanne,' continuing, however, to remark: 'Without for a moment disparaging the intelligent application of lessons from France . . . it may be questioned if Mr Spencer is not showing a better way in working towards unity through what may be called the rough of his native talents.'[60] Clearly, the more conservative English critics found Spencer's lack of interest in European Modernism reassuring, as well as being indicative that a 'national' art (in the High Victorian sense) was still in existence despite the activities of Fry, Bell and other European-oriented critics and artists.

Throughout the twenties Spencer continued to paint landscapes whenever he could find time between work on *The Resurrection, Cookham,* and Burghclere Chapel; for example, at

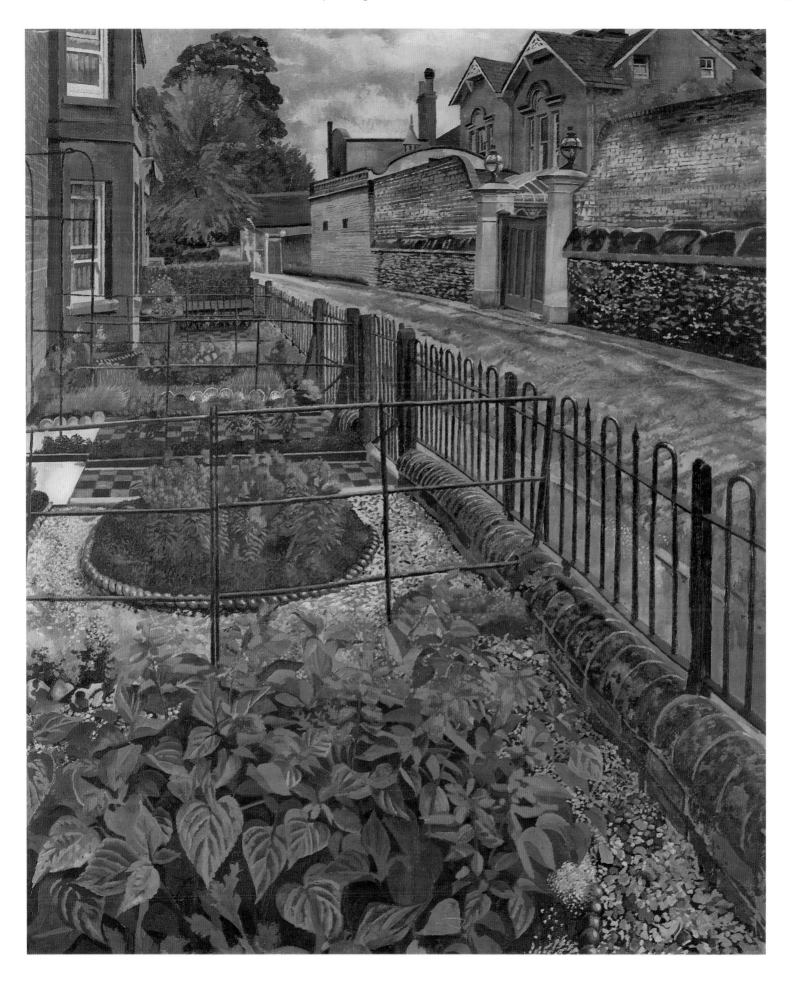

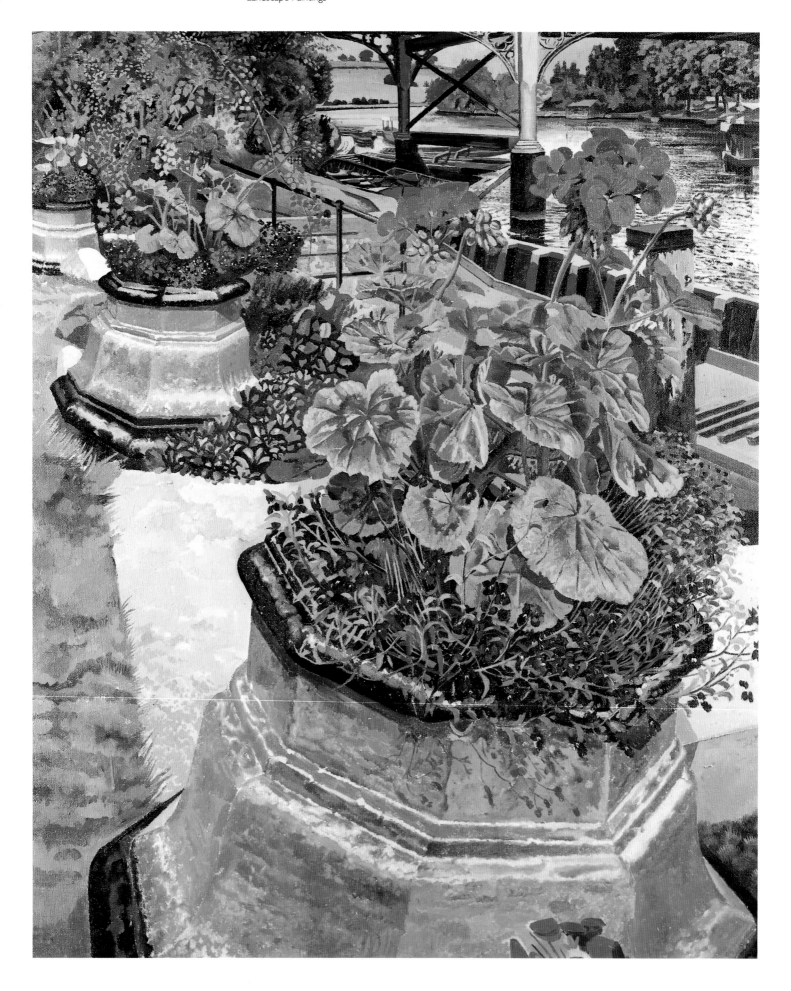

Cat. 215
Upper Reach, Cookham
1936

Cat. 214
Laburnum
1936

Cat. 213
**The Jubilee Tree,
Cookham**
1936

Cat. 219
**Ferry Hotel Lawn,
Cookham**
1936

Cat. 212
The Garden
1936

Cat. 218
Cookham Rise: Cottages
c.1935-6

from Tooth for more paintings led to Spencer's cancelling a projected exhibition in 1933 as well as refusing to send paintings to the Royal Academy: 'I can't make pictures to order,' he wrote to Tooth, who was forced to back off with the placatory 'Paint when you are in the mood.'[68]

It is clear that while Tooth was prepared to carry the figure paintings, he really wanted Spencer to paint landscapes of the kind which had sold so well at Goupil's. Spencer found landscape difficult and slow, and told Tooth he wanted 'to do figure paintings like *Sarah Tubb*' instead.[69] The important purchase by the Tate Gallery of *Terry's Lane, Cookham* (141) in May 1933[70] did nothing to alter his position, and he complained to Tooth that: 'As I feared everyone as usual wants my landscapes . . . I am very sorry that public galleries are taking [them] as being representative works of mine.'[71] Twice, in June 1933 and again in 1937, Spencer tried to stretch his agreement, to create freedom to sell his figure paintings elsewhere. In both cases Tooth reined him firmly in with reminders of their contract.[72]

Despite these difficulties Tooth seems to have established an uneasy truce with Spencer whereby he agreed to sell the figure paintings in exchange for a steady flow of saleable landscapes. This agreement might have held good except that by 1935 Spencer was so seriously in debt that in December he was ordering Tooth to sell his landscapes for whatever price they would fetch.[73] Later, in 1936, Tooth advised Spencer, now totally dependent on him for financial support, to paint as many landscapes as possible.[74] Consequently, Spencer painted seventeen landscapes before the end of 1936 and five flower paintings over the winter, when it was too cold to work outdoors. This pressure to produce continued throughout 1937 and reached a peak in 1938, when Spencer completed nineteen still-life and landscape paintings between 13 February and 10 August. It was only towards the end of 1940, when income from the WAAC commissions started to come in, that Spencer was able to ease the relentless production-line process a little; he painted only three landscapes in 1941, three in 1942 and one in 1943.

If Tooth's pressure to produce landscapes was irksome to Spencer, his hard-headed promotion paid handsome dividends and did much to elevate Spencer's prices and to broaden his public and gallery sales. Despite the Depression he quickly sold *Villas at Cookham* (140) and *Terry's Lane, Cookham* (141) for £85 and £60 respectively;[75] and in July he sold *The May Tree* (142) to Lord Balniel for £150, the price paid by Beddington-Behrens in May of the following year for the important *Sarah Tubb*.[76] Thereafter, prices remained generally stable throughout the thirties, averaging between £100 and £150 for a good-quality 30 x 20 inch landscape, reaching a peak in 1936 when *Bellrope Meadow* (207) fetched £350.[77] In a letter to Spencer of 8 May 1933, Tooth noted that the sale of *Terry's Lane, Cookham* to the Tate Gallery would help to sell four of Spencer's figure paintings which were then at Bruton Street. Tooth was clearly relying on sales to major art galleries to generate interest among collectors. Despite Spencer's urgings in the late thirties, Tooth, with the odd exception, seems to have ignored appeals for quick sales and maintained the level of pricing which he had carefully worked to establish.

Tooth's considerable success in selling the landscapes enabled Spencer to pay off some of the debts accumulated in his extravagant courtship of Patricia Preece.[78] But at the same time the demand for new work frequently interfered with the production of imaginative figure paintings intended for the *Church House*.

Working on the advice of Dudley Tooth, Spencer attempted to respond to market demand by producing the type of work which sold best. In January 1936, for example, he remarked that 'Galleries seem to want bigger landscapes,'[79] and immediately embarked on a number of larger canvases, some of which did indeed sell to galleries that year – notably *Boatbuilder's Yard, Cookham* (210, Manchester City Art Galleries) and *Gardens in the Pound, Cookham* (208, Leeds City Art Galleries). The centrepiece of this campaign was *The Jubilee Tree, Cookham* (213), painted especially for Spencer's 1936 one-man exhibition at Tooth's. On 27 April 1936 Spencer informed Dudley Tooth that in producing the picture he was making 'a big effort for the show,' concluding, '[the picture] adds to the importance and significance of the less big ones [landscapes and Domestic Scenes].'[80]

Spencer worked hard for the 1936 exhibition, keeping several paintings on the go at once and engaging (as he informed

Tooth) in a 'herculean labour' to finish *Corner in the Garden* (216, no. 20 in the exhibition) in time for the opening on 25 June.[81] These efforts paid off, and the majority of the paintings sold while the exhibition was up were landscapes, much to Spencer's evident disgust. 'I am sorry so few of my pictures (not landscapes) sold,' he complained to Dudley Tooth, 'as it was really to have been a show of my pictures and not my landscapes.'[82] Spencer's ire was confined to the buyers, and did not apply to the critics, who for the most part ignored the landscapes to concentrate on the figurative paintings. Some, like Anthony Blunt, went so far as to dismiss the landscapes as trivial, calling 'a few unimportant canvases like *Laburnum*' fillers 'which seem to be included just to show that he can paint prettily if he wants to.'[83] There was at least one critic, however, working for the *Scotsman*, who wrote about the landscapes in an evocative manner which probably reflected quite accurately the sentiments of those people who bought them:

Personally I think Spencer is in the tradition of British Pre-Raphaelitism . . . the poetic naturalistic kind of Hunt, Brown and the young Millais. Spencer paints landscape as they did, not so minutely of course, but with the same prodigious delight in all the facts of nature for their own sake. He loves to paint nettles and grasses leaf by leaf, blade by blade, as they did. He loves it all too much to leave anything out.[84]

The success of Spencer's landscapes in the period between the wars was firmly based in the growing idealization of the countryside which has been identified by Martin J. Wiener (see also Chapter 2),[85] and which found expression in the 'back to the land' movement after the First World War; and which was

Cat. 236
Cottage at Wangford
1937

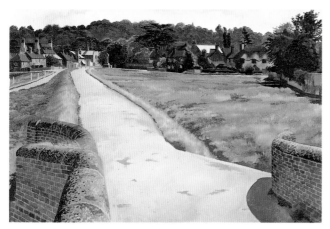

Cat. 234
Cookham Moor
1937

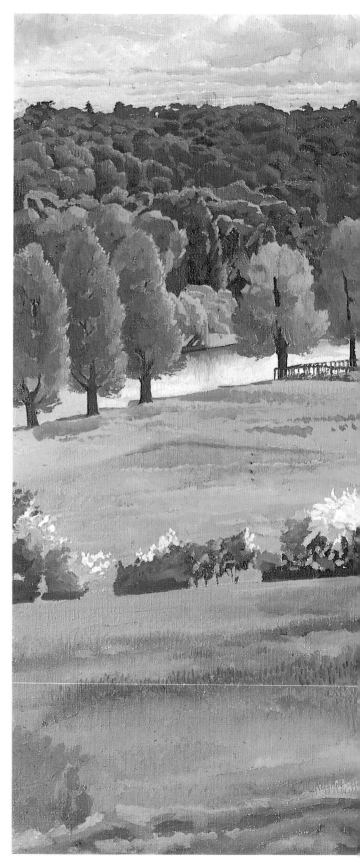

Cat. 233
Cookham on Thames
1937

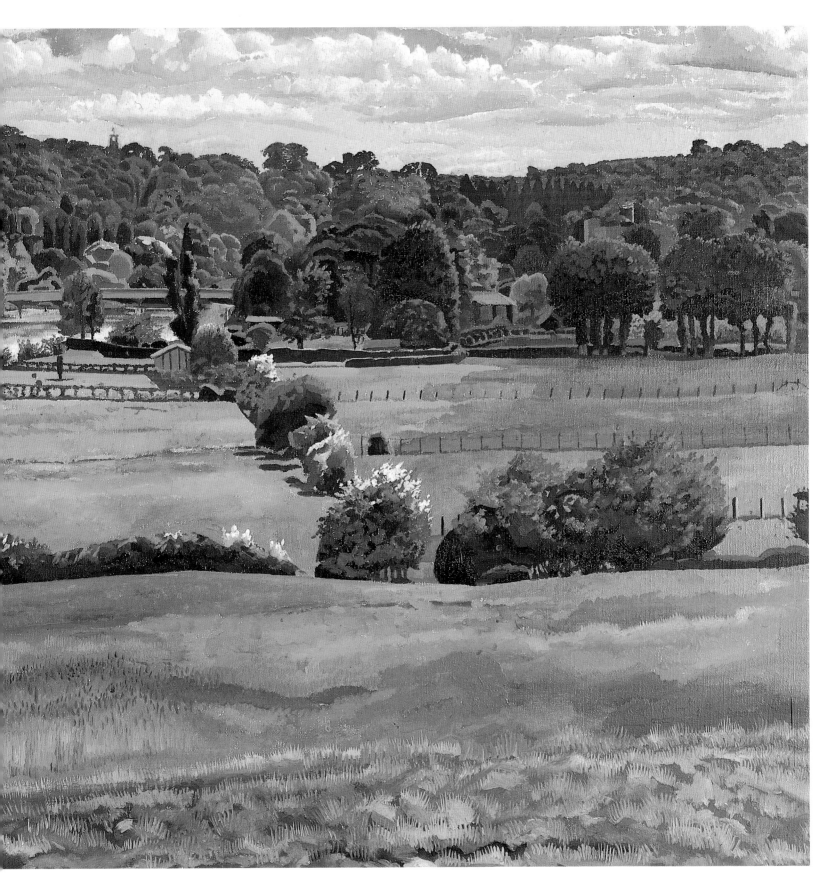

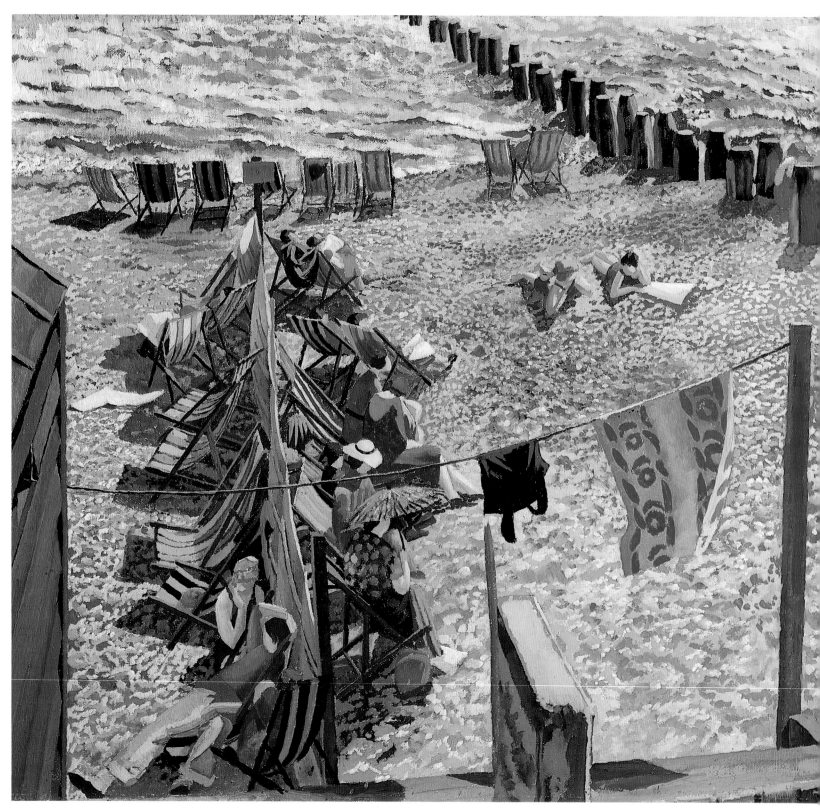

Cat. 235
Southwold
1937

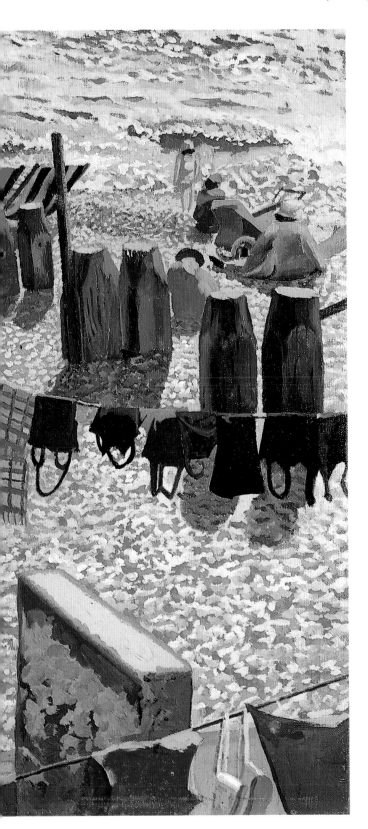

Cat. 238
Wet Morning, St Ives
1937

Cat. 240
The Harbour, St Ives
1937

Cat. 241
Fishing Boats, St Ives
1937

supported by books like Longman's *English Heritage* series in 1929,[86] the programmes produced by the BBC on the 'national character'[87] and the growth of what Osbert Lancaster called the 'cultural cottage.'[88] In 1924, the editor of *Country Life* remarked: 'The villages in days gone by earned us the title of "Merrie England." Now the towns have made us "Wealthy England," but, were it not for the villages, [they] would smother us in their riches.'[89] Spencer's images of tranquil southern landscapes must have strongly appealed to the readers of *Country Life*, with its idealized vision of solid rural English values.

These interests were made more accessible by the increasing ease with which growing numbers of people could explore the rural landscape on day trips in the new motorcars.[90] In the art world this attitude is mirrored in the Nashes' and Carlines' continuing interest in landscape subjects, and in the retreat to the country of Henry Lamb to Coombe Bisset in the twenties and of Augustus John to Fordingbridge. Among writers of both conservative and radical persuasion, there were numerous examples of fascination with rural life. Ronald Blythe remarked on '. . . the

almost religious intensity of the regard for rural life in this country';[91] and E.M. Forster compared town and country and found the former lacking: 'Houses, houses, houses! You came from them and you must go back to them. Houses and bungalows, hotels, restaurants and flats, arterial roads, by-passes, petrol pumps and pylons – are these going to be England? Are these man's final triumph? Or is there another England, green and eternal, which will outlast them?'[92] Elsewhere, in popular literature, similar attitudes can be found in H.V. Morton's *Daily Express* series 'in search of England' (published as a book of that title in 1927),[93] and the commentaries of Arthur Bryant on the BBC.[94] In this context, Spencer's almost naïve vision, with its mixture of sharp, close-up detail, long views over the cultivated countryside, and a combination of picturesque village, garden and farmland views, must have appealed to the growing number of English people (and expatriates) who saw rural Britain as the repository of all that was best about the national culture.

From the beginning, the patrons of Spencer's landscapes fit in well with this image. During the twenties the Slessers and Behrends, both country families, purchased a number of landscapes, often of familiar views.[95] After Tooth's takeover the clientele widened, but continued to be based on families who lived in the country and had business connections with London, like J. Spedan Lewis and J.W. Freshfield who both lived in the Cookham area, or Lady Kleinwort (later the owner of Sezincote).[96] Others who lived in London but maintained country connections, like Lady Gollancz and Wilfrid Evill, were also important supporters, as were expatriates such as E.W. Hayward and J.R. McGregor in Australia.[97] Finally, the resurgence of interest in the English garden, best represented by Gertrude Jekyll's designs and books, probably accounts for the popularity of Spencer's garden scenes, which were purchased by ardent gardeners like the Countess Cawdor, who bought *Flowering Artichokes* (205) in 1936 and *Polyanthus* (256) in 1938.[98] The very 'Englishness' of the image of Spencer as a latter-day portraitist of local landscapes, identified as working in the tradition of Samuel Palmer or Constable, must have been an added attraction to a clientele whose main connections with modern art tended to be the

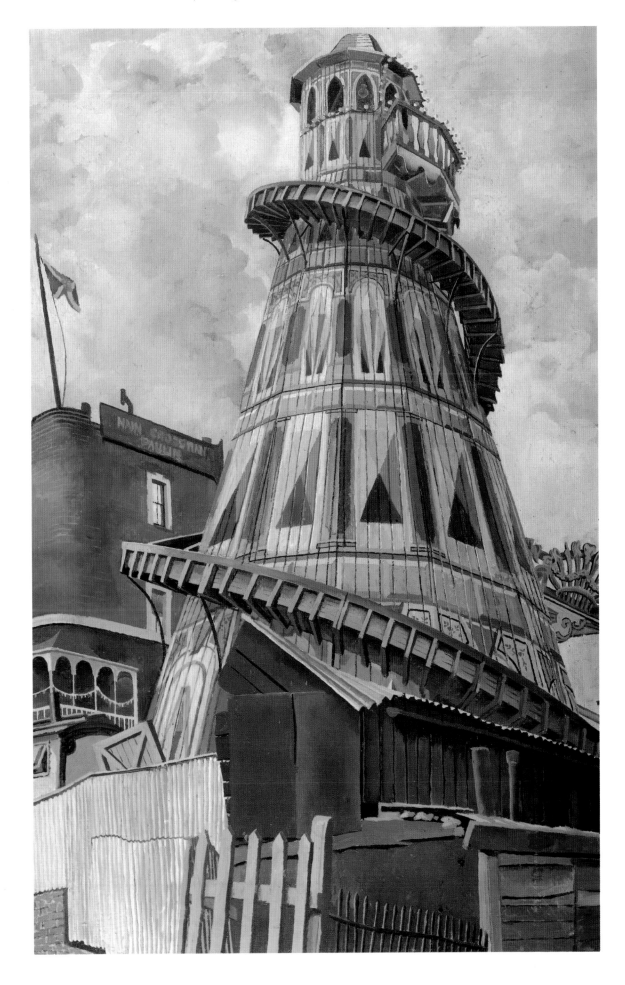

Cat. 244
Helter Skelter,
Hampstead Heath
1937

Cat. 252
**Garden View,
Cookham Dene**
1938

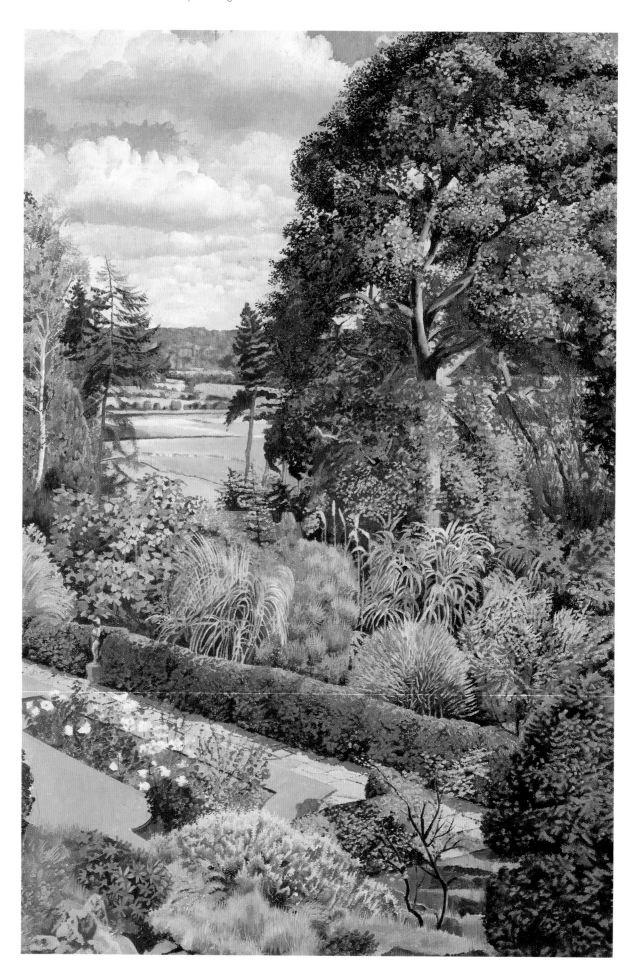

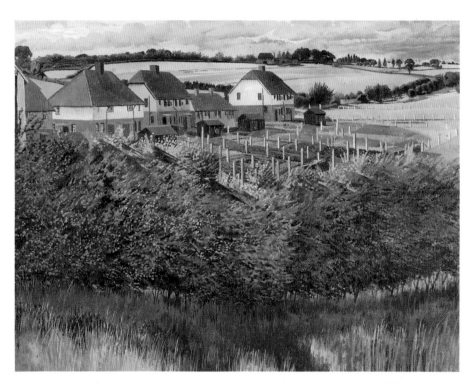

Cat. 265
Cookham Rise
1938

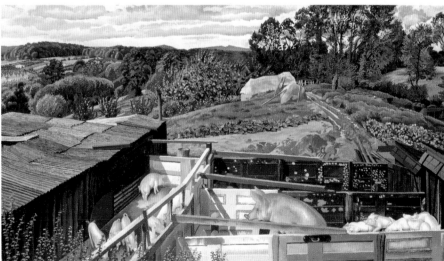

Cat. 253
**Rickets Farm,
Cookham Dene**
1938

Cat. 257
Landscape with Magnolia,
Odney Club
1938

Cat. 242
The White Cockatoo or
Coronation Cockatoo
1937

Cat. 259
Columbines
1938

Cat. 267
Crocuses
1938

Cat. 266
**Cookham,
Flowers in a Window**
1938

Cat. 251
From the Artist's Studio
1938

Cat. 275
Landscape in North Wales
1938

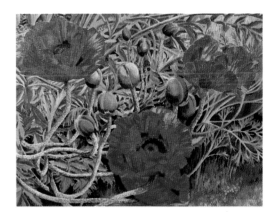

Cat. 260
Poppies
1938

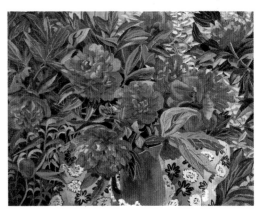

Cat. 273
Peonies
1938

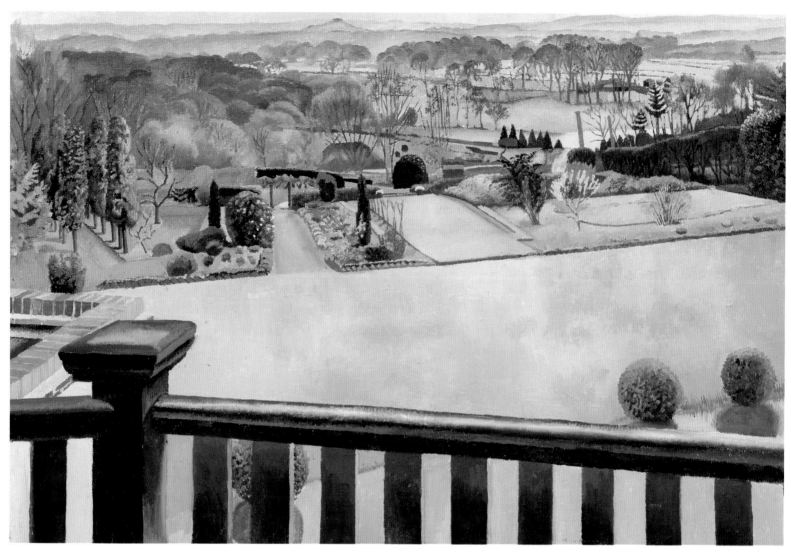

Cat. 285
Oxfordshire Landscape
1939

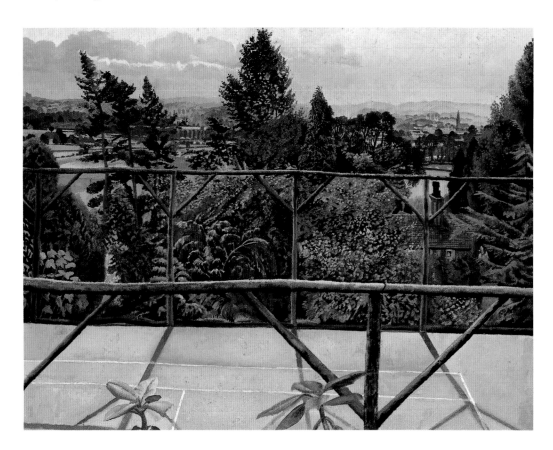

Cat. 272
View from the Tennis Court, Cookham
1938

Royal Academy summer exhibitions, and who were at best indifferent to contemporary developments in so-called avant-garde art. This was still evident in Spencer's surviving supporters from the 1950s, for example, the Martineaus (405), Mr and Mr P. Metz (435) and Mr and Mrs G. Robinson, all of whom visited the Royal Academy Summer Exhibition every year. Marjorie Metz was particularly proud that Spencer's portrait of her had been exhibited there in 1958.[99]

Along with Tooth's assiduous salesmanship and the responsiveness of the public, the other reason for the popularity of Spencer's landscapes was the undoubtedly high quality of his best work. Following his early success with *Cottages at Burghclere*, Spencer produced a string of fine paintings during the thirties, including *The May Tree* (1932; 142), *Gardens in the Pound, Cookham* (1936; 208) and *Cookham Moor* (1937; 234), all of which drew their quality from his intense absorption in familiar views, his unerring control of space, and his childlike ability to depict every detail set before him, almost without discrimination. This need to create a reality which can almost be touched is also found in the figure paintings such as Spencer's nude portraits of Patricia Preece painted between 1935 and 1937.[100]

Spencer's best landscapes were often the product of his own personal feeling about certain places. In the 1940s, for example, he told Tooth that some landscapes like *Bellrope Meadow* and *Moor Posts* were 'studies or preludes' for figure paintings,[101] a statement which probably also applied to *Cookham Moor*, the setting for *Love on the Moor* begun in the same year. Other places had been the sites of pleasurable experiences: in the case of *Southwold* (235), for example, a visit during his honeymoon with Hilda in 1925.

Stylistically, Spencer's landscapes follow the format he had established in the mid-1920s, with a block of foreground detail backed by a sharp plunge into depth. In the thirties, however, he subjected this foreground area to increasingly detailed analysis, leading to a quasi-photographic realism, as can be seen in *The Jubilee Tree, Cookham* (1936; 213), *Greenhouse and Garden* (1937; 243) and *Magnolias* (1938; 248), where plants and old iron railings received the sharply focused treatment normally afforded to still life, a genre upon which Spencer was also concentrating at this time.[102] These cosy, still-life-in-landscape paintings were accompanied by garden studies, like *Cactus in Greenhouse* (1938; 249) and *Rock Roses* (1957; 430) and the occasional still life

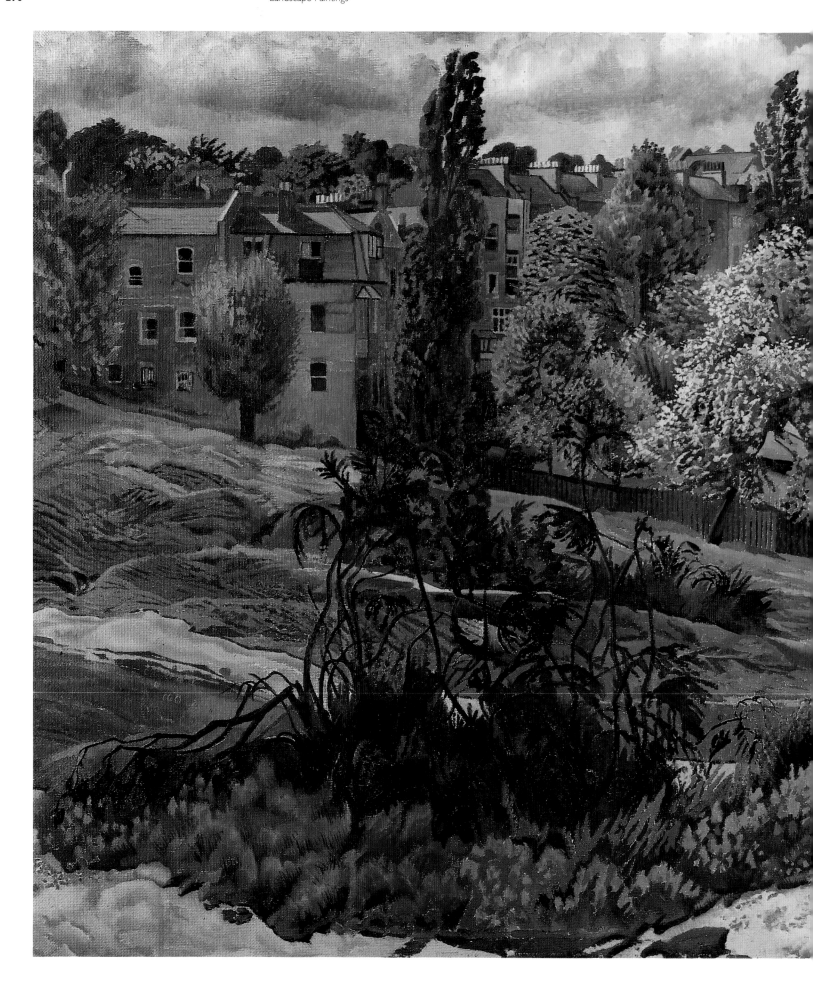

Cat. 278
**Landscape,
Cookham Dene**
1939

Cat. 284
**The Vale of Health,
Hampstead**
1939

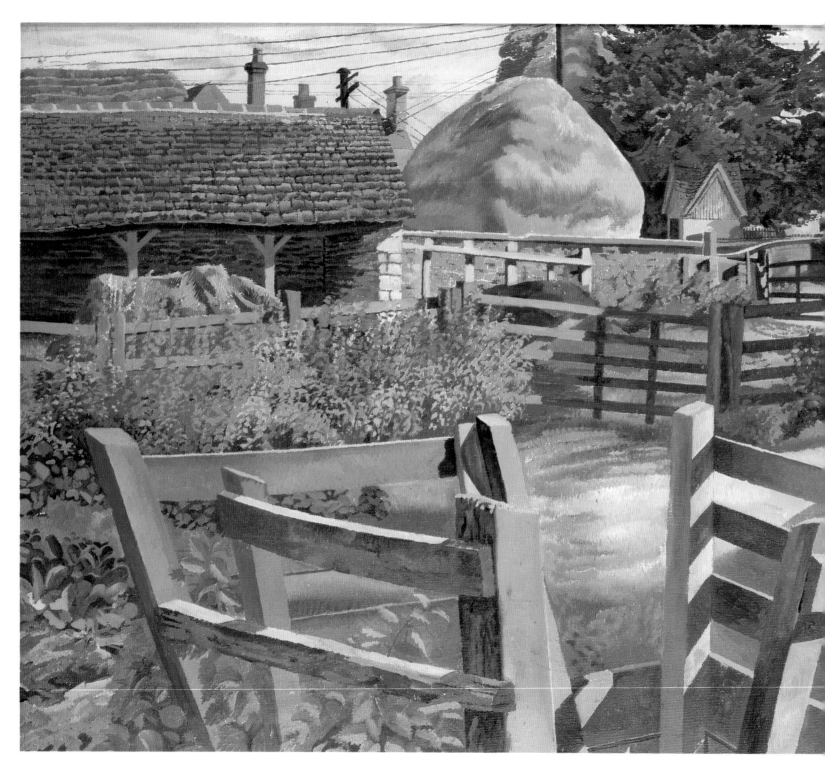

Cat. 300
Priory Farm,
Leonard Stanley
1940

Cat. 303
**The Alder Tree,
Gloucestershire**
1941

Cat. 315
**Marsh Meadows,
Cookham**
1943

Cat. 311
**Rock Garden,
Cookham Dene**
1942

of circumstantial and realistic detail, so that smoking factory chimneys and gasometers are painted with the same sensuous enjoyment of colour and texture that is lavished on flowering shrubs, trees and old farm buildings. Invariably, Spencer evoked a feeling of idyllic warmth and sensuousness: of flopping down in a field of wild flowers on a warm spring day in *Buttercups in a Meadow* (306; 1941-2), of pausing to glance across open fields to a distant line of trees, or of plunging into the thick damp bushes around a millhouse in Gloucestershire. Like a child, Spencer imposed no value judgement or moral considerations on his subject, and the paintings must have reminded prospective purchasers of endless summer holidays in the country. Significantly, perhaps, this uncomplicated vision of a truly English landscape was to remain popular during the war, when a number of Spencer's most evocative landscape paintings were bought by serving officers.[103]

After the war Spencer was still in debt, and faced with the continuing, unenviable task of producing landscapes for quick sale. Dudley Tooth maintained his pressure for picturesque subjects, and complained when Spencer reverted to views immediately to hand like *The Scrap Heap* (317; 1944), which Tooth declared to be 'not everybody's subject.'[104] In the meantime, prices for works like *Apple Trees in Snow* (291; 1940), which sold for £140, were up again to their pre-war level, and by 1947 had finally risen to £200 for *Kings, Cookham Rise* (337) and *Wheatfield at Starlings* (336).[105]

In 1950 the need to produce landscapes eased, with the success of the *The Resurrection, Port Glasgow* paintings and the readmission of Spencer into the Royal Academy.[106] During the remaining nine years of his life Spencer continued the habits of his earlier career, painting landscapes when away from his studio, as for example when he stayed with his brother at Whitehouse in Northern Ireland, or on his trip to China in 1954. At the same time, now once more socially acceptable in Cookham, and more than ever the great, if 'eccentric,' village artist, he received numerous commissions from the commuter-belt ruralists who increasingly made up the population of the Maidenhead area, and who now took up Spencer as the portraitist of their comfortable life-style. In this way Spencer not only painted or drew the Mayor and Mayoress of

such as *White Violets* (1938; 247), the latter apparently painted purely for financial reasons. Finally, Spencer continued to make use of more traditional compositional devices, the most common of which, used for more extensive views, consisted of an elevated viewpoint looking down across the countryside towards the horizon, as in *View from Cookham Bridge* (1936; 209) and *Cockmarsh Hill, Cookham* (1935; 176).

During this period the paint quality of Spencer's pictures also changed, from a relatively thickly worked surface, as in *Cottages at Burghclere*, to the thin, evenly brushed and almost transparent paint of mid-1930s works like *St Ives, Low Tide* (1937; 237) or *Pound Field, Cookham* (1935; 173). The colour also lost some of the richness of the earlier paintings, and often assumed a uniform set of green, brown and greyish tones, with some exceptions, like the brighter *Magnolias* (1938; 248) or *Gardens in the Pound*. There seem to be few specific stylistic reasons for these changes, which also occur in the figurative works, and it appears likely that Spencer thinned out his paint surfaces both as an economy measure in difficult financial times, and to increase his rate of production.

In the best of Spencer's landscapes, the scenes are always supplied with an abundance

Maidenhead, their son and their dog, but also portrayed the garden at their house, Chauntry Court (1953; 388). [107] Other local families, like the Martineaus, and Spencer's most assiduous patron, Mr G.G. Shiel, all acting rather like small-scale eighteenth-century country gentry, also commissioned portraits both of themselves and of their houses or gardens.[108] Flower pieces and still lifes of the opulent gardens around Cookham proved equally popular, and again sold locally, for instance, *Winter Aconites* (1957; 429) to the Rev. Michael Westropp, the vicar of Cookham, or *Snowdrops* (1955; 411) to the Martineaus.

As usual, Spencer found these commissions a strain, complaining to Myra Baggett, a Cookham resident, in 1957 that it was 'hard enough to get myself to start one of these exacting landscapes';[109] the difficulties were increased because of his need to paint directly from the subject, in this case the transitory May blossom, which might vanish before the work was completed. Nevertheless, Spencer clearly took greater care over the commissioned works of the fifties. Without abandoning the thin, even paint surfaces of

the pre-war works, he now paid increasing attention to detail in canvases such as *The Brew House* (1957; 428) and *Wisteria at Englefield* (1954; 394), which achieved a level of photographic realism exceeding even that of some of the thirties paintings, like *The Jubilee Tree, Cookham* (1936; 213).

Throughout his career as a landscape painter, Spencer's popularity with conservative collectors and the Academy-visiting public scarcely wavered. On the other hand, critical supporters of the avant-garde and purchasers of modern movement paintings had for the most part ignored Spencer's landscape works after the early twenties. It is ironic, therefore, that by the time he died in 1959, contemporary art was again about to pay renewed attention to the kind of intensely realistic work that Spencer had practised during the decade and a half since the war.

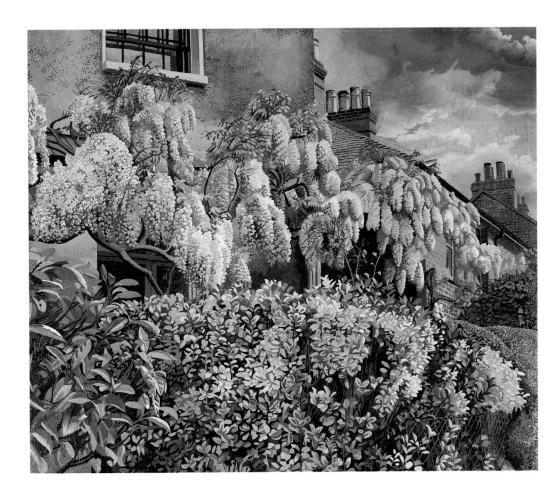

Cat. 310
Wisteria, Cookham
1942

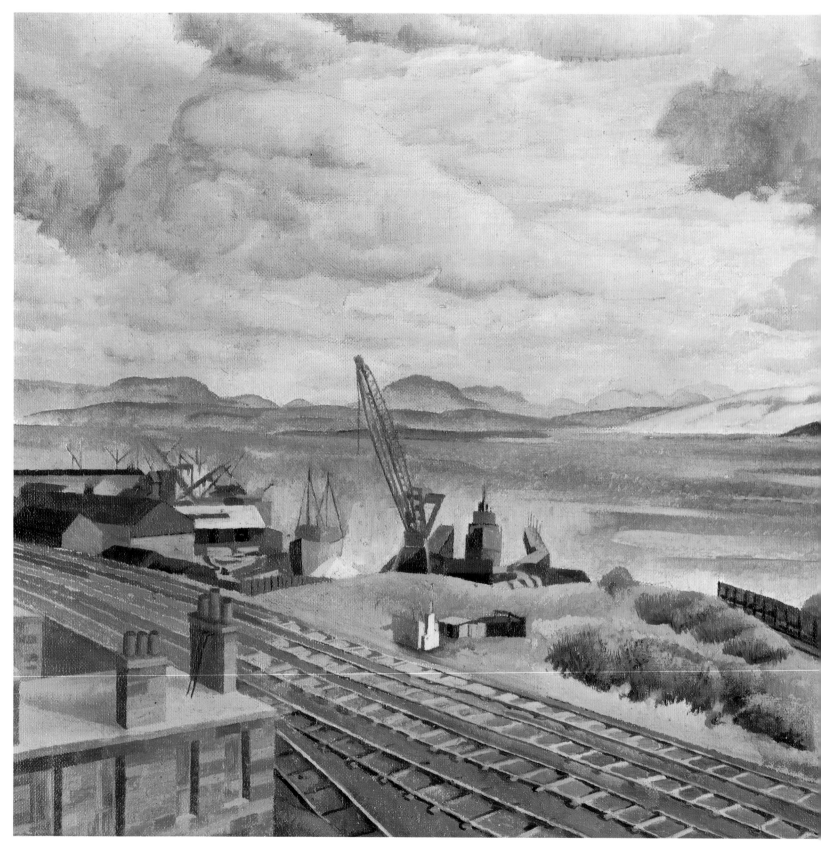

Cat. 322
**The Clyde from Port
Glasgow**
1945

Cat. 317
The Scrap Heap
1944

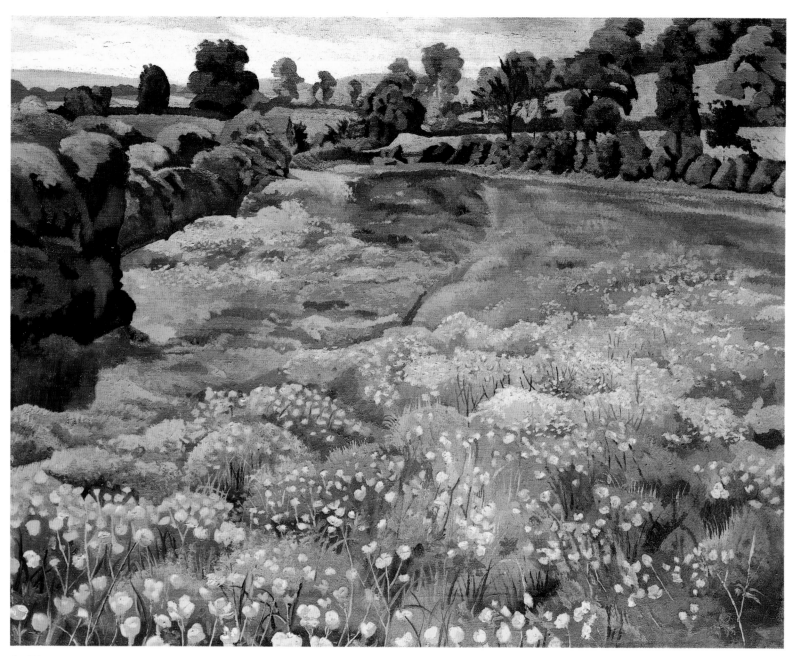

Cat. 306
Buttercups in a Meadow
1941-2

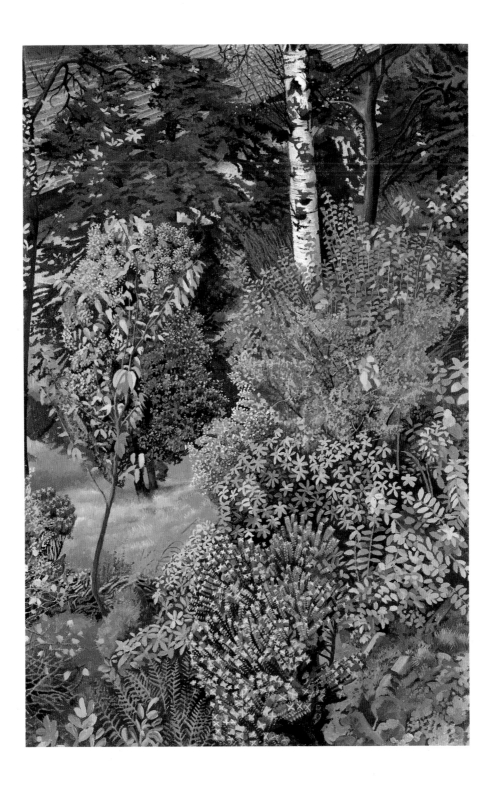

Cat. 318
**Garden Scene,
Port Glasgow**
1944

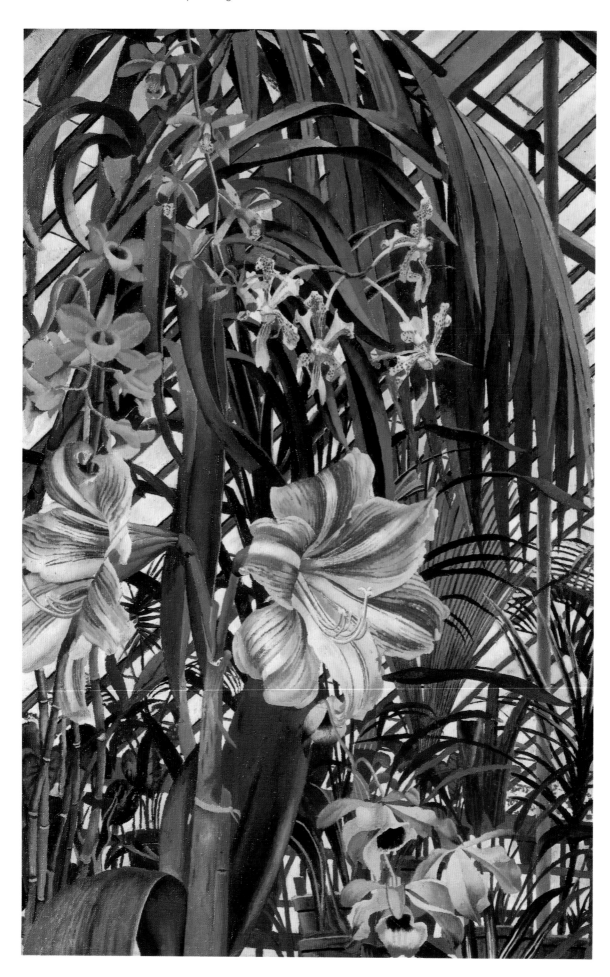

Cat. 326
Orchids, Lilies, Palms
1945

Cat. 335
Garden Study
1947

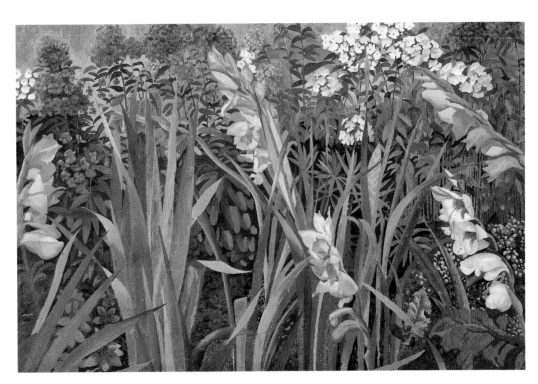

Cat. 325
Peonies
1945

Cat. 338
Port Glasgow Cemetery
1947

Cat. 344
Goose Run, Cookham Rise
1949

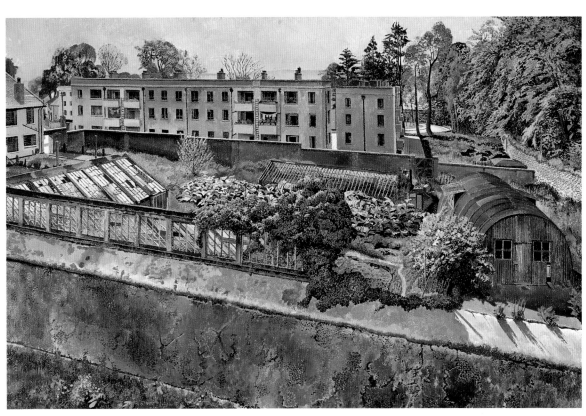

Cat. 369
**Merville Garden Village
near Belfast**
1951

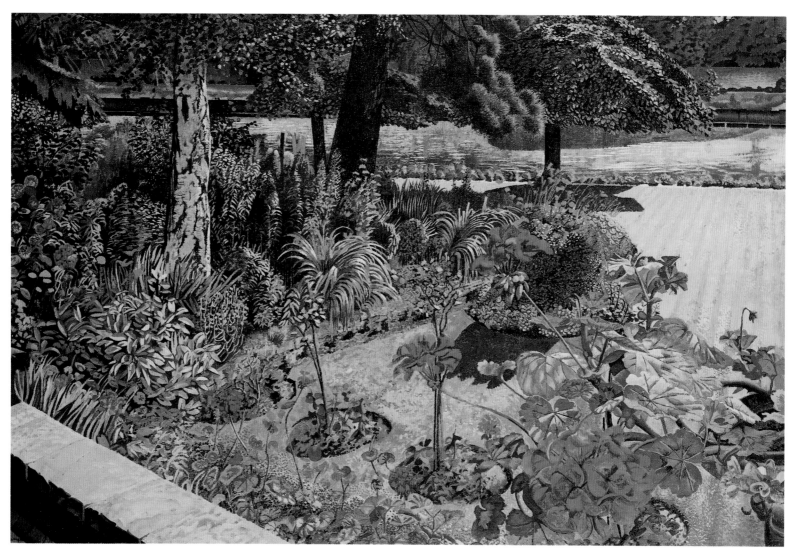

Cat. 388
The Thames at Chauntry
Court
1953

Cat. 362
**Amaryllis in Chauntry
Court**
1951

Cat. 375
**The Monkey Puzzle,
Whitehouse,
Northern Ireland**
1952

Cat. 394
Wisteria at Englefield
1954

Cat. 396
Wallflowers
1954

Cat. 452
**Extensive Landscape with a
Wrought-Iron Gate**
Unfinished

Cat. 398
Ming Tombs, Peking
1954

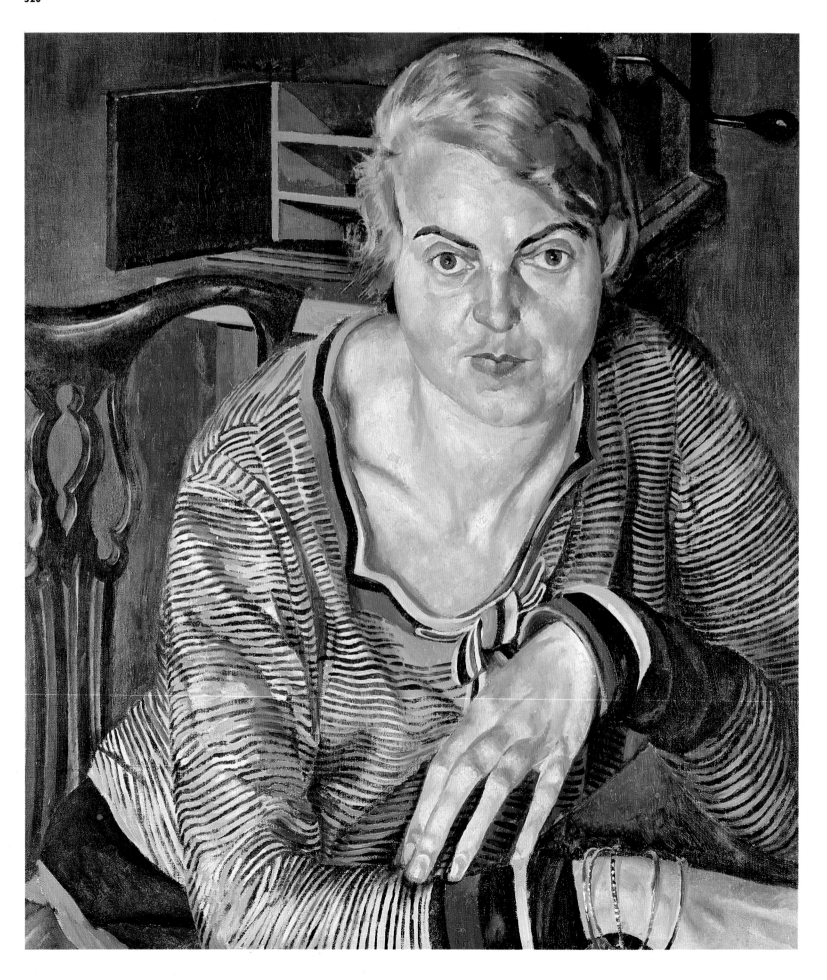

Portraits

Cat. 154
Portrait of Patricia Preece
1933

N early all Spencer's figure paintings were inhabited by portraits of his friends and lovers or self-portraits of Spencer-like personalities who lived in the 'Cookham world' of his imagination. However, Spencer also produced a small but fine body of portraits *per se*: self-portraits, paintings of friends and commissioned portraits, which were, for the most part, independent of his imaginative works.[1] As in the case of the landscapes these pictures have received comparatively little attention in the literature on Spencer; while in exhibitions, portraits have often been treated merely as punctuation-marks in his career. This chapter is intended to provide a clearer understanding of the development of Spencer's portrait style, as well as its sources, and its relationship to other English portraits, particularly those of the 1920s and 1930s.

Spencer's earliest recorded oil portraits, of his brothers Sydney and Will (3, 2), were painted in 1912 or 1913 at about the same time that he began work on the large Tate *Self-Portrait* (17). Spencer later 'lost' both these pictures, but it is likely that they were in the form of small oil sketches, rather than fully finished paintings.[3]

When Spencer returned to portrait painting in the 1920s, it was usually as an aside from work on the more important imaginary figure subjects. He preferred to draw 'heads' of friends or people who took his fancy, a habit

which he had formed during the war, when he drew portraits of patients and orderlies in his spare time. Much later Spencer recalled that he enjoyed this activity because of his 'exquisite appreciation of heads.'[4] With the exception of some early pen and ink self-portraits (see RA, nos. 17, 18), these were usually drawn in pencil, using the Slade style of delicate shading and soft outlines. In the early post-war years Spencer, his brother Gilbert and the Carlines often drew one another in the studio at 47 Downshire Hill, and on one occasion attempted to paint a Miss Silcox at a group sitting.[5] The only oil painting to emerge from these sessions was Spencer's small *Portrait of Richard Carline* (1923; 100) painted in a style similar to Lamb's earlier portrait of *Romilly John* (1923, Manchester City Art Galleries), and making the sitter look every inch the romantic young artist, with his head resting on one hand and his gaze directed moodily to the light.[6] Earlier, in 1920, Spencer had painted *Lady Slesser* (33) in a relaxed mood with her head turned towards the viewer as if in mid-conversation.[7] This leisured pose and informal setting were very different from those of the stuffy, self-conscious society portraits exhibited at the Royal Academy by artists like G. Spencer-Watson or Sir John Lavery RA.[8] Instead it recalls Lamb's 1914 portrait of *Lytton Strachey* (Tate Gallery), or the deliberately unforced portraits of the Camden Town painters, for example Drummond's *19 Fitzroy Street* (c.1913-14, Laing Art Gallery, Newcastle), showing Manson, Gore and Ginner (?)

discussing a painting, and *Portrait of Charles Ginner* (1911, Southampton Art Gallery), or Gore's *North London Girl* (c.1911, Tate Gallery).[9] Through Lamb, Spencer may also have seen or heard of the Bloomsbury artists' equally informal portraits dating back to Duncan Grant's early *Portrait of James Strachey* (1909), and including Vanessa Bell's *Conversation Piece* (1912; University of Hull Art Collection), and *Frederick and Jessie Etchells Painting* (1912, Tate Gallery). After the war the tendency of Bloomsbury '. . . to revert to construction in depth' – as Fry termed it in the catalogue essay for the *London Group Retrospective Exhibition: 1914-1928* – in paintings like Grant's *The Hammock* (1921-3, Laing Art Gallery), brought their work, superficially at least, closer to that of the Carline circle. Spencer's portrait style, however, remained rooted in the direct observation of nature which is also characteristic of his drawings of heads, and in the contemporary work of the Carlines, Lamb, and to some extent William Roberts.[10]

Portrait painting played a considerable part in the activities of the Carline circle in the early 1920s, and Spencer's portrait of Lady Slesser may have emerged, in part, as a response to the ambitious series of paintings produced by Lamb and Carline. Lamb in particular was engaged on a number of group portraits between 1919 and 1926, which included *The Anrep Family* (1919-20, Boston Museum of Fine Arts), *The Kennedy Family* (1921; Charles Kennedy, Esq.), and *The Tea Party* (1926; Lord Moyne, also known as *The Round Table*). The easy relaxed atmosphere which Lamb sought to achieve in these portraits is also to be found in Richard Carline's *Family Group* (1923, formerly Tate Gallery, destroyed), and *Gathering on the Terrace* (1925; private collection), which sum up the private and public aspects of the Carlines' life at 47 Downshire Hill.

In the catalogue to the *Henry Lamb* exhibition held in 1984, Dr Keith Clements suggested (p. 42) that Lamb's paintings, *The Anrep Family* and *The Kennedy Family* (cat. nos. 49-52 in the exhibition), were 'strongly influenced' by Spencer. However, Lamb was already a skilled portrait painter as the Strachey picture shows, and the portraits probably reflect the dialogue which went on between Lamb, Spencer, Richard Carline, and their friends in the Carline circle, rather than the specific influence of Spencer alone. Certainly the emphasis on

the prosaic, almost 'uncomposed' portraits of all three artists suggests that the rejection of deliberately 'arty' picturesque settings by the Carlines' recent teacher Percyval Tudor-Hart also affected the way they went about portrait subjects.[11] While Richard Carline was perhaps the most doctrinaire in his application of Tudor-Hart's teachings (see, for example, the very austere *Portrait of Hilda Carline*, 1918, Tate Gallery), the latter's influence should also probably be seen in Spencer's portrait of Lady Slesser, and Lamb's portraits, particularly those of the Anrep and Kennedy families.[12]

In none of these cases, to my knowledge, were the pictures commissioned, and the artists were able to proceed as they wished. Commissioned portraits soon came to take up more and more of Lamb's time, however, and despite some delightfully informal pictures of the early thirties his work tended to become more traditional in its composition.[13] Spencer, on the other hand, apart from his numerous portrait drawings of heads, either avoided or did not receive any commissions until the 1940s, and particularly the 1950s when his remade reputation at the Royal Academy brought increasing pressure to do portrait work.

During the thirties, as Spencer became more isolated from this circle of artistic friends, his portraits became increasingly intimate, and he confined his subject-matter almost entirely to those who were most immediately involved in his personal life, Patricia Preece and Hilda Carline. Spencer and Preece had become close friends after his return to Cookham in 1932 and by 1933 she began to appear as an important character in several figure paintings, notably *The Meeting* (145) and *Separating Fighting Swans* (152). Working in Cookham, Spencer no longer had access to models, and Patricia agreed to sit for him for a series of portraits, the earliest clothed, but later also in the nude.[14] In the first of these paintings, *Portrait of Patricia Preece* (154), Spencer showed her, looking large-boned and slack, leaning awkwardly on a table, and with her head framed by a gramophone. Despite her fashionable clothes Spencer made no attempt to idealize her as academic portrait painters might have done, choosing instead to accentuate her heavy, rather unattractive features, and large awkward hands.[15]

Spencer continued to paint portraits of

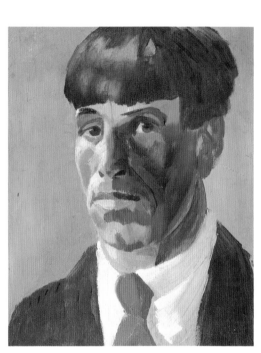

Cat. 102
Self-Portrait
1924

Cat. 17
Self-Portrait
1914

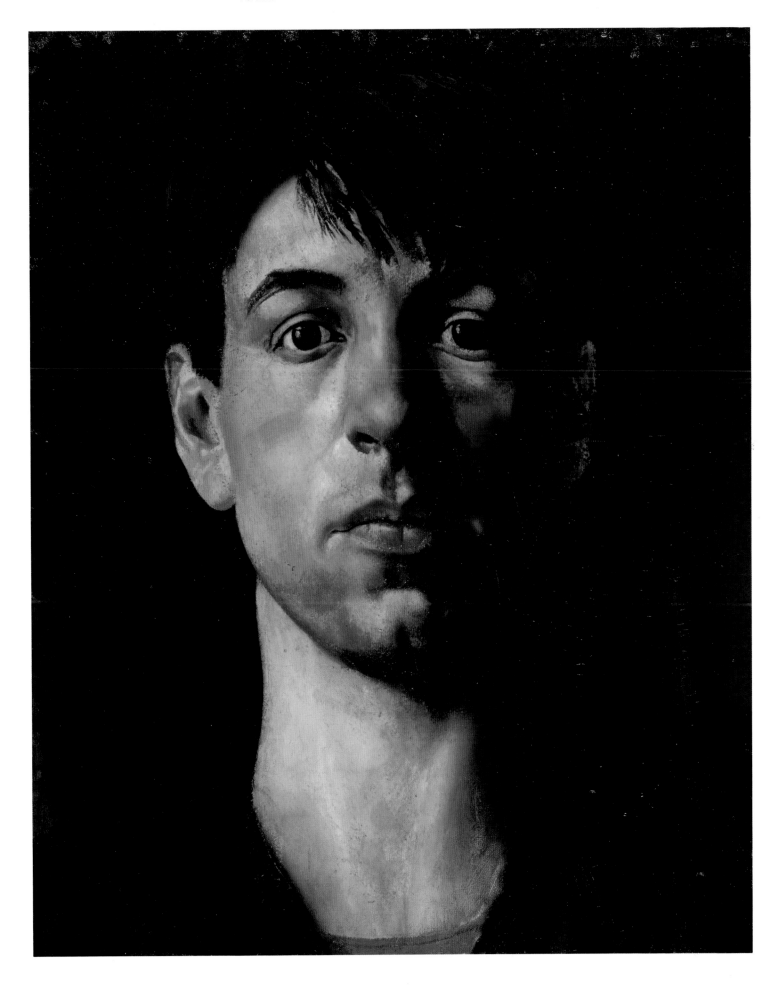

Cat. 69
Mrs C.P. Grant
c.1920-1

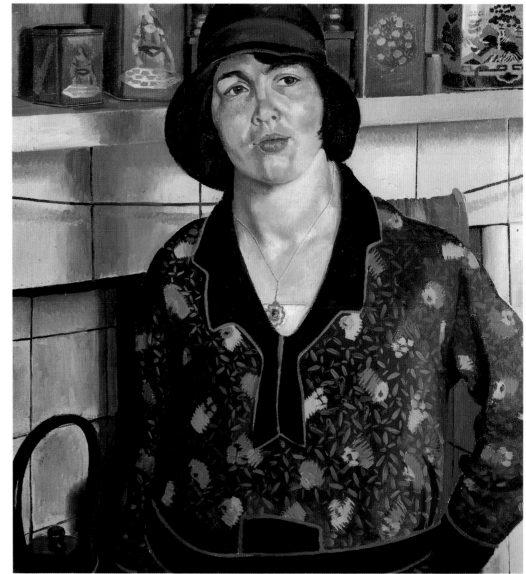

Cat. 129
Country Girl: Elsie
1929

Cat. 100
Portrait of Richard Carline
1923

Cat. 165
**Nude, Portrait of
Patricia Preece**
c.1935

Preece between 1933 and 1937, including six extraordinary and erotic nude studies (165, 166, 167, 222, 223, 225), as well as a number of drawings.[16] Of these, only one, *Nude or Girl Resting* (222) of 1936, showing Preece wearing a black slip and a velvet band round her forehead, approximated to a conventional study. Spencer portrayed her as a thirties *Olympia*, a boudoir nude whose eroticism is enhanced by the rumpled sheets, and by the sharp contrast of smooth skin and lacy underwear, with its suggestive tuck between the thighs.[17] Even here Spencer rejected idealization for unnervingly direct observation which emphasized her coarse hands, and the ungainly tangle of fingers and toes by which she tried to hold the pose.[18]

The intense atmosphere of sexual anticipation found in *Nude or Girl Resting* is also present in the two Nudes (165, 166) of 1935, where Preece is shown in full and half-length, her flesh contrasted with the upholstery to give a real sense of nakedness; and the sexual tension is further emphasized by her suggestive stare, the fuzz of pubic hair and the lovingly painted pendulous breasts.

During the period 1933-7 Spencer's relationship with Preece was fraught with difficulties. He clearly desired her physically, but at times the pressures created by their on-off relationship seem to have made him impotent.[19] Nevertheless, the intensity of his desire had, by 1936, brought him literally into the picture as a participant or perhaps as a supplicating lover. In the first of these Spencer placed himself naked and kneeling beside the bed upon which Preece reclined, his head framed by her breasts and hips. The shock of intimacy is thus heightened, and the invisible lover of *Nude or Girl Resting* now takes his place within the composition.

In the second double nude, *Double Nude Portrait* (1937; 225), Spencer took this idea even further, joining Preece on the mattress, squatting in his favourite position, and staring down at her frankly available flesh. The scene should be erotic, but Preece's indifferent stare, and the fact that Spencer is still wearing his glasses, gives the painting a voyeuristic mood. One is given the impression that, Pygmalion-like, Spencer was trying to will his model into life. The atmosphere was made stronger still by the inclusion of the chop and leg of mutton, emphasizing the rawness of the

unidealized nudes, and pushing the sheer physicality of the encounter to new lengths.[20] Clearly the painting was an outlet for his frustrated sexuality, and a means of preserving his obsessive voyeurism.

When he retrieved the painting from Tooth's in 1955, Spencer still found it 'absorbing and restful to look at,' but commented: 'it is direct from nature and my imagination never works faced with objects or landscape.'[21] This judgement was perhaps rather harsh, but it pointed to Spencer's perennial struggle to achieve 'expressiveness' in his portraits. For his clients, however, this fidelity to nature could on occasion prove to be highly attractive.

Spencer had painted the Preece nudes as individual works with no particular programme in mind. In 1942, however, he allocated them to a special room in the *Church House* devoted to Preece's memory; the *Double Nude Portrait* was to hang in the centre, flanked by the other nudes on the side walls.[22] This concept was replaced in 1948 by an expanded version, which now included selected compositions from the *Scrapbook* drawings series.[23] This mingling of portraits with imaginative works in the Patricia 'Chapel' was unique in the design of the *Church House*, but Spencer clearly felt that the inclusion of explicit nudes was an important part of his theme of sexual freedom within a religious context. As he wrote in April 1947: 'I wanted in the nude section to show the analogy between the church and the prescribed nature of worship, and human love,'[24] a doctrine not unlike that espoused by Eric Gill, who, interestingly, was also an enthusiastic believer in open sexuality in a religious context.[25]

In comparison with the portraits of Preece, Spencer's paintings of Hilda are quite restrained and devoid of sexual tension. The first, *Hilda, Unity and Dolls* (1937; 229), was a sober rendering of Hilda with her younger daughter, painted at 17 Pond Street shortly after the divorce. In this fine portrait the careful juxtaposition of the grinning but malevolently eyeless doll, Unity's sharp challenging stare, and Hilda's slack absent-minded pose, created an unusually expressive image. Spencer for once was able to push beyond the simple imitation of nature.

By comparison, Spencer's other portrait of

Cat. 184
Patricia at Cockmarsh Hill
1935

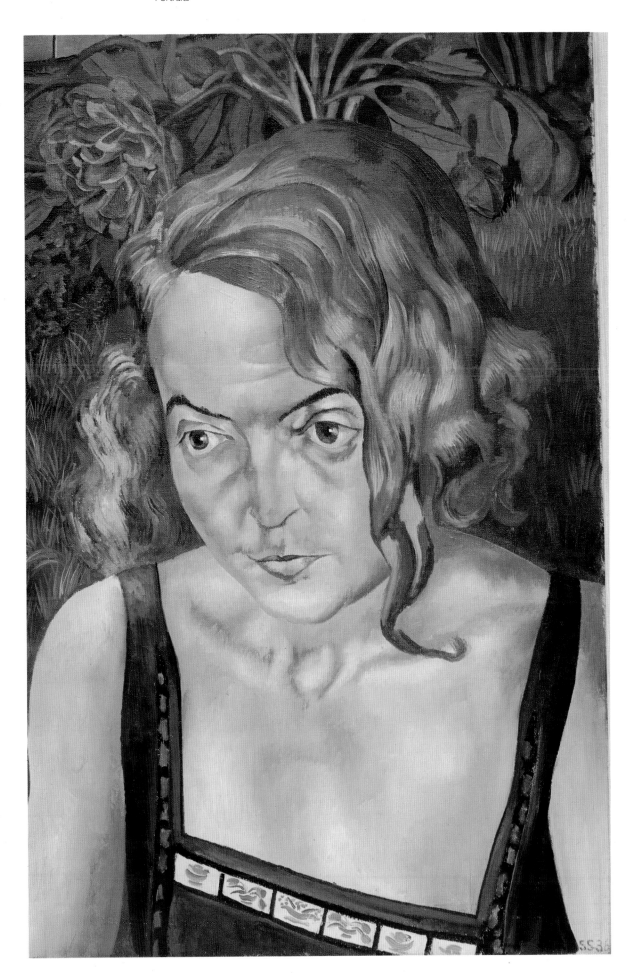

Cat. 187
Portrait in a Garden
1936

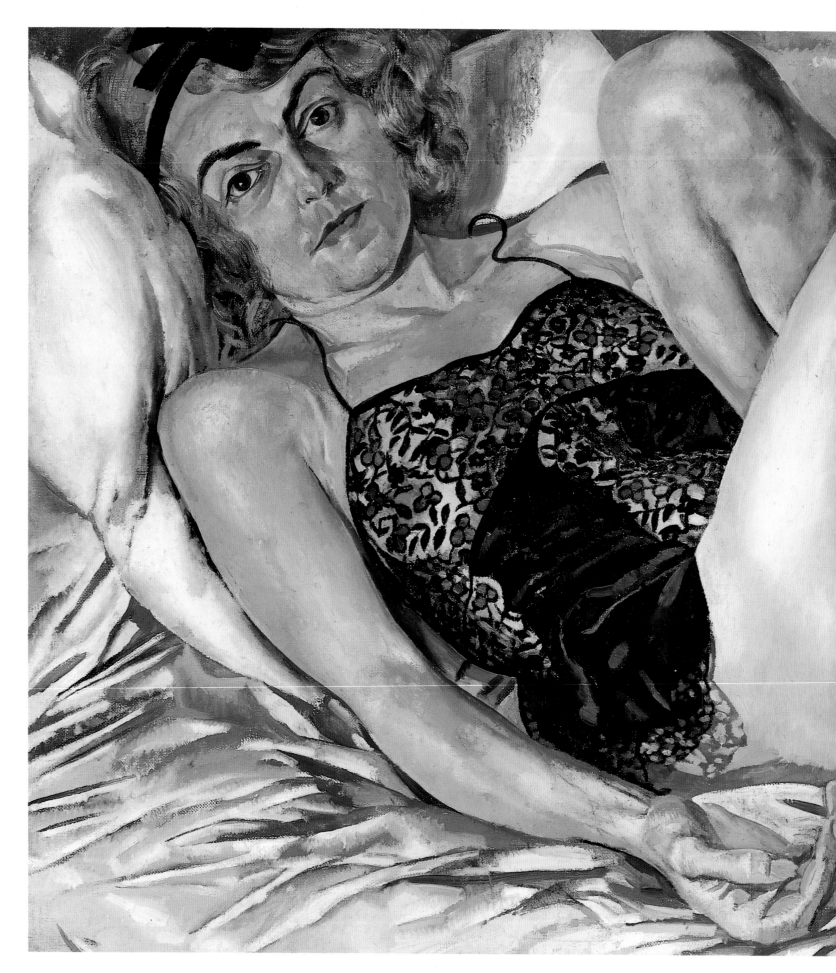

Cat. 222
**Nude
(Portrait of Patricia Preece)**
or **Girl Resting**
1936

Hilda, the *Seated Nude* (1942; 307), painted in part from a life drawing made in the twenties, is more conventional, even academic in appearance.[26] In it Spencer came closer to the work of regular academy exhibitors like Dame Laura Knight ARA, and Dod Procter, without, however, assuming their smooth classicizing style, or slightly self-conscious attempts at allegory.[27]

Spencer continued in his academic vein when he came to paint his only large group portrait, a commissioned picture of the Kitamura sisters (1940; 296), a work which, perhaps because of the war, was never delivered. In the painting the sisters are arranged in the accepted tradition of formal portraiture, dressed elegantly for cocktails and suitably draped over an armchair. As Spencer was still in financial difficulties at this time (1939), it seems likely that he accepted the commission for purely monetary reasons, and that it was the Misses Kitamura who dictated the type of picture which was required. He certainly rose to the occasion, however, and if the composition is a little stiff (and this may have been the way the sitters wished it to be), and lacking in the panache of a Lavery portrait, Spencer demonstrated why at least some aspects of his work were acceptable to the members of the Royal Academy.

The type of fiercely realistic nudes produced by Spencer in the 1930s do not have any direct parallels among his British contemporaries, and it was not until Lucien Freud's paintings of the fifties that another painter produced work with a similar emphasis on the sheer physicality of flesh in an unidealized state. By comparison the remainder of the Carline circle had almost invariably confined themselves to clothed portraits. Both Richard Carline (*Nude Washing*, 1929, private collection) and Henry Lamb (*Phantasy*, 1912, Tate Gallery), in their rare essays into the genre, had either limited themselves to studies which concentrated on tonal and compositional relationships, or to stylized allegory of the type favoured by Duncan Grant in his decorative work.[28]

In fact, Spencer's approach to the nude more closely resembles the pre-war work of the Camden Town artists, and in particular Walter Sickert, whose 'musty, flabby realities' and 'masterly, sordid, unemotional' studies of nudes,[29] notably *L'Affaire de Camden Town* (1909, private collection), *Dawn, Camden Town* (c.1909, private collection), and *Le Lit Cuivre* (c.1906, private collection), are all composed in the 'view through a keyhole' manner recommended by Degas to George Moore,[30] an approach which could also be applied to Spencer's nudes. Sickert's brutally prosaic paintings also sometimes included male participants (for example, *Dawn, Camden Town*), although their role is more ambiguous, and the viewer is not invited to participate in the awkwardly lustful way in which Spencer mentally caresses the flesh of his own subjects.

In the 1930s, although there was a move by some artists like G. Brockhurst ARA and Lancelot Glassen (*The Young Rower*, 1932, Rochdale Art Gallery) to introduce nudes into contemporary settings, a suitable moral justification (sport, modern allegory etc.) was almost invariably found for their nakedness.[31] Of all Spencer's contemporaries, only Dod Procter (1892-1972) made a serious attempt to deal with the psychological implications of sexuality, with a particular emphasis on adolescents and young women, notably in *A New Day* (1935), *The Back Room* (1934), and *Little Sister*. Unlike Spencer's work, however, Procter's pictures were not particularly erotic, and her classicizing 'modern' style had the effect of keeping the viewer continuously aware of the formal properties of her painting, as Anthony Bertram remarked in the *Studio* of February 1929: 'Our first impression when we are confronted with a work by Mrs Procter is of massive three-dimensional form in harmonious relationship. . . .'[32]

Spencer's nudes (and other portraits as well) can also be related to the North European tradition of realist painting, represented in the work of Dürer, Cranach, Holbein, Rembrandt and others, most of whom had been held up to the Slade School students as examples of excellence in drawing. For example Dürer's 1507 *Study of a Nude (Self-Portrait)*, which is drawn with the same unrelenting self-examination which Spencer directed on himself in the *Double Nude Portrait*, with the genitals in each case providing a central focus for the composition. Similarly, Spencer's female nudes bear a distant resemblance to the work of artists like Cranach (the Frankfurt *Venus*), which, despite a certain emphasis on the Northern Renaissance ideal of beauty, nevertheless leave the viewer with a very real sense of the figure's nakedness. Spencer,

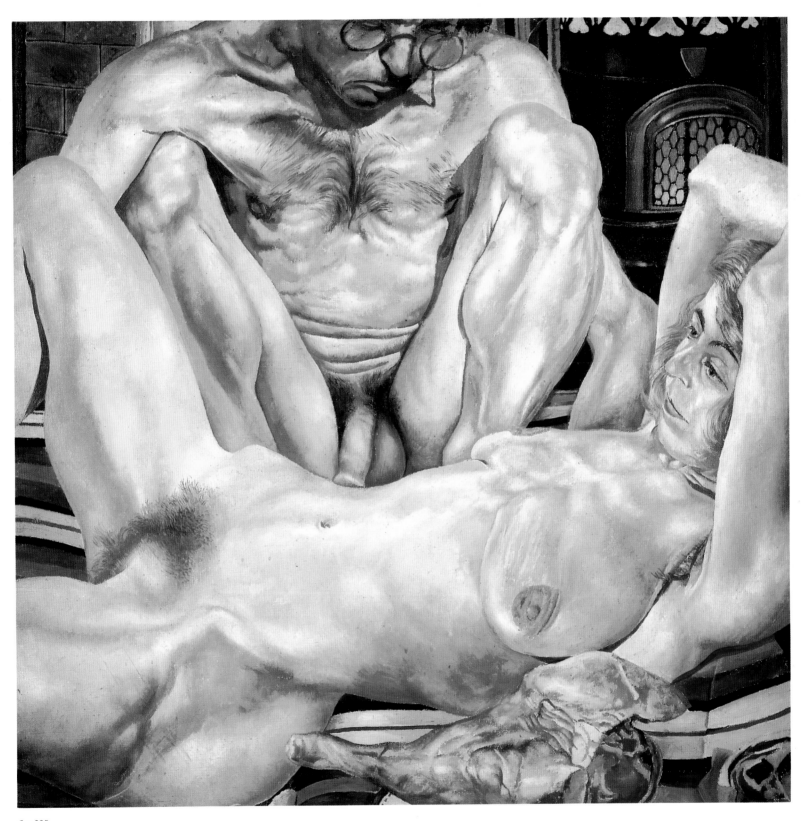

Cat. 225
Double Nude Portrait:
The Artist and his Second Wife
1937

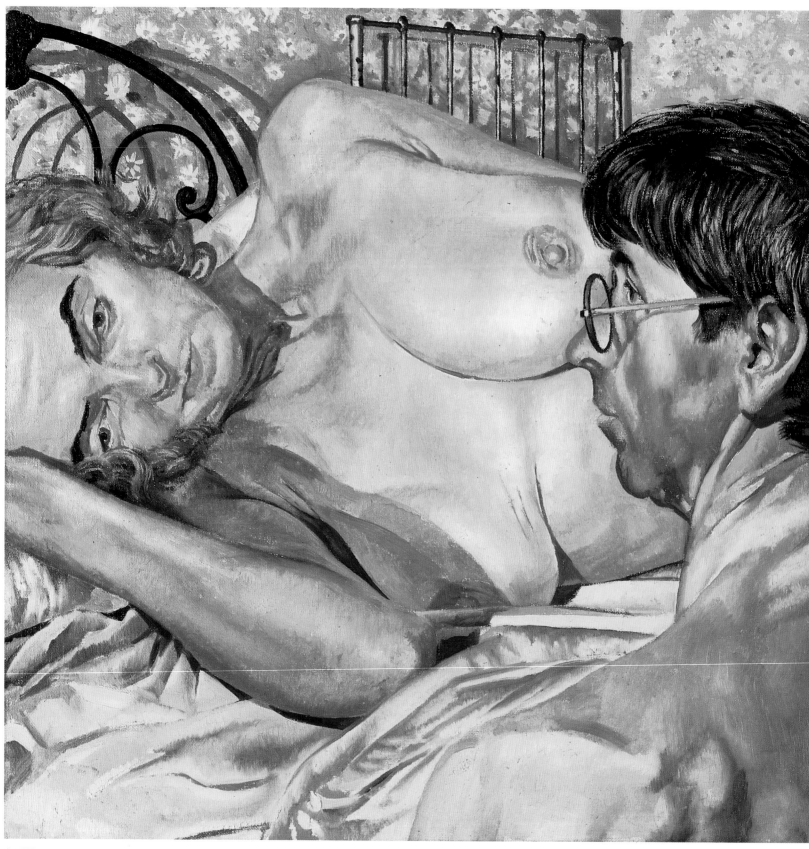

Cat. 223
**Self-Portrait with
Patricia Preece**
1936

Cat. 166
Nude (Patricia Preece)
1935

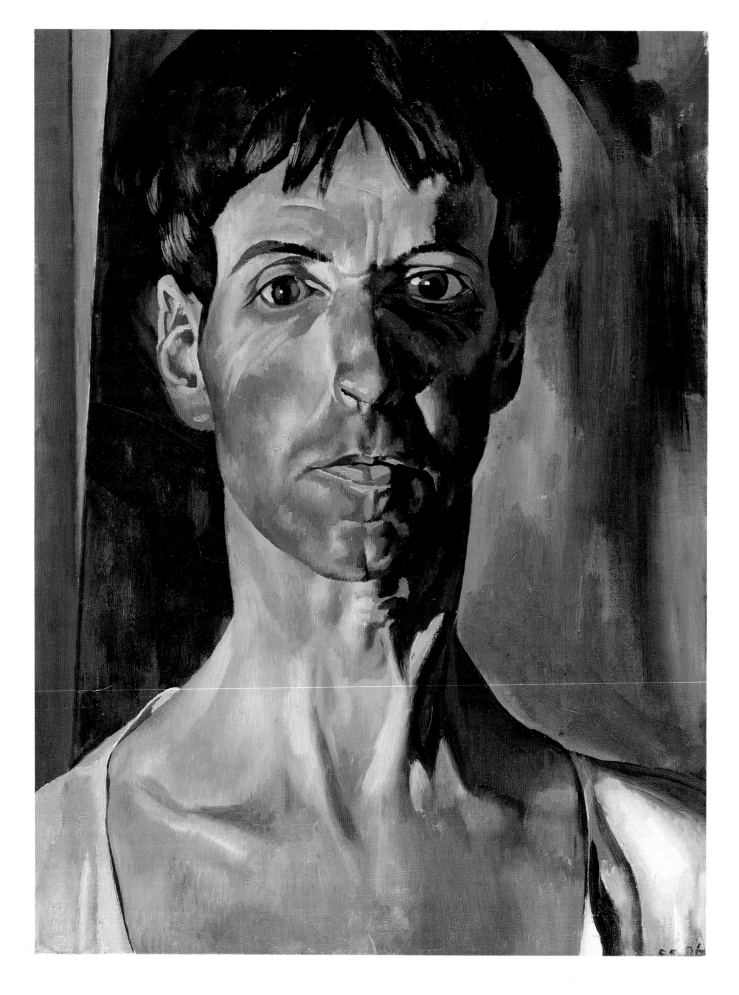

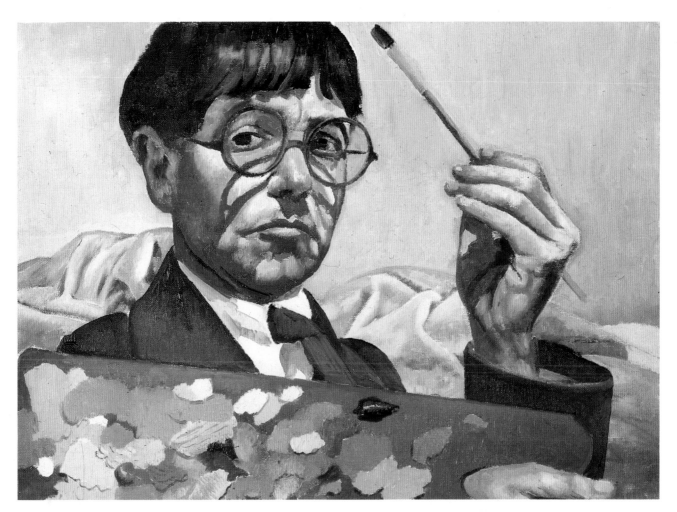

Cat. 286
Self-Portrait
1939

Cat. 320
Self-Portrait
1944

Cat. 224
Self-Portrait
1936

Cat. 296
The Sisters
1940

Cat. 293
Daphne
1940

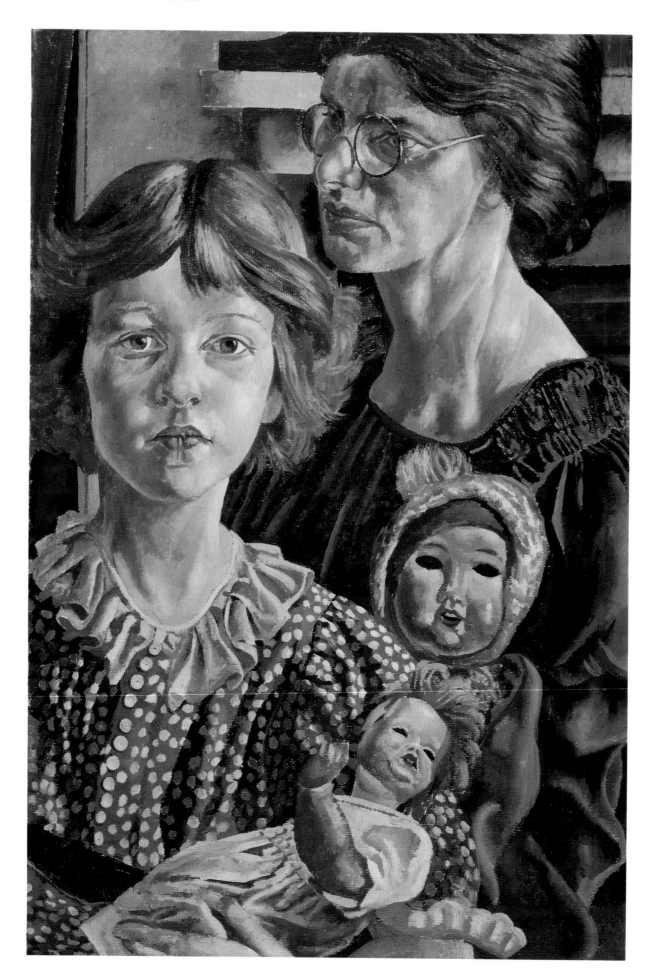

Cat. 229
Hilda, Unity and Dolls
1937

Cat. 279
Portrait of Miss Elizabeth Wimperis
1939

Cat. 297
Daphne
1940-9

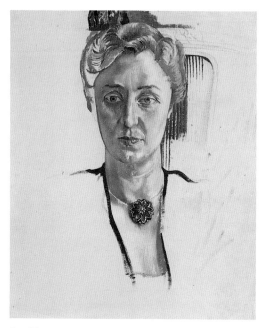

Cat. 453
Portrait of Anny Lewinter Frankl
c.1954-7 (unfinished)

Cat. 153A
Portrait of a Woman
c.1933-7 (unfinished)

however, operating outside any traditional iconographic theme, went one step further, by treating the *whole* of his subject with the same minute realism bordering on caricature, which Northern Renaissance artists usually reserved for clothed portraits; and the mutton and chop in the *Double Nude Portrait* fulfils the same purpose, on one level, as the objects scattered about in front of one of the sitters in a portrait by Holbein.

Most critics have emphasized Spencer's interest in early Italian art, but he also owned a Gowans and Grey book on *Early Flemish Art*, and possibly others in the series on Dürer and Rembrandt. Spencer seems to have studied the Northern Renaissance masters at the Slade School and would certainly have seen them at the National Gallery in London on his pre-war visits there with Henry Lamb. Around 1911 he also began a pen drawing entitled *Melancholia* which was based on Dürer's etching of the same subject.[33] Another drawing of the same

year, *Scene in Paradise* (Slade School of Fine Art, repr. RA, no. 5), also reveals an interest in Northern realism, particularly in the nude on the left which is an odd cross between a Cranach Venus and a life-class model.

Spencer's preoccupation with his personal sex-life and his commitment to an unstinting realism in portrait subjects may also be compared to the work of the German realist painters of a decade or so earlier – notably George Grosz, Otto Dix and Christian Schad although there is no direct evidence that he ever saw their work either at first hand or in reproduction.[34] Schad in particular made forays into the private life of German society, of the kind later recorded by Christopher Isherwood in *Goodbye to Berlin* and *Mr Norris Changes Trains*,[35] in paintings such as *Autoportrait au modèle* (1927) and *Deux Filles* (1928).[36] In these two works, the first showing the artist and his model lying on a bed, the second with two women unenthusiastically masturbating, Schad seems

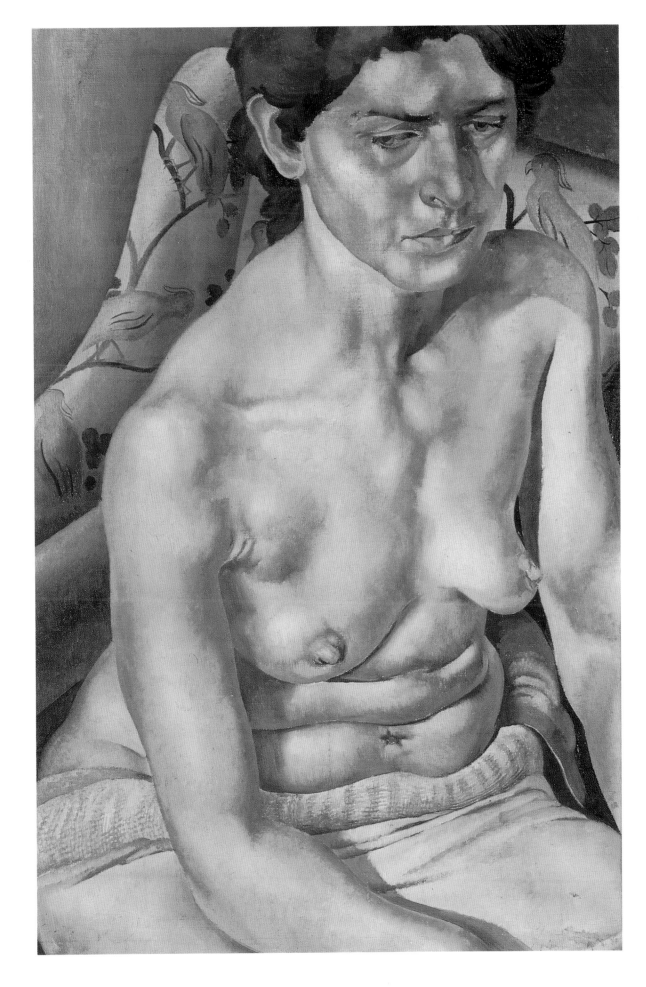

Cat. 307
Seated Nude
1942

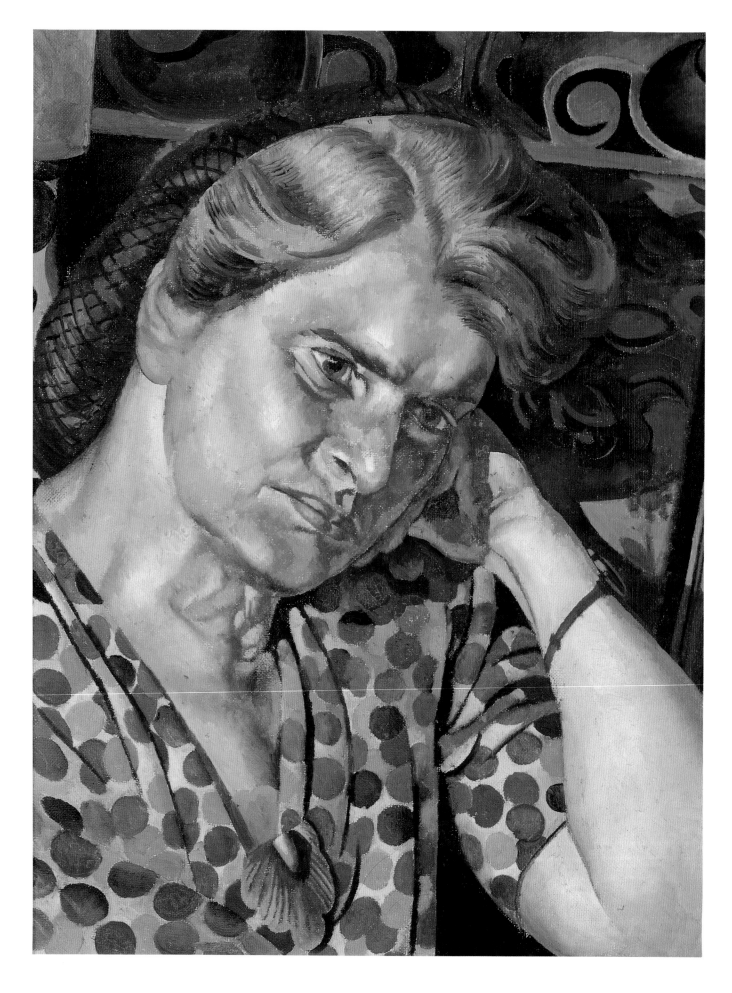

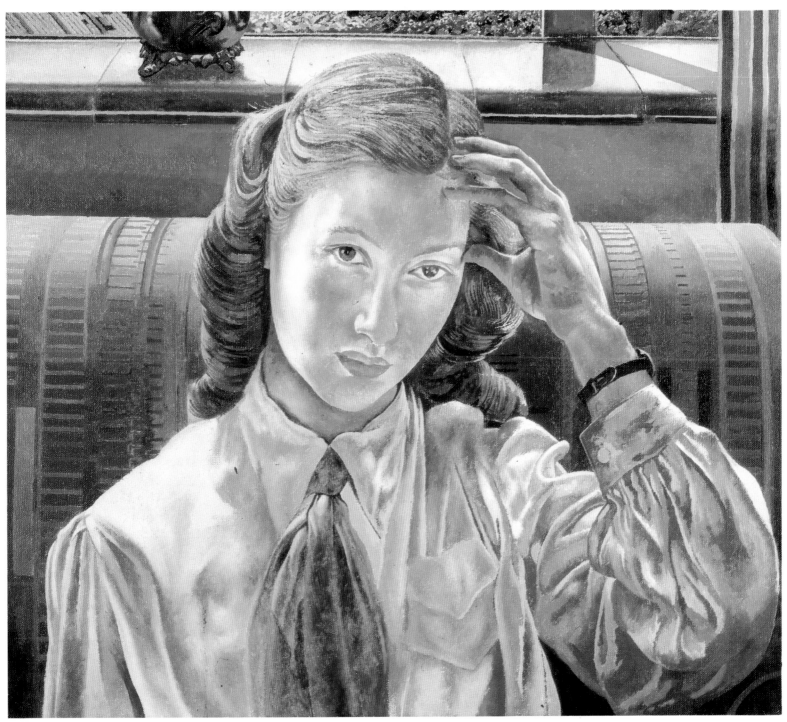

Cat. 372
**Daphne by the Window,
Northern Ireland**
1952

Cat. 346
Portrait of Hilda Carline
1949

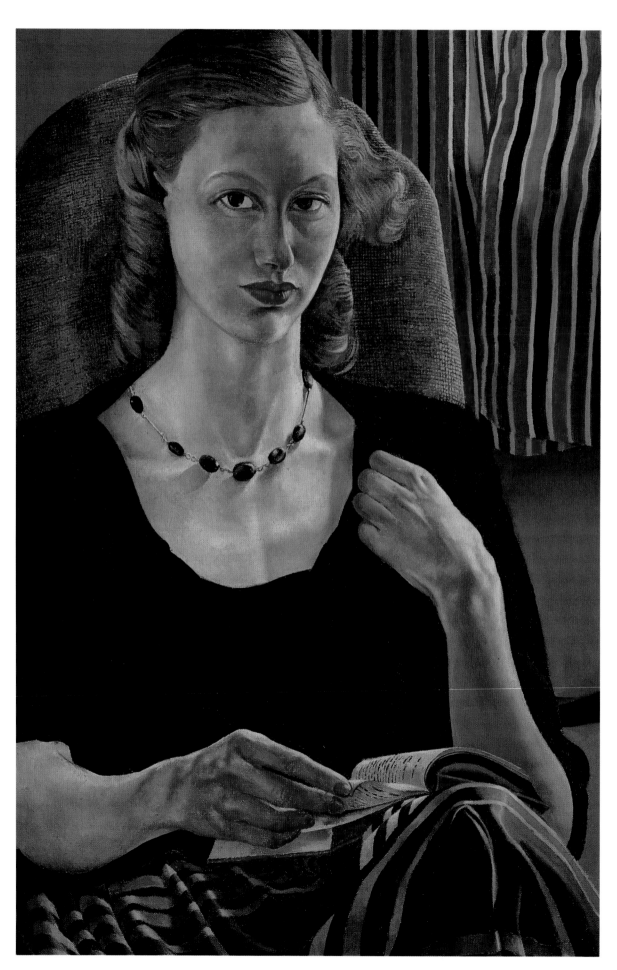

Cat. 370
Portrait of Daphne Spencer
1951

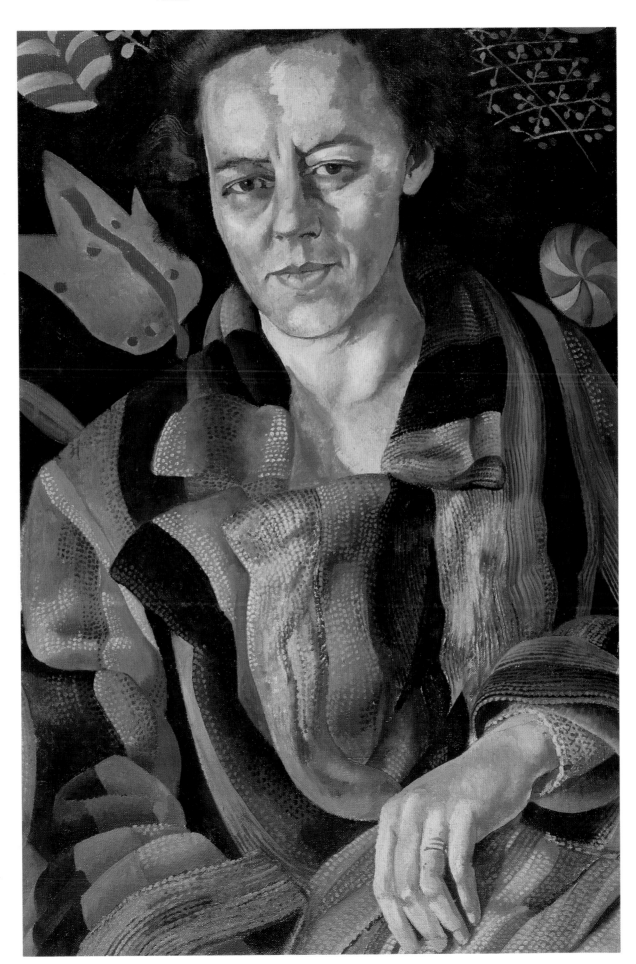

Cat. 327
The Psychiatrist
1945

Cat. 368
Mrs Frank JP
1951

Cat. 351
Dr Osmund Frank
1950

to be dealing with the psychological distance which may still separate people, even when they are placed in the most intimate circumstances – matters which Spencer consciously or subconsciously presented in his own double portraits. He heightened the impact of the experience by drawing the viewer right into the composition, in very much the same way that Schad had done in *Deux Filles*, where the women are seen as if by someone looking down on the bed with no intervening spatial separation.

During the war most of Spencer's time was taken up with the *Shipbuilding* series. However, he did find time to paint some commission portraits in 1943, and three portraits of his two new women-friends, Daphne Charlton and Charlotte Murray.[37] The first of these, *Daphne* (293) painted in 1940, shows Mrs Charlton dressed in eccentric gypsy style, wearing a patterned and ruffled dress, and an elaborate hat bought for the occasion. This ensemble was probably intended to emphasize the sitter's flamboyant, and reputedly passionate, nature. The second portrait, *Daphne* (297), begun in 1940 and completed in 1949, was altogether more sober in nature, and conforms closely to a number of Slade-style drawings which he made of her in 1940-1.[38] Spencer may have also planned other, more intimate portraits, on the model of the Patricia Preece nudes, but if so they were never carried out.[39]

Spencer's third portrait, known as *The Psychiatrist* (327), shows Charlotte Murray, whom he met in Glasgow in 1943.[40] Perhaps because of her German origins, Spencer seems to have found her extremely exotic, painting her in Graham Murray's elegant dressing gown, against a background of patterned cushions whose designs look like strange, astrological symbols placed on either side of her head. Spencer's evident delight in the picture's rich variety of pattern closely corresponded to the intricate patterning of the *Shipbuilding* and *Resurrection, Port Glasgow* series which he was working on at the time.

The next phase of Spencer's portrait painting career began in 1950, on the completion of the *Resurrection* paintings.[41] The award of a CBE, and election as an RA, ensured public recognition of his work, as well as social re-establishment, particularly in Cookham; and there quickly followed a steady flow of commission portraits which continued until

his death. Many of these were probably prompted by the attraction for the sitters of seeing themselves on the walls at the RA summer exhibitions.[42]

Appropriately the first of the new commissions was for a pair of portraits of the Mayor and Mayoress of Maidenhead, *Dr Osmund Frank* (351) and *Mrs Frank JP* (368), dressed in their full civic regalia and seated in the mayoral parlour.[43] In both paintings Spencer intensified his usual obsessive attention to detail, concentrating on the Mayor's chain of office and contrasting it with the broad fur trim of his robes. As a result, the overwhelming impression in these paintings is of a Pre-Raphaelite attention to detail combined with the ruthlessly honest realism of Northern Renaissance painting, which is reflected most clearly in the pudgy, smug-looking face of the Mayor. Hung together (as they were intended to be) the two paintings would have looked like a latter-day Holbein's *Ambassadors*, with the Mayor and his wife surrounded by the instruments of their office.

After painting these extraordinary pictures, Spencer went on to produce a number of other more-or-less formal portraits, including one of *Viscount Astor* (1956; 419). Astor had wanted a traditional dynastic portrait, probably along the lines of the Frank paintings, but Spencer held out for a garden setting on one of the terraces at Cliveden.[44] The resulting picture, with its broad expanse of weed-grown pavement and crowded plant-pots, has more of the appearance of a landscape than a portrait, and Astor looks very much like an afterthought: a rather stiff, dry-looking figure, set in front of the overflowing abundance of the garden.

Spencer's approach to painting these portraits differed little from his method of landscape painting, and every detail had to be reproduced with minute care. When painting the fine portrait of *J.E. Martineau* (405), for example, he insisted that the solid-fuel heater (at right in the painting) should be kept going so that the reality of the picture would correspond exactly with that of the room. Similarly, when the curtains at the back of the room were shortened, Spencer had them returned to their original length. Spencer's own sense that everybody creates a 'nest' or home for themselves which expresses their individual personality, also guided him in his

The artist with the sitter
and the unfinished portrait
of J.E. Martineau

Cat. 405
Portrait of J.E. Martineau
1955-6

overleaf

Cat. 407
Portrait of Sibyl Williams MBE
1955

Cat. 400
Portrait of Eric Williams MC
1954

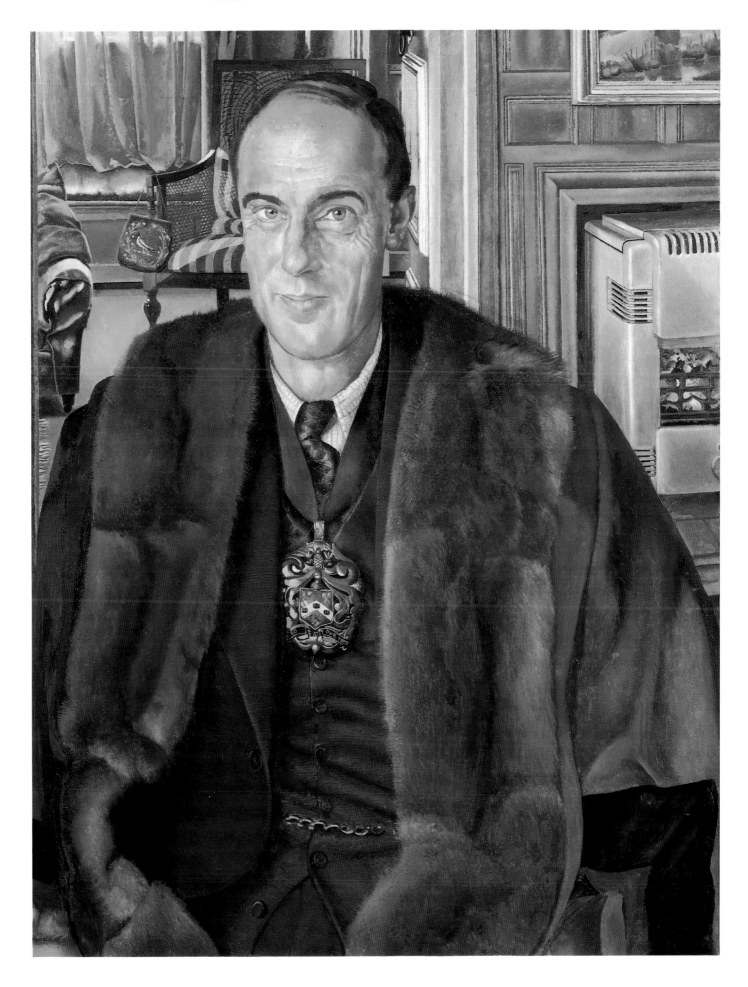

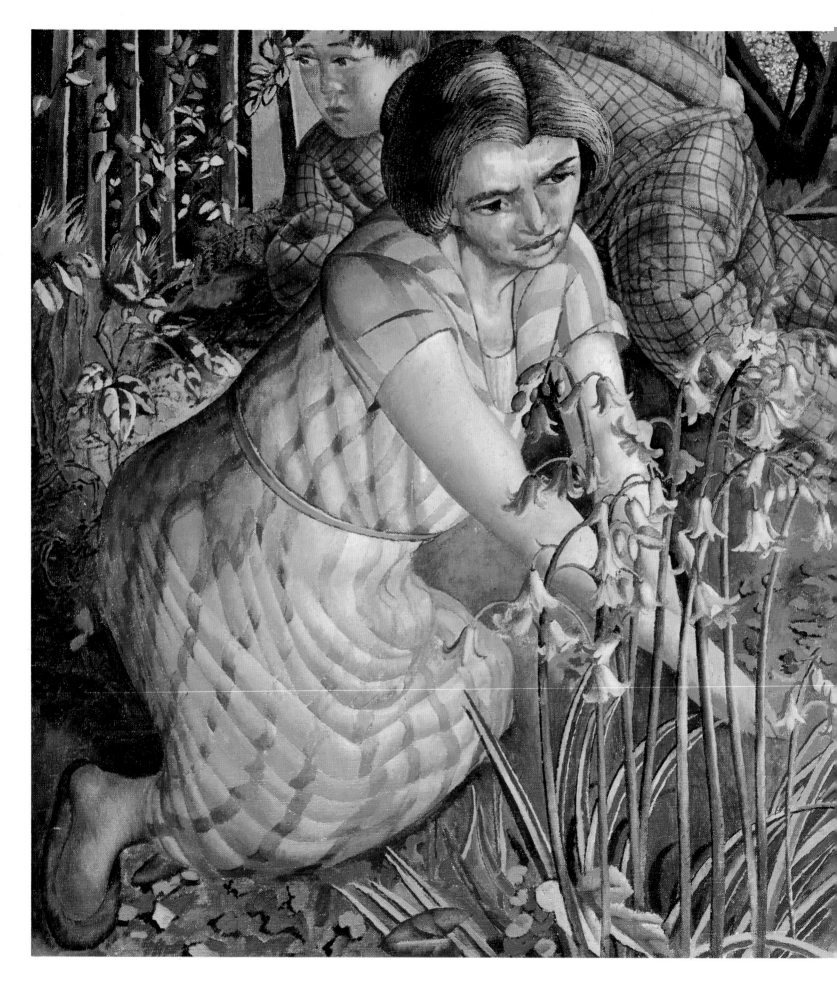

Cat. 402
Hilda with Bluebells
1955

Cat. 439
Portrait of Miss Ashwanden
1958

Cat. 446
Portrait of Rachel Westropp
1959

approach to portrait subjects. In the case of the Martineau painting, for example, he relaxed the potential formality of the work by adding an embroidered bag that Martineau made as a hobby to the chair-arm behind him. In doing so he seems to have been calling attention to the sitter's well-known gentle nature, and deliberately contrasting it with the official badge about his neck.

Spencer's ability to empathize with people whom he liked, and to place them in the settings which were most compatible with their individual personalities, stood him in good stead when he came to paint some of the more informal portraits of the 1950s. With the exception of a few men like Jack Martineau and Louis Behrend, Spencer's closest friendships at this time were with women, who seem to have found him sympathetic, and often in need of a little mothering.[45] Not surprisingly, therefore, most of the portraits he agreed to paint were from the wide circle of female acquaintances that he formed after the war.

In these paintings Spencer normally showed his subjects in half-length or head-and-shoulders formats, either seated in an armchair with a patterned wall behind them, as in *Angela Hobson* (393), or placed in front of a view, as in *Rachel Westropp* (446) or *Priscilla Ashwanden* (439). In each case Spencer unerringly selected a suitable pose and setting: the rather austere *Kate Morrell* (445) seated awkwardly with the collar of her dress riding up round her neck, and

one arm half raised uncertainly towards her chin; *Angela Hobson*, although more relaxed and smiling, leaning back in a floral-patterned armchair, and *Mrs Linda Few Brown* (433), dressed informally, leaning over the lower half of a stable door, rather like a parody of a Renaissance portrait.

By placing his subjects in familiar settings, and posed, or rather simply seated, in their usual way, Spencer was able to create a relaxed yet formally satisfying portrait, which was at the same time strongly revealing of the sitter's personality. Even in the case of *Marjorie Metz* (435) who clearly wanted an 'Academy' style portrait, Spencer was still able to provide some sense of her character, while presenting her, formally dressed, against a pair of Dresden vases, a pose which, when combined with her elegant dress, also gives the painting some resemblance to a society portrait.[46]

Spencer, however, was usually more at home in a less pretentious atmosphere: one of his most unusual portraits was of the garage proprietor and his wife, *Mr and Mrs Baggett* (426), painted in 1957. Perhaps seeking to avoid the more usual academic pose that he had employed for *The Sisters* (296) in 1939, Spencer adopted an updated version of the conversation piece, with the Baggetts in their front room, he busy on the telephone and she pausing in the middle of a stitch to look up at the viewer.

One of the most successful aspects of Spencer's portrait paintings of the fifties was their powerful atmosphere of modernity. His insistence upon accurately rendered detail, the informal nature of the compositions, and his apparent indifference to any significant historical influences, all blended to create paintings which were striking in their contemporary feel. In this, Spencer's work bears some relationship to that of the younger artist Lucien Freud, although the latter used his equally sharp sense of detail to emphasize aspects of the human condition: isolation, tension and desire. These elements were sometimes present in Spencer's nudes of the thirties, but were almost entirely absent from the altogether more relaxed post-war paintings.[47] In taking this unidealized approach Spencer again expressed what Sir John Rothenstein has called 'the inclusiveness of Stanley Spencer's love,' in which all types of humanity, beautiful or ugly, were accorded the

Cat. 410
Jummie III and Dr Frank
1955

Cat. 431
Neville Richard Murphy MA,
Principal of Hertford
College, Oxford
1957

Cat. 423
Portrait of J.L. Behrend
1956

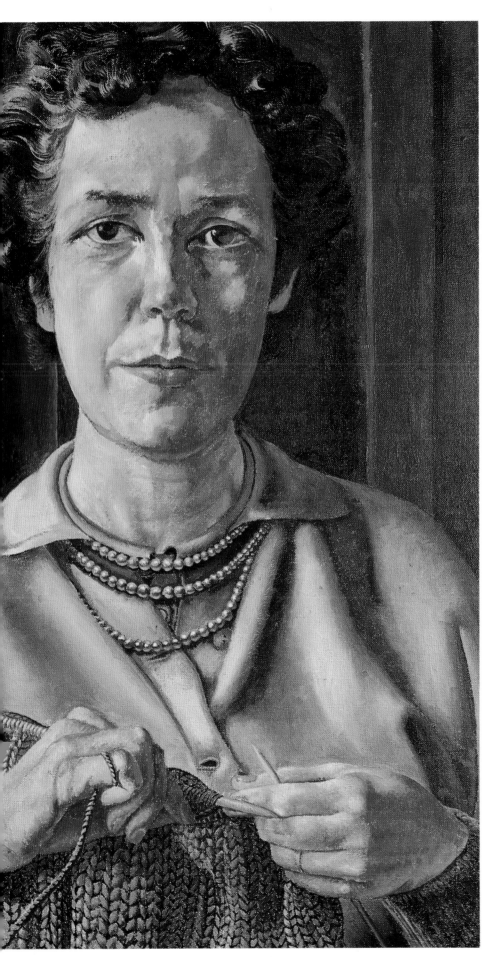

Cat. 426
Portrait of Mr and Mrs Baggett
1956-7

Cat. 433
Mrs Linda Few Brown
1957-8

Cat. 435
Portrait of Mrs Marjorie Metz
1958

same or equal treatment in his paintings; an entitlement to parity which Spencer felt they also deserved before God.[48]

Self-portraits

Together with commissioned and other portraits, Stanley Spencer painted a number of self-portraits at various intervals throughout his career. Spencer never clearly explained his motives for doing so, but his interest in the genre seems to have been based on the traditional artist's fascination with his own changing appearance and moods, as well as an occasional need to use himself as a subject in the absence of a suitable model.[49] In contrast with the generally childlike images of himself which Spencer used in many of his imaginative paintings, the self-portraits are revealingly direct and honest in their rendering of his appearance.

Spencer's earliest self-portraits were four pen and ink 'heads' of c.1913 (see RA, nos. 17, 18) drawn shortly after he had left the Slade School, in a heavy cross-hatched style reminiscent of old master drawings, notably those of the young Michelangelo.[50] These drawings are closely related to Spencer's first oil Self-Portrait (17) of 1914, which in its firmly modelled forms, and concern for the quality of oil paint, has parallels with the old masters. Leder has suggested the influence of Botticelli's National Gallery Portrait of a Youth Wearing a Red Cap; but Spencer's own notes record that he was 'inspired by seeing a reproduction of a head of Christ by a sort of Laini,' perhaps a reference to Luini or Lotto.[51]

The Italianate references in Spencer's painting were common in the Slade at this time, and the picture may be compared to Wadsworth's Self-Portrait of 1911, with its plain brown background and simple head and shoulders composition.[52] Another work produced almost concurrently with the Spencer painting was Henry Lamb's Self-Portrait (National Portrait Gallery), which he painted around the time he became a dresser at the outpatients department of Guys Hospital, London in 1914.[53] This work has many of the characteristics of the Spencer piece, the head is set against a plain ground, and the eyes gaze out intently at the viewer. Spencer and Lamb were in close touch during this time and it is

almost certain that they could have seen and discussed each other's work. Spencer returned to portrait painting after the war with a pair of self-portraits painted in 1923 (96) and 1924 (102), which are close in style to the Portrait of Richard Carline (1923; 100) in their more informal poses, contemporary dress and the broader brushstrokes and simplified forms in which they are painted. At this time Spencer's work still shows the influence of Post-Impressionism in the broadly applied brushstrokes and simplified areas of colour, which can also be found in Gore's Self-Portrait of c.1914 (National Portrait Gallery).

A gap then appears in Spencer's production during the late twenties and early thirties, before he again returned to the subject in Self-Portrait with Patricia Preece (1936; 223) and Double Nude Portrait (1937; 225). At approximately the same time he also drew two 'life size' nude studies of himself, which were either independent drawings, or projects for paintings like Toasting (274j).[54] Spencer later repeated this type of drawing while living in lodgings at Glencairn, Port Glasgow around 1942-3. Shortly afterwards he wrote a brief commentary on these two works, which despite its obscure style, is illuminating about his approach to portrait work:

The two seven and eight foot life drawings of self are drawn with a sense of the drama of ones-self. The whole figure is drawn in the same way and mood as for a portrait drawing of a head. I have spoken of the great journey over the face and its world of places and how the knowledge that one will move from one moment of it to another affects the way one draws it. Now in the front view [of] one of these two one begins with an eye as I usually do and I do it with a sense of meaning to have the whole head explored. . . . (733.9.122).

This topographical approach to portraiture helps to explain the unremitting attention to detail which Spencer displayed in his portraits after c.1930, as well as his tendency to treat each part of his subject and its surroundings with exactly the same emphasis.

Spencer painted only one straightforward self-portrait during the thirties, the Stedelijk portrait of 1936 (224). This work, which was exhibited at the Tooth's 1936 exhibition of

Cat. 365
Self-Portrait
1951

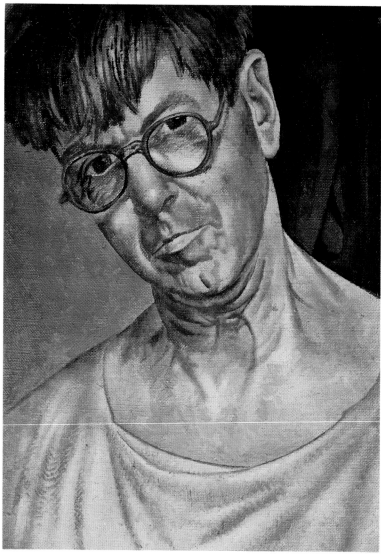

Cat. 364
Self-Portrait
1951

Spencer's paintings, closely resembles his earlier 1914 *Self-Portrait*, and gives the impression of being a deliberate summing up of the changes which had taken place in his appearance in the intervening years.

Spencer's next self-portrait, painted in 1939 (281), departs from the earlier types in showing the artist with the tools of his trade: a palette with the colours ready mixed, and his brush raised as if in the act of painting. By posing himself in this manner, Spencer seems to be proclaiming his position in the tradition of the old masters; for example, Poussin, whose famous *Self-Portrait* is not entirely dissimilar. Spencer painted the picture at 188 Adelaide Road, during a time of near-complete isolation from both his family and fellow artists; and one suspects that the work may be, at least in part, a declaration of the artist's belief in his own worth.[55] There may be a touch of irony intended, too, for in place of the usual paraphernalia of an artist's studio there is only the rumpled bed in the background.[56]

The self-portraits which followed this unusual work show Spencer returning to the straightforward compositions of his early paintings. In these, Spencer treated himself with the same ruthlessly direct manner in which he had once painted Patricia Preece, avoiding pretentious poses and leaving his appearance austere and unidealized. In several paintings, notably *Self-Portrait by Gaslight* (1949; 342), *Self-Portrait* (1951; 364) and the unfinished *Self-Portrait* (c.1950s; 357), this austerity is emphasized by the absence or near-absence of clothing and background detail.[57] There is a sense in these paintings of the calmer, more evenly paced life, which Spencer entered into after the war; together with a balanced, if serious, idea of self which may have been achieved with the help of the psychoanalyst, Dr Karl Abenheimer. This impression is reinforced by Spencer's last *Self-Portrait* (447) painted when he was dying of cancer in 1959. The artist's penetrating gaze is emphasized by the slightly lop-sided spectacles, and his wrinkled and shrunken face is treated with the same attention to detail as the first self-portrait of 1914.

Cat. 447
Self-Portrait
1959

Archive References

1. Tate Gallery Archives: most references are taken from the Tate Gallery Collection of Spencer papers. Each reference is identified by its index number and is accompanied wherever possible by the date, thus: 733.3.1, c.1926; or the page number, thus: 733.3.1, p. 2.

2. Spencer-related correspondence held in the Tate archives is also identified by its index number TAM; for example, TAM 15.

3. Arthur Tooth and Sons: references drawn from the correspondence between Spencer and his dealer Dudley Tooth (Tooth collection) are referred to as SS/DT (Stanley Spencer to Dudley Tooth) or the reverse, DT/SS, and are accompanied by the date.

Abbreviations

Abbreviations are used only where a particular source or exhibition is cited frequently.

Exhibitions

Goupil Gallery, 1927: *The Resurrection and other works by Stanley Spencer*, 1927.

Tooth, 1932 (and subsequently): London, Messrs Arthur Tooth and Sons, who were Spencer's sole agent from 1932.

Leicester Galleries, 1942: London, Leicester Galleries, *Stanley Spencer: Exhibition of Paintings and Drawings*, arranged by Ernest Brown and Philips Ltd, in conjunction with Arthur Tooth and Sons Ltd, November 1942.

Leeds, 1947: Temple Newsam House, Leeds, *Paintings and Drawings by Stanley Spencer*, 25 July-7 September 1947.

Arts Council, 1954: The Arts Council of Great Britain, *Drawings by Stanley Spencer*, 1954. Introduction by David Sylvester.

Tate Gallery, 1955: London, Tate Gallery, *Stanley Spencer, A Retrospective Exhibition*, November-December 1955. Introduction by the artist.

Arts Council, 1961: The Arts Council of Great Britain, *Three Masters of Modern British Painting*, Second Series, touring exhibition, 1961.

Worthing, 1961: Worthing Art Gallery, *Sir Stanley Spencer RA*, 1961.

Cookham, 1962 (and subsequently): Cookham on Thames, King's Hall, Stanley Spencer Gallery, opened 7 April 1962, with an exhibition of works from the permanent collection, augmented by loans.

Plymouth, 1963: Plymouth, City Museum and Art Gallery, *Sir Stanley Spencer CBE RA*, 1963. Introduction by Richard Carline.

Brighton, 1965: Brighton Art Gallery, *The Wilfred Evill Collection*, 1965.

Arts Council, 1976-7: Arts Council Touring Exhibition, *Stanley Spencer*. 1976-7.

Piccadilly Gallery, 1978: London, Piccadilly Gallery, *Sir Stanley Spencer RA, A Collection of Paintings and Drawings*, 1978.

Anthony d'Offay Gallery, 1978: London, Anthony d'Offay Gallery, *Stanley and Hilda Spencer*, 1978. Introduction by Richard Carline.

RA: London, Royal Academy of Arts, *Stanley Spencer RA*, 1980.

Yale, 1981: New Haven, Yale Center for British Art, *Stanley Spencer: A Modern Visionary*, 1981.

CDS, 1983: New York, CDS Gallery, *Stanley Spencer: Heaven on Earth*, 1983.

Books

Bell, RA: catalogue to the 1980 Royal Academy exhibition.

Bell, 1992: Keith Bell, *Stanley Spencer: A Complete Catalogue of the Paintings*, London, Phaidon Press, 1992.

Carline: Richard Carline, *Stanley Spencer at War*, London, Faber, 1978.

Causey: A. Causey, 'Stanley Spencer and the Art of His Time', in *Stanley Spencer RA*, exhibition catalogue, Royal Academy of Arts, 1980.

L. Collis, 1972: Louise Collis, *A Private View of Stanley Spencer*, London, Heinemann, 1972.

M. Collis, 1962: Maurice Collis, *Stanley Spencer*, London, Harvill Press, 1962.

Leder: Carolyn Leder, *Stanley Spencer: The Astor Collection*, Thomas Gibson, 1976. *Note:* The reference is always accompanied by the catalogue number, thus, Leder 7.

Newton, 1947: Eric Newton, *Stanley Spencer*, Harmondsworth, The Penguin Modern Painters, 1947.

Pople: Kenneth Pople, *Stanley Spencer: A Biography*, London, Collins, 1991.

Robinson, 1979: Duncan Robinson, *Stanley Spencer: Visions from a Berkshire Village*, Oxford, Phaidon Press, 1979.

Robinson, 1990: Duncan Robinson, *Stanley Spencer*, Oxford, Phaidon Press, 1990.

E. Rothenstein, 1945: Elizabeth Rothenstein, *Stanley Spencer*, Oxford and London, Phaidon Press, 1945.

E. Rothenstein, 1962: Elizabeth Rothenstein, *Stanley Spencer*, Beaverbrook Newspapers, 1962.

J. Rothenstein, 1979: Sir John Rothenstein (ed) *Stanley Spencer the Man: Correspondence and Reminiscences*, London, Paul Elek, 1979.

G. Spencer, 1961: Gilbert Spencer, *Stanley Spencer*, London, Gollancz, 1961.

Wilenski, 1924: R.H.W. (Wilenski), *Stanley Spencer*, London, Ernest Benn, 1924.

Wilenski, 1951: R.H. Wilenski (introduction), *Stanley Spencer: Resurrection Pictures 1945-50*, with notes by the artist, London, Faber, 1951.

Unpublished Theses

Leder: 'The Early Work of Sir Stanley Spencer: An Examination of the Influences on his Art', MA Report, Courtauld Institute of Art, 1968. *Note:* The reference is always accompanied by the page number, thus, Leder, p. 2.

Gormley: 'The Sacred and Profane in the Art of Stanley Spencer', BA Thesis, University of Cambridge, 1972.

Additional abbreviations

CAS Contemporary Art Society
IWM Imperial War Museum
MOMA Museum of Modern Art, New York
NEAC New English Art Club
RA Royal Academy of Arts (referring, unless otherwise indicated, to the 1980 exhibition)
RSA Royal Scottish Academy
SS/DT Letter: Stanley Spencer to Dudley Tooth
SS/HL Letter: Stanley Spencer to Henry Lamb
SSG Stanley Spencer Gallery, Cookham

1 Spencer also loved classical music, and could play Bach by ear, according to Gilbert Spencer (interview, May 1978).

2 M. Collis, 1962, p. 24.

3 Information originally compiled by Leder, Appendix C. The landscapes by William Bailey and Fred Walker are discussed in the Landscape chapter.

4 Information from Gilbert Spencer, interview, May 1978.

5 M. Collis, 1962, p. 25.

6 733.3.21, p. 46, 1935. Causey (p. 19) thought that Spencer's art at this time was essentially concerned with 'preserving his vision' and quoted his statement: 'Unless I did something to conserve these things and make it clear they were not "child" things, I would have them snatched from me.' Spencer, however, was writing with hindsight, and a feeling that his childhood vision had vanished with the war. In my opinion Spencer's need to paint arose instead from a wish to merge ('marry' is his word) his feelings with the places and people of Cookham. This could best be done through a painting or drawing, but was not a matter of 'preservation.'

7 733.3.21, 1939. Also quoted by Causey, p. 19.

8 All recorded in 733.3.21, written in 1935.

9 The Bible is now in the collection of Miss Unity Spencer.

10 An edition illustrated by Helen Stratton (733.3.21).

11 Hoffman's book was published in England in the 1880s.

12 733.3.21, 'The Pilgrim showed to me no sign of what was to follow.'

13 Gilbert White must have seemed not unlike Spencer's own father, a gifted amateur with an interest in science (in Mr Spencer's case, astronomy). E.H. New was probably an important role-model for Spencer, who could have imagined himself as a similar illustrator of life in Cookham.

14 733.3.21, p. 12; the second part of the quotation also used by Causey, p. 19.

15 733.3.44, 1945. All pen and ink drawings, now lost.

16 Ibid.

17 733.3.21, p. 7: Spencer used the term 'homely' as a value judgement. A 'homely' painting was one which contained the right balance of warmth and familiarity for the viewer to feel perfectly at ease.

18 Carline, p. 20. This tuition had little visible effect on Spencer's work, and he rarely used the water-colour technique, except in the sepia wash drawings of the twenties.

19 Ibid., p. 20.

20 733.3.21. An account of Spencer's early work.

21 Ibid. and Carline, p. 23. Apart from the cast drawings, Spencer recorded only one other 'set subject' at Maidenhead, The Courtship of Miles Standish, c.1907. In his list 733.3.45 this is recorded as 'lost.'

22 733.3.45. All pen drawings. Una and the Lion 1906 (12½ x 10 in/32 x 25.5 cm) is in the collection of O. Koerner, Vancouver.

23 733.3.21, p. 14.

24 Tate Gallery Archives, taped interview of Gilbert Spencer by Sarah Whitfield.

25 Ibid.

26 Pen drawing c.1907-8, whereabouts unknown. 733.3.21.

27 733.2.52. Also quoted by Causey (p. 19), who makes a similar point. The reproduction of Millais's Ophelia, hanging in Fernlea dining-room, may have given Spencer a hint of how figures and places could best be associated.

28 The Spencer/Chute correspondence is in the Stanley Spencer Gallery, King's Hall, Cookham.

29 E. Warner and G. Hough, Strangeness and Beauty: An Anthology of Aesthetic Criticism, 1840-1910, Cambridge, Cambridge University Press, 1983, p. 104.

30 Carline, p. 23.

31 733.3.83, p. 224. Extract from an unfinished essay by Hilda on Spencer, which he asked her to write as part of his projected book on his art, planned in the late 1930s.

32 Carline, p. 29.

33 See RA, nos. 6, 4, 5. According to Allinson (a fellow student) Spencer usually failed to illustrate the set theme of the week, and therefore, although highly praised, he failed to win any prizes (Carline, p. 26).

34 Both also referred to by Causey, p. 20.

35 Spencer told Gilbert Spencer that he would like to draw like Arthur Rackham (interview with G.S., May 1978). See also Robinson, 1979, p. 10.

36 See RA, nos. 2, 5.

37 Pen and ink, 8¾ x 12½ in/22.5 x 31.5 cm, Fitzwilliam Museum. An example first used in this context by Robinson, 1979, p. 11 and pl.3.

38 Reproduced in J.G. Millais, The Life and Letters of Sir John Everett Millais, London, Methuen, 1899.

39 Spencer always wanted to paint in fresco (the intended medium for Burghclere) and in the twenties contacted the recognized expert Mrs Sargant Florence for advice (information from R. Carline, November 1978). Sargant Florence exhibited religious subjects at the NEAC, and gave a demonstration of

fresco technique at the Slade after Spencer had left.

40 See for example RA, no. 39, Study for the Last Supper.

41 733.3.1. c.1937. Also quoted in RA, no. 3.

42 733.3.21.

43 This figure often reappeared in Spencer's later work as an 'approving' presence; sometimes as God the father, but also as a kind of alter-ego.

44 733.3.1, no. 5.

45 733.3.21.

46 Ibid.

47 Spencer emphasized the Pharisees (John 18:6), who 'went backward and fell to the ground,' an unusual addition to the main action of the betrayal.

48 Spencer met Chute (a friend of Eric Gill and later a priest) in Bristol during the war.

49 733.2.51.

50 Ibid.

51 Carline, p. 30, and RA, no. 8; Robinson, 1979, p. 16; Causey, p. 20.

52 Ibid.

53 Connoisseur, Nov. 1912, p. 192.

54 Causey, p. 20.

55 Significantly it was the Raverats who bought John Donne.

56 Robinson, pp. 13-15; Leder, Chapter, 'The Pre-Raphaelites and England'.

57 Leder, ibid.

58 Modern Painters, London, Dent, 1906, vol. ii, part iv, ch. 1, p. 28.

59 Ibid., vol. ii, part iii, sect. I, ch. 1.

60 Warner and Hough, Strangeness and Beauty, vol. i, p.13.

61 Spencer would also have been impressed by Ruskin's comment on True Perception: 'The truth of nature is a part of the truth of God; to him who does not search it out, darkness, as it is to him who does, infinitely.' Ibid., p. 15.

62 Carline (p. 30) suggests Spencer's loyalty to Tonks as the reason for his repudiation of Cézanne in an argument with Mark Gertler in 1913-14.

63 This is Causey's suggestion, RA, p. 20.

64 See, for example, the infinite trouble Hughes took over painting the wild roses in The Long Engagement (1859; Birmingham, City Art Gallery); or Inchbold's In Early Spring (1855; Oxford, Ashmolean Museum).

65 Carline, p. 33.

66 733.3.21, 1939.

67 Carline, p. 34.

68 733.2.85, 1941; and Causey, p. 20.

69 733.8.35.

70 Yann le Pinchon has identified Rousseau's borrowings from such diverse sources as Gauguin and Delacroix, as well as postcards, and book plates of wild animals

(The World of Henri Rousseau, Oxford, Phaidon Press, 1983).

71 Carline (interview, Dec. 1979). remained convinced that Spencer did not see the 1910 Grafton exhibition; however, this seems unlikely when the Slade was full of discussion about the exhibition, and Tonks was moved to complain that all his students were visiting exhibitions of modern work. Spencer must have visited Fry's Second Post-Impressionist Exhibition, of 1912, where his own John Donne was on show.

72 733.1.671. Draft Letter to Christopher Hassall, April 1954.

73 Causey (pp. 20, 21) also noted the parallels with Gertler's work, and cited his Rabbi and Rabbitzin of 1914 as a parallel work; however, the similarities go back to Gertler's 1913 paintings as well, thus making the connections between the two artists' work even closer.

74 733.3.1, no. 7.

75 Causey, p. 22.

76 733.1.672.

77 See A. Causey, Paul Nash, Oxford University Press, 1980.

78 Nevinson, op. cit., p. 37.

79 This group was noted by Robinson, 1979, p. 20, and Causey, pp. 22-3.

80 These exhibitions were first noted by Leder, pp. 16, 17.

81 pp. 226-30.

82 Causey also correctly extends the term to describe some aspects of Vorticism.

83 The Times, 28 February 1927.

84 733.3.32. Spencer saw Epstein as the 'finest' but also mentioned Moore, Hepworth and Dobson. 'As surely as Epstein is the greatest sculptor this country possesses, so surely in my opinion is Duncan Grant the greatest painter. I shall never forget the last exhibition he has had at the Pense Galleries, as neither have I forgotten his exhibition at the Guilliane (?) Gallery several years ago. I felt this last was better . . . and neither have I forgotten the Vanessa Bell exhibition I saw some years ago.' Written in 1934.

85 733.10.64. Written after 1940.

86 For a good discussion of the relationship of the Slade to contemporary developments in English art see Richard Cork, Vorticism and Abstract Art in the First Machine Age, Berkeley, University of California Press, 1976, Vol. 1, Ch. 3, 'Unrest at the Slade.'

87 Nash in Outline, an Autobiography and Other Writings, London, Faber, 1949, pp. 92-3, quoted by Cork, ibid., p. 57.

88 Roberts, A Press View at the Tate Gallery, London, 1956, pp. unnumbered, quoted by Cork, ibid., p. 57.

89 Cork, ibid., pp. 59-60. Nevinson's comment originally appeared in *Paint and Prejudice*, New York, Harcourt, Brace, 1938, p. 33. The *Self-Portrait* is reproduced by Cork, ibid., p. 61.

90 The two paintings by Roberts are reproduced by Cork, ibid., pp. 64, 65.

91 733.3.21.

92 733.12.1. Undated press cutting in the Spencer album.

93 C. Hassall, *Edward Marsh, Patron of the Arts: A Biography*, London, Longmans, 1959, p. 252.

94 Ibid., p. 244. 'Cookham' was Spencer's Slade nickname.

95 Ibid.

96 Ibid., p. 255. Marsh outbid Sir Michael Sadler by £5.

97 Ibid., p. 289. Spencer varnished the *Self-Portrait* at Marsh's flat in Raymond's Buildings on 20 July 1914.

98 Ibid., p. 280. The proposal fell through. Unfortunately, the plan did not materialize as money could not be raised in time.

99 Ibid., p. 254.

100 Ibid., p. 255.

101 Ibid., p. 256. Cézanne, however, was a sore point between Spencer and Gertler, and nearly precipitated a break-up of the Marsh circle when Spencer declared that Gertler's latest painting showed him 'quite incapable of understanding Cézanne' (ibid., p. 255). Gertler's volatile reaction indicated how important French painting was to him (as his post-war paintings show), while Spencer, more secure in his own vision, remained unmoved.

102 Ibid., p. 254.

103 Ibid., p. 258.

104 Ibid. He did, however, agree to go to a Picture Ball dressed as a Futurist picture designed by Lewis!

105 Ibid. Carline (p. 32) states that Fry often 'turned his back' on Spencer.

106 Spencer corresponded with Brooke up to the latter's death; see 733.1.210, c. 1915, letter from Brooke on his feelings about the war. Margaret Keynes was still writing to Spencer in 1957 (733.1.841, 843). Spencer met Brzeska at a party (733.1.669), and at one time owned a book on his work (ibid.).

107 Lord Moyne (Bryan Guinness) informed me in 1979 that Spencer could converse on a wide range of artistic and literary topics when they met in the early twenties.

108 For the Lamb correspondence see TAM 11, 15; the letters to Chute are in the Stanley Spencer Gallery, Cookham.

109 Carline (p. 36) gives this date.

110 Leder, Chapter on *Modern French Painting*.

111 733.1.669. Spencer told Marsh's biographer, Hassall, that Lamb, unable to afford the full price of *Apple Gatherers* for himself, paid Spencer £30, against a later sale for a higher price. He tried unsuccessfully to sell it to the CAS (TAM 11, SS/HL) before Sir Michael Sadler put in an offer for £50. Marsh then offered 50 guineas which secured the painting. 'The idea Henry Lamb had was for me to have some money whilst waiting for the painting to sell.'

112 Carline (p. 36) implies that John, Anrep and Kennedy were at the centre of Spencer's artistic circle before the war, but he seems to have had little to do with them until after demobilization in 1918.

113 Lamb usually brought Spencer books and post-cards when he visited Cookham: TAM 15, SS/HL, 1914: 'I don't want to be greedy but don't forget the post-cards'; SS/HL, 7.3.1914: 'I didn't get a chance to look at the Mantegna book on my last visit'; SS/HL, c.1914, fragment of a letter: '[mentions Lorenzetti] . . . I am getting a very good collection of p/c's I do not put them into a book because I like to look at them separately. I take out one according to how I feel and I put it somewhere in the room . . . It sort of keeps me company and makes me work.' (Also quoted by Carline.)

114 Gwen Raverat (née Darwin) was a close friend of Spencer's at the Slade. She married Jacques Raverat and moved to Cambridge, where she continued to correspond with Spencer.

115 TAM 15, SS/HL, 17.7.1917. Spencer told Lamb that he owned the following Gowans and Greys: 'Giotto, Fra Angelico, Carpaccio, Giorgione, Michelangelo, Gozzoli, Raphael, Claude, Velazquez, Early Flemish Painters.' Spencer also had a *Rossetti*, in the same series, dated '1913'. According to Leder (p. 20) Spencer wanted a Gowans book of his own work.

116 TAM 15, SS/HL, after July 1913.

117 Sydney Spencer's diary (private collection) entry for 8.1.1913. Quoted by Leder. I have been unable to view this document. Elsewhere, in April 1911, Sydney and Spencer studied reproductions of Vezelay and a book on Michelangelo (both Spencer's).

118 First noted by Leder, p. 22.

119 Prior to the 1980 RA exhibition, *Joachim* had last been seen at the 1955 Tate show (no. 4), at which time it was in the J.L. Behrend collection.

120 *Joachim* does bear some resemblance to Gertler's contemporary work, notably *Family Group* (1913, John Woodeson, *Mark Gertler. Biography of a Painter, 1891–1938*, University of Toronto Press, 1973, pl.8), which is also painted in dark glowing colours, and has a similarly serious hieratic mood.

121 Quoted by Carline, p. 28, and RA, p. 44.

122 Ibid.

123 733.3.1.

124 Published in *The Game*, 1919, as 'A Letter from Stanley Spencer'; and in 1978, in an edition of 150 copies, printed at the Cygnet Press for Anthony d'Offay.

125 Ibid.

126 Ibid.

127 Ibid. Spencer's writing in *The Game* reached a reasonably high literary standard, probably as a result of reading Milton, Keats, Shelley and Dostoyevsky.

128 TAM 15, SS/HL, 1913.

129 For example, Spencer complained that the Steep memorial project (RA, no. 64) was too hurried, and left him without a proper chance to consider the idea. This bore fruit later at Burghclere.

130 733.2.155, c.1940.

131 Spencer was still deeply involved in studying Italian art in 1914. In a letter of 4.4.1914 to Lamb (TAM 15), he mentioned Masaccio and Masolino and commented: 'Lorenzetti seems not finer than Giotto.' In another letter (TAM 15, SS/HL, 27.4.1914), telling Lamb he was doing Zacharias in 'Basso Relievo,' he noted, 'the Assisi book has quite inspired me'; and again (TAM 15, 7.5.1914) told Lamb that he had 'copied out a life of Masaccio,' presumably Vasari's.

132 Lamb visited Cookham on several occasions (TAM 11, SS/HL, 27.4.1914). Darsie Japp and Ihlee also went to Cookham in the summer of 1911. Marsh made two trips. Lamb was Spencer's London guide: TAM 11, SS/HL, 30.10.1913.

133 TAM 11, SS/HL, 4.12.1914.

134 At this stage Spencer was still shy of London society. In 1912 he told Lamb that he had been 'rather overawed by Japp's grand home on Tite Street.' TAM 11, SS/HL, 24.10.1912.

135 Gilbert Spencer told Leder of this visit in 1968, but gave her no precise date.

136 Reproduced in Cork, *Vorticism*, pp. 64, 65.

137 David Bomberg also produced at least one religious picture in 1912, *Vision of Ezekiel*, Cork, *Vorticism* (op. cit.), pp. 68-70.

138 *Sunday Times*, 27.2.1927.

139 733.3.21, no. 52.

140 Quoted by Carline, p. 41. Causey (p. 23) thinks that the painting dealt with a vaguely understood sexuality; but although Spencer in later years was fond of spotting subconscious sexual references in his early work, there is little evidence of this in the painting itself.

141 Quoted by Carline, p. 44.

142 733.1.21, no. 56.

143 See, for example, *Cutting the Cloth* (128d).

144 733.8.37, August 1948.

145 733.8.35, c. 1948.

146 Ibid.

147 Causey identified the girl as a 'Miss Griffith.' My identification comes from 733.8.35, but Spencer did sometimes muddle names.

148 733.2.44. Also quoted by Causey (p. 23).

149 Causey, p. 23.

150 Rousseau's influence was noted by Causey (p. 24).

1 Spencer enlisted on 15.7.1915, was on active service from 22.8.1916 to 12.12.1918, and was demobilized on 12.4.1919, TAM 15, SS/HL, 9.8.1919.

2 Both Causey, p. 24, and M. Collis, 1962, pp. 65-6, question Spencer's claim.

3 SS/Chute, Hut 3, D. lines 'W' Coy. RAMC. Tweseldown Camp, Nr. Farnham, Surrey, summer 1916.

4 TAM19, SS/James Wood, 3.3.1918. These mountains appear as the setting for *The Crucifixion* (1921; 77).

5 Ibid., 26.5.1916. Spencer quotes this directly in support of his hospital activities.

6 Causey (p. 24) also notes this aspect but without reference to Saint Augustine.

7 IWM 290/7, and SS/Florence Image, letter of 16.5.1918. For the other drawings see RA, nos. 34-6. Spencer listed his earliest plans for a series of pictures in a letter to James Wood, TAM 19, 3.6.1918.

8 The fan-shape was a favourite compositional device of Spencer's. A travoys was a simple contrivance made of two poles, canvas and a harness; it was used on ground unsuitable for wheeled transport.

9 733.3.1, no. 22. Also quoted by me in RA, no. 34, and Causey, p, 24.

10 Ibid., p. 24.

11 E.G. Clausen, *Youth Mourning*, or Brangwyn, *Mater Dolorosa Belgica*, repr. *Royal Academy Ilustrated*, 1916, pp. 5, 97. Nevinson's best work was on a small scale, but his *Harvest of Battle* (1919; IWM) was more conventional, even lurid in its depiction of wounded men after a 'push' at the front.

12 J.P. Beadle, *Neuve Chapelle, March 10, 1915*; W.B. Wollen, *Defeat of the Prussian Guard, Nov. 11, 1914*, repr. *Royal Academy Illustrated*, 1916, pp. 20-1.

13 Undated cutting from *The Times*, 1919, from Spencer's *Scrapbook* collection, 733.12.1.

14 Ibid. 'However, he was unable to discern any specific line of develop-ment among the "new" men: they are no more alike and no more equal in achievement than their elders. There is no one who is as great a genius among the Post-Impressionists (if we accept that label) as Sargent is among the Impressionists.'

15 These were probably *Scrubbing Clothes* (31) and *Making a Red Cross* (32).

16 M. Collis, 1962, p. 65.

17 Spencer recalled that in 1920 he was 'Still quite at a loss and cannot quite get my bearings at all. Staying at Slesser's because I am continually interrupted at home and no room to myself.' 733.3.1, 1937.

18 733.3.16, 1944. Also quoted by Causey, p. 24.

19 Causey, pp. 24-5.

20 TAM 19, SS/Carline, letter dated 25.11.1919.

21 For example, Spencer contradicted Lamb's severe criticism of Epstein in 1930, saying '. . . I always think that Epstein is very good'; but suggested drastic remedies for 'great' artists! 'I think all artists promising to be great ought to be castrated at an early date to prevent their art from breaking into this deep sonorous greatness that Epstein goes in for.' TAM 15, SS/HL, letter of 23.6.1930.

22 However, Spencer did encounter Lewis, as he recorded in a letter to Lamb of 14.12.1919, TAM 15: 'I saw Wyndham Lewis painting at the museum where the following "dramatic" incident occurred. Scene: Room 4 L.W.M. [London War Museum sic?] Enter – Ian Strang and others. Lewis: Does this represent a battery shelled to you Strang? Strang: No it doesn't Lewis. Lewis: You see this yellow I'm putting on Strang? Strang: I can't see any yellow Lewis. Lewis: Don't be facetious Strang. Strang: I'm not being facetious Lewis. Exit – Lewis frowning. Strang and others laughter.'

23 Spencer to Gwen Raverat, 14.6.1934. Tate Gallery Archives, Box 8216, uncatalogued. This is the most complete indication of Spencer's taste in English art. It is interesting to note that none of his more immediate associates, Lamb, the Carlines or the Nash brothers, were to be included.

24 Spencer came into contact with Richard Carline through a mutual friend, Richard Hartley. Hartley was a fellow student of Carline's at the Tudor-Hart School of Art in Hampstead. He lived at the Crown Hotel, Cookham, and bathed at Odney Pool with Stanley and Gilbert Spencer. Hartley showed Spencer one of Carline's early sketch books, and a correspondence subsequently commenced (information: introduction by R. Carline to *Spencers and Carlines in Hampstead in the 1920's*, exhibition catalogue, SSG, Cookham Festival, 23 May-2 June 1973). Two of these letters are in the Tate Gallery Archives, Box 825, uncatalogued. The first, dated 'May' 1915, refers to Henry Lamb: 'John certainly influenced his work which he knows I do not like'; and Gertler: 'I think Gertler's old works are much better than what he does now.'

25 Ibid., Box 8216.

26 George F. Carline studied at Heatherley's in 1882 and Julian's in 1883. He began exhibiting at the

Royal Academy in 1886, and had his first one-man exhibition at the Dowdeswell Galleries in 1896. He was elected as a member of the Royal Society of British Artists in 1903.

27 John Boulton Smith (Introduction, *Spencers and Carlines*, exhibition catalogue, Morley Gallery, 1980) and I reached some similar conclusions independently through our separate conversations with Richard Carline in 1979-80. Smith called the group 'intelligent and original progressives,' and commented that Spencer leaned towards drawing, while the Carlines were 'inclined towards a painterly colourism' (introduction, n.p.).

28 Information on the Carlines' careers from Richard Carline (1979); correspondence and documents in Tate Gallery Archives, Box 8216; and Boulton Smith's *Spencers and Carlines* catalogue (see note 27). George's wife, Anne Carline, although untutored, also began to paint in 1927. Richard Carline was at the Slade between 1921 and 1924; Hilda enrolled there in 1918, and Sydney, 1909-12.

29 *The Return to the Farm, Wangford, Suffolk*, canvas, 51 x 36 in/129.5 x 91.5 cm, Carline collection, repr. *Spencers and Carlines*, n.p.; *The Fish Shop*, 17 x 14 in/43 x 35.6 cm, Carline Collection, repr. *Spencers and Carlines*, n.p. The picture formerly belonged to Stanley Spencer.

30 Spencer was voted in as a member, but Currie, Gertler, Japp and Paul Nash were all rejected between 6 December 1913 and 7 March 1914. Information from W. Baron, *The Camden Town Group*, London, Scolar Press, 1979, p. 57, fig. 3. According to Richard Carline (interview 1979), Spencer did not like to exhibit his work alongside that of other artists.

31 Information from 'Percyval Tudor-Hart, Painter and Teacher, 1874-1954,' an unpublished article by Richard Carline, dated 12 July 1974. The typescript is in the possession of Nancy Carline.

32 Tudor-Hart may have based his theories in part on the work of W. Kandinsky, of whom he was a great admirer.

33 Quoted by Carline in his essay (see note 31). Bassett published a summary of Tudor-Hart's colour theories in the *Cambridge Magazine* in 1918 and 1921.

34 Ibid., Carline 1974, p. 2.

35 Nancy Carline (interview, July 1984) identified Tudor-Hart's influence on Richard Carline's work in a painting *Nude Washing* (1929), Carline Collection, repr. in colour in *Richard Carline 1896-1980*, catalogue for the

exhibition held at Camden Arts Centre and The Playhouse Gallery, Harlow, 1983.

36 Introduction, *Spencers and Carlines*. Carline's picture was *Portrait of Hilda* (1918), canvas, 30 x 25 in/76.2 x 63.5 cm, Carline Collection; repr. in colour in *Richard Carline 1896-1980*. It is difficult to identify the Spencer painting Carline is referring to unless he meant *The Dustbin, Cookham* which was not painted until 1956 (422). The scene had appeared earlier, however, in the 1927 illustrations made by Spencer for the Chatto and Windus *Almanac*. These scenes (two for each month) could have been the ones Carline had in mind.

37 E. Cowling, Introduction, 'The Early Work,' in the catalogue of the exhibition, *Richard Carline 1896-1980*, pp. 13, 14.

38 *Portrait of the Artist's Mother*, 24 x 24 in/70 x 70 cm, private collection; *Interior of Studio*, 28 3/4 x 20 in/73 x 50.8 cm, private collection. Both reproduced in the catalogue of the exhibition *Richard Carline 1896-1980*.

39 According to Nancy Carline, Tudor-Hart was a common topic of discussion at 47 Downshire Hill during the 1920s.

40 *Studio*, vol. 94, no. 415, pp. 262-7. Among the artists illustrated were: Robert Montenegro, Jose Clemente Orozco and Diego Rivera. Carline was particularly interested in Central and South America. He visited the Orinoco River aboard the sailing ship *Grace Harwar* in 1930, and painted in Mexico and the southern United States, 1937-8.

41 Information from R. Carline's introduction to *Spencers and Carlines*. Gilbert hoped to marry Hilda but was displaced by Spencer. The Carline parents moved from Oxford to 47 Downshire Hill, Hampstead, c. 1918-19.

42 Ibid.

43 Richard Carline was particularly well represented by no fewer than seven paintings.

44 Quoted by R. Carline in *Spencers and Carlines*.

45 Ibid., R. Carline, 1973, Letter to Hilda. Spencer probably had in mind Meninsky's *On the Departure Platform, Victoria Station*, (IWM Collection).

46 20.12.1919.

47 Japp also used an unusual diagonal composition, as well as a stippled impressionistic paint surface similar to another of Lamb's war paintings – *The Bivvy, Palestine* (1923), canvas, 18½ x 32¼ in/47.4 x 82.1 cm, private collection.

48 According to Spencer's own itinerary (733.8.41) he first stayed at 47 Downshire Hill (other than on short visits) in 1922 before the trip to Sarajevo. On his return he went back to lodgings in Petersfield (Mrs Lewis's?) before returning to no. 47. He then alternated between no. 47 and the Vale, while spending a large amount of time elsewhere (Poole, Wangford etc., see *Chronology*). In 1923 he settled at the Vale Studio, staying there until the move to Burghclere in May 1927. Lamb purchased 10 Hill Street, Poole, in April 1922, but continued to rent the Vale Studio; he did not relinquish its tenure until 1926.

49 The exhibition catalogue is in an Album of Sydney Carline memorabilia given to the Tate Gallery Archives by Nancy Carline.

50 *Spencers and Carlines . . .*, op. cit.

51 Ibid.

52 Tate Gallery Archives, Box 8212, letter of 22.1.1917.

53 This term was probably invented by Henry Lamb.

54 Carline recalled in *Spencers and Carlines* that Fry had admired his *Portrait of Hilda Carline* (1918).

55 Ibid. William Roberts was also a frequent visitor to Downshire Hill in the immediate post-war years. According to Nancy Carline (interview, Oxford, July 1984), Roberts was 'very friendly' and 'well disposed' towards Richard Carline.

56 Interview, 17 Pond Street, 1979.

57 Also quoted by Elizabeth Cowling, 'The Early Work,' introduction to *Richard Carline 1896-1980*, op. cit., 1983. First published by Carline in *Spencers and Carlines* .

58 Canvas, 37 x 22¼ in/94 x 56.5 cm, Tate Gallery. The painting may have been influenced by Paul Nash's Dymchurch pictures of 1919-20. Nash's paintings, too, are carefully structured to present an opposition between man-made and natural forms. Carline also incorporated a female figure leaning on the jetty which corresponds closely to Nash's romantic figures in works like *The Sea Wall* (1919; Causey, Cat. no. 276). Carline's composition differs, however, in presenting the jetty and ocean at right-angles to one another. Nash preferred a diagonal viewpoint. Elizabeth Cowling in 'The Early Work' (p. 19) has also suggested, correctly I think, that Carline's work was very much in tune with the 'rigorously planned construction' which Fry later identified as a characteristic of the London Group in 1928 (Fry, *London Group Retrospective*, Burlington Galleries, 1928).

59 For example, Lamb told Richard Carline that he did not like a 'big' painting by Gertler: 'But don't you think the fellow has a very dreary sense of form *essentially*. So had Cézanne in a different way to begin with I suppose, and just as apparently essential.' HL/RC, 17.4.1924, from 17 Hill Street, Poole, Tate Gallery Archives, Box 8212. Spencer, in turn, did not often like Lamb's work, as he told Gwen Raverat in 1913: 'I do not always think his work interesting except sometimes,' 5.12.1913, Tate Gallery Archives, Box 8116.

60 TAM 19, HL/RC, 17.4.1920.

61 Both in Tate Gallery Archives, Box 8216: HL/RC, undated but certainly 1924, '. . . give my love to all the cercle'; HL/RC, 15.11.1924, post-card from Mantua; 'My love to you and all the cercle, Henry Lamb.'

62 Ibid., Box 8216: HL/RC, 10.5.1924, from 10 Hill Street, Poole. Spencer had met Edwin, son of Augustus John, before the war. Part of this letter was quoted by R. Carline in 'Gatherings at Downshire Hill in the 1920's,' *Hampstead One*, exhibition at Gallery Edward Harvane, London, 1973; and Elizabeth Cowling, 'The Early Work,' pp. 15, 21.

63 Box 8212, Tate Gallery Archives, Gertler/R.C., 10.4.24, from Penn Studio, Rudall Crescent, Hampstead.

64 Information from an interview with Carline, September 1979.

65 Sydney was appointed in January 1922. He remained there until his sudden death in February 1929. A copy of Bone's recommendation is in vol.ii of the press cuttings album gathered together by Richard Carline in 1929 and now in the Tate Gallery Archives. Sydney also introduced drawing from the figure, albeit not on the school premises. For the debate which this raised see the two uncatalogued volumes of Sydney's press cuttings and photographs, Tate Gallery Archives.

66 Exact date uncertain. Cutting in Sydney Carline, press cuttings (see note 65).

67 At least some of these have survived; see 733.2.1-11.

68 733.2.11, 733.2.1, 733.2.4, 733.2.3.

69 733.2.1. In a note attached to 733.2.3, Richard Carline states that the lectures were written at the Vale Hotel, 1924-5.

70 733.2.8.

71 The reviewer for the *Oxford Chronicle* of 3.4.1925, called the paintings: 'Resurrection of the Damned and Resurrection of the Blessed,' and 'Unveiling a War Memorial.' The exhibition review was headed 'Some Modernist Pictures.' Gilbert Spencer

exhibited a drawing of Garsington Manor; John Nash one of 'Grange Farm'; and Paul Nash, *Le Pont Royale* and *Dimchurch* [sic]. *Pont Royale* may be either no. 515 or 516 in Causey's, *Paul Nash* catalogue. Both are dated 1925, although the Oxford exhibition is not listed. *Dimchurch* is not listed with the incorrect spelling, but Causey does list six works with the title *Dymchurch*: nos. 296, 350, 351, 392, 442, 501. No. 502 was probably exhibited at the NEAC in April 1925 (177), and so could not have been in the Oxford exhibition held the same month.

72 In January 1930 Richard Carline and a friend, John Duguid, sailed to Venezuela where they spent some time on a trading schooner up the Orinoco River. They returned to England aboard the *Grace Harwar*, one of the last commercial sailing ships.

73 Lamb sent a Rolls-Royce salesman to Spencer after his successful exhibition as a joke – it was not appreciated. According to Lady Pansy Lamb (then Pakenham), Hilda Spencer's 'difficult' manner made social occasions awkward, although she and Lamb did visit Spencer at Burghclere about 1930-1. Lamb had had his doubts about Spencer's personality before. In 1924 he commented to Richard Carline: 'Cookham and Hilda are the limit; and I am sorry for all you Downshires daily feeling the brunt of these limitations . . .' (HL/RC, 10.5.1924, Tate Gallery Archives, Box 8216). Lamb had no doubts about Spencer's painting. In the same letter he remarked: 'The "noble constancy" of the little gentlemen's work . . . together with the astounding novelty of such a personality stepping in . . . to restore narrative art to its primitive purity lost in history since Fra Angelico and in every child after the age of 12 or 13.'

74 After 1930 Gilbert transferred some of his attention to Gertler's Thursday evenings. However, after Gertler moved to a new address at Haverstock Hill and began to entertain Herbert Read, whose *Art Now* Gilbert disliked, the visits ceased. See G. Spencer, *Memoirs of a Painter*, London, Chatto and Windus, 1974, Ch. 8. Other friends also moved away including Darsie Japp who settled at Rooknest Farm, Lambourne, Berkshire, where he turned his talents to farming.

75 Gilbert Spencer's paintings, not unnaturally, were closest to Spencer's in the 1920s, at least in style. In *The Miller*, 1921 (plate la in G. Spencer, 1974, opposite p. 72), Gilbert employed the same sharply receding

perspective path which Spencer had first used in *The Nativity* (11). However, Gilbert never achieved the same kind of spiritual intensity in his own work, even when he imitated his brother's exaggerated expressive gestures – as in the *Balliol Murals*, 1936 – and his figures often have a bucolic flavour which is never found in Spencer's work.

76 Tate Gallery Archives, Box 825, AL 257, SS/Sturge Moore, 26.4.1924, from 3 Vale Studios. The letter concluded with a piece of terrible verse:
When I was young and full of frolic Asian ardour spoiled my Gothic Style. And then the photo nuisance tempted me to try Renaissance. This lasted well. Then being broke I had a shot at the Baroque. And lately though I can't face Titian [Boris] Anrep says my style's Venetian.
'But this last that Anrep says (R.H.W. says all the rest) rather pleases me. I am doing a big picture of the Resurrection, and Anrep when he said this was referring to some trees I have painted in this picture.' The reference to the 'photo nuisance' probably recalls Spencer's interest in Henry Lamb's postcards of paintings and the Gowans and Grey picture books (see Ch. 1).

77 Pen and ink, wash, 6 x 10 in/15.3 x 25.4 cm, IWM collection.

78 733.12.1. The photograph is glued into Spencer's press-cutting scrapbook. Spencer was to be influenced again by Roberts in the late twenties, when the latter had developed his social-realist subject-matter and tubular style.

79 First noted by Causey, p. 25.

80 733.3.1.

81 733.3.21, written c.1938.

82 Ibid. This in part accounts for Spencer's novel approach to the subject of the dressing station. By comparison Nevinson, in *La Patrie* (repr. *Paint and Prejudice*), was concerned with the unpleasantness of suffering; and Henry Tonks's *An Advanced Dressing Station, France, 1918* (IWM), repr. in 'Professor Tonks: War Artist,' by Julian Freeman, *Burlington Magazine*, vol. cxxvii, no. 986, May 1985, 285-93, is a more clinical approach influenced by his medical training.

83 Spencer moved into the Slessers' house late in 1920 and stayed there until the end of 1921.

84 Spencer's complete letters to Chute are in the collection of the Stanley Spencer Gallery, Cookham.

85 See Carline for an account of the Hawksyard episode, pp. 110-11.

86 *The Last Supper* hung for many years in the Slessers' oratory, where it served

as an altarpiece.

87 The information on Steep comes mainly from a long unpublished letter (733.1.175) which Spencer wrote to the Behrends in the 1950s concerning his various commissions. He seems to have fallen out with the Bones over a personal letter or postcard which he read by mistake. Spencer also claimed that Bone interfered ('he was much too pressing') over the Bedales commission, causing its loss. Spencer's grandiose scheme for Steep Hall was probably too large for Bone's limited budget, and this too may have upset Spencer.

88 In a letter to Spencer of 18.7.1919, Yockney told him that Bone 'still hopes you may feel inclined to carry them [some small Macedonian studies] out.' IWM Archives.

89 733.1.175. 'Bone reconed [sic] I had not shown sufficient interest or done a proper set out scheme. Anyway he paid me £25 to go into the next street.' Spencer moved to a series of lodgings at Mrs Knight's, No. 1, The Square, Steep; Mrs Lewis's near Petersfield, and 10 High Street (Petersfield?), 733.8.41; Carline also discussed the Steep scheme, pp. 73, 199, 208.

90 733.3.1.

91 SS/Yockney, IWM Archives, 27.7.1919.

92 Information from *Stanley Spencer by his Brother Gilbert*, p. 153. This has been verified by the Tate Gallery, who x-rayed the painting.

93 7383.3.1. Also quoted by Bell in RA, p. 52, no. 28.

94 C. Leder, p. 17. The Fra Angelico painting is in the National Gallery, London.

95 Causey does not refer to this painting. It may have been this small oil study, and not the design for the 1915 painting, which Spencer showed to Gordon Bottomly in 1922 (see Causey, p. 25).

96 See Causey, ibid. Spencer may have had in mind some form of Resurrection for his projected series of paintings for Petersfield Village Hall in 1922 (see Bell, RA, no. 64). Writing to Henry Lamb he reported: 'I have a wonderful place for the fresco to start. A long concrete floored room with fireplace and overlooking Petersfield churchyard so that I am in immediate communication with the dead. They are buried in the side of a bank so that they only have to push at the gravestones a little bit forward and they are in my room.' SS/HL, 2.2.22, from c/o Mrs New, Bell Hill, Steep. The note is accompanied by a

drawing of the artist at work with a figure stepping out of his grave as though the tombstone were a door. Spencer used this air of relaxed intimacy in *The Resurrection, Cookham*.

97 733.3.1, no. 81.

98 For example, *Christ Carrying the Cross* (1920; 38) and *Christ's Entry into Jerusalem* 1(1921; 69).

99 John Liston Byam Shaw, *The Blessed Damozel* (1895), 37 x 71 in/94 x 180 cm, Guildhall Art Gallery, London; D.G. Rossetti, *Dantis Amor* (1859), 29½ x 32 in/75 x 81 cm, Tate Gallery, London.

100 Carline joined the Art Committee of the Colonial Council for Native Education in 1931. In 1935 he organized *Negro Art*, an exhibition of tribal art, work by contemporary black artists, and related work by British artists, at the Adams Gallery, London. He also contributed the main text to *Arts of West Africa* edited by Sir Michael Sadler, begun in 1931 and published in 1935. In April 1935, he published 'West African Art and Its Tradition' in *Studio*, vol. 109. He also collected African and other non-European artefacts, but I am uncertain when these were acquired.

101 733.3.16.

102 733.3.85, c. 1946.

103 733.3.1. See 733.3.1, 81, for Spencer's discussion of Donne and the *Resurrection*. Richard Carline informed me in September 1979 that Eastern religions were often discussed at 47 Downshire Hill in the 1920s.

104 733.3.1.

105 Ibid.

106 Ibid.

107 Ibid.

108 Ibid.

109 Ibid.

110 Ibid.

111 The sub-title was mentioned by Causey (p. 26). It appeared in an interview which Charles Aitken gave to the *Daily Mail* on 7.2.29. It has a rather pompous ring to it, and it is difficult to imagine Spencer seriously contemplating its use. Spencer may have been persuaded to use the title as a means of clarifying his intentions. The fact that it was not used in the 1927 Goupil Gallery exhibition suggests that the title was a later addition, or that Spencer had already decided to drop it.

112 733.3.16, inscribed 'Jan. 1939-Mar. 1941.' Spencer also made detailed reference to the presence of several Stanleys and Hildas in 733.3.85, c.1945.

113 Both 733.3.82.

114 Ibid.

115 3.3.27, anon.

116 28.3.27.

117 25.2.27.

118 *Observer*, 6.3.27.

119 3.3.27.

120 28.2.27, anon. Other enthusiastic reviews came from the *Morning Post*, 25.2.27, 'A Great Picture: Mr Stanley Spencer's Resurrection,' the *Daily Chronicle*, 2.2.27, a 'Second Blake,' and *Sphere*, 12.3.27, p. 413, 'The Most Discussed Picture of the Year.'

121 7.3.27, anon.

122 Ibid.

123 9.3.27, anon.

124 *Nation and Athenaeum*, 12.3.27, 'Mr Frank Dobson and Mr Stanley Spencer', by Roger Fry.

125 *Apollo*, vol. v, no. 28, April 1927, 162-6, 'Stanley Spencer.'

126 William Blake died on 12 August 1827. The event was celebrated by an article – 'The Blake Centenary' by Archibald Russell in *Apollo*, vol. v, no. 30, June 1927, 258-61.

127 *Apollo*, vol. v, no. 27, March 1927, 140-1. Review of an exhibition of work by Fry, Frederick Porter, Bernard Meninsky.

128 It seems very possible that Fry's name was mentioned at this point in the conversation. Spencer had continued, 'I'm simply unable to understand modern painting.' Ibid., 162.

129 Ibid., 164.

130 12.3.27, anon. *The Resurrection, Cookham* was reproduced alongside the review.

131 Tonks's position is discussed by Simon Watney in *English Post-Impressionism*, Studio Vista/Eastview Eds. Inc., London, 1980, p. 19.

132 *Daily Sketch*, 3.3.27, anon. The article was entitled 'A Primitive Artist of Today.'

133 Vol. ii, *From Constable to the Present Day*, London, Chapman and Hall, 1924.

134 Ibid., p. 304. Hind was referring to what he felt was the rejection of 'Cézanne and Monet and Picasso and Matisse . . . as if they had never been,' by Allan Gwynne Jones, who, he saw with evident approval, had swung back 'to the Pre-Raphaelite stalwarts, not from any desire to imitate them, but because he sees as they saw, and feels as they felt.' Lewis Hind also celebrated the recent work of Edward Wadsworth who 'has freed himself from the Young Man of the Sea called Cubism, and has allowed his own personal vision free play.' (p. 305). Finally, the writer concluded by saluting 'my countrymen and countrywomen who are carrying on, and re-expressing, and rejuvenating the British love of landscape painting' (p. 308).

135 3.3.27, anon.

136 3.3.27.

137 Ibid.

138 *Observer*, 6.3.27.

139 2.2.27, anon.

140 9.4.27, anon.

141 6.11.30, anon. Significantly the critic was discussing Spencer's *Landscape at Burghclere*. 'Its beauty is abiding,' he wrote, 'There is in this landscape none of the heartless swish-swash of myopic Cézanne disciples.'

142 15.6.29, anon.

143 28.2.27. This opinion was repeated in a review of Spencer's 'Burghclere Landscape' (*Cottages at Burghclere* ?).

144 Op. cit. He had called it '. . . the most important picture painted by any English artist during the present century.'

145 April 1927.

146 *English Art 1870-1940*, Oxford University Press, 1978, p. 248.

147 733.12.1. Unidentified press cutting, 1919, entitled 'Soldier Artists' War Pictures,' a review of the exhibition of that name held at Burlington House in 1919. *Travoys* (30) was picked out for special praise.

148 The Leicester Galleries exhibition took place in April. Lamb moved from his studio at 28 Maida Hill West to Brookside, at Coombe Bissett, in 1928. Lamb's decline as an artist in the late 1920s was also noted by Clements and Martin in the introductory essay to the exhibition *Henry Lamb*, Manchester City Art Gallery, 9 May-16 June 1984. Significantly, the exhibition contains only a few works painted after 1928, and the majority of these are portraits. Lamb's work as a war artist in the Second World War was particularly disappointing.

149 *London Group Retrospective Exhibition 1914-28*, held at the New Burlington Galleries, April-May 1928. The point was made by Farr in *English Art and Modernism*, p. 233.

150 Op. cit., *Apollo*, March 1927, 140.

151 *Men and Memories*, vol. ii, London, Faber and Faber, 1932, p. 225.

152 Ibid. All quotations from p. 223.

153 Rothenstein commented favourably on these artists on p. 225, although this does not seem to represent a complete list of names. Gilbert Spencer and Paul Nash might well have been included.

154 This condition is discussed in M.J. Wiener's book, *English Culture and the Decline of the Industrial Spirit 1850-1980*, Cambridge University Press, 1981. Wiener identifies the south of England, Spencer's home territory, as the centre of the mythical English landscape which remained unchanging despite the industrial and political turmoil of the nineteenth and twentieth centuries.

155 Quoted by Wiener, p. 61.

156 Ibid., p. 62.

157 The editions of *Georgian Poetry* sold well – 10-20,000 copies of all but the last edition. Wiener, p. 62. See also R.M. Ross, *The Georgian Revolt, Rise and Fall of a Poetical Ideal 1910-22*, London, 1967.

158 Wiener, p. 62.

159 Ibid.

160 'Stanley Spencer', 162-6.

161 756-48.1918.

162 7.3.27.

163 The exhibition was held at Heal's Mansard Gallery in March 1920. See Charles Harrison, *English Art and Modernism 1900-1939*, Allen Lane, 1981, pp. 157, 158, 164.

164 The nearest Spencer came to influencing another artist was during 1919-21, when Henry Lamb's paintings came very close to Spencer's own work. However, as I have pointed out, the Spencer/Lamb connection often seems to be more of a shared style than a case of one-way influence. This style also included Gilbert Spencer and John Nash, the only younger artist.

165 Interview, December 1979. Ms Bone was particularly struck by Spencer's figure paintings.

166 See RA, no. 42, and Carline, pp. 122-3.

167 For a list of mural projects during the twenties see R. Shone, *The Century of Change: British Painting Since 1900*, Oxford, Phaidon Press, 1977, p. 28.

168 In 1924 C. Lewis Hind felt that the poster painters were important enough to merit a complete chapter in his *Landscape Painting*, vol. ii. Some posters were quite radical in design, see F.C. Herrick's RMSP design, Lewis Hind, repr. facing p. 330.

169 For Paul Nash's works see A. Causey, *Paul Nash*, pp. 373-5. Nash later blamed Spencer for the collapse of the scheme (Causey, p. 375). Spencer claimed that he resigned from the scheme because he discovered that the 'city fathers' were against the idea, and that no money was available. 733.1.175, draft letter to Mary Behrend, no date but after 1935.

170 For example, Stoke's *Warwick Castle* and Brangwyn's *Royal Border Bridge, Berwick* in C. Lewis Hind, *Landscape Painting*, repr. facing pp. 324-6.

171 For a slightly later example see Budd's 'Travel Underground between 10 and 4'; London Transport Executive, repr. *Thirties: British Art and Design Before the War*, Hayward Gallery, 1979-80, catalogue, repr., p. 220, no. 18.7.

172 TAM 15. Letter to Richard Carline, 5 July 1928.

173 Ibid.

174 *Observer*, 6 March 1927.

175 *The Times*, 17 December 1932.

176 *Since Fifty. Men and Memories 1928-38. Recollections of Sir William Rothenstein*, London, Faber 1939, p. 96.

177 *English Painting*, Faber, 1933, pp. 280-5.

178 Newton, 1947, p. 15.

179 Ibid.

1 See M. Collis, 1962, p. 101. Spencer bought Lindworth early in 1932 for £1000, part of the proceeds of his 1927 Goupil exhibition.

2 733.10.58.

3 In a notebook entry of 1949 Spencer emphasized his need for a new home and family to replace the atmosphere of Fernlea:
'At Fernlea as a child I consummaged [sic] all through Pa and Ma and Home Life, this gives the required lived-in element to all I experienced there in Fernlea. But when I went away to do my work, in an empty room in a cottage, 'The Ship' I saw that in order to be able to consummate my experience I should have to be married . . . If I wanted the Fernlea lived-in feeling I must create a new thing that provides it: a new Pa and Ma.' Gormley, p. 68.

4 Draft letter to Hilda, 1937, quoted by Gormley, p. 63, note 2. Spencer met Hilda for the first time in December 1919, but they did not marry until March 1925, after a prolonged intermittent relationship. According to Lady Pansy Lamb (interview, September 1978), Hilda faked pregnancy to push Spencer into marrying her. I have been unable to verify this statement. Spencer was 34 before he first experienced sex. For a sympathetic account of the Spencer-Hilda relationship, see R. Carline.

5 733.1.1641. An essay fragment written in the forties by Hilda for Spencer's projected book on himself and his art. Hilda also claimed that when she met Spencer in 1919 'he was becoming stale,' and implied that the success of much of his work of the twenties was due to her role in his life as a 'muse.'

6 Even the Burghclere compositions had been established by the end of 1923, and the three central paintings of the Empire Marketing Board commission were taken from drawings made in 1921.

7 In the second and third editions of *Who's Who in Art* (1929, 1934), Spencer described himself as a mural painter.

8 Letter to Hilda, 24 November, 1948, quoted by Gormley, p. 2.

9 Richard Carline informed me that he knew of the *Church House* by c.1933, and that Spencer talked about it quite freely among his friends (interview, September 1979).

10 See M. Collis, 1962, chs. 7-11. However, Collis was preoccupied with the role of Spencer's erotic paintings in the *Church House*, and he did not explain the entire project.

11 Anthony Gormley, *The Sacred and the Profane in the Art of Stanley Spencer: A Study in the Figure Paintings, 1933-9*, B.A. Thesis, Cambridge.

12 D. Robinson, *Stanley Spencer: Visions from a Berkshire Village*, Oxford, Phaidon Press, 1979; A. Causey, 'Stanley Spencer and the Art of His Time,' in *Stanley Spencer RA*, exhibition catalogue, Royal Academy of Arts, 1980, pp. 19-36.

13 733.3.6. In 1923 Spencer had also proposed a series of 'domestic incidents occurring between myself and Louie [Behrend],' showing them at work on the plans for the chapel. These pictures would have been placed in the proposed 'narthex,' which was never built (Carline, p. 158). Nothing came of the idea.

14 Ibid.

15 Ibid.

16 Ibid.

17 Ibid.

18 Ibid.

19 At Burghclere, Spencer planned the painting series first; in the *Church House* the building design came first, leaving him free to evolve the paintings for the building gradually.

20 Causey, p. 29.

21 See 733.2.3, 1947.

22 Most notably in *The Resurrection, Cookham*.

23 733.3.82. (a) Spencer explained this feeling, c.1940, in a notebook: 'I like making memorials of people and places. At this moment I am painting a memorial of myself, Daphne, and Stonehouse. This couple picture belongs to a number . . . I have done in which their union and the circumstances where and when it occurred is the theme.' The painting was for the *Church House, Daphne Memorial*.
(b) In the late thirties Spencer even attempted to supplement the scheme with an artistic autobiography to accompany illustrations of his work. In the event Elizabeth Rothenstein wrote the book (*Stanley Spencer*, published by Phaidon in 1945). Spencer did not achieve his ideal until Wilenski gave him space to write in *Stanley Spencer Resurrection Pictures*, Faber and Faber, London, 1951.

24 Spencer liked to lay out all his drawings and muse over the events depicted there; and the *Church House* is just an enlarged extension of this idea. When visitors were present, he would explain not only the meaning of the work, but also the wider events surrounding the setting and characters in the painting. Spencer's obsessive interest in everyday events (or 'gossip') often gives his paintings, and their descriptions, the same drama and repetition as a radio or television 'soap opera,' with its

unidealized characters and its magnification of petty human events.

25 These were mainly secular subjects, e.g., the 'chapels' commemorating Spencer's wives and women friends, but they also included the big *Christ Preaching at Cookham Regatta* (383) series.

26 Letter to Hilda, 20.1.48, 733.2.375.

27 Spencer discussed the Cana idea at length in 733.3.6, p. 54.

28 Gormley, p. 4.

29 Gormley (p. 5) counted only four chapels, but Spencer planned five, including one for Charlotte Murray, for which he made no drawings or paintings. 733.10.124.

30 A point made by Gormley, p. 5.

31 See 733.2.427, 'Saints and Villagers.'

32 By the mid-thirties Spencer had lost interest in the religious side of the *Church House*, as his obsession with sex increased.

33 E. Rothenstein, p. 14.

34 Spencer's unwillingness to leave any detail out of his schemes is demonstrated in the vague 'commission' to paint a mural series at the University Library, Cambridge, for which he was probably proposed by the Raverats. Together with two end-wall paintings, *The Tower of Babel* (147), and *Pentecost* (a previously unremarked use of the *Church House* idea) Spencer proposed using the two corridors on either side of the Index room for '. . . a history of literature in pictures . . . a complete monumental statement each 200 feet long' (!), 733.3.1, 96.

35 This reluctance, also found in the late completion of *Furnaces* for the *Shipbuilding* series, has also been noted by Causey, p. 31.

36 Spencer preferred the term 'Last Day' to 'Last Judgement,' because it implied a simple transition into a heavenly state, without the threat of punishment.

37 For example, *Love on the Moor* was not completed until 1955.

38 Gormley, p. 3.

39 Quoted by Gormley, p. 3. I was unable to find this quote in the Tate Archives.

40 Ibid.

41 733.3.5, 60.

42 Spencer sold some 50 of these drawings, and two *Adorations* paintings, to Anton Zwemmer in late 1937; most were sold privately and are not lost. Zwemmer had attempted to poach Spencer from Tooth's, using as bait his willingness to purchase figure paintings which Tooth was reluctant to sell. Spencer sold the two paintings for £20 each, and the drawings for £100 (DT/SS, 15.7.38 and SS/DT, July 1938). Tooth bought some drawings back in a deal with

Zwemmer, note by Dudley Tooth, Tooth Archive, 29.7.37.

43 Preece had trained at the Slade and in Paris, before returning to England in 1925. She moved to Cookham in 1927, where she lived with a friend, Dorothy Hepworth, at Moor Thatch, situated at the Cookham Moor end of Cookham High Street. Before forming a relationship with Spencer, Preece went out with Richard Carline (Carline to the writer, interview, December 1979).

44 Both M. and L. Collis make this point. Lady Pansy Lamb informed me in October 1978 that one of the causes of the break-up of the Spencer-Henry Lamb relationship was Hilda's 'difficult' manner, which made her something of a social liability.

45 A point made by Lady Pansy Lamb (October 1978), who claimed that Spencer became increasingly arrogant after his successes. Richard Carline was of a similar opinion.

46 733.3.1, p. 96. Also quoted by me in RA, no. 141.

47 Spencer completed the lower half of *Swan Upping* in 1919. The joint is invisible, and the artist must have hoped that his life might proceed in a similar undisturbed fashion.

48 The bollard may have another association: with the Linga, the Indian symbol of the god Shiva. Spencer's pursuit of Patricia, and the accompanying paintings, are also generally reminiscent of the story of Rada and Krishna, and the erotic paintings accompanying the tale.

49 733.3.1. Also quoted by me in RA, no. 143.

50 733.3.1, 92.

51 Ibid.

52 *Sarah Tubb and the Heavenly Visitors* of 1933 was also destined for the *Church House*, but mixing of the Tubb story and the Last Day theme again places it in an intermediate position.

53 First quoted by M. Collis, 1962, pp. 138-9.

54 733.3.1.

55 Ibid.

56 Information from R. Carline, September 1979. Carline had wide ranging interests in non-European art, and contributed to a book, *The Arts of West Africa*, edited by Sir Michael Sadler, in 1935.

57 See Gormley, p. 13. Robinson, 1979, also refers to Oriental influences, pp. 49, 53.

58 Ibid.

59 Ibid.

60 Spencer learned of Islam from the Carlines on their trip to the Islamic region of Yugoslavia; and from the painter James Wood, an expert on

Eastern religions (Carline to the writer, interview, November 1979).

61 Quoted by Robinson, 1979, pp. 49, 53.

62 In a letter to Hilda (733.3.85, 210), Spencer referred to 'the Indian sculpture book we bought in Munich,' in 1922. Also, 'In my "Wonders of the World" there is a description of the temple of Boro-a-dur [sic] and three mile frieze, eight feet high, of the life of Buddha . . . some of the most magnificent carving the world ever saw.'

63 Quoted by Robinson, 1979, pp. 49, 53.

64 733.2.135, 28.11.42.

65 Spencer found other means of making his point, for example, the peeled banana proffered by a man to a woman in *Love on the Moor* (415).

66 Quoted by Robinson, 1979, p. 65.

67 The exhibition was later closed down by the police who temporarily confiscated thirteen paintings. Spencer was unlikely to have missed the attendant publicity, which predated his own troubles with censorship at the Royal Academy in 1935.

68 Lawrence and Spencer shared certain tastes; an early interest in Italian art (Lawrence had copies of a print of *Joachim and the Shepherds* by Giotto in 1915); the Pre-Raphaelites, mentioned in *The White Peacock*; and the 'primitive' element in Gauguin's work and Post-Impressionism.

69 Spencer may have heard something of the relaxed sexual politics of Bloomsbury through his affair with Preece. The Lawrence paintings are illustrated in *The Paintings of D.H. Lawrence*, edited by Mervyn Levy, Cory, Adams and Mackay, London, 1964.

70 Eric Gill, *Autobiography*, The Right Book Club, London, 1944, pp. 246-7.

71 *The Letters of Eric Gill*, letter to Graham Carey, 2.11.28.

72 *Autobiography*, 1940 edition, p. 119.

73 *Design for a Headstone of Alice Jameson*, 1933, pencil and watercolour, 15 x 10

]¹/₂ in/38 x 27 cm, dated 20.2.33. Repr. E.R. Gill, *The Inscribed Work of Eric Gill*, London, 1964, no. 593.

74 *The Times*, 5.5.34; *New Statesman*, 12.5.34.

75 July 1935, p. 16.

76 *The Times*, 27.4.35, anon

77 5.5.34, anon. These were: *Saint Francis and the Birds*, *The Dustmen* or *The Lovers*, *The Builders*, *Workmen in the House*, *The Scarecrow*.

78 See D. Sutton, *Walter Sickert*, Michael Joseph, London, 1976, pp. 238-9.

79 Letter of 18.4.35, quoted in full by M. Collis, 1962, p. 115.

80 W.N.R. Lamb was the Secretary to the Academy.

81 M. Collis, 1962, p. 115.

82 26.4.35. Headed 'ARA's Rejected Pictures.'

83 Spencer told *The Times* for 26 April that the three accepted Academy works were to be exhibited 'elsewhere,' meaning at Tooth's.

84 127.4.35. *The Times* published the full text of Spencer's letter.

85 M. Collis, 1962, p. 115.

86 *Saint Francis* was greeted by universal hostility when shown at Tooth's, but was sold at once to Spencer's friend, Miss Silcox, headmistress of Southwold Girls' School.

87 June 1935.

88 John and Sickert both wrote to the press in Spencer's support.

89 *Observer*, 1951, Spencer press cutting collection, 733.12.5

90 27.4.35, anon.

91 Ibid.

92 11.5.35, anon.

93 *Sunday Times*, May 1935, Spencer press cutting collection, 733.12.5.

94 4.5.35, anon.

95 3.5.35, anon.

96 3.5.35, anon.

97 4.5.35, anon.

98 D.S. MacColl 1859-1949. Successively art critic to the *Spectator*, *Saturday Review*, *Weekend Review*; editor of *Architectural Review* and *Artwork*, WWW.

99 Pp. 703-11, Spencer press cutting collection, 733.12.5.

100 Glasgow University Library, Special Collections: letters between Shaw and MacColl, S133A, S134, S135, May 1916. MacColl had attacked Shaw for his support of Picasso and Cézanne.

101 MacColl cleverly turned the words of the Academy supporters against themselves – quoting one review from a 'Sunday Paper' which he felt was typical of their tendency to 'play for safety': '"Lady (Gomer) Berry and her daughter" is a modern version of the traditional English Grand Style in portraiture. Classical in . . . it is romantic in . . . ; it is yet modern in Fortunate in the attractiveness of his sitters, dexterous and tactful in presenting them so decoratively, W.G. de Glehn RA has produced a picture which is certain to be immensely popular.' (MacColl's editing.)

102 H. Tonks/MacColl, 19.5.35, Glasgow University Library, Special Collections, T369.

103 F. Brown/MacColl, undated but probably c.1935, ibid., B683. Frederick Brown (1852-1914), was a painter, member of the NEAC and Slade Professor of Fine Art at London University, 1892-1917. Brown's gossip came from Spencer's 'wife,' and apparently related to the broken Spencer marriage – 'not a nice

picture.' Brown also felt that Spencer could not 'draw without a model,' and that he thought himself a 'genius,' playing upon it 'because it brought him notoriety and money.'

104 30.4.35. The approach taken by the reviewer in discussing *The Dustmen or The Lovers* suggests that his attitude to Spencer's work was prompted by a familiarity with Surrealist theory.

105 28.4.35. This review and others are preserved in Tooth's press cutting books, formerly in the possession of Nicholas Tooth.

106 There are numerous examples of this type of writing in both the Tooth and Tate Archives. They are particularly prevalent in the years 1935-40, at which time Spencer was under considerable stress; but examples occur elsewhere at moments of tension.

107 The same position was to some extent shared by Sickert and John, both of whom would have remained within the Academy had it been prepared to show a small amount of liberalism.

108 *The Family*, exh. RA,1932, *Studio*, July, 1932, pl.70; *Hiking*, Laing Art Gallery, Tyne on Wear; *The Young Rower*, 1932, RA, 1932, ill. *Studio*, July 1932, p. 76.

109 For example: *Mrs Fraser's Flat, 22 Upper Gloucester Place, London*, repr. *Studio*, July 1932, p. 50.

110 Interview with writer (September 1979). Carline insisted that Spencer was not influenced by contemporary art; however, strained relations between the artist and the Carline family in the thirties prevented art from being seriously discussed.

111 Carline informed me (September 1979) that Spencer met both artists at parties in London.

112 733.1.671. Draft letter to Christopher Hassall in reply to an enquiry about Gertler, 1954.

113 See, for example, Roberts, *Sawing Wood* (1930), Ulster Museum; and *Sun Bathing* (1936), David Hicks, Esq. Robinson, 1979, p. 42, also cites Roberts as an artist working in the same area of interest.

114 Reproduced in Woodeson, *Mark Gertler*.

115 Interviews with Gilbert Spencer, April 1978, at the Martineaus' and with R. Carline, November 1979.

116 One example was 'In Search of the Absolute,' a discussion of abstract art by William Gaunt in *Studio*, November 1933, pp. 271-3; and Wadsworth's 'The Abstract Painter's Own Explanation,' in the same edition, pp. 274-6.

117 *Studio*, 1932, pp. 248-61.

118 Causey (p. 30) mentions both Benton and Rivera as parallels to Spencer's art in the thirties.

119 Causey (p. 30) also refers to the American painter's ideal of the worker-hero.

120 Spencer, however, made no mention of American art in his writings.

121 At least some of Spencer's drawings for the *Adorations* and *Love Among the Nations* were made c.1932-3, at the same date that *The Studio* was running its articles on Benton and the American Regionalist and Ash Can painters.

122 Information from Mr Nicholas Tooth.

123 Also noted by Robinson, 1979, p. 42.

124 Spencer concentrated on exhibiting figure paintings at the Academy; of nine paintings shown there in 1933 and 1934, only two, *The Angel, Cookham Churchyard* (1933), and *Scarecrow* (1934), were landscapes.

125 DT/SS, 7.5.34; DT/SS, 3.7.34; DT/SS, 11.5.34. Beddington-Behrens also reluctantly paid £300 for *Souvenir of Switzerland* which he had commissioned.

126 SS/DT, 31.3.44. Tooth was concerned at the time Spencer took over the larger figure paintings, hence the 'smaller,' easier-to-paint, compositions.

127 Spencer cancelled Tooth's first exhibition of his work in 1933. The 1936 exhibition was intended to replace the lost Academy showing.

128 However, *Neighbours* (199), *Dusting Shelves* (200) and *The Nursery* (197) were all adapted from Spencer's illustrations to the Chatto and Windus *Almanac* of 1926, and recall Spencer's childhood domestic life, thus linking the two periods.

129 733.3.1, 103.

130 733.3.1, also quoted by me in RA, p. 142.

131 First noted by Gormley, p. 21.

132 This is borne out in several ways. Hilda's continual appearance in his art in her role as mother, the partner in the symbolically resurrected family life enjoyed by Spencer in his Cookham childhood. This would also explain her dominating size, representing comfort and security to the tiny figure of the artist.

133 733.3.7, 80.

134 She stayed at their St Ives lodgings with Dorothy Hepworth and refused to allow Spencer into her room. On their return to Cookham she returned to Moor Thatch; he to Lindworth.

135 Spencer lavished vast quantities of clothing and jewellery on Patricia. Between 1935 and 1936 he spent £1500 on items for her.

136 Gormley, p. 25.

137 Ibid.

138 These were: *Adoration of Old Men, Adoration of Girls, Promenade of Women, A Village in Heaven, Sunflower and Dog*

Worship, Village Lovers. Gormley's list (p. 25) omits *Village Lovers*.

139 733.3.2. Also quoted by me in RA, no. 186.

140 733.3.2, no. 37. See also RA, no. 185a.

141 Gormley does not make this point, but suggests, I think correctly, that the children witnessing the scene also emphasize the new absence of shame associated with free sexual love after *The Resurrection*.

142 733.3.1.

143 Brighton, 1965, no. 211; see also RA, no. 187.

144 733.2.43.

145 733.3.1.

146 Ibid.

147 733.3.2, pp. 15, 16.

148 733.3.2.

149 733.3.2, p. 126.

150 733.3.3.

151 M. Collis, 1962, p. 144, and RA, no. 188.

152 733.10.179. This is a useful but rather confused discussion of the 'distortion' question which evidently bothered Spencer badly. The first serious accusation of distortion seems to have been made over *Saint Francis and the Birds* in 1935, and continued intermittently thereafter.

153 733.1.363. I have been unable to find out who 'Olive' was. The letter dates from the mid-1950s, but is undated and was probably not posted.

154 733.3.68. Undated but probably 1940s. The Bradbury in question may have written a letter to the paper. As some of the *Beatitudes* were exhibited at the Spencer exhibition at the Leicester Galleries in 1942, this may have been the occasion of Bradbury's criticism. Spencer probably never sent the letter, for which this is a draft.

155 Interview, November 1979.

156 Lady Pansy Lamb (interview, October 1978) remarked on what an ugly couple Spencer and Hilda made when she saw them c.1932. Hilda's subsequent mental and physical decline did not improve her appearance later.

157 Ibid.

158 SS/DT, 19.10.32.

159 SS/DT, 17.11.32.

160 SS/DT, 23.3.33. Tooth's response (23 March) emphasized the difficulty of promoting an artist's work without exhibitions, and recalled a recent one-man show by Richard Wyndham at Tooth's, in which nine paintings were sold, as an example of a sales success.

161 SS/DT, 4.6.34.

162 Telegram, 11.6.34. 'Cancel show writing – Spencer.' Followed by a letter of explanation, 12.6.34.

163 DT/SS, 16.7.34. *Parents Resurrecting* to the Walker Art Gallery, Liverpool;

Villagers and Saints to the Carnegie Institute, Pittsburgh; *A Portrait* to Huddersfield Municipal Art Gallery. In a further letter (17.7.34) Spencer objected to the loan idea on the grounds that the galleries did not usually buy his work. After the 1935 Academy fiasco, however, *Villagers and Saints* and *Parents Resurrecting* were sent to an unnamed exhibition in Brussels (DT/SS, 15.5.35).

164 In 1932 and again in 1938.

165 SS/DT, 19.12.35.

166 Statement of accounts from Tooth, 21.7.36.

167 *Truth*, 1.7.36, anon.

168 *Christian Science Monitor*, 14.7.36, anon.

169 The two exhibitions were reviewed jointly by the *Guardian*, 26.6.36, under the heading 'London Art Shows.'

170 2.7.36, anon.

171 28.6.36.

172 26.6.36, anon.

173 Ibid.

174 14.7.36.

175 *Daily Telegraph*, 1.7.36.

176 11.7.36.

177 *Apollo*, August 1936.

178 Munnings attacked the purchase of *The Resurrection, Port Glasgow* by the Chantrey Fund on the implied grounds that Spencer must be mad or perverted, or both!

179 4.7.36, anon.

180 23.6.36, anon.

181 Ernest Procter ARA, 1886-1935. Studied at the Forbes' School of Painting, Newlyn, and at the Atelier Colarossi, Paris. He was appointed Director of Studies in Design and Craft at Glasgow School of Art, 1934.

182 According to Procter the painting had no particular inspiration, although the pose has obvious connections with the traditional sleeping Venus theme. The painting toured England and America, and was seen by 60,638 people at Birmingham City Art Gallery in February 1928. Information from the catalogue to the exhibition *Painting in Newlyn 1880-1903*, the Barbican Art Gallery, 1985, p. 143, no. 122.

183 A. Bertram, 'Contemporary British Painting: Dod Procter,' *Studio*, vol. xcvii, 430, February 1929, pp. 92-7.

184 The 1939 exhibition of his work at the Leger Gallery consisted entirely of earlier pieces.

185 DT/SS, 29.12.36.

186 733.3.82, written at Leonard Stanley, 1940-1. Spencer was prompted in this lament by the recollection that a favourite early work – *Travoys* – now belonged to the Imperial War Museum. He was also concerned that the sale of compositional drawings meant the loss of potential paintings. In this respect he compared the

Goupil Gallery, whom he claimed had stored unsold drawings, and Zwemmers Gallery, who had bought drawings in 1937 but had permitted the artist to keep them until he had 'drawn them up onto canvas,' with Tooth's reputed policy for quick sales. These difficulties were almost certainly the reason why he began to make and hoard the *Scrapbook* drawing studies in 1939-40. In the 1950s, the Astor family purchased these drawings but left them with Spencer until his death.

187 Occasionally these problems precipitated a crisis, for example on 29 December 1936, when Spencer instructed Tooth not to show his work in any mixed exhibitions, even those at Tooth's. Tooth's response was firm ('I regret that the time has come to speak plainly'), and he insisted that the gallery must be given a free hand in dealing with Spencer's work ('We do not accept dictation'). Tooth also interestingly revealed that one of Spencer's major fears was that his work would 'show to disadvantage when hung with paintings by other artists,' and that this would damage both his reputation and market (DT/SS, 29.12.36). Spencer capitulated in a letter (now missing) to Tooth the following day (DT/SS, 31.12.36).

188 Spencer left because Lindworth, now in Patricia's name, was being let to provide her with an income. Spencer retained use of the garden studio (M. Collis, 1962, p. 148).

189 M. Collis, 1962, p. 153. Spencer saw virtually no one while staying at Adelaide Road, and he only contacted Dudley Tooth in early February 1939. It was at this time that Tooth assumed control of Spencer's tangled finances.

190 This idea was first put forward by Gormley, p. 44. Quotation also p. 44.

191 In Indian religions animals have a specific place on earth as the companions of man. Spencer could have read of this in his book on Indian temples.

192 Spencer later cited Thoreau's *Walden* as his inspiration for the *Wilderness* paintings (Causey, p. 32), but this rather distant literary parallel obscures his close identification with Christ's lonely experience in the wilderness, or, in the artist's case, the spartan room in Adelaide Road.

193 733.3.22, written at 188 Adelaide Road.

194 Also quoted by Causey, p. 32.

1 The paintings were put on show at the National Gallery on completion and toured the country during the war. They were also shown at the Glasgow Art Gallery, *War Artists' Exhibition*, 1945. Spencer was also the subject of a *Picture Post* photo spread.

2 Murray was a painter and art teacher at Port Glasgow High School where he met Spencer in the winter of 1943-4. Spencer was a frequent visitor to the Murrays' flat at No. 7 Crown Circus, where a room was set aside for him as a studio. The Murrays held musical evenings, where the artist first met Dr Abenheimer who was also a talented musician. Mrs Charlotte Murray, who later trained as a psychiatrist, became Spencer's lover at some time during this period. She later moved to London but the affair petered out shortly after 1950 (see no. 327). I am grateful to Graham Murray for informing me about Spencer's meeting with Abenheimer, and his subsequent analysis (letter of 9 January 1980). This important episode in Spencer's life has not been previously noted. Some surviving letters from Charlotte Murray to Spencer are in the Tate Gallery Archives, 733.1.1058-88.

3 After the war Tooth's was able to raise the price of landscapes like the 30 x 20 in *Turkeys*, first to £160 in 1946 and later, in 1947, to £200. *The Resurrection* series also fetched good prices, the smaller works selling for £650 and the big *Resurrection, Port Glasgow* (358i) for £2000, twice the sum paid by the Tate for *The Resurrection, Cookham* (1926). (Information from Tooth archives.)

4 This is especially apparent in the continuous additions to the *Church House*, notably the *Cookham Regatta* series and the 'memorial' Chapels, all conceived during the fifties.

5 'So good do I think what I have written about my pictures I would almost prefer that other people should paint them in order to leave me to write about them.' Letter to Hilda, 14 February 1949, 733.3.69.

6 To take just one example, he painted *Rock Roses* (1957; 430) for the Martineaus as well as a *Portrait of J.E. Martineau* (405); both took some months to paint. In 1958 he painted four portraits, two landscapes and three figure paintings, two of which were commissions for Aldenham School.

7 The smaller paintings were clearly designed to be sold separately if necessary. However, Spencer also broke up the three main paintings of *The Resurrection, Hill of Zion* and *Angels of the Apocalypse*.

8 Wilenski, 1951, p. 2.

9 SS/DT, 30.5.44; two undated letters SS/DT, probably May; one undated letter, probably September/October, SS/DT.

10 SS/DT, May? 'I would rather none of this new series from *The Resurrection* was shown until I have completed the series.'

11 DT/SS, 27.11.44.

12 Tooth archive.

13 DT/SS, 27.1.45. 'I hope all goes well with you and that you are finding time to paint some of those Resurrection scenes from the drawings you showed me.'

14 *Stanley Spencer: Resurrection Pictures.*

15 Wilenski, 1951, p. 2.

16 Ibid.

17 SS/DT, 27.10.44.

18 Information from Gilbert Spencer, interview, May 1978.

19 Spencer never abandoned his Pre-Raphaelite love of background detail, particularly plant life. He knew the names of all the wild flowers in the Cookham area. Information from Gilbert Spencer, May 1978.

20 Spencer cannot have conceived of the whole *Resurrection* series as a unit to be hung together; indeed, the smaller pictures were probably created on a modest scale in order that they should be sold independently. Their consistent theme was, however, demonstrated when they were brought together in Wilenski's book, *Stanley Spencer: Resurrection Pictures*.

21 By 1950 Spencer was also free of his romantic entanglements. He was no longer seeing Mrs Charlton or Mrs Murray, and his other relationships, while not always platonic, did not create any major upsets.

22 For example, the Martineaus often fed Spencer as well as commissioning pictures from him: see 405, 430.

23 Wiener, *English Culture and the Decline of the Industrial Spirit 1850-1980*.

24 24.4.50.

25 29.4.50.

26 29.4.50.

27 28.4.50.

28 Unfortunately, the *Standard* did not list the runner-up.

29 For example, *Daily Mail*, 29.4.50; *Daily Express*, 29.4.50; *Daily Mirror*, 29.4.50.

30 29.4.50.

31 29.4.50.

32 29.4.50.

33 29.4.50.

34 29.4.50.

35 Ibid.

36 7.5.50.

37 Ibid.

38 29.4.50.

39 1.5.50.

40 20.5.50.

41 8.5.50.

42 24.7.50.

43 Ibid.

44 Munnings himself might reasonably have expected to have his work chosen, particularly as a recently retired (1949) PRA. Hence, perhaps his choice of Morot's painting – significantly a very 'horsey' one – as a comparison to *The Resurrection*.

45 *Daily Telegraph*, 22.7.50, letter from William Luscombe. This comment was common, and led to a general assault on the 'so-called moderns' by K.L. Graham (*Daily Telegraph*, 9.8.50) who also took (a rather belated) swing at 'the dreadful stuff emanating from the Paris School in the past and at present.' See also *Daily Telegraph*, 26.7.50, letter from Nicholas Argenti.

46 *Daily Telegraph*, 26.8.50, from Rev. J.W. Hubbard.

47 *Daily Telegraph*, 2.8.50, from Anthony Atkinson; see also J.W. Waterer, *Daily Telegraph*, 1.8.50, who praised *The Resurrection* as 'a work of imagination' and commended the Chantrey Committee for their 'perception' in purchasing the painting.

48 Munnings even went so far as to participate in the destruction of two of Spencer's compositions (see Ch. 3) in October 1950.

49 J. Steyn, review of 'How New York Stole the Idea of Modern Art: Abstract Expressionism, Freedom and the Cold War,' *Oxford Art Journal*, 7:2, 1985.

50 *Guardian*, March 1956, quoted by Steyn, p. 60.

51 See, for example, *The Forgotten Fifties*, exhibition catalogue, Graves Art Gallery, Sheffield etc., 31 March-23 September 1984.

52 *Arena*, 1951, p. 46, quoted by Steyn, p. 61.

53 One gets the impression that after 1950 Hilda was rarely any more than an extension of Spencer's own personality – his feminine side. His letters to her seldom require a reply and really represent a dialogue with himself, as well as being an affirmation of his own self and rightness. Hilda's death perfected this situation and Spencer could manipulate the fantasy, like the *Church House*, to his own satisfaction.

54 Charlotte Murray had left her husband after the war to become a psychiatrist in London. Their correspondence is in the Tate Gallery archives, 733.1.1045 to 1088.

55 The exceptions were *Gramophone*, Leder 94; *Shopping*, Leder 96; *Life Drawing*, Leder 95a; *On Odney Common, Dogs*, Leder 93a.

56 If Spencer made any studies for the Charlotte 'Chapel' they are now lost. The Murray relationship was very discreet and did not end in the drama

attending his earlier affairs.

57 For example, Leder 73, Leder 76.

58 These were: Leder 74, 75, 78, 79, 80.

59 He had toned down the violence of *The Betrayal* (1914) when he returned to the subject in 1922.

60 J. Rothenstein, 1979, p. 131.

61 'The first beginning of the idea was . . . in the late twenties . . . I did a drawing of Christ preaching from the Ferry House barge only it was out in mid-stream . . . it was surrounded with boats and punts.' 733.1.1685, SS/Hilda, 8.4.53.

62 Ibid. The exercise-book is now lost. Spencer made at least one other study 1938-49: *Christ Preaching* dated 'Feb. 1940' squared for transfer, coll. F.T. Davis, c.1940.

63 733.1.1685, SS/Hilda, 8.4.53. In fact Spencer did punt on the river 1920-1, while staying with the Slessers at Bourne End.

64 Ibid.

65 G. Spencer, 1961, pp. 84-7. The bridge appears in *Swan Upping at Cookham* (1915-19; 27)

66 Ibid., p. 85.

67 In conversation with the writer, Cookham, May 1978.

68 733.1.669. In 1954 Spencer told Christopher Hassall of 'Henry's kindness' to him.

69 For example, *Girls Listening* is 54 x 60 in, and *Conversation between Punts* 43 x 36 in. There is no consistency either in composition or figure scale.

70 For example, H.W. McGregor in Australia.

71 'This belongs to the part of the Hilda series which deals with our Hampstead life.' 733.3.1686, draft letter to Hilda, 1954.

72 Ibid., 1686.

73 Ibid., 1686, p. 14. 'The idea for the letters comes from . . . the time I was at Burghclere. When I did a lot of writing to you.' The idea of the 'votive offering' occurs in another note to Hilda, 733.4.13, dated 7.3.56.

74 Ibid., 1686.

75 Ibid., 1686, p. 13. Significantly, this female insect was 'many times larger than its husband. 'Spencer was reading from his four-volume *The Wonders of Nature* in hospital in 1959 shortly before he died. M. Collis, 1961, p. 238. This is probably the book he was referring to in the letter to Hilda.

76 J.E. Martineau (see 405) was Chairman of the Brewers' Company for 1957.

77 Leder 137 is also set in Cookham and shows the moment when Christ is nailed to the cross. Spencer also painted a much smaller *Deposition* in 1956 (424).

78 Also noted by Causey, p. 34.

79 Spencer took much more care over the quality of the paint surface than was usual in most of his paintings of the fifties.

80 Information from Geoffrey Robinson, interview, May 1979. Spencer also had to use this technique with other large canvases, notably *The Resurrection, Port Glasgow*. The necessity of painting section by section may be one explanation of the awkward clumping of figures, and the disjointed compositions of some of the largest late canvases.

81 The Astors had taken Spencer up after the War and commissioned a portrait of Viscount Astor (1956; 419); as well as purchasing *Listening from Punts* and the *Scrapbook* drawings which were loaned back to Spencer for his lifetime.

82 *The Deposition and the Rolling Away of the Stone* (424).

83 Spencer list 733.3.88, 1959.

84 He painted Mrs Smith's portrait (421) as well as the last *Self-Portrait* (447) while staying with her at Hill House.

1 For example, M. Collis, R. Carline.

2 Causey's RA essay, for example, contains no major references to the landscapes, and D. Robinson only acknowledges their evident quality (1979, p. 52). C. Harrison's *English Art and Modernism* also only refers to the figure paintings.

3 William Bailey's *Cookham Bridge*, *Willow Trees* and *Marsh Meadows* hung in the dining room; Fred Walker's *Geese in Cookham Village* in the bedroom, and William Bradley's watercolour, *Cookham Church and River* and Millais's *Ophelia* in the drawing room. Information from Leder, Appendix C.

4 733.3.45, now lost. Taken from an important list of early works made by Spencer c.1945. These were not available to Leder. There are a total of thirty pen and ink landscapes listed for the years 1905-9.

5 733.3.45. Spencer refers to three illustrations of the months, *August*, *September* and *October*, copied from Hans Andersen. Information on E.H. New in Leder, p. 8.

6 733.3.21.

7 Ibid.

8 733.3.45. *Mrs Stanley's Cottage*, *Ovey's Farm*, *Calico Printing Block Cottage*, *Mrs Pendles* (whereabouts unknown).

9 733.3.45, pen drawings. The landscape drawings were listed as *Young Tree at the Strand* and *Stream at the Strand*.

10 733.3.45. *Exmoor View, Clayhidon*; *Fields at Clayhidon*; *Back of Squire Harrisons*; *Gravelpit, Clayhidon* (whereabouts unknown).

11 733.3.45. These were two slight sketches on paper: *Piebald Pony down Mill Lane*; *Sketch from Imagination, Cotton Mill Lane*; and a pencil drawing: *Trees, Mill Lane*. The Zacharias site: *Wellington Fir in Saint George's Lodge Garden*; *Yew and Fir and Greenhouse*.

12 733.3.45. Spencer lists three studies for this period: *Bellrope, Elm Tree* and *Cockmarsh*. The role of landscape in Spencer's early figure paintings is discussed in Chapter 1.

13 Information from Leder. The Rossetti book (collection Unity Spencer) was dated 1913 on the flyleaf in Spencer's hand.

14 Paul Nash, too, was unable to absorb the impact of Post-Impressionism before his work was interrupted by the war. Nash, however, was in the military by December 1914, while Spencer did not enlist in the RAMC until July 1915. See Causey, *Paul Nash*.

15 The sketchbook is in the Tate Gallery Archives, 733.3.83, 5 x 3 in/12.7 x 7.62 cm, sketches slightly smaller.

16 See, for example, Sydney's *The Trail of War, Rayak, Syria* (1919), canvas 14 x 18 in, Carline collection. Repr.

Carline, *Spencers and Carlines* (no. 45); or *British Scout Machines (Camels) starting on patrol through early morning mists, Asiago, Italy* (1919) Imperial War Museum, repr. *Christian Science Monitor*, 25.11.1921.

17 Spencer to William Rothenstein, letter of 23.4.1920, quoted by Rothenstein in *Men and Memories*, vol. ii, pp. 348-9. The main body of the letter dealt with the Leeds Town Hall decoration proposal. George Carline, 'the father of the flock,' died later that year in Assisi. Stanley and Gilbert Spencer also had other motives for their presence – they were competing for the attention of Hilda Carline. See G. Spencer, *Memoirs of a Painter*, Ch. 6.

18 Richard and Sydney were elected members of the London Group in September 1920. Richard probably first exhibited with the group at their 15th exhibition held at Heal and Son in the Mansard Gallery, October/November 1921. He showed four landscapes: 67, *Sussex Village*; 79, *Mist on Hampstead Heath*; 91, *Moonlight Scene*; 102, *Sunset at Sea*. Of these, 79 and 91 were oils, 67 and 102 either watercolour or pencil sketches. He continued to show with the London Group for most of his active painting career. Paul Nash had first exhibited with the London Group in March 1914.

19 According to Richard Carline, interview, October 1979.

20 Both exhibited in *Spencers and Carlines*, nos. 11 and 13, both repr.

21 In *The Jetty, Seaford*, 1920 (no. 10 in Richard Carline, Camden Arts Centre, 1983, repr. p. 23), Carline set off a single small figure against the jetty, plunging the perspective sharply to the beach, on to which dark stylized waves roll from the high horizon. The painting has the same simplified man-made forms (the jetty), isolated figures, and sharp spatial changes found in Nash's work; for example, *Coast Scene* (1920) or *Night Tide* (1919) (the latter has no figures), nos. 295 and 262 in A. Causey, *Paul Nash*.

22 Sydney Carline never again achieved the same critical success that he obtained from his war-time paintings, which were widely exhibited and reported, e.g., *Guardian*, 27.3.20, 'Fine pictures of Wonderful Places.' However, he did win some praise for his post-war paintings; for example the *Evening News* of 14.6.1925 called *Gwendolyn in Fancy Dress* 'one of the few easily recognizable paintings,' at the London Group Exhibition. According to Nancy Carline, Sydney's work declined in quality in the late twenties, probably she

suggested (interview, July 1984), because he was too busy running the Ruskin School. A contemporary reviewer summed up the general attitude when he wrote: 'His landscapes are preserved from being merely pretty by a certain bareness and severity of design, but the bareness is not imposed (as is not seldom the case in advanced circles) for fashion's sake, but because the artist's temperament and his subject matter demands it' (*Lincolnshire Echo*, 23.11.29, review of 'Paintings by Sydney Carline at Usher Art Gallery').

23 *Cornfields, Wiston, Suffolk*, c.1918, oil on canvas, 22 x 36 in/56 x 92 cm, ex. collection Edward Le Bas. Exh. in *British Landscape Painting 1900-1960*, London, Blond Fine Art Ltd, 17 May-9 June, 1979, cat. no. 19, repr. frontis; *The Cornfield*, 1918, oil on canvas, 27 x 30 in/68.6 x 76.2 cm, Tate Gallery (6074).

24 According to Richard Carline (interview, October 1978), Spencer had met John before the war through Henry Lamb.

25 TAM 11, SS/HL, 20.6.20.

26 Spencer's paintings were certainly appreciated in the John household, as Dorelia bought a landscape, *Bourne End, Looking Towards Marlow* (53, in 1920 (TAM 11, SS/HL, 2.2.22).

27 733.10.143.

28 Ibid.

29 Ibid.

30 Ibid.

31 Ibid.

32 Ibid.

33 G. Spencer, 1974, p. 190.

34 Ibid.

35 Ibid.

36 TAM 19, GS/RC, postmarked 'Wishampton, Dorset.' Gilbert's reference is to Spencer's two paintings, *The Tarry Stone, Cookham* (126) and *High Street, Cookham* (127), which were views of Cookham High Street done from opposite ends. The letter has a bitter, sarcastic tone, and Gilbert was evidently smarting from what he believed had been his removal from London a few years earlier in a conspiracy by Stanley's friends, aimed at preventing him from holding the limelight in Hampstead. He still retained this opinion when he came to write his autobiography, commenting: 'Spencers are at first too obliging and too angry too late' (pp. 68-70). To what extent his accusations are true is difficult to ascertain, but, having also lost Hilda Carline's interest to his brother in 1925, Gilbert may well have been persuaded by well-meaning friends to leave London for a while.

37 Sir John Rothenstein, *John Nash*, London, Macdonald and Co., 1983, p. 24.

38 TAM 25, SS/GS, 21.11.49.

39 733.3.85, written in 1949.

40 See Lamb's *The Piggery and Rectory, Havelin's Farm, Dorset*, (1921), coll. Mrs R. Draper. Repr. *Henry Lamb*, exhibition catalogue, 1984, pl.36.

41 Spencer must have seen Nash's *The Cornfield* (1918), at Eddie Marsh's house, as the latter purchased it shortly after its completion. J. Rothenstein, *John Nash*, op. cit., p. 55.

42 Spencer differed only in his reluctance to devote himself more or less full time to the subject, in contrast to John Nash who spent most of his time painting landscapes.

43 I do not agree, however, with Sir John Rothenstein's conclusion that John Nash remained almost entirely uninfluenced by contemporary artistic movements (see J. Rothenstein, *John Nash*). Rothenstein based this on Nash's statement that he missed the first Post-Impressionist exhibition, and 'did not dream of visiting the second.' *The Cornfield* (1918; Tate Gallery) is evidence that Nash was well aware of contemporary painting as it was represented in the London exhibitions; however, like Spencer, this influence did not last beyond the early 1920s.

44 Lamb and Gilbert Spencer also barely altered their styles, except that Lamb's work became somewhat softer and impressionistic in the 1930s.

45 9.2.29.

46 For example, William Holman Hunt, *Our English Coasts* (1852), Tate Gallery. Spencer later adopted an even more detailed approach to foregrounds which rendered each individual plant botanically identifiable. The Pre-Raphaelite insistence on accuracy must have appealed to Spencer, who, according to Carline (interview, 1978), could identify most wild and domesticated plants and trees with ease.

47 See Carline, pp. 132-60 for a detailed account of the journey.

48 Ibid., p. 132: '. . . and having you, Mrs Carline, Sydney and Richard all three working round me would be inspiring. It was so, when I was at Seaford.' He had other reasons for going: nostalgia for Macedonia (Carline, p. 131) and a growing interest in Hilda Carline.

49 Spencer was asked to leave the Bones' house at Steep on 1 December 1921, after a disagreement. He then lived nearby in lodgings, considering but rejecting a plan to take in pupils to earn a living (ibid., p. 130).

50 The longer views and steep mountainsides required a different approach from the intimate close-in space of the English landscape.

51 Information from the Goupil Gallery sales ledger, Tate Gallery Archives.

52 Wilenski, *Stanley Spencer*, p. 30, illus. However, Wilenski makes no comment on the landscapes in his introduction.

53 Lynda Grier was a steady buyer of Spencer's landscapes.

54 Goupil Sales ledger, Tate Gallery Archives.

55 Ibid.

56 3.3.27. Spencer kept the exhibition reviews in a scrapbook, 733.12.1.

57 11.4.27, anon.

58 7.3.27, anon.

59 See Causey, *Paul Nash*.

60 *The Times*, undated cutting, anon., 733.12.1.

61 SS/Chute: letter no. 52, c.1927, SSG.

62 Ibid.

63 Ibid.

64 DT/SS, 6.3.32.

65 SS/DT, 25.10.32.

66 SS/DT, 4.11.32.

67 DT/SS, 21.10.32; gives details of the arrangement. There is no surviving written correspondence with Goupil's; however, Spencer had continued to sell at least some of his work while exhibiting at the Gallery.

68 SS/DT, 23.3.33: Spencer told Tooth's that his paintings were not to go to the RA Summer Exhibition, and that the exhibition of his work at Tooth's was off as well. Tooth's placatory letter was written the same day (SS/DT 23.3.33).

69 SS/DT, 4.5.33: 'I have got into a sort of laborious cramped state over landscapes.'

70 DT/SS, 8.5.33: the Tate purchased *Terry's Lane* for £60.

71 SS/DT, 12.6.33.

72 On the first occasion Spencer told Tooth (28.6.33) that he had 'two commissions' for large paintings (probably *Souvenir of Switzerland* (158) and the Stanley Burton project), and would not be able to provide Tooth with any new work until they were done. Tooth replied (28.6.33), reminding Spencer of the terms of their agreement. The second occasion was the attempt by Zwemmer to handle Spencer's 'difficult' figurative work in 1937-8.

73 M. Collis, 1962, p. 120.

74 DT/SS, 1936, n.d.

75 Tooth informed Spencer of these sales in letters dated 4.5.33 and 8.5.33.

76 Tooth also sold *White Lilac* to Sir Kenneth Clark for £45 (DT/SS, 9.5.33).

77 DT/SS, 19.11.36.

78 Between 6 April 1935 and 5 April 1936, Spencer made £766.15s.3d after deductions – most of this being the proceeds of landscape painting sales (DT/SS, 8.7.36).

79 SS/DT, 2.1.36. *Bellrope Meadow* sold on 19 November 1936 for the very large sum of £350. DT/SS, 19.11.36.

80 SS/DT, 27.4.36.

81 SS/DT, 18.5.36. *The Jubilee Tree, Cookham* was bought by the Art Gallery of Ontario, Toronto.

82 SS/DT, 16.7.36. Three more landscapes, *Moor Posts, Cookham* (217), *Widbrooke* (204) and *Clipped Yews* (180), all sold after the exhibition came down for £100 each. Exhibition Statement, 21.7.1936, Tooth Archive.

83 Blunt in the *Spectator*, 11.7.36.

84 2.7.36.

85 *English Culture and the Decline of the Industrial Spirit 1850-1980*.

86 Ibid., p. 73.

87 Ibid.

88 Ibid.

89 Ibid., p. 49.

90 Spencer himself owned a car in the late twenties (see Carline, pl.24).

91 Wiener, *English Culture*, p. 78.

92 *Abinger Harvest*, first published in 1934: Wiener, *English Culture*, p. 76.

93 Ibid., p. 75.

94 Ibid., p. 75. Wiener quotes numerous other examples in Ch. 4, 'The English Way of Life.'

95 The Behrends, for example, lent *The Mill, Durweston* (62) to the 1927 Goupil Exhibition, and bought *Pumpkins* (74 in exh.) for 50 guineas from the show.

96 In 1936 J.W. Freshfield bought *Moor Posts, Cookham* (217), *Syringa* (220), and *Bellrope Meadow* (207).

97 Wilfrid Evill was Spencer's solicitor and the most important collector of his thirties figure paintings. Among Evill's eighteen canvases were a number of landscapes: *A Gate, Yorkshire* (125), *Stinging Nettles* (109), *The Tarry Stone, Cookham* (126) and *Ming Tombs* (398).

98 Cawdor Castle has a famous flower garden.

99 Interview with Mrs Metz, November 1979.

100 See Ch. 6 for a discussion of the affinities between the two genres.

101 733.2.87.

102 In 1938, for example, he painted *Cinerarias, Polyanthus, Crocuses, Sunflower* and *Columbines*.

103 For example, Major E.O. Kay, *Rock Gardens, Cookham Dene* (1942); Major Frank Barker, *Snowdrops* (1940), *Bluebells, Cornflowers and Rhododendrons* (1945); Major F.J.R. Abbey, *Garden Scene, Port Glasgow* (1944); Flt. Lt. George Mitchell, *Buttercups* (1942). Sales remained slightly reduced during the war. DT/SS, 21.8.44.

104 DT/SS, 21.8.44.

105 Richard Smart/SS, 27.8.47 and 22.11.47. Smart was an assistant at Tooth's and handled much of the post-war correspondence with Spencer. In 1950, *Garden Path, Cookham Rise* was sold at the Royal Academy Summer Exhibition for £300.

106 *The Resurrection, Port Glasgow* was priced at £2000, *Hill of Zion* £800, and the triptychs at £650 each. RS/SS, April 1950.

107 See 351, 368, 388, 392, 410.

108 For discussion of the portraits, see Ch. 6.

109 733.1.6. The Baggetts were the local garage proprietors and were the subject of a rare double portrait (426).

1 The major exception being the nude portraits of Patricia Preece (1935-7). These were, however, painted as independent works, only later being included in the *Church House* scheme.

2 I have emphasized these two decades because this was the period when Spencer's portrait style matured. It is also a period in which little has been written about English portraiture outside the avant-garde circles of Bloomsbury, and the post-Vorticist work of Wyndham Lewis.

3 733.3.1 *Will Spencer*: 'lost by my own neglect.' *Sydney Spencer*: 'All in very warm yellow ochre tone, looking down and wearing a scarf. Lost.'

4 733.3.193. Spencer continued to use this style up to his death; his last drawing study, another head, being of Anthony Eden for Eton College in 1959. Spencer had also had plenty of practice making portrait drawings during the war: see Bell, RA, p. 55, no. 32.

5 Spencer, Gilbert and Hilda all participated. Miss Silcox was headmistress of Southwold Girls' School. Spencer scrubbed out his own canvas (see RA, no. 87). Spencer also had plenty of figure drawing from the model when he attended the Slade again in the spring of 1923, and at Richard Carline's studio at Downshire Hill.

6 See in particular Lamb's *Portrait of Stanley Spencer* (1921), panel, 13¼ x 9½ in/34 x 24.5 cm, Art Gallery of Western Australia.

7 Probably painted as a gift. Spencer was staying with the Slessers at the time.

8 See, for example, G. Spencer Watson, *The Saddler's Daughter*, or Sir John Lavery, *Mrs Bowen-Davis*. Both works exhibited at the RA in 1924, and reproduced (pp. 17, 46) in the *Royal Academy Illustrated*, 1924.

9 See also Gilman's *Contemplation* (c.1914), City Art Gallery, Glasgow; Lamb's *Portrait of Edie McNeill* (c.1910), A.R. Burrows; or Sickert's *The New Home* (1908), Fine Art Society.

10 Roberts's portraits were already becoming stylized in the twenties but paintings like *The Artist's Son* (c.1927, exh. New Grafton Gallery, *English Painting 1900-1940*, 1974, no. 21 repr.) also shows a direct realist treatment of the subject. Gilbert Spencer, relying heavily on Lamb's manner, took a similar approach. See Grafton Gallery 1974, *Portrait of a Collector*, 1931-2 (no. 26, repr.). The *London Group Retrospective* was held at the New Burlington Galleries in 1928.

11 See R. Carline, Percyval Tudor-Hart. For a more extensive discussion of Tudor-Hart, see Ch. 2.

12 This is particularly evident in Carline's *Gathering on the Terrace*, where his attempts to create a kind of structured informality (two interlocking pyramids of figures) resulted in a curiously stilted picture. It should also be noted that Henry Lamb's *Lytton Strachey* portrait is to some extent related to Duncan Grant's own *Lytton Strachey* (1909, Tate Gallery) and *Portrait of James Strachey* (1909, Tate Gallery), in their relaxed informality. Other comparisons can also be made with the Bloomsbury painters; for example, Fry's *Portrait of Nina Hamnet* (1917, Courtauld Institute Galleries), which shares an austere composition and atmosphere with Richard Carline's *Portrait of Hilda Carline* (1918, Tate Gallery), repr. in colour in the catalogue of the exhibition *Richard Carline* (Camden Arts Centre, 1983). After the First World War the Bloomsburyites were also occasionally interested in group portraits in interiors; for example, Duncan Grant, *Interior* (1918, Ulster Museum); Fry's *Round Table* (1920, Mayor Gallery); or Vanessa Bell's *The Nursery* (1930-2, whereabouts unknown, repr. in Frances Spalding, *Vanessa Bell*, Ticknor and Fields, 1983). Lamb's pre-war connections with Bloomsbury clearly provided a link here, and Spencer and Carline could have seen their work at the London Group and other exhibitions.

13 Many of Lamb's later portraits, in particular the commission works (e.g., the Guinness family), slipped into a formal kind of prettiness; however there were some vigorous portraits in the thirties, notably *Evelyn Waugh* (1930) and *The Artist's Wife* (1933) (nos.′68, 70, in the 1984 *Henry Lamb* exhibition, repr. in catalogue, pp. 50, 51).

14 733.8.2. Commenting on the nudes in the forties Spencer wrote: 'I wish there were more of them, but I have never had professional models, not liking the idea.' Patricia, an artist herself, came from the liberated Bloomsbury Group, and was therefore unconcerned about posing in the nude.

15 See L. Collis, 1972, opp. p. 88 for a contemporary photograph of Preece.

16 For Patricia's account of these events, see L. Collis, 1972, Ch. 6.

17 Nudes exhibited at the RA were more covert in their eroticism, relying on traditional themes as justification. Subjects like *Adolescence* (G. Brockhurst, ARA) or *Spring* (W. Russell Flint, RA) were popular; as was a new genre of 'sporting eroticism', a speciality of

L.M. Glasson (e.g., *The Four*), and lesbianism, Laura Knight's *Dawn*. All repr. in *RA Illustrated* for 1933.

18 Preece was unused to modelling and found the work difficult. Spencer for his part seems to have found the awkwardness almost attractive, accentuating it in all his portraits of her.

19 M. Collis, 1962, p. 128: 'The lost cause with her is the dread of my sexual impotence.'

20 Spencer's obsession with Patricia's nakedness is outlined in an oddly adolescent poem, written in the thirties:
Hanging lumps of pendant you
Thick and soft with lavishness
Other eyes of you are there
Pink eyes that at me do stare
Repeated twice in breast and thigh
Mysterious symmetry of you
On the wide domain of your back
Female parts my fingers track.

21 733.8.2, also quoted in RA, p. 152, no. 178.

22 733.3.49; this includes a diagram of the room and the positions of the pictures.

23 733.2.430.

24 733.8.2. Also quoted in Bell, RA, p. 179, no. 178. Spencer also made a number of drawings of Patricia, listing six studies from the nude: nude reclining diagonally to left; nude reclining, bent forwards; nude on yellow paper; nude with stockings and shoes on; nude sitting knees raised (733.7.2, Spencer's titles); and a life-size nude study 'on wallpaper,' apparently done at the same time that Spencer made two similar studies of himself (733.7.17).

25 Spencer had met Gill at Hawksyard in 1919.

26 First noted by Robinson, Arts Council exh. cat., 1976, p. 38, no. 42.

27 For example, Laura Knight, *Dawn*, repr. *RA Illustrated*, 1933, p. 58; and Procter, *Little Sister*, repr. *RA Illustrated*, 1933 p. 86; *A New Day*, Studio, Jan. 1935, repr. facing p. 3.

28 Carline's *Nude Washing* was a very austere version of a popular Camden Town theme, for example, Gore's *Interior with Nude Washing* (c.1907-8, City of Leeds Art Gallery) or Sickert's *Sally – the Hat* (c.1909, private collection).

29 *Daily Telegraph*, 17 December 1912, commenting on *Dawn, Camden Town*, quoted by Baron, *The Camden Town Group*, p. 325.

30 George Moore, 'Degas: The Painter of Modern Life,' *The Magazine of Art*, 13 (1890), p. 425.

31 Glasson tried to temper the obvious erotic overtones of his picture in a commentary on the work written for

the *Studio* when it was reproduced as a 'Studio print': 'One might say that my picture represented modern girlhood, breaking away from the inhibitions of the past and eagerly enjoying the sports and pastimes once reserved to men, and in doing so manifesting herself, as something full of life and health – mental and bodily.' *Studio*, cvi, no. 489, December 1933, p. 344.

32 Anthony Bertram, *Dod Procter*, pp. 92-7, part of an occasional series on *Contemporary British Painting*. Procter (née Shaw) trained at Newlyn under Stanhope Forbes and began exhibiting at the RA in 1922. *A New Day*, exh. RA 1934, whereabouts unknown; *The Back Room*, exh. RA 1934, whereabouts unknown; *Little Sister* c.1935, whereabouts unknown.

33 First noted by Bell (RA, no. 5). The *Melancholia* survives in the Tate archives (733.11.1).

34 Spencer made no reference to contemporary German art in his writings although this is not conclusive evidence that he was unaware of their work. His main contact with the art world, the *Studio*, normally avoided this more radical realism, preferring to stick to more traditional subjects painted in a rather academic 'modern' style. A good example of this kind of taste can be found in a *Studio* survey of *Contemporary Spanish Painting* by Javier Colmena Solis, cxii, no. 532, October 1936, pp. 175-200.

35 *Goodbye to Berlin*, London, Hogarth Press, 1935; *Mr Norris Changes Trains*, London, Hogarth Press, 1969 [1935].

36 Christian Schad: *Autoportrait au modèle*, canvas, 28¼ x 20½ in/76 x 52 cm, private collection, Hamburg; *Deux Filles*, 43 x 31½ in/109.5 x 80 cm, private collection, Hamburg.

37 Tooth, probably trying to find additional income for Spencer, obtained commissions from Dr Bierer (314) and Major E.O. Kay (316) who also collected Spencer's landscapes. The portrait of *Lars Larsen* (312) and *Baby in High Chair* (313) came through Cookham connections.

38 For example, *Daphne Charlton*, pencil 48.3 x 39 cm, whereabouts unknown, Tooth photo. no. 284692.

39 There are a number of intimate nude drawing studies showing Daphne alone and with Spencer; 733.11.11, 733.11.12.

40 See RA, p. 195, no. 234.

41 Spencer returned permanently to Cookham in 1945. With the exception of *William Kilbourne Kay* (1949; 345) no commissions came his way until 1950.

42 This possibility certainly attracted Marjorie Metz (435) when Spencer painted her in March 1958 (interview with the writer, June 1978).

43 Spencer also painted their son *Andrew Nicholas Frank* (1954; 392) and Dr. Frank's dog *Jummie III* (1955; 410).

44 Spencer tried to avoid painting Astor, but was defeated by the prompt arrival of a limousine to collect him each morning.

45 This opinion came from a number of his friends of the fifties: Mrs 'Cash' Martineau, Joyce Fothergill Smith, Marjorie Metz, and Daphne Robinson – all in conversation 1978-80. See also Leder nos. 34, 35, 38.

46 Spencer, sensing Mrs Metz's wishes, chose the dress and the setting for the portrait (Marjorie Metz, interview, December 1979).

47 For example: *Double Nude Portrait* (1937), *Double Nude* (1937). In *A Century of Change*, Richard Shone compares Freud's portraits to those of Spencer; and also remarks on the similarities which Freud's work bears to fifteenth-century Flemish painting (pl.137).

48 *Modern English Painters*, London, Macdonald and Jane's, 1976, p. 190.

49 Rembrandt comes to mind here. Spencer had complained to Patricia about his lack of models in the thirties: 733.8.2.

50 For example: Michelangelo, *Madonna and St Anne* (c.1505), Paris, Louvre, Cabinet des Dessins. Spencer's brother Percy, a great Michelangelo enthusiast, may have influenced his brother's taste.

51 Leder, p. 18; also see Bell, RA, no. 23. Spencer's note, 733.3.1, no. 14. His understanding of old master techniques, however, almost certainly came from actual observation at the National Gallery.

52 Edward Wadsworth, *Self-Portrait* (1911; 16 x 14 in, private collection) repr. in *Wadsworth*, catalogue to the Colnaghi exhibition in London, 16 July-6 August 1974, frontis. Wadsworth painted himself in Italian Renaissance costume. Wadsworth studied at the Slade School 1909-12, winning the first prize for landscape composition in 1910, and first prize for figure painting in 1911 with *Nude in the Life Room* (1911, 24 x 20 in, Slade School Collection).

53 Exhibited in the *Henry Lamb* exhibition 1984, which originated at Manchester City Art Gallery, cat. no. 53, repr. p. 44. This was Lamb's most successful self-portrait.

54 Spencer lists these in 733.7.17. He had made smaller full-length studies from the male nude at the Slade: e.g., *Study of a Nude Male*, c.1911-12, coll. Eric Freifield, Tooth photo. no. 784687.

55 Spencer's only outside contacts at this time, apart from Dudley Tooth, were Sir John and Elizabeth Rothenstein.

56 Consciously or unconsciously, the empty bed may also imply the absence of Patricia, who had appeared on a similarly rumpled set of sheets in the nude portraits. Now Spencer had only himself to paint.

57 This must have been a deliberate choice; Spencer's commission portraits, by comparison, were often crowded with detail.

The catalogue is arranged chronologically, except in certain cases, where important series (e.g. *The Resurrection, Port Glasgow*) have been grouped together. Only works which are mentioned in the main narrative text have been retained; for details of omitted pictures, please refer to the original edition (Bell, 1992).

Normally pictures are given the title by which they were originally exhibited, but occasionally that by which they are best known. In certain cases, where the original meaning has been obscured by a later title, the title has been changed to accord with Spencer's own lists of works.

A simple date, after the title, indicates that the picture was definitely executed, or, if painted over a span of years, completed during this year. A date preceded by 'c.' indicates that the picture was executed at some point during this span of years, thus: c.1924-5.

Sizes are given in inches and centimetres; height precedes width.

184
p.328
PATRICIA AT COCKMARSH HILL 1935
Canvas, 30 x 20 in/76.2 x 50.8 cm
Private collection

187
p.329
PORTRAIT IN A GARDEN 1936
Canvas, 30 x 20 in/76.2 x 50.8 cm
Private collection

189
SHIPBUILDING 1936
Canvas, 24 x 36 in/61 x 91.5 cm
Private collection

190
p.127
RIVETERS 1936
Canvas, 24 x 36 in/61 x 91.5 cm
Private collection

191-200
THE DOMESTIC SCENES

191
p.128
TAKING OFF COLLAR or BUTTONING THE COLLAR 1935
Canvas, 19½ x 16 in/50 x 40 cm
Private collection

192
p.130-1
AT THE CHEST OF DRAWERS 1936
Canvas, 20 x 26 in/50.8 x 66 cm
Private collection, on long-term loan to the Stanley Spencer Gallery, Cookham

193
p.129
ON THE LANDING or LOOKING AT A DRAWING 1936
Canvas, 26 x 20 in/66 x 50.8 cm
Private collection

194
p.132
CHOOSING A PETTICOAT 1936
Canvas, 30 x 20 in/76.2 x 50.8 cm
Private collection

195
p.133
CHOOSING A DRESS 1936
Canvas, 26 x 20 in/66 x 50.8 cm
Private collection

196
TRYING ON STOCKINGS 1936
Canvas, 19¼ x 23 in/49 x 58.5 cm
Private collection

197
p.136
THE NURSERY, or CHRISTMAS STOCKINGS 1936
Canvas, 30 x 36¼ in/76.2 x 91.8 cm
The Museum of Modern Art, New York, gift of the Contemporary Art Society, London

198
p.134
GOING TO BED 1936
Canvas, 30 x 20 in/76.2 x 50.8 cm
Private collection

199
NEIGHBOURS 1936
Canvas, 30 x 20 in/76.2 x 50.8 cm
Private collection

200
p.135
DUSTING SHELVES 1936
Canvas, 30 x 20 in/76.2 x 50.8 cm
Private collection

201
p.138
COWS AT COOKHAM 1936
Canvas, 30 x 20 in/76.2 x 50.8 cm
Ashmolean Museum, Oxford

202
GIRLS RETURNING FROM A BATHE 1936
Canvas, 30 x 20 in/76.2 x 50.8 cm
Private collection

203
p.139
CROSSING THE ROAD 1936
Canvas, 30 x 20 in/76.2 x 50.8 cm
Private collection

205
p.269
FLOWERING ARTICHOKES 1936
Canvas, 14 x 18 in/35.5 x 45.7 cm
Private collection

207
p.271
BELLROPE MEADOW 1936
Canvas, 36 x 51 in/91.5 x 129.5 cm
Rochdale Art Gallery

208
p.273
GARDENS IN THE POUND, COOKHAM 1936
Canvas, 36 x 30 in/91.5 x 76.2 cm
Leeds City Art Galleries

209
VIEW FROM COOKHAM BRIDGE 1936
Canvas, 28 x 37 in/71 x 94 cm
Private collection

210
p.259
BOATBUILDER'S YARD, COOKHAM 1936
Canvas, 33¼ x 28 in/86 x 71 cm
Manchester City Art Gallery

212
p276
THE GARDEN 1936
Canvas, 59¼ x 20 in/150.5 x 50.8 cm
Private collection

213
p.275
THE JUBILEE TREE, COOKHAM 1936
Canvas, 36 x 30 in/91.5 x 76.2 cm
Art Gallery of Ontario, Toronto

214
p.275
LABURNUM 1936
Canvas, 30 x 20 in/76.2 x 50.8 cm
Private collection

215
p.274
UPPER REACH, COOKHAM 1936
Canvas, 38 x 23 in/96.5 x 58.5 cm
Private collection

216
CORNER IN THE GARDEN 1936
Canvas, 30 x 20 in/76.2 x 50.8 cm
Private collection

217
MOOR POSTS, COOKHAM 1936
Canvas, 30 x 20 in/76.2 x 50.8 cm
Destroyed by enemy action in the war 1939-45

218
p.278
COOKHAM RISE: COTTAGES c.1935-6
Canvas, 29¾ x 19½ in/75.6 x 49.5 cm
The Lynda Grier Collection, Lady Margaret Hall, Oxford

219
pp.276-7
FERRY HOTEL LAWN, COOKHAM 1936
Canvas, 28 x 37 in/71 x 94 cm
Dundee Art Gallery

222
pp.330-1
NUDE (PORTRAIT OF PATRICIA PREECE) or GIRL RESTING 1936
Canvas, 24 x 36 in/61 x 91.5 cm
Private collection

223
pp.334-5
SELF-PORTRAIT WITH PATRICIA PREECE 1936
Canvas, 24 x 36 in/61 x 91.5 cm
Fitzwilliam Museum, Cambridge

224
p.336
SELF-PORTRAIT 1936
Canvas, 24¼ x 18 in/61.6 x 45.7 cm
Stedelijk Museum, Amsterdam

225
p.333
DOUBLE NUDE PORTRAIT: THE ARTIST AND HIS SECOND WIFE or THE LEG OF MUTTON NUDE 1937
Canvas, 36 x 36¾ in/91.5 x 93.5 cm
Tate Gallery, London

226
ADORATION OF GIRLS 1937
Canvas, 36¼ x 44 in/92.2 x 111.8 cm
Private collection

227
pp.140-1
ADORATION OF OLD MEN 1937
Canvas, 36½ x 44 in/92.7 x 111.8 cm
Leicestershire Museums and Art Galleries

228
pp.142-3
A VILLAGE IN HEAVEN 1937
Canvas, 18 x 72 in/45.7 x 182.9 cm
Manchester City Art Gallery

229
p.340

HILDA, UNITY AND DOLLS
1937
Canvas, 30 x 20 in/76.2 x 50.8 cm
Leeds City Art Galleries

230
p.144

THE VILLAGE LOVERS c.1937
Canvas, 35½ x 41½ in/90 x 105.4 cm
Private collection

233
pp.280-1

COOKHAM ON THAMES 1937
Canvas, 24 x 36 in/61 x 91.5 cm
Private collection

234
p.280

COOKHAM MOOR 1937
Canvas, 19½ x 29¾ in/49.5 x 75.5 cm
Manchester City Art Gallery

235
pp.282-3

SOUTHWOLD 1937
Canvas, 31¼ x 20 in/81 x 50.8 cm
Aberdeen Art Gallery

236
p.279

COTTAGE AT WANGFORD
1937
Canvas, 20 x 30 in/50.8 x 76.2 cm
Private collection

237

ST IVES, LOW TIDE 1937
Canvas, 28 x 37½ in/74 x 95.5 cm
Private collection

238
p.283

WET MORNING, ST IVES 1937
Canvas, 20¾ x 27½ in/53 x 70 cm
Carrick Hill Trust, Hayward Bequest,
Adelaide

240
p.283

THE HARBOUR, ST IVES 1937
Canvas, 30 x 37½ in/76.2 x 95.3 cm
Private collection

241
p.284

FISHING BOATS, ST IVES 1937
Canvas, 20 x 24 in/50.8 x 61 cm
Private collection

242
p.289

**THE WHITE COCKATOO or
CORONATION COCKATOO**
1937
Canvas, 35 x 23½ in/89.5 x 59 cm
Private collection

243
p.238

GREENHOUSE AND GARDEN
1937
Canvas, 30 x 20 in/76.2 x 50.8 cm
Ferens Art Gallery, Hull

244
p.285

**HELTER SKELTER,
HAMPSTEAD HEATH** 1937
Canvas, 36 x 23 in/91.5 x 58.5 cm
Graves Art Gallery, Sheffield

245
p.145

**SUNFLOWER AND DOG
WORSHIP** 1937
Canvas, 27½ x 41½ in/
69.8 x 105.4 cm
Private collection

246
pp.146-7

**PROMENADE OF WOMEN or
WOMEN GOING FOR A WALK
IN HEAVEN** 1938
Canvas, 17¾ x 90½ in/45 x 229.8 cm
Private collection

247

WHITE VIOLETS 1938
Canvas, 12 x 16 in/30.5 x 40.6 cm
Private collection

248

MAGNOLIAS 1938
Canvas, 22 x 26 in/56 x 66 cm
Private collection

249

**CACTUS IN GREENHOUSE,
COOKHAM DENE** 1938
Canvas, 30 x 20 in/76.2 x 50.8 cm
Private collection

251
p.291

FROM THE ARTIST'S STUDIO
1938
Canvas, 20 x 30 in/50.8 x 76.2cm
Carrick Hill Trust, Hayward Bequest,
Adelaide

252
p.286

**GARDEN VIEW, COOKHAM
DENE** 1938
Canvas, 36 x 24 in/91.4 x 61 cm
Art Gallery of South Australia,
Adelaide

253
p.287

**RICKETS FARM, COOKHAM
DENE** 1938
Canvas, 26 x 46 in/66.5 x 117 cm
Tate Gallery, London

256

POLYANTHUS 1938
Canvas, 16 x 12 in/40.6 x 30.5 cm
Private collection

257
p.288

**LANDSCAPE WITH
MAGNOLIA, ODNEY CLUB** 1938
Canvas, 36 x 24 in/91.5 x 61 cm
National Gallery of Canada, Ottawa

259
p.289

COLUMBINES 1938
Canvas, 16 x 20 in/40.6 x 50.8 cm
Private collection

260
p.293

POPPIES 1938
Canvas, 17½ x 23 in/44.5 x 58.5 cm
Newark Town Hall

262

**THE MOUNT, COOKHAM
DENE** 1938
Canvas, 26 x 46 in/66 x 116.8 cm
Private collection

265
p.287

COOKHAM RISE 1938
Canvas, 18 x 27½ in/45.7 x 70 cm
Warwick District Council, Art Gallery
and Museum, Leamington Spa

266
p.290

**COOKHAM, FLOWERS IN A
WINDOW** 1938
Canvas, 20 x 30 in/50.8 x 76.2 cm
Carrick Hill Trust, Hayward Bequest,
Adelaide.

267
p.290

CROCUSES 1938
Canvas, 8 x 6 in/20.2 x 15.2 cm
Private collection

272
p.295

**VIEW FROM THE TENNIS
COURT, COOKHAM** 1938
Canvas, 22 x 28 in/56 x 71 cm
Private collection

273
p.293

PEONIES 1938
Canvas, 20 x 26 in/50.8 x 66 cm
Nottingham Castle Museum and Art
Gallery

274a-j

**THE BEATITUDES OF LOVE
SERIES** 1937-8

274a

BEATITUDE 1: NEARNESS
1938
Canvas, dimensions unknown
Whereabouts unknown

274b

BEATITUDE 2: KNOWING
1938
Canvas, 26 x 22 in/66 x 56 cm
Private collection

274c

BEATITUDE 3: SEEING 1938
Canvas, 21¼ x 20¼ in/56 x 53 cm
Private collection; according to Tooth's
records, destroyed by fire in1968

274d
p.148

**BEATITUDE 4: PASSION or
DESIRE** 1938
Canvas, 30 x 20 in/76.2 x 50.8 cm
Private collection

274e
p.149

**BEATITUDE 5:
CONTEMPLATION** 1938
Canvas, 35¼ x 24 in/91 x 61 cm
Stanley Spencer Gallery, Cookham

274f
p.150

**BEATITUDE 6:
CONSCIOUSNESS** 1938
Canvas, 30 x 22 in/76.2 x 56 cm
Private collection

274g
p.151

**BEATITUDE 7: ROMANTIC
MEETING** 1938
Canvas, 41 x 20 in/104 x 50.8 cm
National Art Gallery and Museum,
Wellington

274h
p.152
BEATITUDE 8: WORSHIP 1938
Canvas, 35¾ x 29 in/91 x 73.5 cm
Private collection

274i
BEATITUDE 9: AGE 1938
Canvas, dimensions unknown
No record of ownership; possibly
destroyed

274j
**BEATITUDES OF LOVE:
SOCIABLENESS (also known
as TOASTING** c.1937-8
Canvas, 30 x 20 in/76.2 x 50.8 cm
Private collection

275
pp.292-3
**LANDSCAPE IN NORTH
WALES** 1938
Canvas, 22 x 27¾ in/55.9 x 70.7 cm
Fitzwilliam Museum, Cambridge

278
p.297
**LANDSCAPE, COOKHAM
DENE** 1939
Canvas, 28 x 36 in/71.1 x 91.5 cm
Nottingham Castle Museum and Art
Gallery

279
p.341
**PORTRAIT OF MISS
ELIZABETH WIMPERIS** 1939
Canvas, 26 x 22 in/66 x 56 cm
National Gallery of Canada, Ottawa

281
**SELF-PORTRAIT (ADELAIDE
ROAD)** 1939
Canvas, 30 x 20 in/76.2 x 50.8 cm
Private collection

283a-h
**THE CHRIST IN THE
WILDERNESS SERIES:** 1939-54
Canvas, 22 x 22 in/56 x 56 cm
(all paintings the same dimensions)
Art Gallery of Western Australia,
Perth

283a
p.154
**CHRIST IN THE WILDERNESS:
THE FOXES HAVE HOLES**
1939

283b
p.154
**CHRIST IN THE WILDERNESS:
HE DEPARTED INTO A
MOUNTAIN TO PRAY** 1939

283c
p.155
**CHRIST IN THE WILDERNESS:
THE SCORPION** 1939

283d
p.156
**CHRIST IN THE WILDERNESS:
CONSIDER THE LILIES** 1939

283e
p.157
**CHRIST IN THE WILDERNESS:
RISING FROM SLEEP IN THE
MORNING** 1940

283f
p.156
**CHRIST IN THE WILDERNESS:
DRIVEN BY THE SPIRIT INTO
THE WILDERNESS** 1942

283g
p.158
**CHRIST IN THE WILDERNESS:
THE EAGLES** 1943

283h
p.159
**CHRIST IN THE WILDERNESS:
THE HEN** c.1954

284
pp.296-7
**THE VALE OF HEALTH,
HAMPSTEAD** 1939
Canvas, 24 x 32 in/61 x 81.3 cm
Glasgow Art Gallery and Museum

285
p.294
OXFORDSHIRE LANDSCAPE
1939
Canvas, 20 x 30 in/50.8 x 76.2 cm
Santa Barbara Museum of Art, Gift of
Will and Mary Richenson, Jr.

286
p.337
SELF-PORTRAIT 1939
Canvas, 15½ x 21¾ in/
39.6 x 55.2 cm
Fitzwilliam Museum, Cambridge

287
p.161
THE WOOLSHOP 1939
Canvas, 36 x 24 in/91.5 x 61 cm
Private collection

291
APPLE TREES IN SNOW 1940
Canvas, 20 x 30 in/50.8 x 76.2 cm
Private collection

292
pp.160-1
**VILLAGE LIFE,
GLOUCESTERSHIRE** 1940
Canvas, 31¼ x 44 in/79.4 x 112 cm
Cheltenham Art Gallery and Museum

293
p.339
DAPHNE 1940
Canvas, 20 x 24 in/50.8 x 61 cm
Tate Gallery, London

296
p.338
THE SISTERS 1940
Canvas, 48 x 30 in/122 x 76.2 cm
Leeds City Art Galleries

297
p.341
DAPHNE 1940-9
Canvas, 20 x 16 in/50.8 x 40.5 cm
Private collection

298
p.163
**THE COMING OF THE WISE
MEN (THE NATIVITY)** 1940
Canvas, 35¾ x 27½ in/91 x 70 cm
Private collection

300
pp.298-9
**PRIORY FARM, LEONARD
STANLEY** 1940
Canvas, 20 x 30 in/50.8 x 76.2 cm
Baring Brothers and Co. Ltd.,
London

303
p.299
**THE ALDER TREE,
GLOUCESTERSHIRE** 1941
Canvas, 27 x 36 in/70 x 91.5cm
Hill Samuel Bank Limited

306
p.304
**BUTTERCUPS IN A
MEADOW**
1941-2
Canvas, 16 x 20 in/40.5 x 50.8 cm
Private collection

307
p.343
SEATED NUDE 1942
Canvas, 30 x 20 in/76.2 x 50.8 cm
Private collection

310
p.301
WISTERIA, COOKHAM 1942
Canvas, 25 x 30 in/63.5 x 76.2 cm
Harris Museum and Art Gallery,
Preston.

311
p.300
**ROCK GARDEN, COOKHAM
DENE** 1942
Canvas, 28 x 37 in/71 x 94 cm
Birmingham City Museum and Art
Gallery

315
p.299
**MARSH MEADOWS,
COOKHAM** 1943
Canvas, 25 x 30 in/63.5 x 76.2 cm
National Gallery of Canada, Ottawa

317
p.303
THE SCRAP HEAP 1944
Canvas, 20 x 30 in/50.8 x 76.2 cm
Art Gallery of New South Wales,
Sydney

318
p.305
**GARDEN SCENE, PORT
GLASGOW** 1944
Canvas, 30 x 20 in/76.2 x 50.8 cm
The Beaverbrook Art Gallery,
Fredericton

320
p.337
SELF-PORTRAIT 1944
Panel, 16 x 11 in/40.6 x 28 cm
National Gallery of Canada, Ottawa

322
p.302
**THE CLYDE FROM PORT
GLASGOW** 1945
Canvas, 20 x 30 in/50.8 x 76.2 cm
Yale Center for British Art,
New Haven

324
p.164
GARDENING 1945
Canvas, 30 x 20 in/76.2 x 50.8 cm
Leeds City Art Galleries

325
p.307
PEONIES 1945
Canvas on board, 8 x 24 in/
20.5 x 61 cm
Carrick Hill Trust, Hayward Bequest,
Adelaide

404 **THE HOE GARDEN NURSERY**
p.316 1955
Canvas, 26⅝ x 42⅝ in/
67.8 x 108.2 cm
Plymouth City Museums and Art
Gallery

405 **PORTRAIT OF J.E.**
p.351 **MARTINEAU** 1955-6
Canvas, 35¼ x 28 in/91 x 71 cm
Private collection

407 **PORTRAIT OF SIBYL**
p.352 **WILLIAMS MBE** 1955
Canvas, 18 x 14 in/45.5 x 35.5 cm
Plymouth City Museums and Art
Gallery: Loan Collection

410 **JUMMIE III AND DR FRANK**
p.356 1955
Canvas, 20¼ x 15½ in/53 x 39.5 cm
Private collection

411 **SNOWDROPS** 1955
Canvas, 7 x 10 in/18 x 25.5 cm
Private collection

413 **CHRIST PREACHING AT**
p.224 **COOKHAM REGATTA:**
CONVERSATION BETWEEN
PUNTS 1955
Canvas, 42 x 36 in/106.7 x 91.5 cm
Private collection

414 **HILDA AND I AT**
p.219 **BURGHCLERE** 1955
Canvas, 30 x 20¼ in/76.2 x 51.8 cm
Private collection

415 **LOVE ON THE MOOR** 1937-55
pp.220-1 Canvas, 31 x 122 in/
79.1 x 310.2 cm
Fitzwilliam Museum, Cambridge

416 **FROM UP THE RISE** 1936-56
Canvas, 31½ x 42 in/80 x 107 cm
Private collection

419 **PORTRAIT OF VISCOUNT**
ASTOR 1956
Canvas, 27½ x 36 in/70 x 91.5 cm
Private collection

420 **IN CHURCH** 1956
p.232 Canvas, 36 x 24 in/91.5 x 61 cm
St Edmund Hall, Oxford

422 **THE DUSTBIN, COOKHAM**
p.230 1956
Canvas, 30 x 20 in/76.2 x 50.8 cm
Royal Academy of Arts, London

423 **PORTRAIT OF J.L. BEHREND**
p.357 1956
Canvas, 19½ x 11½ in/49.5 x 29.4 cm
Private collection

424 **THE DEPOSITION AND THE**
p.234 **ROLLING AWAY OF THE**
STONE 1956
Canvas, 43½ x 22¾ in/110.5 x 58 cm
York City Art Gallery

425 **CHRIST PREACHING AT**
pp.226-7 **COOKHAM REGATTA:**
DINNER ON THE HOTEL
LAWN 1956-7
Canvas, 37½ x 53½ in/95 x 136 cm
Tate Gallery, London

426 **PORTRAIT OF MR AND MRS**
pp.358-9 **BAGGETT** 1956-7
Canvas, 27½ x 36 in/70 x 91.5 cm
Private collection

427 **THE BATHING POOL, DOGS**
p.231 1957
Canvas, 36 x 24 in/91.4 x 61 cm
Private collection

428 **THE BREW HOUSE** 1957
Canvas, 24 x 36 in/61 x 91.5 cm
Private collection

429 **WINTER ACONITES** 1957
Panel, 14 x 10 in/35.5 x 25.5 cm
Private collection

430 **ROCK ROSES, OLD LODGE,**
p.317 **TAPLOW** 1957
Canvas, 27½ x 15¾ in/70 x 40 cm
Private collection

431 **NEVILLE RICHARD MURPHY**
p.356 **MA, PRINCIPAL OF**
HERTFORD COLLEGE,
OXFORD 1957
Canvas, 23¼ x 19¼ in/59 x 49 cm
Hertford College, Oxford

433 **MRS LINDA FEW BROWN**
p.360 1957-8
Canvas, 33 x 25 in/84 x 63.5 cm
Private collection

434 **AT THE PIANO** 1957-8
p.230 Canvas, 36 x 24 in/91.5 x 61 cm
Private collection

435 **PORTRAIT OF MRS**
p.361 **MARJORIE METZ** 1958
Canvas, 50 x 22 in/127 x 56 cm
Stanley Spencer Gallery, Cookham

436 **PORTRAIT OF DAME MARY**
CARTWRIGHT 1958
Canvas, 30 x 19½ in/76.2 x 49.5 cm
Girton College, Cambridge

439 **PORTRAIT OF MISS**
p.355 **ASHWANDEN** 1958
Canvas, 30 x 20 in/76.2 x 50.8 cm
Herbert Art Gallery, Coventry

440 **SAINT PETER ESCAPING**
FROM PRISON 1958
Canvas, 14½ x 14½ in/37 x 37 cm
Private collection

441 **THE CRUCIFIXION** 1958
p.235 Canvas, 85 x 85 in/216 x 216 cm
Private collection

442 **IN CHURCH** 1958
pp.232-3 Canvas, 24 x 85 in/61 x 216 cm
The Letchmore Trust

443 **CHRIST PREACHING AT**
COOKHAM REGATTA:
PUNTS BY THE RIVER 1958
Canvas, 39¼ x 60 in/99.5 x 152 cm
Private collection

444 **THE GLOVE SHOP** 1959
Canvas, 30 x 20 in/76.2 x 50.8 cm
Private collection

445 **PORTRAIT OF KATE**
MORRELL
1959
Canvas, 19 ½ x 30 in/50 x 76.2 cm
Private collection

446 **PORTRAIT OF RACHEL**
p.355 **WESTROPP** 1959
Canvas, 23¼ x 21½ in/59 x 55 cm
Private collection

447 **SELF-PORTRAIT** 1959
p.365 Canvas, 20 x 16 in/51 x 40.6 cm.
Tate Gallery, London

448 **CHRIST PREACHING AT**
pp.228-9 **COOKHAM REGATTA**
Unfinished
Canvas, 81 x 211 in/
205.7 x 535.9 cm
Private collection, on loan to the
Stanley Spencer Gallery, Cookham

449 **ME AND HILDA,**
p.237 **DOWNSHIRE HILL** Unfinished
Canvas, 55½ x 38 in/141 x 96.5 cm
Private collection

450
pp.236-7
HAMPSTEAD HEATH LITTER or THE APOTHEOSIS OF HILDA 1959 Unfinished
Canvas, 79 x 278 in/200.5 x 706 cm
Private collection

451
CHRIST [?] AND FIGURES
Unfinished
Canvas, 41½ x28 in/105.4 x 71.1 cm
Private collection

452
p.318
EXTENSIVE LANDSCAPE WITH A WROUGHT-IRON GATE Unfinished
Canvas, 19½ x 27½ in/49.3 x 69.8 cm
Private collection

453
p.342
PORTRAIT OF ANNY LEWINTER FRANKL c.1954-7
Unfinished
Canvas, 36 x 24 in/91 x 61 cm
Private collection

In alphabetical order

ABBOTT, C.C. and BERTRAM, A. *Poet and Painter, Being the Correspondence between Gordon Bottomley and Paul Nash.* Oxford University Press, 1955.

ALISON, JANE. "The Apotheosis of Love', in *Stanley Spencer: The Apotheosis of Love.* London: Barbican Art Gallery, 1991. pp. 11-27.

ANON. 'Editorial: A Neglected Phase of British Art,' *Apollo* (March 1970), 174-85.

—— 'Stanley Spencer', *Art News Review* (27 April 1950), 8-9.

—— 'Experimental Work by Mr Stanley Spencer,' *Birmingham Post,* 7 March 1927.

—— 'Recent Work of Mr Spencer,' *Birmingham Post,* 6 July. 1936.

—— 'Pictures by Stanley Spencer in the Fitzwilliam Museum Cambridge,' *Burlington Magazine* (November 1965).

—— 'The Cambridge Drawing Society Exhibition,' *Cambridge Review,* ii (May 1934), 387.

—— 'Spencerisms,' *Cavalcade,* 4 July 1936.

—— Review of the 1927 Goupil Gallery exhibition, *Country Life,* 9 April 1927.

—— 'Second Blake,' *Daily Chronicle,* 2 February, 1927.

—— 'Sound and Fury in the Royal Academy,' *Daily Express,* 26 April 1935.

—— Review of the RA Summer exhibition, *Daily Express,* 29 April 1950.

—— 'Stanley Spencer's Problem,' *Daily Graphic,* 29 April 1950.

—— Review of Tooth's 1936 Spencer exhibition, *Daily Mail,* 23 June 1936.

—— 'Man with the tombs returns in triumph,' *Daily Mirror,* 29 April 1950.

—— 'A Primitive Artist of Today,' *Daily Sketch,* 3 March 1927.

—— 'Picture of the Year,' *Daily Telegraph,* 29 April 1950.

—— 'Painters Sell More,' *Evening Standard,* 7 August 1950.

—— 'Burlington House,' *Field,* 11 May 1935.

—— Review of the 1927 Goupil Gallery exhibition, *Guardian,* 3 March 1927.

—— 'Stanley Spencer's Cookham,' *The Lady,* 3 January, 1985, 4-5.

—— The Academy Dispute, *Guardian,* 26 April 1935.

—— 'London Art Shows, Salvador Dali and Stanley Spencer,' *Guardian,* 26 June 1936.

—— 'Tooth Galleries,' *Guardian,* 3 July 1938.

—— Review of the RA Summer exhibition, *Guardian,* 24 April 1950.

—— Review of the RA Spencers and Tooth's Spencer exhibition, *Guardian* 29 April 1950.

—— Review of the RA Summer exhibition, *Guardian,* 2 May 1950.

—— Review of the Burghclere murals, *Illustrated London News,* 17 December 1932.

—— Review of the RA Summer exhibition, *Illustrated London News* (12 May 1934), 745.

—— *Illustrated London News,* 29 April, 1950, 658-9.

—— 'Rebel RA attracts the crowds,' *Morning Advertiser,* 28 April 1950.

—— 'A Great Picture: Mr Stanley Spencer's "Resurrection,"' *Morning Post,* 25 February 1927.

—— 'Goupil Salon,' *Morning Post,* 6 November 1930.

—— The 1927 Goupil Gallery exhibition, *Near East and India,* 3 March 1927.

—— 'The Royal Academy,' *Northern Daily Despatch,* 4 May 1935.

—— Review of Tooth's 1936 Spencer exhibition, *Scotsman,* 2 July 1936.

—— 'The Most Discussed Picture of the Year,' *The Sphere* (12 March 1927), 413.

—— 'Stanley Spencer's Chapels in the Air,' *Studio,* cli (February 1956), 54-5.

—— 'Stanley Spencer', *Sunday Graphic,* 28 April, 1935.

—— 'They Hail Him or Hate Him: Rebel Artist,' *Sydney Sun,* 27 December, 1955.

—— 'The Occupations of Peace–Stanley Spencer,' *Time and Tide,* 11 July 1930.

—— Review of the Goupil Gallery exhibition, *The Times,* 28 February 1927.

—— The Resurrection, Cookham bought for the Tate Gallery, *Times,* 8 March, 1927.

—— 'Goupil Salon,' *Times,* 16 October, 1931.

—— 'Mr Stanley Spencer's Year,' *Times,* 5 May 1934.

—— 'The Essential Eccentricity of Mr Stanley Spencer's Art,' *The Times,* 3 November 1955.

—— 'Form in English Painting; Mr Spencer's Domestic Interiors,' *The Times,* 29 June 1936.

—— 'The RA Pictures of the Year,' *The Times,* 30 April, 1938.

—— 'Review of the RA Summer exhibition, *The Times,* 29 April 1950.

—— 'Review of the RA Summer exhibition, *The Times,* 30 April 1950.

—— 'CAS Loan Exhibition to the Tate Gallery,' *The Times,* 20 March 1952.

—— 'Stanley Spencer,' *Times Literary Supplement,* 26 (1 1980), 1063.

—— 'Mr Stanley Spencer,' *Truth,* 1 July 1936.

AYRTON, MICHAEL. 'The Heritage of British Painting: 1 Continuity,' *Studio,* cxxii (August, 1946), 33-41.

—— 'The Heritage of British Painting,' *Studio,* 644 (November 1946), 144-49.

BARON, WENDY. *The Camden Town Group.* London: Scholar Press, 1979.

BATES, PERCY. *The English Pre-Raphaelite Painters.* London, 1910.

BEAVERBROOK ART GALLERY. *Catalogue of the Beaverbrook Art Gallery.* Fredericton, New Brunswick, 1959.

BEHREND, GEORGE. *Stanley Spencer at Burghclere.* London: Macdonald, 1965.

BELL, CLIVE. 'Post Impressionism and Aesthetics,' *Burlington Magazine* (January 1913), 226-30.

—— *Art.* London: Chatto, 1914.

—— 'Inside the "Queen Mary" a Business Man's Dream,' *Listener* (6.4.36).

BELL, KEITH. Section Introductions and Catalogue entries, *Stanley Spencer RA,* Exhibition Catalogue, RA (1980), xcvii, 37, 53, 97-8, 122-3, 181, 196, 209; catalogue entries.

—— *Stanley Spencer: A Complete Catalogue of the Paintings.* London: Phaidon, 1992.

BERGER, JOHN. 'St. Vincent and Gabriel,' *New Statesman,* 12 November, 1955.

BERTRAM, ANTHONY. 'Contemporary British Painting: Dod Procter,' *Studio,* 430 (February 1929), 92-7.

BLUNT, A. Review of Tooth's 1936 Spencer exhibition, *Spectator,* July 1936.

BONE, JAMES. 'Contemporary British Painting,' *Studio,* 97 (March 1929), 161-8.

BONE, STEPHEN. Review, *The Guardian,* 3 November 1955.

—— Review of Drawings by Stanley Spencer, *Guardian,* 5 November 1955.

BOULTON-SMITH, JOHN. 'Introduction,' *Spencers and Carlines: The Work of Stanley and Hilda Spencer and their Families.* Exhibition Catalogue, London, Morley Gallery (1980-8), np.

BRATBY, JOHN. *Stanley Spencer's Early Self-Portrait.* London: Cassell, 1969.

BRIGHTON ART GALLERY. 'Introduction,' *The Wilfrid Evill Collection* (1965), 3-4.

BROWN, AIMEE. B. 'Stanley Spencer's "The Builders,"' *Yale University Art Gallery Bulletin,* xxiv (December 1963), 22-3.

CANNAN, GILBERT. *Mendel.* London: T. Fisher Unwin, 1916.

CARLINE, R. 'New Mural Paintings by Stanley Spencer,' *Studio,* 96 (November 1928), 316-23.

—— 'West African Art and Its Tradition,' *Studio,* 9 (April 1935), 186-93.

—— 'Fine Art in Modern America,' *Studio* (September 1940), 66-79.

—— 'Dating and Provenance of Negro Art,' *Burlington Magazine,* 77 (October 1940), 114-20.

—— 'Courbet and the Carlines,' *Shropshire Magazine* (March 1958, reprint in the National Art Library, Box 111.199c).

—— 'Introduction,' *Sir Stanley Spencer CBE, RA.* Exhibition Catalogue, Plymouth, City Museum and Art Gallery (1963).

—— 'Sidney, William and Richard Carline,' *Art News,* 71 (April 1972), 13.

—— 'Introduction,' *Spencers and Carlines in Hampstead in the 1920's.* Exhibition Catalogue, SSG (May 1973), np.

—— 'Percyval Tudor-Hart, Painter and Teacher, 1874-1954' (typed manuscript, 3 pp., 1974).

—— 'Recollections of Stanley Spencer,' *Stanley Spencer.* Exhibition Catalogue, Arts Council (1976), 11-13.

—— 'Introduction,' *Stanley and Hilda Spencer.* Exhibition Catalogue, Anthony d'Offay Gallery (1978), np.

—— *Stanley Spencer at War.* London: Faber, 1978.

—— 'Stanley Spencer: His personality and mode of life,' *Stanley Spencer RA.* Exhibition Catalogue, RA (1980), 9-18.

CARRINGTON, N. ed. *Mark Gertler: Selected Letters.* London: Rupert Hart-Davis, 1965.

CAUSEY, A. *Paul Nash.* Oxford University Press, 1980.

—— 'Stanley Spencer and the Art of His Time,' *Stanley Spencer RA* Exhibition Catalogue, RA (1980), 19-36.

CAUSEY, A., Thomson, R. eds. *Harold Gilman, 1876-1919.* Exhibition Catalogue, Arts Council (1981), 3-34.

CHAMOT, MARY. *Modern Painting in England.* London: Country Life, 1937.

—— 'Modern Mural Decorations,' *Country Life,* lxxxv (28 January 1939), 86-7.

CHARLTON, GEORGE. 'The Slade School of Fine Art,' *Studio* 643 (October 1946), 114-21.

CLARK, KENNETH [LORD CLARK]. 'The Future of Painting,' *Listener* (2 October 1935), 35-6.

CLEMENTS, KEITH (AND SANDRA MARTIN). 'Henry Lamb: Life and Art,' *Henry Lamb,* Exhibition Catalogue, Manchester City Art Gallery (1984), 5-9.

CLUTTON, BROCK, A. Tooth's 1950 Spencer exhibition, *The Times,* 8 May, 1950.

COLLINS, IAN. *A Broad Canvas. Art in East Anglia since 1880.* Norwich: Parke Sutton Publishing, 1990. 'The Strange Mr Spencer,' 59-63.

—— 'Stanley Spencer,' *Modern Art,* i (June 1955), 2-6.

COLLIS, L. *A Private View of Stanley Spencer.* London: Heinemann, 1972.

COLLIS, MAURICE. 'Stanley Spencer,' *Time and Tide,* 20 May 1950.

—— 'A Cookham Visionary,' *Art News and Review* (3 June 1950).

—— *Stanley Spencer.* London: Harvill Press, 1962.

—— *The Journey Up: Reminiscences, 1945-68,* London: Faber and Faber, 1970.

COMPTON, M.G. (?). 'Some Recent Acquisitions: Pictures and Sculpture,' *Leeds Art Calendar* iv (Autumn and Winter, 1950-1), 11-13.

—— *Leeds Art Calendar* viii, 29

(Spring 1955), 23-6.

COOPER, DOUGLAS. *The Courtauld Collection, a Catalogue*. London: Athlone Press, 1954.

CORK, R. *Vorticism and Abstract Art in the First Machine Age*. 2 vols. Berkeley: University of California, 1976.

COWLING, E., MORPHET, R. 'Richard Carline' and 'The Early Work,' *Richard Carline 1896-1980*. Exhibition Catalogue (1983), 7-31.

DAVIS, FRANK. 'Funny Fantastic Frank Davis assesses the eccentric visionary painter Sir Stanley Spencer,' *Art and Antiques Weekly*, 24 August, 1974, 6-7.

DENVIR, BERNARD. 'Art Collectors and their Collections: 1. Sir Edward Marsh,' *Studio*, 134 (July 1947), 127-33.

DEVAS, NICOLETTE. *Two Flamboyant Fathers*. London: Collins, 1966 (reprinted 1978).

DUVEEN, SIR JOSEPH. 'Thirty Years of British Art,' *Studio* (Special Autumn Number, 1930), 151-4.

DWYER, EILEEN. 'The Mexican Modern Movement,' *Studio*, 94 (October 1927), 265-7.

EARP, T.W. Review of Tooth's 1936 Spencer exhibition, *Daily Telegraph*, 1 July 1936.
—— Tooth's 1950 Spencer exhibition, *Daily Telegraph*, 15 May 1950.

FARR, D. *English Art 1870-1940*. Oxford University Press, 1978.

FEAVER, WILLIAM 'The Last Pre-Raphaelite,' *Observer*, 14 and 21 September 1980.

FOTHERGILL, JOHN. *The Slade . . . 1893-1907*. London, University College, 1907.

FOX, CAROLINE GREENACRE, FRANCIS. *Painting in Newlyn 1880-1930*. Exhibition Catalogue, Barbican Art Gallery, 1985.

FREEMAN, JULIAN. 'Professor Tonks: War Artist,' *Burlington Magazine*, cxxvii, 986 (May 1985), 285-93.

FRY, ROGER. 'Mr Frank Dobson and Mr Stanley Spencer,' *Nation and Athenaeum* (12 March 1927).

FULLER, PETER. 'Spencer's Lost Paradise,' *New Society* (25 September 1980).

GAUNT, WILLIAM. 'Stanley Spencer,' *Drawing and Design*, 9 (March 1927), 59-60.
—— 'In Search of the Absolute,' *Studio* (November 1933), 271-3.
—— *A Concise History of English Painting*. London: Thames and Hudson, 1964.

GEORGE, JOAN. 'Stanley Spencer, painter and visionary,' *Yorkshire Post*, 7 November, 1955.

GILL, ERIC. *Beauty looks after herself*, essays. London: Sheed and Ward, 1933.
—— *Autobiography*. London: The Right Book Club, 1944.
—— *Art*. London: Bodley Head, 1950 (first published 1934).

GLASSON, L. 'Studio Print,' *Studio*, 489

(December 1933), 344.

GOODISON, J.W. 'Three Paintings by Stanley Spencer,' *Burlington Magazine*, cvii (November 1965), 597.

GORMLEY, A. 'The Sacred and the Profane in the Art of Stanley Spencer,' *Stanley Spencer*. Exhibition Catalogue, Arts Council (1976), 21-3.

GRAVES ART GALLERY. *The Forgotten Fifties*. Exhibition Catalogue (March 1984).

GRAY, ANNE. 'A Portrait of Stanley Spencer – and Henry Lamb,' *The Art Gallery of Western Australia: Bulletin* (1980), 26-33.

GRIFFITHS, SARAH. 'Introduction,' *John Currie*, Exhibition Catalogue, Stoke on Trent, City Museum and Art Gallery (1980), np.

HAMILTON, G.H. *Painting and Sculpture in Europe 1880-1940*. Harmondsworth: Penguin Books, 1967.

HARRISON, CHARLES. *English Art and Modernism 1900-1939*. London: Allen Lane, 1981.

HASSALL, C. *Edward Marsh, Patron of the Arts: A Biography*. London: Longmans, 1959.
—— ed. *Ambrosia and Small Beer. The Record of a Correspondence between Edward Marsh and Christopher Hassall*. London: Longmans, 1964.

HAWKINS, J., HOLLIS, M., eds. *Thirties. British Art and Design Before the War*. Exhibition Catalogue, Hayward Gallery, 1979.

HAYES, C. *Scrapbook Drawings of Stanley Spencer*. London: Lion and Unicorn Press, Royal College of Art, 1964.

'H.L.C'. Review of the Goupil Gallery exhibition. *Graphic*, 12 March 1927.

HOLROYD, MICHAEL. *Augustus John*. Harmondsworth: Penguin, 1979.

HONE, JOSEPH. *The Life of Henry Tonks*. London: Heinemann, 1939.

HORTON, PERCY. 'The Revival of Mural Painting,' *Studio*, 556 (July 1939), 2-13.
—— 'War as Inspiration to the Artist,' *Studio*, 560 (November 1939), 226-35.
—— 'The Ruskin School of Drawing and Fine Art,' *Studio*, 644 (November 1946), 178-83.

HUGHSON, JOAN. 'Introduction,' *Stanley Spencer, War Artist on Clydeside, 1940-45*. Exhibition Catalogue, Glasgow, Scottish Arts Council (1975).

HUTCHINSON, S.C. *The History of the Royal Academy 1768-1968*. London: Chapman and Hall, 1968.

HYMAN, TIMOTHY, 'The Sacred Self,' in *Stanley Spencer: The Apotheosis of Love*. London: Barbican Art Gallery, 1991, 29-33.

IRONSIDE, ROBIN. *Painting Since 1939*. Harmondsworth: Penguin, 1947.

JEFFREY, IAN. *The British Landscape 1920-1950*. London: Thames and Hudson, 1984.

JOHNSON, CHARLES. *English Painting from the*

Seventeenth Century to the Present Day. London: Bell, 1932.

JOHNSON, ROBIN. 'Stanley Spencer: Shipbuilding on the Clyde,' *Stanley Spencer*. Exhibition Catalogue, Arts Council (1976), 24-5.

G.L.K [KENNEDY]. *Henry Lamb*. London: Ernest Benn, 1924.

KENNEDY, B. 'Stanley Spencer: a recently discovered Crucifixion,' *Burlington Magazine.*, cxxiii, (November 1981), 672-5.

KLEPAC, LOU. 'Perth's Great Spencer,' *The Art Gallery of Western Australia: Bulletin* (1979), 4-9.

KONODY, P.G. 'The NEAC,' *Observer*, 4 January 1920.
—— 'Mr Stanley Spencer's Great "Resurrection",' *Observer*, 6 March, 1927.
—— 'Modern British Painting,' *Studio Special Number* (1931).

LAUGHTON, BRUCE. 'Introduction,' *The Slade 1871-1971*. Exhibition Catalogue, RA (1971), 3-11.

LEDER, CAROLYN. 'Influences on the Early Work of Stanley Spencer,' *Stanley Spencer*, Exhibition Catalogue, Arts Council (1976), 14-17.
—— *Stanley Spencer, The Astor Collection*. London: Thomas Gibson, 1976.

LEVY, M. *The Paintings of D.H. Lawrence*. London: Cory, Adams and Mackay, 1964.

LEWIS HIND, C. *Landscape Painting from Giotto to the Present Day,. vol. ii: From Constable to the Present Day*. London: Chapman and Hall, 1924.

LEWIS, WYNDHAM. 'Stanley Spencer,' *Listener* (18 May 1950).
—— 'Fifty Years of Painting: Sir William Rothenstein's Exhibition,' *Apollo* (March 1970), 218-23.

LLEWELYN, SIR WILLIAM. 'ARA's Rejected Pictures,' *Times Weekly Edition*, 2 April 1934.

MACCARTHY, FIONA. *Stanley Spencer: An English Vision*. New Haven: Yale University Press, 1997.

MACCOLL D.S. 'Super and Sub Realism, Mr Stanley Spencer and the Academy,' *The Nineteenth Century and After*, cxvii (June 1935).

MARSH, SIR E.H. *Rupert Brooke: a memoir*. London: Sidgwick, 1918.
—— *A Number of People: A Book of Reminiscences*. London: Heinemann, 1939.

MATTHEWS, D. 'The Sir Edward Marsh Bequest to the Contemporary Art Society,' *Studio* 725 (August 1953), 33-9.

MIDDLETON, TOM. 'Spencer R.A. – Happy and Humble,' *She*, July 1959, 50-1.

MILLAIS, J.G. *The Life and Letters of Sir John Everett Millais*. London: Methuen, 1899.

MORRIS, LYNDA, ED. *Henry Tonks and the 'Art of Pure Drawing,'* Exhibition Catalogue, Norwich School of Art Gallery (nd), 7-56.

MUNNINGS, SIR ALFRED. Letter, *Daily Telegraph*, 20 July, 1950 (see also *Daily Express*, 6 October 1950).

'N'. 'The Rejected Stanley Spencer Paintings at Tooth's,' *Guardian*, 30 April, 1935.

NASH, PAUL, STANLEY SPENCER, DAVID LOW, ET AL. *Sermons by Artists*. London. Golden Cockerell Press, 1934.

NASH, PAUL. *Outline, an Autobiography and Other Writings*. London: Faber, 1949.

NEAVE, C. 'Sacred and Profane Resurrection: A Changing View of Stanley Spencer,' *Country Life*, clx (23 September, 1976), 796-7.
—— 'What a day for a daydream: Stanley Spencer,' *Country Life*, clxviii (9 October, 1980), 1252-4.
—— 'In Gilbert Spencer Country,' *Country Life*, clvi (18 July 1974), 152-3.
—— *Unquiet Landscape. Places and ideas in 20th century English Painting*. London: Faber and Faber, 1990, 20-40.

NEVINSON, C.R.W. *Paint and Prejudice*. London: Methuen, 1937.

NEWS CHRONICLE, 19 May, 1958, 'No Controversy please, Stanley Spencer wants quiet reception for his "Crucifixion."'

NEWTON, ERIC. 'The Inner and the Outer Eye' (the Zwemmer exhibition), *Sunday Times*, 19 December 1937.
—— 'War Artists Exhibition,' *Sunday Times*, 22 August, 1943.
—— *Stanley Spencer*. Harmondsworth: Penguin, 1947.
—— Commentary on the RA Spencers. *Sunday Times*, 7 May 1950.

OLIVER, W.T. Review of the RA Summer exhibition, *Yorkshire Post*, 29 April 1950.

OTTAWA. National Gallery of Canada, *Catalogue Vol. 2, Modern European Schools*, 1959.

POPLE, KENNETH. STANLEY SPENCER: *A Biography*. London: Collins, 1991.
—— 'Stanley Spencer's Paintings,' *Manchester Guardian Weekly*, 5 June, 1958.

QUEEN, 'A Day with Stanley Spencer,' 1 July, 1958.

RAWSON, I.M. 'Patrons of Talent: the Behrends at Burghclere,' *Country Life*, clxiv (26 October, 1978), 1347-9.

READ, H. *Art Now. An Introduction to the Theory of Modern Painting and Sculpture*. London: Faber, 1933.
—— *Contemporary British Art*. Harmondsworth: Penguin Books, 1951.

ROBERTS, W. *A Press View at the Tate Gallery.* London, 1956.

ROBINSON, D. 'The Oratory of All Souls, Burghclere,' *Stanley Spencer,* Exhibition Catalogue, Arts Council (1976), 18-22.

—— *Stanley Spencer: Visions from a Berkshire Village.* Oxford and London: Phaidon Press, 1979.

—— *Stanley Spencer.* Oxford: Phaidon Press, 1990.

—— *Stanley Spencer: A Modern Visionary.* Exhibition Catalogue, Yale Center for British Art, New Haven, Connecticut, 1981.

RODKE, JOHN. 'The New Movement in Art,' *The Dial Monthly,* 17 (May 1914) 176.

ROSS, ALLAN. 'War paint. Allan Ross discusses the art of war, focusing on one of the greatest works of the 20th century, Stanley Spencer's cycle at Burghclere,' *Royal Academy Magazine,* no. 14, 1987, 28-30.

ROSS, R.M. *The Georgian Revolt. Rise and Fall of a Poetical Ideal 1910-22.* London, 1967.

ROTHENSTEIN, E. *Stanley Spencer.* Oxford and London: Phaidon Press, 1945.

—— 'Portrait of the Artist No. 34, Stanley Spencer,' *Art News and Review* (3 June 1950), 1.

—— *Stanley Spencer.* London: Express Art Books, 1962.

—— *Stanley Spencer.* London: Purnell, 1967.

ROTHENSTEIN, SIR JOHN. 'Stanley Spencer,' *Apollo* v, 28 (April 1927), 162-6.

—— *British Artists and the War.* London: Peter Davies, 1931.

—— 'Stanley Spencer,' *Picture Post* (8 April, 1939).

—— 'State Patronage of Wall Painting in America,' *Studio,* 604 (July 1943), 1-10.

—— 'The Genius of Stanley Spencer,' *The Tablet,* 3 December, 1955.

—— 'Art in our Churches,' *Picture Post,* 19 May, 1956.

—— *British Art Since 1900.* Oxford and London: Phaidon Press, 1962.

—— *Summers Lease, Autobiography I.* London: Hamish Hamilton, 1966.

—— *Brave Day Hideous Night, Autobiography II.* London: Hamish Hamilton, 1966.

—— *Time's Thievish Progress, Autobiography III.* London: Cassell, 1970.

—— *Modern English Painters.* London: Macdonald and Jane's, 1976.

—— ed. *Stanley Spencer the Man: Correspondence and Reminiscences.* London: Paul Elek, 1979.

—— *John Nash.* London: Macdonald and Co., 1983.

ROTHENSTEIN, SIR WILLIAM. *Men and Memories Vol.II.* London: Faber and Faber, 1932.

—— *Since Fifty. Men and Memories, vol. ii, 1928-1938. Recollections of Sir William Rothenstein.* London: Faber, 1939.

—— 'Forty Years Evolution in the Fine Arts,' *Studio* (March 1933), 216-31.

ROYAL ACADEMY. *Royal Academy Illustrated* (1907 and subsequently).

—— *Royal Academy Exhibitors 1905-70: A Dictionary of Artists and their Work in the Summer Exhibitions of the Royal Academy of Arts, Vol. 6: Sherraf-Z.* London: EP, 1982.

RUSKIN, JOHN. *King of the Golden River.* New York: John Wiley and Sons, 1882.

—— *Modern Painters.* London: Dent, 1906.

—— *The Seven Lamps of Architecture.* London: Dent, 1907.

RUTTER, F. *Some Contemporary Artists.* London: Leonard Parsons, 1922.

—— Review of the Goupil Gallery exhibition, *Sunday Times,* 27 February 1927.

—— 'Stanley Spencer's Puzzle,' *Sunday Times,* 28 February, 1927.

—— *Evolution in Modern Art: A Study in Modern Painting.* London: Harrap, 1927.

—— 'Goupil Salon', *The Times,* 1 November 1931.

—— *Art in My Time.* London: Rich and Cowan, 1933.

—— 'Storm in a Paintbox,' *The Times,* 28 April 1936.

—— 'British Art Abroad,' *Sunday Times,* 28 June, 1936.

—— 'Facts and Fancies. Stanley Spencer's Puzzle,' *Sunday Times,* 28 February 1937.

SADLER, SIR MICHAEL, ed. *The Arts of West Africa.* London, 1935.

SADLER, MICHAEL. *M.E. Sadler.* London: Constable, 1949.

SALIS, JOHN ['JAN GORDON']. 'Stanley Spencer,' *Studio,* 126 (August 1943), 50-3.

SEABROOKE, ELLIOT. 'The London Group,' *Studio,* 129 (February 1945), 33-45.

SHEPHERD, MICHAEL, 'Resurrection Day,' *Sunday Telegraph,* 21 September, 1980.

SHEWRING, WALTER. 'Stanley Spencer to Desmond Chute: Extracts from Letters of 1916-26,' *Apollo* (June 1966), 460-7.

SHONE, RICHARD. *Bloomsbury Portraits.* London: Phaidon Press, 1976.

—— *A Century of Change: British Painting Since 1900.* London: Phaidon, Press, 1977.

SICKERT, W. Letter to the editor, *Daily Telegraph,* 29 April 1935.

SOBY, J.T. *Contemporary Painters.* New York: Museum of Modern Art, 1948.

SORRELL, MARY. 'A Day With Stanley Spencer,' *Queen* (1 July 1953).

—— 'The Loved World of Stanley Spencer,' *Studio,* cxlvii (February 1954), 33-9.

SPALDING, JULIAN. 'Royal Academy: Stanley Spencer,' *Burlington Magazine,* cxxii (November 1980), 788-91.

SPALDING, F. 'Sacred and Profane: the Vision of Stanley Spencer,' *Connoisseur,* ccv (November 1980), 168-75.

—— *Roger Fry: Art and Life.* Berkeley: University of California Press, 1980. et al. *Mark Gertler: the Early and the Late Years.* Exhibition Catalogue, London, Ben Uri Art Gallery (1982), 3-18.

—— et al. *Landscape in Britain 1850-1950.* Exhibition Catalogue, Arts Council (1983), 9-44.

SPEAIGHT, ROBERT, WILLIAM ROTHENSTEIN. *The Portrait of an Artist in his Time.* London: Eyre and Spottiswoode, 1962.

—— *The Life of Eric Gill.* London: Methuen, 1966.

SPENCER, GILBERT. *Stanley Spencer.* London: Gollancz, 1961.

—— *Memoirs of a Painter.* London: Chatto and Windus, 1974.

SPENCER, STANLEY. *A Letter, The Game,* 1 (Corpus Christi 1919), 1-8 (republished as *A Letter from Stanley Spencer,* in a limited edition of 150 copies printed by the Cygnet Press for Anthony d'Offay, Christmas 1978).

—— *Almanac.* London: Chatto and Windus, 1926 (with illustrations by Stanley Spencer).

—— 'Footnote on Sarah Tubb,' *Carnegie Magazine,* 7 (November 1933), 184.

—— 'A Note on "Burners", "Welders" and "Riveters."' Catalogue of an exhibition of war subjects circulated by the Ministry of Information for showing in schools. First Selection, March 1942.

—— 'Lone Journey,' *Pavement,* 1 (May 1946), 3-4.

—— 'Domestic Scenes. Seven New Drawings by Stanley Spencer,' *The Saturday Book,* 6th Year. London: Hutchinson, 1946, 249-56.

—— 'Introduction,' *Stanley Spencer, A Retrospective Exhibition.* Catalogue, Tate Gallery (1955).

—— 'The Painter's Progress. Thinking over ideas for pictures,' *The Times,* 5 November 1955.

STEYN, JULIET. 'Review of How New York Stole the Idea of Modern Art: Abstract Expressionism, Freedom and the Cold War,' *Oxford Art Journal,* 7:2 (1985).

STURROCK, ALEC. 'Artists at the Seaside,' *Scottish Arts Review* (1955).

SURTEES, VIRGINIA. *The Paintings and Drawings of D.G. Rossetti. A Catalogue Raisonné* Oxford: Clarendon Press, 1971.

SUTTON, DENYS. *The Letters of Roger Fry.* 2 vols. London: Chatto and Windus, 1972.

SYLVESTER, DAVID. 'Two Painters: Stanley Spencer and Lucien Freud,' *Britain Today,* 171 (July 1950), 36-9.

—— 'Introduction,' *Drawings by Stanley Spencer.* Exhibition Catalogue (1954).

SWAFFER, HANEN. 'Artist Triumphs after 15 Years,' *Daily Herald,* 29 April 1950.

TATE GALLERY. *Catalogue. Modern British Painters,* vol. 2, N-Z, London: Oldbourne, 1964.

TAYLOR, BASIL. 'Two Painters,' *New Statesman* (20 May 1950), 572.

THOREAU, H.D. *Walden: or, Life in the Woods.* New York: Potter, 1970.

TOOK, ROGER. 'Heaven on Earth: Stanley Spencer's "Church House" Exhibition catalogue,' CDS Gallery, New York (1983), np.

TORONTO, ART GALLERY OF ONTARIO. *Ilustrations of Selected Paintings and Sculptures from the Collection,* 1959.

TUDOR-HART, P. 'Colour Harmony,' *Cambridge Magazine* (January-March 1921), 106-9.

VAIZEY, MARINA. 'Stanley Spencer: The Making of a Visionary,' *Sunday Times,* 21 September 1980.

—— 'An everyday story of artistic folk,' *Sunday Times,* 5 October 1978.

—— 'A Life of Wedlock,' *Guardian,* 28 April, 1979.

WADSWORTH ATHENAEUM. *Bulletin,* 28 (December 1957), 7.

WADSWORTH, E. 'The Abstract Painter's own Explanation,' *Studio* (November 1933), 274-6.

—— *Edward Wadsworth 1889-1949. Paintings and Drawings.* Exhibition Catalogue, P. and D. Colnaghi, 1974.

WALEY, D.P.G. 'Two Stanley Spencer Letters from Salonika,' *British Library Journal,* 3 (Autumn 1977), 167-8.

WARNER, E. AND HOUGH, G. *Strangeness and Beauty: An Anthology of Aesthetic Criticism, 1840-1910,* Cambridge, Cambridge University Press, 1983.

WATNEY, S. *English Post-Impressionism.* London: Trefoil Books, 1981.

WEES, WILLIAM. *Vorticism and the English Avant Garde.* University of Toronto Press, 1972.

WEIGHT, CAREL. 'The Resurrection, Cookham,' *Listener* (16 February 1961).

WHITE, GILBERT. *The Natural History of Selbourne.* London: Methuen, 1906.

WHITTET, G.S. 'The Royal Academy', *Studio,* 725 (August 1953), 40-3.

WIENER, MARTIN J. *English Culture and the Decline of the Industrial Spirit 1850-1980.* Cambridge University Press, 1981.

R.H.W. [WILENSKI]. *Stanley Spencer.* London: Ernest Benn, 1924.

—— 'Artists Whom the Royal Academy Ignores,' *Harpers Bazaar* (January 1931).

—— *English Painting.* London: Faber, 1933.

—— *Stanley Spencer: Resurrection Pictures.* London: Faber, 1951 (Notes by the artist).

—— *The Modern Movement in Art.* London: Faber, 1927 (revised ed., 1945).

WILSON, S. *British Art from Holbein to the Present Day.* London: Bodley Head, 1979.

WOODESON, JOHN. *Mark Gertler. Biography of a Painter, 1891-1938.* University of Toronto Press, 1973.

WOODWARD, JOHN. *A Pictorial History of British Painting.* London: Vista, 1962.

YORKE, M. *Eric Gill: Man of Flesh and Spirit.* London: Constable, 1982.

Unpublished Research on Stanley Spencer

GORMLEY, A. 'The Sacred and Profane in the Art of Stanley Spencer.' BA Thesis, Department of History of Art, University of Cambridge, 1972.

LEDER, C. 'The Early Work of Sir Stanley Spencer: An Examination of the Influences on His Art.' MA Report, Courtauld Institute of Art, 1968.

Unpublished Sources

TATE GALLERY ARCHIVES: Spencer Collection, 733 series.

TATE GALLERY ARCHIVES: Letters between Spencer and Henry Lamb, Florence Image, James Wood, Richard Carline, TAM series.

TATE GALLERY ARCHIVES: Uncatalogued Spencer-Carline papers contained in boxes 825 and 8212.

IMPERIAL WAR MUSEUM ARCHIVES: Spencer war artist files from the First and Second World Wars.

ARTHUR TOOTH AND SONS (now Tooth Paintings): Spencer-Tooth correspondence. Now in the Tate Gallery Archives.

RICHARD CARLINE PAPERS (given in part to the Tate Gallery Archives, boxes 825 and 8212).

STANLEY SPENCER GALLERY, Cookham: Spencer-Chute correspondence.

GLASGOW UNIVERSITY LIBRARY, Special Collections: D.S. MacColl Papers.

Acknowledgements

The publishers are grateful to all museums, institutions and private owners who have given permission for works in their possession to be reproduced and who have kindly provided photographs. We would particularly like to thank Mr Gardner-Medwin, Trustee of the Stanley Spencer Gallery in Cookham-on-Thames, which is devoted exclusively to the work of the artist and is open to the general public daily from Easter to October, and weekends and Bank Holidays only from November to Easter.

Sources of Photographs

Barbican Art Gallery: 162, 192, 195, 222, 246, 307, 358h, 360, 413, 414, 450; Bridgeman Art Library: 292; Browse & Darby: 40, 215, 388, 434; Christie's: 41, 166, 191, 205, 240, 297, 298, 351, 362, 368, 410, 452; Anthony d'Offay Gallery: 184; Ferens Art Gallery: Hull City Museums and Art Galleries: 112, 165; Courtesy Thomas Gibson Fine Art Ltd.: 198, 329; Bernard Jacobson Gallery: 37, 156, 176, 194, 212, 214, 241, 344, 358c, 364, 373, 396, 433; Peter Nahum London: 423; The Board of Trustees of the National Museums & Galleries on Merseyside: 140; The National Trust Photographic Library: 130a-s; Royal Academy of Arts: 30, 128e; Max Rutherston: 58; Sotheby's: 51, 59, 67, 80, 102, 144, 242, 291, 357, 380, 383, 386, 441; Spink and Son Ltd.: 190, 306; Stanley Spencer Gallery: 446, p.77; Tooth photograph archive, collection Simon Matthews: 36, 180, 226, 247, 257, 293, 297, p.57, p.194, p.350; By courtesy of Warwick District Council Museum Service: 265.

Photographers: Chris Andrews, A.C. Cooper Ltd., Prudence Cuming Associates, Stephen Curtis, Studio Edmark Photography, Eye of Man Photography, Anderson McMeekin, David Nicholls, Clare Pawley, Joe Rock, Angus Smith.